TURNER
AND THE SUBLIME

ANDREW WILTON

TURNER
AND THE SUBLIME

The University of Chicago Press

COVER ILLUSTRATION: J. M. W. Turner, *The Upper Fall of the Reichenbach: rainbow* (Yale Center for British Art, Paul Mellon Collection)

The University of Chicago Press, Chicago 60637
British Museum Publications Ltd., London WC1B 3RA

© 1980 Art Gallery of Ontario and the Yale Center for British Art
All rights reserved. Published 1980
Phoenix edition 1981
Printed in England

87 86 85 84 83 82 81 1 2 3 4 5

Library of Congress Cataloging in Publication Data
Wilton, Andrew
 Turner and the sublime.
 Originally published in 1980 by British Museum Publications for an exhibition held at the Art Gallery of Ontario, Nov. 1, 1980–Jan. 4, 1981; Yale Center for British Art, Feb. 11–Apr. 19, 1981; and the British Museum, May 15–Sept. 20, 1981.
 Bibliography: p.
 Includes index.
 1. Turner, Joseph Mallord William, 1775–1851 – Exhibitions.
I. Art Gallery of Ontario. II. Yale Center for British Art.
III. British Museum. IV. Title.
N6797.T88A4 1981 760'.092'4 80–28398
ISBN 0-226-06189-2

CONTENTS

	Author's Acknowledgments		*page 6*
	Photographic Acknowledgments		*6*
	Preface		*7*
ONE	The Classic Sublime		*9*
TWO	The Landscape Sublime		*25*
THREE	The Turnerian Sublime		*65*
	Conclusion		*104*
CATALOGUE	Notes to the Catalogue		*106*
	The Picturesque Sublime	*nos* 1–11	*109*
	The Architectural Sublime	12–17	*113*
	The 'Terrific'	18–39	*116*
	The Historical Sublime	40–54	*133*
	The Sea	55–69	*145*
	Darkness	70–80	*155*
	Cities	81–93	*165*
	Mountains	94–106	*173*
	Lakes	107–123	*181*
	Bibliography		*189*
	Concordance		*190*
	Index		*191*

AUTHOR'S ACKNOWLEDGMENTS

This book and the exhibition it accompanies owe their inception to the enthusiasm and energy of Katharine Jordan Lochnan, Curator of Prints and Drawings at the Art Gallery of Ontario; I am very grateful to her and to the Art Gallery's Director, William Withrow, for inviting me to organise the exhibition and for encouragement and help throughout the undertaking. The work could never have been completed in the time available without the unstinted support of my own Director, Edmund Pillsbury, who has been exceptionally indulgent in enabling me to write the text with the minimum of interruptions. John Gere, Keeper of Prints and Drawings at the British Museum, has likewise made my task as pleasant as possible by his amiable co-operation.

Several people have helped me considerably by being willing to discuss the subjects of Turner and the Sublime, and I am grateful to all of them for their ideas. David Bindman, Joan Friedman and Stephen Parks drew my attention to items which I have found particularly useful. Walter Amstutz of de Clivo Press, Zürich, has kindly made available two colour transparencies, originally made for his *Turner in Switzerland* (1976).

Where the practical details of assembling material and preparing it for the press are concerned, my debts are numerous. I should particularly like to thank Angela Bailey, Dolores Gall, Michael Marsland, Patrick Noon, Joe Szaszfai, Christopher White and Lib Woodworth for all their efforts in making and collecting photographs, typing and reading the text, and providing moral support under pressure. Stephanie Kosarin, Ursula Dreibholz and Mark Walas assembled, cleaned and mounted items at Yale, and at the British Museum Ann Forsdyke, Martyn Tillier and Reginald Williams have been constantly ready to deal with problems as they arose. Finally, I must express my gratitude to the staff of British Museum Publications for their efficient dispatch of the book itself; especially Michael Hoare, Celia Clear and Susan Leiper.

ANDREW WILTON

Photographic Acknowledgments

The author and publishers would like to thank the following institutions and individuals for their kind permission to reproduce photographs:
Art Gallery of Ontario, Toronto: Colour 7; British Museum, London: 7, 12–14, 16, 18–22, 30, 31, 40, 45–7, 50, 55, 59–61, 66, 75, 80, 82, 89, 94, 96, 98, 100, 102, 103, 107, 112, 114, 118, 121, Colour 1, 3–6, 8–10, 12, 14, 15–17, 19, 21–3, 25, 27, 28, 30–2, FIGS I, V, XI; de Clivo Press, Switzerland: Colour 24, 26; Henry E. Huntington Library and Art Gallery, San Marino, California: FIG. III; Museum of Fine Arts, Boston: FIG. XVI; National Trust, Uppark (photo by courtesy of the Courtauld Institute of Art, London): FIG. IX; Private Collection, U.S.A.: Colour 29; Royal Academy of Arts, London: FIG. X; Städelsches Kunstinstitut, Frankfurt am Main: FIG. XII; the Tate Gallery, London: FIGS VII, VIII, XIII, XV; Yale Center for British Art, Paul Mellon Collection: 9–11, 24–6, 32–9, 42–4, 48, 49, 52–4, 56–8, 62–5, 67, 68, 70–4, 76–9, 81, 83, 84, 86, 87, 93, 95, 101, 108, 110, 111, 113, 122, 123, Colour 2, 11, 13, 18, 20, FIGS II, IV, VI, XIV.

PREFACE

This exhibition explores one aspect of Turner's art, in watercolours, drawings and prints. The Sublime as an aesthetic concept has been discussed by numerous writers, and Turner's own interest in the theory as propounded in the eighteenth century by Edmund Burke and others has often been noted. But far from being bound by any theoretical conceptions, he used these as the starting-point for a whole series of technical and artistic innovations. Turner made many very large watercolours which emulated the grandeur and importance of oil-paintings. Several of these, together with their no less impressive full-scale preparatory studies, are included in this exhibition, some being shown for the first time. The most significant paintings in the genre of the Sublime are represented by fine impressions of prints, often engraved under the close supervision of Turner himself.

There have been many exhibitions of Turner's art in recent years, but none has attempted to define his relationship to theories of the Sublime. Andrew Wilton's introduction discusses Turner's training and early career in the light of traditional attitudes to the Sublime, and goes on to consider the mature Turner's use of them for his own ends. The selection of works is mostly drawn from the rich resources of the Turner Bequest, at present deposited in the British Museum, but also includes watercolours and a large group of prints from the Paul Mellon Collection at Yale, together with some works belonging to private owners and to the University of Toronto. We are very grateful to the Trustees of the British Museum and other lenders for their co-operation and generous support. We are also greatly indebted to Andrew Wilton, author of the excellent catalogue, and Katharine Jordan Lochnan, Curator of Prints and Drawings at the Art Gallery of Ontario, who jointly conceived the exhibition and brought it to fulfilment.

J. A. GERE,
Keeper, Department of Prints and Drawings, The British Museum

EDMUND P. PILLSBURY,
Director, Yale Center for British Art

W. J. WITHROW,
Director, Art Gallery of Ontario

The fact is, that sublimity is not a specific term – not a term descriptive of the effect of a particular class of ideas. Anything which elevates the mind is sublime, and elevation of mind is produced by the contemplation of greatness of any kind; but chiefly, of course, by the greatness of the noblest things. Sublimity is, therefore, only another word for the effect of greatness upon the feelings – greatness, whether of matter, space, power, virtue, or beauty: and there is perhaps no desirable quality of a work of art, which, in its perfection, is not, in some way or degree, sublime.

RUSKIN, *Modern Painters*, 1843, Book I, Section II, chapter 3

THE CLASSIC SUBLIME

All the different Degrees of Goodness in Painting may be reduc'd to these three General Classes. The Mediocre, or Indifferently Good, the Excellent, and the Sublime. The first is of a large Extent; the second much Narrower; and the Last still more so . . . I take it to consist of some few of the Highest Degrees of Excellence in those kinds, and Parts of Painting which are excellent; the Sublime therefore must be Marvellous, and Surprising. It must strike vehemently upon the Mind, and Fill, and Captivate it irresistibly.

JONATHAN RICHARDSON: *The Connoisseur*, 1719

There is, indeed, an originality of so high a class, that too few are the minds able to comprehend its excellence: I mean that which shows itself in the highest department of art, which we term the grand style. Of this style it may be asserted, that, although it appeal to us with great and commanding powers, though it convey a sentiment the most awful and impressive, yet it speaks a language so little cultivated or even rudely known, that none but minds the most highly enlightened can be made fully sensible of its essence.

JAMES NORTHCOTE: *The Artist*, 1807

In 1840, when James Fenimore Cooper was introducing his readers to one of his romances of the lakes and forests of North America, he began with this pronouncement: 'The sublimity connected with vastness is familiar to every eye.' He did not mean simply that it is pleasant to stand at a suitable vantage-point and enjoy a good view. Looking at landscape in the early nineteenth century was more complicated than that, a process accompanied by a host of mental events that took the sightseer far beyond the material circumstances of the scene – beyond, even, the confines of this world altogether: 'The most abstruse, the most far-reaching, perhaps the most chastened of the poet's thoughts,' Cooper goes on, 'crowd on the imagination as he gazes into the illimitable void. The expanse of the ocean is seldom seen by the novice with indifference; and the mind, even in the obscurity of night, finds a parallel to that grandeur, which seems inseparable from images that the senses cannot compass.'[1]

By invoking the notion of the sublime, Cooper was giving his novel a frame of reference that presupposed an almost unlimited extension of ideas by association. He was encouraging his reader to consider the story in the most serious light as a profoundly significant statement about life and the conditions of human existence. Although he begins by speaking of vastness, he quickly progresses to more general ideas, of grandeur, of illimitability, of obscurity; ideas so abstract, indeed, that we may wonder what exactly they imply.

Cooper is using the word 'sublime' in a sense very distant from its modern colloquial one, as in phrases like 'sublimely unconscious of danger' or 'sublime indifference to the feelings of others'; though these applications of the word do carry a suggestion of superiority, even if only the blissful superiority of ignorance, which retains some vestigial hint of the full meaning of the term. Not that the expression in its full sense (or senses) is entirely obsolete now; but it has probably lost much of the force that it used to possess, if only because many of its applications assume an attitude to the world, and to its creator, which is now moribund or at least dormant.

Nowadays it is usually literary historians who talk about the Sublime; and they do so very much in an archaeological spirit. But in the early nineteenth century, and for

at least two centuries before that, the term was often used to express a whole range of important ideas, and was endlessly debated and redefined by scholars and critics. They were ready with long and elaborately categorised interpretations to demonstrate that in this one word all that is most significant to the human mind and consciousness is neatly packed. Not so neatly that they could not argue about details; but the main points remained settled for most of the period. Naturally the meaning of the word changed to some extent. We shall be examining some of the ways in which it did so. But one thing everyone was sure about: the sublime 'produces a sort of internal elevation and expansion; it raises the mind much above its ordinary state; and fills it with a degree of wonder and astonishment, which is certainly delightful; but it is altogether of the serious kind: a degree of awfulness and solemnity, even approaching to severity, commonly attends it when at its height; very distinguishable from the more gay and brisk emotions raised by beautiful objects.'[2]

The reference to 'beautiful objects' betrays that this quotation is of relatively late date. For by tradition the sublime had been discussed primarily in connection with literature. It was in the context of rhetoric and poetry that it was treated as early as the first century AD by an unidentified writer in Greek who is known as Longinus, and who contributed the first substantial definition of the word.

'Longinus observes,' says an eighteenth-century commentator, 'that the effect of the sublime is *to lift up the soul; to exalt it into ecstasy; so that, participating, as it were, of the splendors of the divinity, it becomes filled with joy and exultation; as if it had itself conceived the lofty sentiments which it heard.*'[3] 'All sublime feelings,' the same writer says elsewhere, 'are, according to the principles of Longinus, . . . feelings of exultation and expansion of the mind, tending to rapture and enthusiasm; and whether they be excited by sympathy with external objects, or arise from the internal speculations of the mind, they are still of the same nature. In grasping at infinity,' he continues, offering an exact philosophical parallel to the thoughts of Cooper that we have already considered, 'the mind exercises the powers . . . of multiplying without end; and, in so doing, it expands and exalts itself, by which means its feelings and sentiments become sublime.'[4]

These remarks occur in Richard Payne Knight's *Analytical Inquiry into the Principles of Taste*, published in 1805. The word 'taste' itself seems to have enjoyed a more complex use in Payne Knight's time than it does now. We should hardly include in our own discussions of taste such matters as the higher contemplations of philosophers or scientists, but these activities certainly implied, to the eighteenth century, an elevated state of the 'affections' of the mind, and therefore a superior 'taste'. Payne Knight was far from unusual in grouping the sublime with other topics under the general heading of 'taste'. Most accounts of it published in Britain occur in general essays on aesthetics, or in philosophical treatises. The topic was well suited to the new intelligentsia of eighteenth-century England, a class of educated and thoughtful people eager to get to grips with important ideas, to assemble, regulate and assess the mass of information that was becoming increasingly accessible to them about the arts and sciences, the historical past and the ever-expanding universe. It is no accident that the whole fashion for discussions of taste, including the concept of the sublime, was instigated by a popular journal – Joseph Addison's *Spectator*.

In eleven numbers of June and July 1712 Addison published a long essay *On the Pleasures of the Imagination*, a masterly example of the educational popularising of serious ideas that he excelled in. Nearly all the matter of the later expositors and quibblers can be found, in more or less complete and lucid form, in Addison's essay. The word 'sublime' itself hardly occurs – though it does so once, in a significant context, as we shall see – but all the same, Addison manages to cover most of the ground trodden by subsequent writers. These, although they borrowed extensively from Addison, modelled themselves on the more august precedent set by John Locke

in his *Essay Concerning Human Understanding*, which had appeared in 1689, offering new insight into the nature of our perception of the external world. They were anxious to apply its methods, and even some of its concepts, to their own preoccupations; and they tended to set their meditations in a broad context which ranged through all the branches of knowledge.

The purpose of this book is to show not only that the sublime was a philosophical concept rigorously and repeatedly analysed by theorists, but that it was felt to have a vital relevance to the creative practice of artists as well as writers in the period immediately before and during Turner's lifetime (1775–1851). In particular, we shall, I hope, see that Turner himself, who is often thought of as a painter sublimely free (I use the phrase deliberately) of the fetters of eighteenth-century theory, was fully aware of the idea and its implications, and indeed built his art upon a foundation, and in a philosophical context, established by the theorists of the sublime.

Although Turner was able to put the theory to new and vital use, by his time it was, as we have already seen, thickly overgrown with the learned argument and dry exegesis of scholars. We must try to disentangle the principle themes from the muddle they have left. It is logical and convenient to begin with Addison. He says that pleasure proceeds 'from the sight of what is great, uncommon, or beautiful'.[5] Note that he is explicitly concerned with pleasures perceived by the *eye*. This may be why he does not use the term 'sublime', which at the period still applied more usually to works of literature than to visual things.[6] He distinguishes between the pleasures of the imagination and those of the understanding, and includes under both heads what was later to be termed the sublime. 'One of the final causes of our delight in anything that is great may be this,' he says. 'The Supreme Author of our being has so formed the soul of man, that nothing but Himself can be its last, adequate, and proper happiness. Because, therefore, a great part of our happiness must arise from the contemplation of his being, that he might give our souls a just relish for such a contemplation, he has made them naturally delight in the apprehension of what is great or unlimited. Our admiration, which is a very pleasing motion of the mind, immediately rises at the consideration of any object that takes up a great deal of room in the fancy, and, by consequence, will improve into the highest pitch of astonishment and devotion when we contemplate his nature . . .'[7]

This leads Addison into a somewhat circular argument to the effect that God has formed man in such a way that he finds pleasure in external objects which were created to be pleasurable – it is by a dispensation of God, and not through our own discrimination, that we perceive beauty in objects that are in any case beautiful. But the element of religious feeling contained in the notion of the sublime is very important. In words that recall those of some of his own hymns, Addison speaks of the pleasures of contemplating the grandeur of space:

> When we survey the whole earth at once, and the several planets that lie within its neighbourhood, we are filled with a pleasing astonishment, to see so many worlds, hanging one above another, and sliding round their axles in such an amazing pomp and solemnity. If, after this, we contemplate those wild fields of ether, that reach in height as far as from Saturn to the fixed stars, and run abroad almost to an inifinitude, our imagination finds its capacity filled with so immense a prospect, and puts itself upon the stretch to comprehend it. But if we rise yet higher, and consider the fixed stars as so many vast oceans of flame, that are each of them attended with a different set of planets, and still discover new firmaments and new lights that are sunk further into those unfathomable depths of ether, so as not to be seen by the strongest of our telescopes, we are lost in such a labyrinth of suns and worlds, and confounded with the immensity and magnificence of nature.[8]

The sublime of science and the sublime of theology here unite in a supreme ecstasy of contemplation. Later writers were to point out that the mere mathematical idea of numerical ascent carried with it sublime connotations.[9] But the impalpable 'immen-

sity and magnificence of nature' is more commonly brought forward as the focus for ideas that are fundamentally religious.

The overt religious associations of the term 'sublime' are perhaps what differentiate its eighteenth-century usage most sharply from that of our own day. A characteristic example of its occurrence in the daily language of that period is Mr Allworthy's conception of the virtue of Charity, in *Tom Jones* (1749): 'that sublime Christian-like disposition, that vast elevation of thought, in purity approaching to angelic perfection, to be attained, expressed, and felt only by grace'.[10] The vocabulary is almost hackneyed: vastness, elevation, purity, perfection – these words recur constantly in connection with the sublime, and even when the word 'sublime' itself is not mentioned, we can infer its presence in the writer's mind as the ultimate designation of such ideas. Often a term such as 'grandeur' is substituted; but as Hugh Blair decided, 'Grandeur and Sublimity are terms synonymous, or nearly so. If there be any distinction between them, it arises from Sublimity's expressing Grandeur in the highest degree.'[11]

Whatever the exact term used, the quality we are discussing was felt to be a very positive one. The sense of elevation towards the supreme Good, towards God, is frequently to be understood. The enlargement and enrichment of the mind in contemplating the wonders of creation is thought of as a noble, uplifting experience. And the very ineffability of the ideas involved led men to attach importance to those works of literature in which great writers had succeeded in evoking the limitless splendour of God or his works. The Bible, of course, had a special advantage in this respect: not only did it contain some of the most impressive and stirring passages of human history, it was actually inspired directly by the Deity, and so the very idea of it was sublime. In addition, it was a work of venerable antiquity, dating from the period before even Greek civilisation, the period that Jacob Bryant and William Blake (1757–1827) thought of as the 'heroic age of the world' when men were nobler and altogether greater of achievement than they are now. Coleridge called the Bible 'the sublimest, and probably the oldest, book on earth'.[12]

But there was another claimant to similar distinction: Homer. It is true that Homer could not pretend to be God, but he wrote much better Greek than the authors of the New Testament, and that in itself was a favourable point. Although Milton ranked a close second to Homer as a poet of the sublime, he suffered the great disadvantage of having written his greatest work – *Paradise Lost* – in English. Conscious of this, he attempted to make his own language approximate as nearly as possible to Latin, but still, as Addison said, 'his Paradise Lost falls short of the Aeneid or the Iliad . . . rather from the fault of the language than from any defect of the author. So divine a poem in English is like a stately palace built of brick, where one may see architecture in as great a perfection as one of marble, though the materials are of a coarser nature.'[13] But then again, Milton had the edge over Homer in respect to subject-matter. The protagonists of his epic are not the imaginary gods of ancient Greece but the True God and his Angels, fallen and otherwise. People were even prepared to believe, or pretend to believe, that *Paradise Lost* was an apocryphal addition to the canonical Bible. Jonathan Richardson (1665–1745), who, though a painter by profession, was a most sophisticated connoisseur and critic, quoted lines from the poem which he claimed were 'as great as ever entered into the heart of man not supernaturally inspired, if at least this poet was not so'.[14] It will be useful to have a sample of Milton's most elevated verse for reference, and Richardson's selection is a representative one:

> On heavenly ground they stood, and from the shore
> They view'd the vast immeasurable abyss,
> Outrageous as a sea, dark, wasteful, wild,

Up from the bottom turn'd by furious winds,
And surging waves, as mountains, to assault
Heaven's height, and with the centre mix the pole.
 Silence, ye troubled waves, and thou deep, peace,
Said then th'omnific Word, your discord end.
 Nor staid; but on the wings of Cherubim
Uplifted in paternal glory rode
Far into Chaos, and the world unborn;
For Chaos heard his voice: him all his train
Follow'd in bright procession, to behold
Creation, and the wonders of his might.
Then staid the fervid wheels, and in his hand
He took the golden compasses, prepar'd
In God's eternal store, to circumscribe
The universe, and all created things:
One foot he center'd, and the other turn'd
Round through the vast profundity obscure,
And said, Thus far extend, thus far thy bounds,
This be thy just circumference, O world.[15]

The salient matter here is the image of God creating the universe out of chaos. Illustrative detail such as the 'surging waves as mountains' is minimal: Milton contrives to evoke in an extraordinarily concrete way what is essentially vague, imponderable. This was his great merit for the eighteenth century, as indeed it is perhaps still for us. Commentators made much of the fact that it was the peculiar flexibility of poetry that made such feats possible. The imagination is stimulated more fully by words which suggest vast ideas than by specific details of the appearance of things. It was for this reason, primarily, that painting could only struggle into second place against poetry in the attempt to produce art that was sublime. Artists were well aware of the problem; but they could point to some triumphant successes. The Milton passage just quoted leads us immediately to one great visual equivalent: Michelangelo's own account of the Creation on the Sistine Chapel ceiling. Everyone agreed that here was a truly sublime work of visual art. In it Michelangelo found an appropriate language in which to express the grand ideas embodied in his subject: and in a sense there is a perfectly reasonable parallel to be drawn between his style and Milton's. Both avoid superfluous detail; they deal in large terms and bold, heroic gestures. Colour is definitely subordinated to grand design – these technical terms of painting apply by natural analogy to Milton; when colour does obtrude it is to suggest the exalted status of the characters or the primitive contrasts of glorious light and brooding chaos. The rhythms of both are stately and sweeping. We might recall also the famous comparison made by Wölfflin between Michelangelo's *Expulsion of Adam and Eve from the Garden of Eden* (FIG. 1) and the music of Beethoven: he describes the compositional hiatus between the angel on the left and the fleeing couple on the right as being like 'one of Beethoven's pauses'.[16] The atmosphere of Beethoven's music is very much the atmosphere of the sublime: Berlioz, himself much concerned with the communication of grand ideas, sets this Beethovenian atmosphere firmly in its sublime context in describing the slow movement of the Fourth Symphony: 'This movement,' he says, 'seems as if it had been sadly murmured by the Archangel Michael on some day when, overcome by a feeling of melancholy, he contemplated the universe from the threshold of the Empyrean.'[17] The contemplations and tribulations of the titanic hero are a subject to which we shall have to return in due course.

To grasp the way in which Michelangelo was 'placed' by the eighteenth-century mind in its scheme of things we should turn to the thoughts of Sir Joshua Reynolds

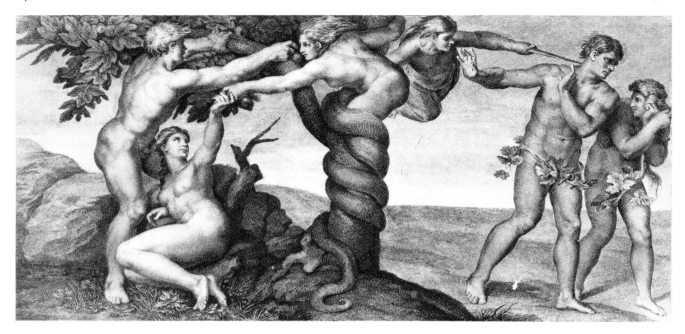

FIG. I
Antonio Capellan *after*
Michelangelo, *The Expulsion of
Adam and Eve from the Garden*,
Sistine Chapel ceiling, Rome,
engraving. British Museum,
London

(1723–92). Reynolds is the epitome of the eighteenth-century English intelligence: learned, articulate, a believer in progress by means of justly formulated rules, and in the cautious but purposeful evaluation of all knowledge so that it can be used and reused by others. He is an excellent example of the sorting, sifting mind of the eighteenth century. As the first President of the Royal Academy he was also the figurehead of the professional and educational movement which advanced the visual arts so impressively in the period. When he painted an allegorical figure of *Theory* (seated on clouds and holding a scroll inscribed with the word *Nature*) to decorate the entrance hall of the new Academy building, he nicely summed up the main bent of his own mind and those of most of his colleagues and thinking contemporaries. He himself said: 'I had something of an habit of investigation, and a disposition to reduce all that I observed and felt in my own mind, to method and system.'[18] His discourses given annually to the students of the Academy Schools are a compendium of intelligent theory and criticism which still commands the respect of artists and historians, even if most of his ideas have been out of fashion for nearly a century. For him the creation of the Royal Academy was a crucial step on the road toward a finer national art, and this of course meant an art that dealt with the highest and noblest ideas. He lost no time in stating his position; in the first Discourse, of 1769, he spoke of Raphael: 'Raffaelle, it is true, had not the advantage of studying in an Academy; but all Rome, and the works of Michael Angelo in particular, were to him an Academy. On the sight of the Capella Sistina, he immediately from a dry, Gothick, and even insipid manner, which attends to the minute accidental discriminations of particular and individual objects, assumed that grand style of painting, which improves partial representation by the general and invariable ideas of nature.'[19]

The 'sublime of Michael Angelo' became a constant referent throughout the Discourses, and, as is well known, Reynolds devoted the whole of his last Discourse to a discussion of the Master. Again, we notice a tendency to attribute supernatural powers to the great artist: Reynolds called Michelangelo 'that truly divine man'[20] and spoke of his style as 'the language of the Gods'.[21] When he sought a comparison for his achievement he was compelled to refer to Homer, and asked his audience whether the sensations excited by looking at 'the personification of the Supreme Being in the centre of the Capella Sistina, or the figures of the Sybils which surround that chapel, to which we may add the statue of Moses' are not the same as the

sensations excited by 'the most sublime passages of Homer'. In fact, Reynolds argues, 'without [Michelangelo's] assistance we never could have been convinced, that Painting was capable of producing an adequate representation of the persons and actions of the heroes of the Iliad'.[22]

This 'grand style' to which Reynolds so earnestly and insistently set all the Royal Academy students was, then, essentially an art of illustration – a visual equivalent of the greatest episodes of literature or history. It was a style almost wholly concerned with the communication of exalted ideas by means of the depiction of the human figure.

The familiar dictum of Horace, that poetry should reproduce the qualities of painting – *Ut pictura poesis*[23] – was acknowledged as a solemn and essential truth, but the position was reversed: it was now the duty of painting to fulfil the conditions of poetry, which had proved itself capable of expressing the highest flights of the imagination. Even an enthusiastic and knowledgeable collector of paintings and drawings like Payne Knight felt that the visual arts laboured under a disadvantage: 'The means . . . which sculpture and painting have of expressing the energies and affections of the mind are so much more limited, than those of poetry, that their comparative influence upon the passions is small; few persons looking for anything more in a picture or a statue, than mere exactitude of imitation, or exertions of technical skill; and when more is attempted, it never approaches to that of poetry; the artist being not only confined to one point of time, but to the mere exterior expressions of feature and gesture . . .'[24]

It was taken for granted that the subject-matter of both arts was identical, even though the medium differed. And the poetry that mattered was epic, treating of gods and heroes, according to the rule laid down by Aristotle in his *Poetics*: only by choosing characters distinctive and exalted among human beings could the poet achieve universality.[25] In Dryden's opinion, 'A Heroic Poem, truly such, is undoubtedly the greatest work which the soul of man is capable to perform.'[26] So painting too should be concerned with the communication of exalted ideas by means of the depiction of the human figure in dramatic action. Henry Fuseli (1741–1825), one of the Academy's early Professors of Painting, explicitly equated the 'delineation of character' in painting with 'the drama'.[27] Even when an artist aimed at less than the heroic sublime he was well advised to take his subject-matter from the best literature. Shakespeare was considered a proper source even if he was not purely a sublime writer: the many subjects taken from his works for the ambitious 'Shakspeare Gallery' of Alderman Boydell[28] reflect Johnson's view that Shakespeare was most himself in comedy. But comedy too involved human nature and the study of psychology, concerns that the serious artist could not avoid. Johnson summed up Shakespeare's significance for the period when he spoke of him as 'the first considerable author of sublime or familiar dialogue in our language'.[29] Fuseli chose subjects of fantasy and fairyland for many of his contributions to Boydell's Gallery, but the vivid drawings that he made for his own pleasure are scenes of violence from the histories, or of horror and pathos from Hamlet and Macbeth. They alternate with Homeric subjects in his work as well as in that of his contemporaries. Other literary sources were selected with an eye to similar harvests of grand drama. One of the most popular in the 1770s was Ossian, the 'Northern Homer', whose sagas of the ancient Gaelic heroes were 'translated' and published by James Macpherson in the 1760s. Although 'Ossian' was later shown to be a hoax, his rambling, misty and violent stories of love, death and witchery in the bleak northern wilds were irresistible to artists.[30] Macpherson's peculiar staccato prose-poems are a complete catalogue of what the age understood by the sublime.

It is interesting that the genre of theatrical portraiture which became very popular in the second half of the century hardly hints at these histrionic developments.

Although they depicted actors and actresses in tragic scenes, artists like Benjamin Wilson (1721–88) and Johann Zoffany (1735–1810) rarely attempted more than to reproduce exactly the appearance of the stage set, the expressions and gestures of the performers at selected moments of famous productions. If anything, scenes from comedy were more popular than those from tragedy. But in any case no attempt was made to study atmosphere and create a fully realised pictorial mood. An exception to this is Hogarth's (1697–1764) portrait of Garrick in the role of Richard III (FIG. 11), in which, with no supernatural or imaginative additions, the artist conveys, simply by the grand scale and immediacy of his rendering of the actor's deportment, a fairly impressive sense of terror. But the sublime was not Hogarth's métier, and it is precisely his failure to employ those strokes of fantasy that Fuseli turned to such advantage, which mitigates the impressiveness of his picture. It has to be admitted that, despite this, Hogarth's work is at least as interesting as Fuseli's fantastic drawing of Macbeth in a similar scene,[31] for the powerful elements of 'sublime' invention in which Fuseli specialised, and which he deployed so effectively, are nevertheless rather empty gestures.

The great misfortune of the Academy under Reynolds and his successors was that he set it on a course towards the most exalted perfection which was hardly related to the abilities or inclinations of most of its members. When Reynolds admitted that his own profession of portrait painting was 'more suited to my abilities, and to the taste of the times in which I live' (a confession which came out at the very end of his last

FIG. 11
William Hogarth and C. Grignion *after* Hogarth, *Garrick in the character of Richard III*, 1746, engraving. Yale Center for British Art, Paul Mellon Collection

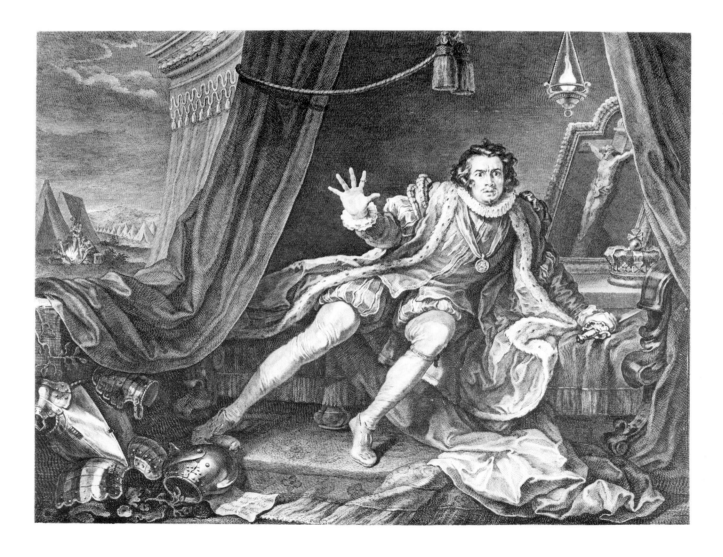

Discourse),[32] he seems not to have been aware of the extent to which he was condemning his whole argument as irrelevant. If he hoped to encourage a substantial number of students to follow their bent for 'history painting' to a level of real success, he was not concerned with the other ways in which artistic talent could manifest itself. In fact, although many artists tried their hands at history, few were as successful as Fuseli, whose work is convincing by its vigour and force of design rather than by any profundity of thought or human insight. Although Reynolds professed that 'were I now to begin the world again, I would tread in the steps' of Michelangelo,[33] he had prudently failed to do so in the actual circumstances in which he found himself. But he nevertheless applied many of his own lessons to his own painting, which undoubtedly betrays a more intelligent application of the principles he was inculcating than that of any other painter of the period. An ability to read between the lines of Reynolds's Discourses was essential to any young artist who was at all likely to profit from them.

The dichotomy between Academic theory and the actual abilities of the Academy's members, to say nothing of the needs of eighteenth-century English society (both of which factors Reynolds was quite aware of in his own case) was a grave, if largely suppressed, problem. No one had any doubt as to what constituted great art, just as no one doubted that the Academy, a long-awaited 'ornament suitable to' the 'greatness' of Britain,[34] ought to teach the highest and most glorious aspects of its subject. Students whose talents lay in lower fields must use their intelligence and capacity for rigorous self-discipline to produce technically accomplished work that incorporated whatever of the theory might be applicable. As Reynolds showed by his own success, portraiture, however inferior a branch of art, was of far more immediate use to the world he lived in than the grandiose theatricals which passed for 'high art'. Not that Reynolds eschewed literary or imaginative subjects altogether: he had a rather popular line in 'fancy' pictures which borrowed motifs and themes from Correggio, Guido Reni, and others among the great masters he taught his students to admire; and he finished a few large-scale historical pieces which are on the whole decidedly less successful, though, coming from his brush, they were influential.

What Reynolds demonstrated marvellously was that, even in portraiture, the grand motifs of the great masters could be reused imaginatively to endow modern sitters with dignity and heroic poise; even though the faces could not be infused with intense emotion they could be 'generalised' to suggest a universal and elevated standard of the human physiognomy, while gesture, background and colouring could all be enlisted to create a mood quite independent of the sitter or his personality. Sometimes, if the sitter is a man, the mood reflects his profession – military men are depicted in strategical cogitation before backdrops of swirling smoke and falling citadels; but ladies carried with them few connotations besides those of beauty or motherhood; they were cast as goddesses or muses or virtues, and suitable Renaissance models were wittily adapted to bring in overtones which the connoisseur might readily spot and enjoy (FIG. III).

Landscape, equally inferior to history, presented perhaps an even greater problem than portraiture. It did not deal in the human figure at all, or at least only to a very limited extent, and so was hardly amenable to the subtle jugglery that Reynolds so deftly handled. As far as the greatest masters of the past were concerned, landscape was nearly always a matter of background material. Michelangelo scarcely painted a tree in his life; Raphael did so more frequently, but always with a definitely subsidiary purpose. Raphael was, theoretically, an even greater artist than Michelangelo; but of course that last Discourse revealed Reynolds's true feelings better than the carefully weighed statements he had previously come out with. Raphael's 'Taste and Fancy' were placed against Michelangelo's 'Genius and Imagination', the 'beauty' of the one against the 'energy' of the other.

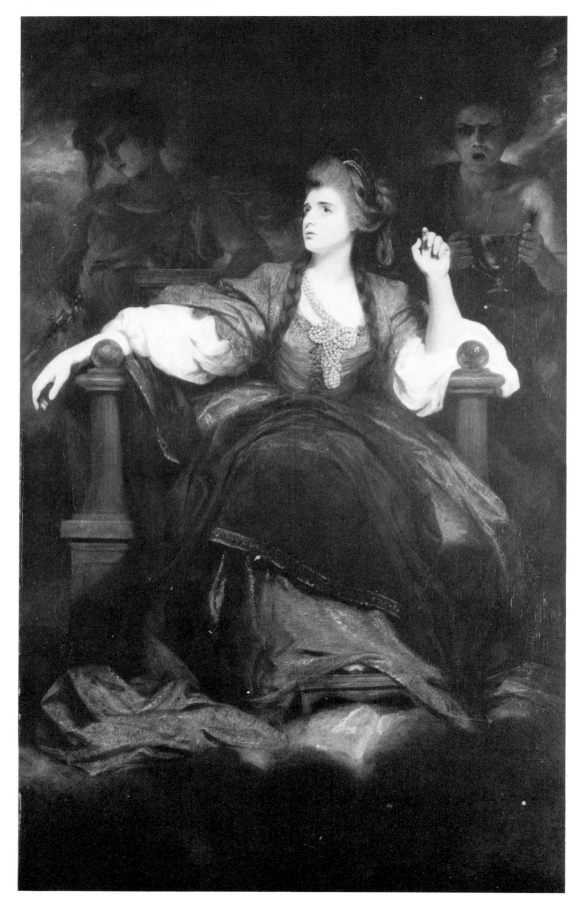

Reynolds's vocabulary with regard to the two artists is interesting, especially since we are largely concerned here with understanding eighteenth-century terminology. The words he uses to describe Raphael's work are: chaste, noble, of great conformity to their subjects; he speaks of 'the propriety, beauty, and majesty of his characters'.[35] Both 'noble' and 'majesty' are terms that fit easily into the vocabulary of the sublime. And yet he suggests that Raphael is not strictly a sublime artist: 'if, as Longinus thinks, the sublime, being the highest excellence that human composition can attain to, abundantly compensates the absence of every other beauty, and atones for all other deficiencies, then Michael Angelo demands the preference'.[36] Reynolds singled out Michelangelo's 'simplicity' as one of his most characteristically sublime attributes – the single-mindedness with which he expresses an overpowering idea, without any admixture of what Reynolds calls the 'ornamental'. Raphael, for all his grace and 'nobility' in the frescoes of the Vatican, which he produced directly under Michelangelo's influence, also painted a number of smaller works, altar pieces particularly, which are intended to create harmonious and pleasing compositions, and employ landscape to help in this. Michelangelo, of course, was first and foremost a sculptor, and landscape is almost completely irrelevant to the sculptor's art:[37] sculpture, since it was all that the eighteenth century knew of ancient art, had a particular importance as embodying in the clearest form the achievement of the Greeks. Reynolds did not have to have read Winckelmann[38] to draw a logical conclusion for himself: painting that confined itself to the human figure executed with purity of outline and dignity of conception approximated more nearly to the classical ideal than works of a more diffuse nature.

Landscape, then, was at best a dilution of history painting. It could only justify itself as an art form in its own right if it partook of the same idealisation and generalisation which elevated the depiction of the human figure above the local and particular. Claude Lorrain (1600–82) was the perfect example of an artist who did this. Claude 'was convinced, that taking nature as he found it seldom produced beauty', Reynolds said. 'His pictures are a composition of the various drafts which he had previously made from various beautiful scenes and prospects.'[39] This practice he advocated as 'there can be no doubt' that it was preferable to the mere representation of 'accidents', that is, individual places and local effects, as was the habit of the Dutch and Flemish schools. The principle was that of Apelles in painting Helen of Troy, who combined the perfections of several models in order to create an ideal heroine. Even the lowest subject-matter was the better for this quality of generality. Reynolds's position on landscape is summed up in his third Discourse: 'As for the various departments of painting, which do not presume to make such high pretensions [as Dürer, a figure painter who failed to attain the sublime because of his preoccupation with local detail], they are many. None of them are without their merit, though none enter into competition with this universal presiding idea of the Art. The painters who have applied themselves more particularly to low and vulgar characters, and who express with precision the various shades of passion, as they are exhibited by vulgar minds (such as we see in the works of Hogarth), deserve great praise; but as their genius has been employed on low and confined subjects, the praise which we give must be as limited as its object. The merry-making or quarrelling of the Boors of Teniers; the same sort of productions of Brouwer or Ostade, are excellent in their kind; and the excellence and its praise will be in proportion, as, in those limited subjects, and peculiar forms, they introduce more or less of the expression of those passions, as they appear in general and more enlarged nature. This principle may be applied to the Battle-pieces of Bourgognone, the French Gallantries of Watteau, and even beyond the exhibition of animal life, to the Landscapes of Claude Lorraine, and the Sea-Views of Vandervelde. All these painters have, in general, the same right, in different degrees, to the name of a painter, which a satirist, an

FIG. III
Joshua Reynolds, *Mrs Siddons as the Tragic Muse*, 1784, oil on canvas. Henry E. Huntington Library and Art Gallery, San Marino, California

epigrammatist, a sonneteer, a writer of pastorals or descriptive poetry, has to that of a poet.'[40]

The line of division between the 'sublime' of history or literary painting and the lower categories was as firmly drawn as that between the 'sublime' of Michelangelo and the 'beautiful' of Raphael, or, for that matter, the 'sublime' of Homer and the 'beautiful' of Virgil, as Addison classified them. The habit of categorising was deep-rooted and everyone indulged in it. Luckily for the 'department of landscape', and for my argument, there was one painter whose work was readily categorised as 'sublime' by Reynolds and the rest, but who produced a significant body of true landscapes. This was Nicolas Poussin (1594–1665), whose contemporaneity with Claude enabled the eighteenth century to pair the two off as representing the sublime and the beautiful in landscape. Poussin's eye, Reynolds declared, 'was always steadily fixed on the Sublime';[41] and yet he undoubtedly devoted much of his labour to landscape. What is the force of that 'always'? Are even Poussin's pure landscapes, after all, above the common run and truly poetical, truly elevated? His great secret was that he 'lived and conversed with the ancient statues so long, that he may be said to have been better acquainted with them, than with the people who were about him. I have often thought,' Reynolds reflects, 'that he carried his veneration of them so far as to wish to give his works the air of Ancient Paintings.'[42]

Perhaps Reynolds is referring here only to those cool, exquisitely poised figure compositions in which Poussin expatiates on Biblical and mythical themes; but in fact the same qualities of balance and dignified abstraction are to be found even in the few landscapes that he painted with no specific human motifs. Usually, his landscape is the setting for a human drama which, in itself, would be a perfectly fit subject for the history painter, though he chooses to develop it with ideas taken from the natural world. But those natural elements are refined and 'distanced' by Poussin's intellect so that they become factors in his composition of equal weight with the figures. The whole exercise is suffused with the austere though often very beautiful thought of a philosopher. Nearly always, the landscape is heavily impressed with the works of men: it is scattered with buildings to give a firm sense of the close interrelation between men and nature; sometimes the structures are clustered so densely that nature itself seems to be a work of architecture. And, as Reynolds suggests, they are based on classical models to evoke an ideal vision of an heroic world, in which any figures that appear, however unimportant their actions, are by consequence of heroic stamp themselves. Normally, though, the human event that forms the nucleus of the picture has greater relative importance. Reynolds admired Poussin particularly for welding the two disparate elements of such designs, figures and landscape, into a totally coherent, homogenous statement. It was this coherence, this unity of thought, which placed Poussin on such a high plane in Reynolds's estimation. Even his handling was at one with the central idea: '. . . the language in which some stories are told, is not the worse for preserving some relish of the old way of painting, which seemed to give a general uniformity to the whole, so that the mind was thrown back into antiquity not only by the subject, but the execution.'[43]

But how was the painter, whose calling was for landscape, to accomplish the leap from the 'local' and trivial to the grand and universal, in eighteenth-century England where the principal demand for landscape, as for portraiture, was from those who wanted flattering but recognisable delineations of their own property? In his field, Reynolds had succeeded in bridging the gulf by drawing unashamedly on the sublime language of the great masters; but in landscape such a universal language hardly existed; at any rate, it was far less articulate, having been formulated by only one or two artists for what, on the whole, were secondary purposes.

Even Claude seemed too circumscribed when judged by the highest criteria: he had concerned himself with painting 'nature's littlenesses'.[44] It is not surprising, then,

that the eighteenth century produced several landscape painters whose aim was generalisation before all else. Three names are a representative sample. One is Alexander Cozens (*c.* 1717–86), whose theorising, analytical mind epitomised the contemporary concern with rules and methods. Although he published a book illustrating the *Shape, Skeleton and Foliage of thirty-two different species of Trees, for use in Landscape*,[45] he very rarely drew a recognisable species in any of his own compositions, which are predominantly executed in ink wash, on a small scale, and consist of the most generalised forms, basic landscape elements presented in endlessly varied combinations, as if Cozens were conducting an experiment, or demonstrating a mathematical proposition. This was precisely his approach, though many of his patterns do in fact achieve a harmony and even an atmosphere that is genuinely poetical. He made his living as a drawing master, and his art shows that he was temperamentally well suited for that career. He could certainly not have pursued his abstruse landscape experiments professionally and expected to live off the proceeds. In the same way, Thomas Gainsborough (1727–88) combined his pastime of landscape painting with a profitable practice as a fashionable portrait painter. His landscapes, too, especially those of his later life, are 'abstractions', compositions formed by the combination and recombination of conventional elements.[46] The third of these practitioners of the ideal is Richard Wilson (1714–82), who made the mistake of abandoning portraiture for landscape rather than maintaining it as a profitable side-line. As a result, though he probably came nearer than anyone else to the contemporary notion of 'elevated' landscape, he met with little success and was not really accorded his due meed of praise until after his death in 1782.[47] By that date the progress of the arts in England had entered a new phase – a phase in which landscape began to assert its independence.

Wilson's great contribution, it was then realised, was that he had succeeded where Claude had failed. Claude had 'painted nature's littlenesses'; Wilson, on the contrary, 'gives a breadth to nature, and adopts only those features that more eminently attract attention. His forms are grand, majestic, and well selected; and his compositions are not encumbered with a multitude of parts, a fault frequently observed in Claude . . . Wilson's compositions are grand, with a tone of colour truly Titianesque . . .'[48]

The reminiscence of Titian was perhaps more a compliment paid by the critic than any intentional allusion on Wilson's part. But there was more to Wilson's achievement than a mere simplification of the Claudean model, or the use of striking colour. Although we should now judge him principally by his pure landscapes, those in which the poetic rendering of scenery is the prime motive, he was admired first of all by his contemporaries as a painter of scenes that were historical not only in manner but also in theme. The canvases of Wilson that came to be cited as specially fine are those which take their central idea from literature, and use a number of figures, often in the context of violent action: *Cicero at his Villa*, *Celadon and Amelia*, *The Destruction of the children of Niobe*: these titles are resonant of the literary or 'poetic' preoccupations of the time, and the pictures had their due effect.

Niobe[49] was a subject from Ovid's *Metamorphoses* which had been treated as a sculptural group in classical times; Wilson borrowed the attitudes of some of his principal figures from this group, in true Reynoldsian spirit. At the same time, he invented a storm-tossed landscape to set off the action and interact with it, which is equally plainly borrowed, this time from Poussin.[50] The tragedy of the subject and the angry grandeur of the scenery are linked and combined according to Poussin's example to achieve a landscape painting that is, as nearly as such a work can be, 'sublime'. If Reynolds himself was critical of the piece, that was for incidental reasons; we shall have an opportunity to examine his comments later.

Wilson's *Celadon and Amelia* (FIG. IV),[51] on the other hand, was not taken from classical but from modern literature. It illustrates an episode from James Thomson's

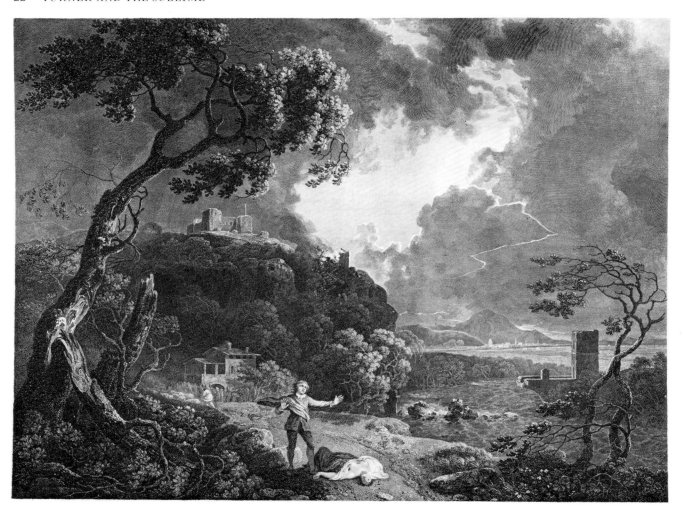

poem *Summer*, in which Amelia is struck dead by lightning before her lover's eyes.[52] It is an incident violent and dramatic like that of Niobe's children, but with the advantage that it occurs in the work of an English poet. Wilson's interpretation does not make any capital of the fact that it is set in English scenery: on the contrary, he deliberately suggests a more 'generalised' setting, vaguely evocative of Italy. This reflects the aim of Reynolds and his colleagues to show, not only that modern Britain had nurtured a great school of painters, but that its culture as a whole was a worthy counterpart to that of the ancient world which was taken as the ideal standard. This was an important spur to the use of motives from Milton, Shakespeare and other indigenous authors. Thomson was a particularly significant choice.

If we are to explain the rise of 'serious' landscape painting in the second half of the eighteenth century, we must look to literature for clues, just as we do in examining the fashion for history painting. *Ut pictura poesis* (in its modern, reversed form) applied, of course, in both fields. Portraiture was lucky in this respect: its palpable utility to society largely obviated formal excuses. Landscape painters might imitate Claude or borrow from Poussin as much as they pleased: they still required to show that their art could speak eloquently of the things treated by literature. Poussin and Claude, to be sure, had shown the way: but where was the modern equivalent of Milton and Shakespeare? To what contemporary source of myth and legend creditable to the patriotic ambitions of the Academy could they turn? Nature poetry was much inclined to be 'pastoral' or 'descriptive': types firmly relegated by Reynolds to

FIG. IV
William Woollett *after* Richard Wilson, *Celadon and Amelia*, 1765, engraving. Yale Center for British Art, Paul Mellon Collection

inferior positions in the hierarchy. Thomson's *Seasons* burst on the artistic world (very belatedly) with something of the revelatory force with which it had affected the world of letters in the first half of the century. These four poems, published between 1726 and 1730, and progressively enlarged and rewritten, were greeted when they appeared as a new and stimulating development in the progress of English poetry, the product of an imagination 'rich, extensive, and sublime'.[53] In this century they have almost completely lost their reputation as, collectively, one of the supreme poems in the language, and it is not hard to understand why we do not take them very seriously. And yet they are probably underrated. The vividly observed detail of natural phenomena, recorded with scientific care, brought a new realism to the familiar pentameters of blank verse — a realism that made it possible for Thomson to grip and convince his audience with descriptions of a quite different kind than had previously been attempted.

> When from the pallid sky the sun descends,
> With many a spot, that o'er his glaring orb
> Uncertain wanders, stain'd — red fiery streaks
> Begin to flush around. The reeling clouds
> Stagger with dizzy poise, as doubting yet
> Which master to obey; while rising slow,
> Blank, in the leaden-colour'd east, the moon
> Wears a wan circle round her blunted horns.
> Seen through the turbid, fluctuating air,
> The stars obtuse emit a shivering ray;
> Or frequent seem to shoot athwart the gloom,
> And long behind them trail the whitening blaze.[54]

Thomson's *Seasons* are full of long descriptions of storms and other natural events, often highly dramatic, brought before the mind's eye by means of an insistent repetition of progressive detail. The rhythm and sometimes the language retain the solemnity of Milton, but the content is quite unlike that of even the most circumstantial passages of *Paradise Lost*. As Johnson remarked, *Paradise Lost* 'has this inconvenience, that it comprises neither human actions nor human manners. The man and woman who act and suffer [Adam and Eve] are in a state which no other man or woman can ever know. The reader finds no transaction in which he can be engaged; beholds no condition in which he can by any effort of imagination place himself; he has, therefore, little natural curiosity or sympathy . . . Of the ideas suggested by these awful scenes, from some we recede with reverence, . . . and from others we shrink with horror, or admit them only as salutary inflictions . . . Such images rather obstruct the career of fancy than incite it . . . poetical pleasure must be such as human imagination can at least conceive, and poetical terrors such as human strength and fortitude can combat. The good and evil of eternity are too ponderous for the wings of wit; the mind sinks under them in passive helplessness, content with calm belief and humble adoration.'

Thomson, on the other hand, 'at once comprehends the vast, and attends to the minute' (Johnson again is the commentator).[55] It was by ensuring that each separate incident, and each part of each incident, was fully realised that Thomson succeeded in evoking more elusive and indefinable effects. He also refers constantly to the human response to nature by peopling his landscapes with representative examples of common humanity, so that the criticism Johnson levelled at Milton is met. Indeed, the mainspring of Thomson's realism is the continual appeal to our experience to confirm and sympathise, to envisage pain and pleasure with equal vividness. It is no coincidence that after the success in London of Haydn's oratorio *The Creation*, based on Milton, he was asked to compose a sequel based on the *Seasons*.[56]

Johnson thought it the great weakness of these poems that they lack 'method' in the assemblage of their incidents. But the many set pieces in which Thomson describes the fortuitous conflicts between man and nature constitute a drama which no doubt Thomson himself would have defended as inevitably casual and without literary 'form'. They are rendered vivid by the exploitation of human sympathy, by placing men and women in the landscape and studying their response to it. In doing so, Thomson virtually created an important genre of the later eighteenth century: the rustic sentimental. At the same time, by attempting to treat 'great and serious subjects', as he put it, in the context of 'wild romantic country',[57] he gave the impetus to a new branch of serious art: the landscape sublime.

NOTES TO CHAPTER ONE

1. James Fenimore Cooper, *The Pathfinder* (1840), Modern Library edition, New York, 1952, p. 3.
2. Hugh Blair, *Lectures on Rhetoric and Belles Lettres*, 3rd ed., London 1787, p. 58.
3. Richard Payne Knight, *An Analytical Inquiry in the Principles of Taste*, London 1805, p. 329.
4. Payne Knight, *op. cit.*, p. 36.
5. *Spectator*, no. 412, 23 June 1712.
6. In general, Addison discusses the arts under the heading of literature, pointing out that 'most of the observations that agree with descriptions are equally applicable to painting and statuary'. (*Spectator*, no. 416, 27 June 1712.)
7. *Spectator*, no. 413, 24 June 1712.
8. *Spectator*, no. 420, 2 July 1712.
9. For instance, Lord Kames, *Elements of Criticism*, Edinburgh 1762, vol. I, p. 274.
10. Henry Fielding, *Tom Jones*, Book II, chapter V.
11. Blair, *op. cit.*, p. 58.
12. S. T. Coleridge, *Biographia Literaria*, Everyman edition, p. 112. Compare William Blake's reverence for 'The Sublime of the Bible'; *Milton*, 1804, plate I.
13. *Spectator*, no. 417, 28 June 1712.
14. Jonathan Richardson, *Works*, 1792, p. 242.
15. *Paradise Lost*, Book VII, ll. 210–31.
16. Heinrich Wölfflin, *Classic Art*, 1899, trans. Peter and Linda Murray, London 1958, p. 56.
17. Hector Berlioz, *A Critical Study of Beethoven's Nine Symphonies*, trans. Edwin Evans, Sen., London n.d., p. 56.
18. *Discourse XV*, 1790, Wark ed., p. 268.

19. *Discourse I*, 1769, Wark ed., pp. 15–16.
20. *Discourse XV*, 1790, Wark ed., p. 282.
21. *Discourse XV*, 1790, Wark ed., p. 278.
22. *Discourse XV*, 1790, Wark ed., p. 275.
23. Horace, *Ars Poetica*, 9.
24. Payne Knight, *op. cit.*, p. 334.
25. Aristotle, *Poetics*, I, 2.
26. John Dryden, *Virgil and the Aeneid* (1697).
27. Henry Fuseli, *Lectures on Painting*, London 1801, p. 4.
28. See Winifred H. Friedman, *Boydell's Shakespeare Gallery*, New York 1976.
29. Samuel Johnson, *Proposals for Printing the Dramatick Works of William Shakespeare*, 1756, ed. Walter Raleigh, Oxford 1908, p. 2.
30. See Henry Okun, 'Ossian in Painting', *Journal of the Warburg and Courtauld Institutes*, 1967, vol. XXX, pp. 327–56; and *Ossian und die Kunst um 1800*, exhibition catalogue, Hamburg, Kunsthalle 1874.
31. Gert Schiff, *Johann Heinrich Füssli*, 2 vols, Zurich 1973, no. 458. Fuseli also drew the Richard III subject; it was engraved as an illustration by J. Neagle in 1804 (Schiff 1284).
32. *Discourse XV*, 1790, Wark ed., p. 282.
33. *Ibid.*
34. *Discourse I*, 1769, Wark ed., p. 13.
35. *Discourse V*, 1772, Wark ed., p. 83.
36. *Ibid.*, p. 84.
37. Not entirely; see for instance certain first-century AD Roman genre subjects, such as the *Farm Scene* in the Glyptothek, Munich.

38. J. J. Winckelmann (1717–68); his *Reflections on the Painting and Sculpture of the Greeks* (1755) was translated into English by Fuseli in 1765.
39. *Discourse IV*, 1771, Wark ed., pp. 69–70.
40. *Discourse III*, 1770, Wark ed., pp. 51–2.
41. *Discourse IV*, 1771, Wark ed., p. 68.
42. *Discourse V*, 1772, Wark ed., p. 87.
43. *Ibid.*, p. 88.
44. Thomas Wright, *Some Account of the Life of Richard Wilson, Esq. R. A.*, London 1824, p. 63.
45. In 1771. See A. P. Oppé, *Alexander and John Robert Cozens*, London 1952, pp. 27–8; 90.
46. See John Hayes, *The Drawings of Thomas Gainsborough*, 2 vols, London and New Haven 1971, vol. I, pp. 10–14.
47. See W. G. Constable, *Richard Wilson*, London 1953.
48. Thomas Wright, *loc. cit.*
49. Wilson treated the subject more than once. The most famous version is now in the Yale Center for British Art, Paul Mellon Collection. See Constable, pls 18–20.
50. Compare Poussin's *Landscape with a Storm* known from Louis de Chatillon's engraving (Blunt 263).
51. Constable, pl. 24b.
52. *Summer*, ll. 1191–1214. Thomson's dates are 1700–48.
53. Lord Lyttelton, *Dialogues of the Dead*, London 1760, p. 129.
54. *Winter*, ll. 118–29.
55. Johnson, *Lives of the Poets*, 'Milton'.
56. Joseph Haydn (1732–1809); *The Creation* was first performed in 1799; the *Seasons* in 1801.
57. Introduction to *Winter*, 2nd ed., 1746.

THE LANDSCAPE SUBLIME

Ye rocks on precipices pil'd;
Ye ragged desarts waste and wild!
Delightful horrors hail!

JOHN LANGHORNE: *Lines left with the Minister of Riponden,*
a Romantic Village in Yorkshire, 1758

. . . the tall rock,
The mountain, and the deep and gloomy wood.
Their colours and their forms were then to me
An appetite; a feeling and a love,
That had no need of a remoter charm,
By thought supplied, nor any interest
Unborrowed from the eye.

WILLIAM WORDSWORTH: *Lines composed a few miles above*
Tintern Abbey, 1798

Without the definitive success of Thomson's *Seasons* in the first half of the century, the development of landscape painting in England would have been rather different and perhaps delayed. The impact of the poem on the visual arts was not, of course, a simple one-way influence: as critics have frequently pointed out, Thomson himself derived many of his attitudes to landscape from the work of the French and Italian painters of the seventeenth century.[1] It was precisely because his literary vision was so well founded in an existing tradition of painting that it could stimulate artists as it did. To this extent, poetry was indeed, in Horace's sense, following painting. But artists, as we have seen, needed to feel themselves supported by a valid literature. Thomson supplied such a literature for the landscape painter in one comprehensive work. He also, of course, stimulated other writers and pointed to other useful sources. His grandeur and his specificity were exactly what artists were looking for; and were also what a number of poets required to set their own muses working.

The remoter aspects of nature, the 'wild romantic country' that Thomson thought so promising from a human point of view, had simply not been looked at so carefully before. Even those who were able to do so had rarely felt the urge to articulate their feelings at length. A typical early eighteenth-century example is that of a young lawyer, John Tracy Atkyns, who toured the northern counties of England in 1732, making detailed and rapturous notes[2] about the houses and gardens he visited – places such as Castle Howard, Studley Royal, or Newby – but mentioning only briefly the uncultivated landscape of Yorkshire, Northumberland and the Lakes. Here he is crossing the moors from Newcastle to Carlisle:

For fifteen miles together we travell'd through one of the most barren places in England, what they call the Fells, not a Tree, nor even a Stump to be seen, now & then a straggling sheep appears, that with the utmost difficulty keeps itself from starving, perhaps once in a Year an unthinking Crow or Two fly over it, you see a small Number of Huts scatter'd up & down in some Parts of it. The Inhabitants I believe are Aborigines or at least descended from the Ancient Picts, for no Modern would ever think of taking up his Habitation in

such a Desart, you may still see great Remains of the famous Wall built by the Picts, it runs across the steepest of their Hills, and there are still standing Part of One or Two Buildings that were originally Forts . . .

It is what we might call an economic view of the landscape. One wonders whether Atkyns's interest in the wall would have been greater if he had known it to have been constructed by the Romans. He was not inaccessible to stronger feelings, but on the whole he preferred to find grandeur in more familiar places. Just as he enjoyed a well laid out garden for its judicious variety of effect, so he responded to nature most warmly when she provided contrast and what was soon to be known as 'Picturesque' diversity. A natural waterfall, for instance, gives him pleasure rather as an artificial one would do, though there is a hint that he finds an added *frisson* in the element of surprise and danger:

> . . . the river is exceeding Rapid, and just at the Bridge is one of the most Beautiful natural Cascades that I ever saw. The Water falling down a steep among some huge Rocks, makes a very notable Roar, and dashing against 'em throws it to such a Height, that Wheat [Atkyns's companion] affirms the Water very often wash'd your face as you ride over the Bridge . . .

But his response to wild nature is more emphatic when it is closely associated with human achievement. Atkyns warms decidedly to the combination of ruggedness and venerable antiquity at Tynemouth:

> I landed among the Rocks in a Place call'd the Prior's Haven, the most monstrous ones I ever saw, a horrid, yet a pleasing look at the same Time, over 'em is a Light House . . . here are very fine Ruins, of an ancient Monastery one of the first Religious Foundations in England, the most beautiful Gothic Building that can be seen . . .

Once again, it is the 'economic' connotations which help Atkyns to respond. But that tug-o'-war between the 'horrid' and the 'pleasing' is exactly the state of mind that was to crystallise in the ensuing decades as the appropriate response to uncultivated nature. There grew up a love-hate relationship assiduously nursed, a source of frictions that were to provide many sparks for the Muses' fire.

Atkyns's is a rare case of an articulate account surviving from the early decades of the century. It antedates even the famous letters of Thomas Gray describing his visit to the Grande Chartreuse in 1739. These, however familiar, must be quoted again here as a *locus classicus* of the emergence of the landscape sublime.

> It is six miles to the top; the road runs winding up it, commonly not six feet broad; on one hand is the rock, with woods of pine-trees hanging overhead; on the other, a monstrous precipice, almost perpendicular, at the bottom of which rolls a torrent, that sometimes tumbling among the fragments of stone that have fallen from on high, and sometimes precipitating itself down vast descents with a noise like thunder, which is still made greater by the echo from the mountains on each side, concurs to form one of the most solemn, the most romantic, and the most astonishing scenes I ever beheld: add to this the strange views made by the craggs and cliffs on the other hand; the cascades that in many places throw themselves from the very summit down into the vale, and the river below; and many other particulars impossible to describe; you will conclude we had no occasion to repent our pains.[3]

The last comment is revealing: the letter is to Gray's mother, and we are left in no doubt that she would have understood the kinds of feelings he describes. He was not, therefore, alone in his heightened response to the Alps. But it is likely that he brought to them a capacity for wider association than most travellers:

> I do not remember to have gone ten paces without an exclamation, that there was no restraining: not a precipice, not a torrent, not a cliff, but is pregnant with religion and

poetry. There are certain scenes that would awe an atheist into belief, without the help of other argument. One need not have a very fantastic imagination to see spirits there at noon-day: you have Death perpetually before your eyes, only so far removed, as to compose the mind without frighting it . . . I have Livy in the chaise with me, and beheld his 'Nives coelo prope immistae, tecta informia imposita rupibus, pecora jumentaque torrida frigore, homines intonsi et inculti, animalia inanimamque omnia rigentia gelu; omnia confragosa, praeruptaque' . . . Mont Cenis, I confess, carries the permission mountains have to be frightful rather too far; and its horrors were accompanied with too much danger to give one time to reflect upon their beauties.[4]

This passage illustrates the intimate connection between the landscape sublime and the religious feeling we have already found to be strongly present in sublime ideas. The characteristic patterns of sublime association are much in evidence. Gray can comfort himself with the reflection that such scenes were known to the Ancients; Livy was to prove a useful source for historical painters in future.[5] But the line drawn between the horrid and the pleasing is still present, as we see from his comments on the Mont Cenis. Gray's appreciation is still a matter of degree. And there now begins to creep in a new note, a note of which we hear overtones in Gray's judgement that 'too much danger' prevents us enjoying the 'beauties' of grand scenery. I have had occasion elsewhere to compare Gray's experience with a considerably earlier one, that of the Yorkshire antiquarian and topographer, Ralph Thoresby. I think it is worth bringing them together again here. Thoresby wrote of a journey made in 1681:

. . . the precipice grew to that height and narrowness, and withal so exceedingly narrow, that we had not one inch of ground to set a foot upon to alight from the horse. Our danger here was most dreadful, and, I think, inconceivable to any that were not present: we were upon the side of a most terrible high hill . . . We had above us a hill, so desperately steep, that our aching hearts durst not attempt the scaling of it it being much steeper than the roofs of many houses; but the hill below was still more ghastly, as steep for a long way as the walls of a house . . . To add to our torments there was a river run all along (which added to the dizziness of our heads) close to the foot of the precipice, which we expected every moment to be plunged into, and into eternity.[6]

Thoresby does not indulge in the complex associational meditations of Gray, and his apprehension of the impressiveness of nature here resolves itself crudely into one of fear; but his relish in telling the story, his insistence on the danger, indicate that he was responding at a level rather higher than that of simple brute terror. His account does not realise the possibilities of the landscape sublime, but it implies them.

The ingredient of *fear* in fact plays an important part in this new development of the theme. It is present, of course, in the classic theory of the sublime, but bears only obliquely on the mental patterns discussed by that theory. It is a sub-category, as it were, of the religious awe that is central to the idea. 'Awe' comprehends both the exalted state of mind appropriate to the contemplation of God, and the 'fear and trembling' also associated with that state. As Kant observed 'the virtuous man fears God without being afraid of him' – it is largely a question of one's relative position; does the object of our contemplation threaten us or are we protected (by virtue or some more material barrier) from its power? On this ambiguity pivots the change of stress that came over the eighteenth-century definition of the sublime. Some writers argued that the emotion of fear was too base and contemptible to be associated with it. '. . . the word *sublime*, both according to its use and etymology,[8] must signify *high* or *exalted*; and, if an individual chooses that, in his writings, it should signify *terrible*, he only involves his meaning in a confusion of terms, which naturally leads to a confusion of ideas.'[9] Others felt that it was a special *kind* of fear which was present in the sublime experience. 'The combination of passions in the sublime, render the idea of it obscure. No doubt the sensation of fear is very distinct in it; but it is equally obvious, that there is something in the sublime more than this abject passion. In all

other terrors the soul loses its dignity, and as it were shrinks below its usual size: but at the presence of the sublime, although it be always awful, the soul of man seems to be raised out of a trance . . .'[10]

There was excellent authority for the idea that fear is central to the experience of sublime art, for Aristotle had laid it down that tragedy depends for its effect on the two emotions, fear (or terror) and pity.[11] This rule was usually agreed to without question but its application to the drama raised a philosophical problem. As Payne Knight put it, 'how any man, in his senses, can feel either fear or danger, which he knows to be fictitious, I am at a loss to discover; . . . I sympathise, indeed, with the expressions of passion, and mental energy, which those fictitious events recite; because the expressions are real; . . . but the acute Stagirite [that is, Aristotle] appears to have been lead into an error, on this point, by imagining that stage exhibitions were really meant to be deceptions . . .'[12]

The question is, do we attribute 'sublimity' to objects or events, or do we use the term to describe our emotions on experiencing those objects or events? In the case of a play, we cannot experience any *real* emotion in response to what is enacted; and yet it is true that 'the expressions are real', and they embody the sublimity of great poetry. Payne Knight refuses to admit that he can even temporarily 'believe' what the actors tell him, 'never having found any such pliability in my own feelings'. But in general, we adopt quite involuntarily the strategem that Coleridge described in his famous phrase, 'that willing suspension of disbelief for the moment, which constitutes poetic faith'.[13] Poetic faith is necessary to the business of enjoying a great deal of art; with art that operates on the 'highest' emotional level, demanding our complete involvement, it is essential. The sublime in nature is, perhaps, as Ralph Thoresby shows, and as even Gray hints, not conductive to human pleasure since, at its most intense, it involves dangers that obliterate delight. In art, conversely, conviction has to be won, since the medium itself cannot be either awe-inspiring or terrifying. The processes by which this conviction is attained will occupy us considerably later on.

An indication of the extent to which the concept of fear as a pleasurable experience had attached itself to eighteenth-century aesthetic thinking is the place given to it by Edmund Burke in his *Philosophical Enquiry into the Origin of our Ideas of the Sublime and Beautiful*, which appeared in 1757. Here the Sublime is not simply one of many moral and aesthetic categories. It is treated as a phenomenon in its own right, paired with the beautiful and so by implication a matter of aesthetics, but in fact tackled by Burke (as his title encourages us to notice) in a thorough-going scientific way as a universal philosophical question. Burke couches his argument in the language of the moral philosophers, going back, of course, to Locke, but relying too on the more recent work of David Hume, whose dour Scottish logic and rational doubt was not perhaps very congenial to Burke, but whose clear reasoning set a dialectical standard for his age. Hume, discussing Beauty and Deformity in his *Treatise of Human Nature*, put the point very plainly that 'Beauty of all kinds gives us a peculiar delight and satisfaction; as deformity produces pain . . . Pleasure and pain, therefore, are not only necessary attendants of beauty and deformity, but constitute their very essence.'[14] Accordingly, Burke traces our sense of the beautiful and the sublime to sources in our notions of pleasure and pain. Obviously what is beautiful produces pleasure. But it is more basic even than that: the principal source of human gratification or pleasure is that associated with what Burke calls 'generation', or what we would now more bluntly refer to as 'sex'. This was a point Addison had made when he observed that the beautiful markings of birds performed the function of attracting mates.[15] Female beauty in humans is likewise the central and definitive source of our notion of beauty. A similar physiological cause lies behind the concept of the sublime: 'Whatever is fitted in any sort to excite the ideas of pain and danger, that is to say, whatever is in any sort terrible, or is conversant about terrible objects, or operates in a manner

analogous to terror, is a source of the *sublime*; that is, it is productive of the strongest emotion which the mind is capable of feeling.'[16] We are therefore to understand that the sublime is an emotion perceived in ourselves as a result of certain experiences. It is not strictly to be used in describing the objects that give rise to those experiences. But Burke and several other writers make all too little distinction here. 'Grandeur and sublimity have a double signification', Lord Kames explained. 'They generally signify the quality or circumstance in the objects by which the emotions are produced; sometimes the emotions themselves.'[17] Often we are told, in effect, that a sublime object occasions sublime sensations in the observer – the word covers the whole range of ideas from the external phenomenon through the gamut of intermediary events and sensations to the felt emotion.

Kant, who admired Burke's analysis of the sublime, clarified matters somewhat by suggesting that the sublime was characterised primarily by boundlessness while the beautiful, dependent on form, naturally resulted from the presence of boundaries. The boundlessness of the sublime, which reflects or implies all the central significance of the classic conception that we have discussed, entails its practical inconceivability. Something that is inconceivable cannot be conceived as sublime or as anything else – but the act of imagining it, even though it is beyond the power of imagination to envisage it, is itself a strenuous exalted mental or emotional state which we may describe as 'sublime'. Hence Kant says that the sublime is a dynamic state of mind while the beautiful is contemplated by the mind at rest. And he justifies Burke's association of pain with the sublime by arguing that there is a 'painful' discrepancy between the capacity of the reason to estimate the magnitude of an external phenomenon, and the capacity of the imagination to represent it. Hence the contemplation of, say, mountain peaks, chasms, vast solitudes or high waterfalls does not engender real fear, 'but only an attempt to feel fear by the aid of the imagination'.[18] These objects 'raise the energies of the soul above their accustomed height, and discover in us a faculty of resistance of a quite different kind, which gives us courage to measure ourselves against the apparent almightiness of nature.'[19] Thus Kant united the two aspects of the sublime in a specifically mental state centering on a moral capacity of human beings to transcend danger.

There is an important idea to be gleaned from this awkward controversy: despite the elevated and idealising tendencies that the idea carries with it in its classic definition, it also contains an appeal to, even a demand for, what we nowadays call a 'gut reaction'. There is no difficulty in demonstrating this. Most of the phenomena which, thanks to Thomson and later to Burke and the 'terror' school of sublime theorists, the eighteenth century came to associate with the sublime were events of the type that can also be described, in another modern term, as 'sensational'. The common fascination with death (especially violent death), human tragedies and natural disasters, the love of grandiose spectacle and everything grotesquely out of the ordinary (like the giants and dwarfs, the fat men and thin women who appear in works of reference like the *Guinness Book of Records*, a world best-seller), all this is a popular and perverted manifestation of the power of the sublime. A little book of 1683 entitled *The Surprizing Miracles of Nature and Art* illustrates how universal and perennial the interest is. Its sub-title is: 'The Miracles of Nature, or the Strange Signs and Prodigious Aspects and Appearances in the Heavens, the Earth, and the Waters . . .' and it lists, at great length, not only innumerable miracles of the saints (a fascination with miracles, real or imagined, is one of the few surviving vestiges of the religious sublime in the popular mind), but earthquakes, volcanic eruptions, storms, shipwrecks, fires, wars, and all the hideous brutality ensuing on war: rapine and torture, described in careful detail; together with monsters and prodigies of every sort – elephants, whales and so on. The atmosphere of the book is close to that of a modern popular newspaper. Dugald Stewart, one of the most thoughtful commentators on the

sublime, remarked that 'according to the phraseology of Longinus . . . the opposite to the *sublime* is not the *profound*, but the *humble*, the *low*, or the *puerile*.'[20] Sometimes a sublime event elicits a response at the opposite end of the scale.

Before we turn away from this apparent digression let us remember that it is owing to the close connection between the sublime and the vividly shocking that the subject concerns us at all. In order to 'work', art must demonstrate its relevance to us as human beings in whatever age we happen to live. It was the most ambitious art which most required complete conviction. When painters attempted the 'grand style' advocated by Reynolds they tended to fail of conviction. When they attempted it in the landscape mode, they had, on the whole, much better success. But landscape, it will be said, can hardly be shocking. Nor does it in itself express heroic virtues, as the eighteenth century saw. That was why it was an inferior branch of art. But because of the growing confusion between the sublime in external objects and events, and the sublime in human perceptions and emotions, the power of landscape to move came to be seen as relatively greater. In addition to this, from a fairly early date there was felt to be some sort of correspondence between landscape types and poetic types. We have seen Reynolds drawing a parallel between epigrammatist, sonneteer and so on and the minor branches of painting. Likewise, the pigeonholing instinct of the time could pair off categories of landscape with different poets. Addison gives a key example: 'Reading the Iliad, is like travelling through a country uninhabited, where the fancy is entertained with a thousand savage prospects of vast deserts, wide uncultivated marshes, huge forests, misshapen rocks and precipices. On the contrary the Aeneid is like a well-ordered garden . . . But when we are in the Metamorphoses, we are on enchanted ground, and see nothing but scenes of magic lying around us.'[21]

Now Homer is the one writer of whom Addison speaks explicitly as 'sublime';[22] 'Homer,' he says, 'fills his readers with sublime ideas.' His epithets 'mark out what is great', 'his persons are most of them godlike and terrible'.[23] The landscape that is evoked as symbolic of these qualities is 'uninhabited', 'vast', 'uncultivated', 'huge', 'savage'. All these terms are to be found over and over again in later descriptions of sublime landscape. Lack of cultivation, for instance, was essential to the sublime when Archibald Alison discussed it: 'The sublimest situations are often disfigured by objects that we feel unworthy of them – by the traces of cultivation, or attempts towards improvement . . .'[24] A tract of land with no inhabitants would automatically suggest the hostility of the place to human life, and so evoke fear. A few inhabitants, if sufficiently 'savage', could however enhance the sense of isolation and remoteness, as in the case of John Tracy Atkyns and the 'aborigines' of the northern wilds. Alternatively the absence of human life might leave the fancy free to invent some on appropriate lines: 'Observe this mountain which rises so high on the left, if we had been farther removed from it, you might see behind it other mountains rising in strange confusion, the furthest off almost lost in the distance, yet great in the obscurity; your imagination labours to travel over them, and the inhabitants seem to reside in a superior world.'[25]

The vast, the remote, the obscure, qualities that give rein to the imagination, can be enumerated in respect to landscape more easily and precisely than in connection with religious, mental or abstract ideas. The greatness of a Greek hero is an abstract conception; the greatness of a mountain is very palpable. In fact, once the idea had caught on, it became much easier to talk about the sublime in terms of landscape than in the context of Aristotelian heroics. Hence, although Burke's treatise is a general philosophical discussion, the clear-cut categories into which he divided sublime experience – obscurity, privation, vastness, succession, uniformity, magnificence, loudness, suddenness and so on – came to be affixed enthusiastically to aspects of nature which were beginning to be appreciated not only by poets like Gray but by the rank and file of cultured English folk. The desire to put these ideas into words

remained the first response; but that was bound, in the end, to produce paintings, since artists were, in a sense, only waiting for the literary stimulus in order to begin. As the wish to travel became more widespread, so the publication of 'Tours' became a fashion. By the 1770s it was a regular craze:

> As every one who has either traversed a steep mountain, or crossed a small channel, must write his Tour, it would be almost unpardonable in Me to be totally silent, who have visited the most uninhabited regions of North Wales – who have seen lakes, rivers, seas, rocks, and precipices, at unmeasurable distances, and who from observation and experience can inform the world, that high hills are very difficult of access, and the tops of them generally very cold.[26]

So wrote Joseph Cradock in 1777, introducing his *Account of some of the most Romantic Parts of North Wales*, a production typical of its time in everything but its author's ironic consciousness of the voguishness of his activity. Most people were more pompous, and many saw fit to enshrine their experiences in blank verse. Some used them to advance private aesthetic theories of their own; notably the Rev. William Gilpin, Prebendary of Salisbury, who, having conceived the notion of 'the Picturesque' while visiting Lord Cobham's new house, Stowe, in the 1740s,[27] applied the rules governing Cobham's careful design of his gardens as a sequence of changing vistas and rustic tableaux to the whole of nature. It was Gilpin who promulgated the fully-fledged 'Picturesque Tour' in which aesthetic theory and topographical observation are combined in one supremely didactic exercise. His authoritative statements on such matters as the correct disposition of hills in a view, or the number of cows permissible in a painting, were exactly attuned to the eighteenth-century longing for clear distinctions and definitions and enabled countless sightseers to appreciate actively the natural scenery which was of culturally legitimate interest for the first time. Some of Gilpin's rules were genuinely helpful: when he pronounced, for instance, that a ruin is bound to be more pleasing in a landscape than a newly built house he did not merely reflect a whim of contemporary taste; he reinforced a perennial truth about our perception of the environment. His basic premise, that when looking at nature we try to find combinations of elements that correspond to what we have already experienced in art, is equally valid. He became tendentious only when he asserted his own talent for discriminating desirable arrangements from undesirable ones as superior to nature's. At Gilpin's starting-point, the landscape garden, this was a valid position. It had, indeed, been held by Addison: 'we find the works of nature still more pleasant, the more they resemble those of art'. Much of the essence of Gilpin's message is to be found in the *Spectator* essay: 'We take delight in a prospect which is well laid out, and diversified with fields and meadows, woods and rivers; in those accidental landscapes of trees, clouds, and cities, that are sometimes found in the veins of marble; in the curious fret-work of rocks and grottos; and, in a word, in any thing that hath such a variety or regularity as may seem the effect of design in what we call the works of chance.'[28]

Variety was the core of Gilpin's Picturesque, and his survey of the works of nature as potential subject-matter for the aesthetician of course included wild, mountainous and 'terrific' scenery as well as the more homely diversity of cultivated land. But precisely because he was mainly concerned with 'that particular quality, which makes objects chiefly pleasing in painting',[29] Gilpin was inclined to shy away from the unpaintable immensities of the sublime. He recognised that sublime elements could enormously heighten our response to scenery; but like Gray he was prepared to go only so far. He would have found James Fenimore Cooper's North America too much altogether:

> In America the lakes are seas; and the country on their banks, being removed of course to a great distance, can add no accompaniments [to the view].

Among the *smaller* lakes of Italy and Switzerland, no doubt, there are many delightful scenes: but the *larger* lakes, like those of America, are disproportioned to their accompaniments: the water occupies too large a space, and throws the scenery too much into the distance.

The mountains of Sweden, Norway, and other northern regions, are probably rather masses of hideous rudeness, than scenes of grandeur and proportion. Proportion, indeed, in all scenery is indispensably necessary; and unless the lake, and its correspondent mountains have this just relation to each other, they want the first principle of beauty.[30]

For Gilpin's was a theory of beauty quite explicitly: he sought those aspects of nature that he found in the works of Claude and Poussin. But there was another seventeenth-century painter of landscape who had evolved a pictorial language of the 'horrid': Salvator Rosa (1615–73). The popularity of Salvator's paintings in England from his lifetime onward should contradict the idea that the more hostile aspects of nature were not enjoyed in England before the mid-eighteenth century; at least so long as they were confined to works of art. And in so far as Gilpin could find the rugged rocks, stark tree-stumps and stormy skies that were for Salvator what full-leaved chestnuts, verdant valleys and classical temples were to Claude, he included such scenes in his category of the Picturesque. There was no doubt, either, that this subject-matter was not strictly beautiful: wild and savage, decidedly uncultivated, often suggestive of desert, Salvator's was clearly the landscape sublime.[31] As such it epitomised that brand of the sublime which derives, *à la* Burke, from fear rather than from elevation or grandeur. So the theory of the Picturesque, while not directly bearing on the sublime proper, played an important role in the establishment of the accepted language of the landscape sublime. Thomson made the distinction in his often-quoted couplet in the *Castle of Indolence* (which came out in 1748 and so predates almost all Gilpin's writings):

> Whate'er Lorraine light-touch'd with softening hue,
> Or savage Rosa dash'd, or learned Poussin drew.[32]

We might speak of the two sublimes as the 'savage' and the 'learned' but I shall adhere to my chosen nomenclature, asking the reader to bear in mind the ambiguous place held by Poussin in this set of correspondences.

In spite of the prescribed limits of his interest, or rather because of them, Gilpin was of some use to artists in their exploitation of the new field of sensibility. His recipes and regulations gave guidance for the digestion of somewhat daunting raw material into acceptable pictorial fare; he writes, for instance, of the North of England:

> . . . it cannot be supposed that every scene, which these countries present, is *correctly picturesque*. In such immense bodies of rough-hewn matter, many irregularities, many deformities, must exist, which a practised eye would wish to correct. Mountains are sometimes crouded – their sides are often bare, when contrast requires them to be wooded – promontories form the water-boundary into acute angles – and bays are contracted into narrow points, instead of swelling into ample basons.

> In all these cases, the imagination is apt to whisper, What glorious scenes might here be made, if these stubborn materials could yield to the judicious hand of art! – And, to say the truth, we are sometimes tempted to let the imagination loose among them.

> By the force of this creative power an intervening hill may be turned aside; and a distance produced. – This ill-shaped mountain may be pared, and formed into a better line . . .[33]

It need not be supposed that landscape artists earnestly studied the Rev. William Gilpin and solemnly acted on his advice: this was largely directed at the layman. But we may assume that his attitudes coincide more or less with the mental processes of artists engaged in the problems presented by landscape composition. He spoke for his

period, even if he was not a leader in it. But his ideas could have direct influence upon painters: we know, for instance, that the youthful Turner copied some of Gilpin's illustrations, and did so very much in Gilpin's spirit, altering them according to his own ideas of picturesque composition as he went along.[34] His approach was certainly not that of an amateur: we have evidence in plenty of Turner's dedicated professionalism from his early years. But, dedicated as he was, and ambitious as he was, he was never afraid to learn from others. Gilpin was not, perhaps, the kind of model that Reynolds would have recommended, but as he matured Turner quickly found more rewarding masters. The lessons of Gilpin remained with him, however, and he was to put them to good use during the first decade or so of his career.

In addition to copying plates from Gilpin's books, he made his own studies of the kinds of scenery that Gilpin drew, and which were also recorded in the verse of the Picturesque tourists. When Turner, on his tour of South Wales in 1795, went to Melincourt to draw the waterfall there (FIG. V), he may have known that in the

FIG. V
J. M. W. Turner, *Melincourt Waterfall*, 1775, pencil and watercolour. British Museum, London

previous year a *Tour through parts of Wales* in blank verse pentameters had been published by William Sotheby, containing these effusions on the same spot:

> . . . lured by the fall
> Of the far flood through pathless glens I roam,
> Where Melincourt's loud echoing crags resound.
> Not bolder views Salvator's pencil dashed
> In Alpine wilds romantic. Far descried
> Through the deep windings of the gloomy way,
> The hoar Cledaugh, swoln by autumnal storms,
> Down the o'erhanging rock's declivity
> Curves the broad cataract, and on the stones
> Rent from the shattered mass prone rushing, spreads
> The foamy spray around . . .

The subject was also illustrated (FIG. VI) by one of the leading picturesque watercolourists of the time – John 'Warwick' Smith (1749–1831).[35] Unlike Turner's concentrated sketch of the fall of water itself, the rocks and shrubs round it only outlined in pencil, Smith's view presents the wall of rock extending from one side of the composition to the other, in a formal design which Turner himself was later to make use of in his views of Hardraw Force and Malham Cove.[36] For the moment, however, the waterfall is studied as an isolated picturesque phenomenon.[37]

A few of the oil paintings that Turner submitted for exhibition at the Academy in the 1790s belong to the class that has come to be known as the 'Picturesque Sublime' – a term that indicates the origin of this type of landscape in ideas promulgated by Gilpin, or akin to his theories. For the most part, it is not sublime in any of the full

FIG. VI
S. Alken *after* John 'Warwick' Smith, *Melincourt Cascade*, aquatint. Yale Center for British Art, Paul Mellon Collection

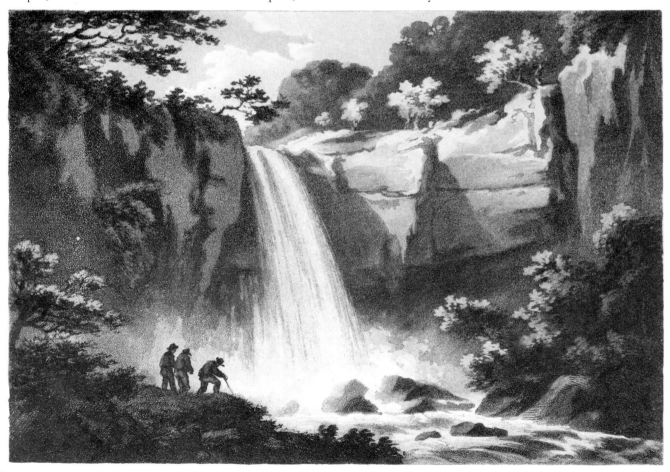

senses we now have terms for: it is a diluted sublime, in which the rather circum-scribed imagination of the good Prebendary can be felt to operate.

Typically these pictures choose subjects from the mountains of the North Country, such as Gilpin had drawn to people's attention, but they do not seek to *frighten* us. One of them, exhibited under the title *Buttermere Lake with part of Cromackwater, Cumberland, a shower* (FIG. VII),[38] contains many of the elements of this type of landscape in a very mature form. The dark sides of the mountains rise into turbulent vapours around the faintly gleaming lake, which partially reflects light from the obscured sky and the arc of a brilliant rainbow that spans half the composition. Beneath its arch lies a flat alluvial valley dotted with buildings, also reflecting light. Beyond, a sombre mountain heaves itself up into the clouds. The stillness of the lake in the foreground is emphasised by a small boat containing two figures, which creates slight ripples as it moves. The evocation of climate and space is assured, and the picture is remarkable for the simplicity of its design, the stately dignity of its rhythms. Only a few branches of trees in the left lower corner betray a self-conscious need on the part of the artist to 'balance' his composition. The ingredients of the Picturesque Sublime are handled with confidence and conviction; the view that the picture presents to us is impressive – grand in a sense that Gilpin could fully have understood and approved. Even so, at least one of his contemporaries thought Turner's effort 'timid'.[39] This may reflect the fact that Turner has carefully elaborated the detail of his subject rather than suppressing it in favour of generalised grandeur: we feel that his intention was to persuade by the accuracy of his statement rather than by aiming at stark grandeur. Why indeed did he so carefully inform the viewer that he was painting 'a shower' – which in itself is far from being a sublime phenomenon?

FIG. VII
J. M. W. Turner, *Buttermere Lake*, 1798, oil on canvas. Tate Gallery, London

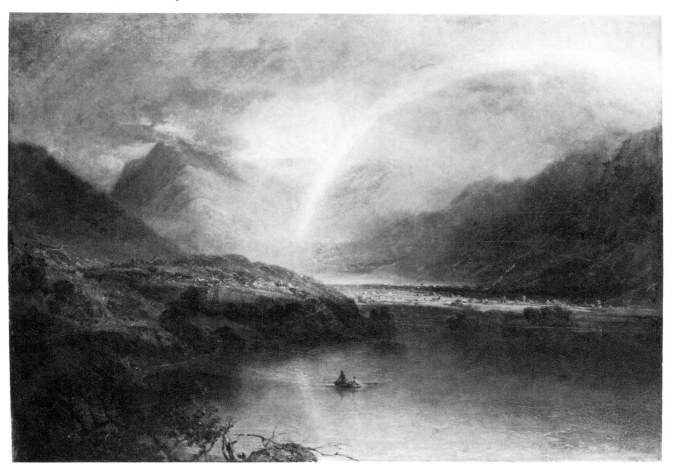

The picture was not, however, merely a visual statement. Turner printed with the title in the catalogue a few verses taken from Thomson's *Spring*, which are clearly meant to underline this quality of specific description:

> Till in the western sky the downward sun
> Looks out effulgent – The rapid radiance instantaneous strikes
> The illumin'd mountains – in a yellow mist
> Bestriding earth – the grand ethereal bow
> Shoots up immense, and every hue unfolds.[40]

These lines, chosen deliberately by Turner to accompany his painting during its exhibition, confirm that his aim was to create an image conveying a sublime natural effect – an effect involving 'effulgence', 'grandeur' and 'immensity', among other ideas mentioned in Thomson's lines. But it was an honest attempt to copy these incidents direct from nature; a young man's homage, as it were, to the self-sufficiency of his raw material. The coloured sketch that he made of the subject in one of his notebooks is evidence that he painted what he saw, and embellished only just sufficiently to round out his design.[41]

If it is a picture painted in homage to the natural world that must supply the landscape artist's subject-matter, *Buttermere Lake* is also a homage to Thomson. It was not the only one of Turner's paintings to be linked with his poetry: in the same exhibition another north-country subject, *Dunstanburgh Castle*,[42] was also accompanied by lines from the *Seasons*. Numerous similar parallels, drawn by Turner himself between his paintings and Thomson's poetry, occur in the Academy's exhibition catalogues. They are evidence of a lifelong regard for the poet which is apparent in Turner's own attempts to write verse. For he inherited in full measure the traditional view of the alliance between painting and poetry, and demonstrated that alliance throughout his career. He did this not only by printing verse with the titles of his pictures in exhibition catalogues from the first year that the Academy rules allowed the practice (1798), but also by composing poetry himself. One of the primary influences on his own verse was undoubtedly that of Thomson. For instance, these lines, which appeared with *Hannibal crossing the Alps*[43] in the catalogue of 1812, are Turner's own:

> . . . still their chief advanced,
> Looked on the sun with hope; – low, broad, and wan;
> While the fierce archer of the downward year
> Stains Italy's blanch'd barrier with storms . . .

They evidently derive from memories of a passage from *Winter*:

> Now when the cheerless empire of the sky
> To Capricorn and Centaur-Archer yields,
> And fierce Aquarius stains the inverted year –
> Hung o'er the farthest verge of Heaven, the sun
> Scarce spreads o'er ether the dejected day.
> Faint are his gleams, and ineffectual shoot
> His struggling rays, in horizontal lines,
> Through the thick air; as cloth'd in cloudy storm,
> Weak, wan, and broad, he skirts the southern sky . . .[44]

And the longest of all Turner's contributions to the catalogues consists of no less than thirty-two lines composed specially by him to commemorate Thomson. They accompany his picture of 1811, *Thomson's Aeolian harp*,[45] and are, of course, an imitation of his style. The picture reminds us that Thomson was buried at Richmond, close to Turner's own house at Twickenham, and we know that the painter

liked to see the landscape of that area through Thomson's eyes from the quotation from *Summer* appended to his picture of *Richmond Hill*[46] in 1819:

> Which way, Amanda, shall we bend our course?
> The choice perplexes. Wherefore should we chuse?
> All is the same with thee. Say, shall we wind
> Along the streams? or walk the smiling mead?
> Or court the forest-glades? or wander wild
> Among the waving harvests? or ascend,
> While radiant Summer opens all its pride,
> Thy Hill, delightful Shene?

We know from Turner's lecture notes, made in preparation for the courses he gave at the Academy in his capacity as Professor of Perspective, that he was in the habit of referring to Thomson for verbalisations of his own response to landscape, as well as for models of poetic excellence. Looking for an example of the poetic description of a river, he chooses Thomson's account of the Nile,[47] 'as poetic, metaphorical, Historical and with geographical truth'.

That last criterion, of 'truth', is important. The word is ambiguous in the context of eighteenth-century criticism, for it could be applied to artists when they were 'generalising' in Reynolds's sense: for instance, one writer observes that Richard Wilson's 'taste was so exquisite, and his eye so chaste, that whatever came from his easel bore the stamp of elegance and truth'.[48] Here the word refers to that truth to what we conceive as the ideal in nature which Reynolds advocated. The 'truth' that Turner found in Thomson no doubt partook of this sense, but it also and more clearly refers to Thomson's factual accuracy, the love of precision that prompted the poet to revise his *Seasons* periodically to bring them up to date with the latest scientific knowledge. Turner's sketchbooks testify to his own lifelong attention to the literal truth of nature as the foundation of his art. Just as Thomson saw that he could only bring the full grandeur of natural events to bear on his readers' imaginations by vivid exactness, so Turner believed that close observation of the real world was vital to his purpose in landscape painting. Hence the precise adherence of *Buttermere Lake* to its study, and the careful delineation of detail that seemed 'timid'.

In his first exhibited pictures the desire to achieve a clear, unambiguous image is even more marked than in *Buttermere Lake*. In 1796 he made his début as a painter in oil with *Fishermen at Sea* (FIG. VIII).[49] This was a night-piece – in itself evidence that he was in search of 'effect': although he had cast himself as a landscape painter, he intended from the outset to use landscape as a vehicle for statements appealing to the emotions at a more intense level than that of gentle pastoral subjects viewed in full unimpeded daylight. Even compared with *Buttermere Lake*, *Fishermen at Sea* is a work of very careful and precise execution. Its subject is not one of violent drama, but what it sets out to convey it conveys with the utmost nicety. The brooding darkness, the windy sky, the heaving surface of the sea, are not made the excuses for a flurry of expressive brushwork. This is an exercise in classic purity of technique, a purity that Turner was soon to find at odds with his intentions. Here, in his first publicly shown painting, he demonstrates that he can handle the oil medium as chastely as any academician. In particular he seems to have been thinking of the night-pieces of Joseph Wright of Derby (1734–97), which are themselves of unusual crispness and refinement of finish, reminiscent not of the work of his English contemporaries but of continental artists like Philippe Jacques de Loutherbourg.[50] De Loutherbourg (1740–1812) was a virtuoso of the sharply defined manner of presentation that he brought to England from France, and his essays in the landscape sublime were to have considerable influence on Turner, who owned a number of his drawings. But all these artists looked back to the acknowledged master of contemporary landscape, Claude-

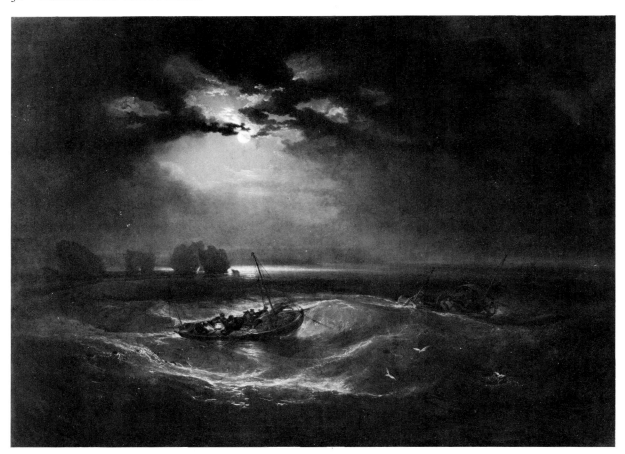

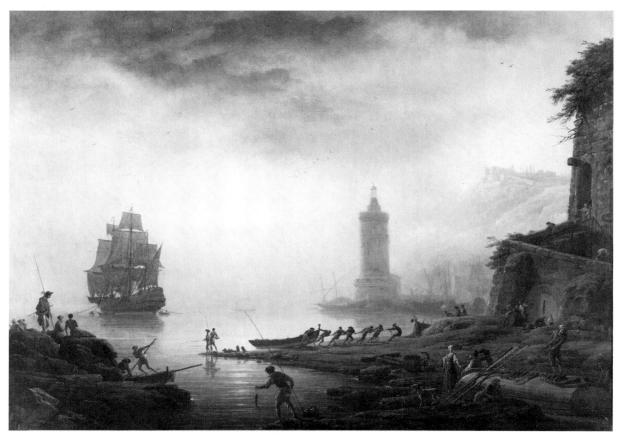

Joseph Vernet (1714–89), who specialised in romantic sea-pieces (FIG. IX), and whose work Turner is known to have copied.[51] Vernet's supremacy in his field was universally recognised. His Mediterranean harbours suffused with the golden light of sunset, peopled with elegantly grouped fisherfolk or fashionable ladies and gentlemen, were considered the direct descendants of Claude. But they marked an advance on Claude: 'Vernet', wrote Diderot, 'balance le Claude Lorrain dans l'art d'élever des vapeurs sur la toile; et il lui est infiniment supérieur dans l'invention des scènes, le dessin des figures, la variété des incidents, et le reste. Le premier n'est qu'un grand paysagiste tout court; l'autre est un peintre d'histoire, selon mon sens . . .'[52] Vernet showed how landscape could be raised to a more serious level of communication, and we shall see Turner later concerning himself with just these questions of 'the invention of scenes', 'the variety of incidents' and so on, which Diderot mentions. It was Vernet who in the 1750s had encouraged Wilson to take up landscape painting, and his mixture of landscape and history (in a sense that Diderot understood and approved) was what Wilson himself attempted. There can be no doubt that Diderot considered Vernet an artist of the sublime. 'Ce n'est donc plus de la Nature, c'est de l'art; ce n'est plus de Dieu, c'est de Vernet que je vais vous parler.'[53] Of a *Moonlight* shown at the Salon of 1763 Diderot remarks 'Il a rendu en couleur les ténèbres visibles et palpables de Milton.'[54] Again: 'C'est comme le Créateur pour la célérité, c'est comme la nature pour la vérité.'[55] Notice that, as with Wilson, the idea of grandeur alternates in the critic's mind with the idea of 'truth'; and Diderot does not mean truth to an ideal only: in 1767 he said of a Vernet canvas at the Salon: 'Tout est vrai. On le sent . . . J'ai oui dire à des personnes qui avaient fréquenté longtemps les bords de la mer, qu'elles reconnaissaient sur cette toile, ce ciel, ces nuées, ce temps, toute cette composition.'[56]

The landscape painter must astonish his audience by the immediacy of his effects, and that immediacy is produced by a truth both of general conception and of detail in the rendering of light, air, climate, space and atmosphere. It is a truth that forces the viewer to say: 'I recognise this from my own experience', which is the first premise in the argument by which he is to be convinced of the grandeur of the artist's intention. Whatever that intention may be, the landscape painter is confronted willy-nilly by the necessity for accurate imitation. This involves the spanning of a particularly wide gap: the gap between infinite space and the constricted two-dimensionality of the canvas.

Turner tried Vernet's method partly because it had such remarkable results in Vernet's hands, and partly to impress his colleagues with his technical proficiency. But he did not regard it as the only answer to his own problems. Few other pictures of his are executed in the tight, smooth manner of *Fishermen at Sea*, though at different times in his career he returned to the technique for special reasons: to reproduce the immaculate realism of Dutch seventeenth-century landscape in the *Dort* of 1818, for instance,[57] or to explore again in later life the complex lighting system of contrasted flame and moonlight that he had used in *Fishermen at Sea* when he painted his *Keelmen heaving in Coals by night* of 1835.[58] Already in the 1798 *Morning amongst the Coniston Fells, Cumberland*[59] a more broken touch is noticeable, the paint applied more richly and the lights scumbled warmly across darker glazes of sensuously laid in colour. This upright composition, soaring from a gloomy ravine towards the mist-wreathed peaks of mountains lit by the pale radiance of dawn, is at a far remove from Vernet. It owes something to the Welsh subjects of Wilson, whose sonorous colouring it approaches. Wilson also employed his brush in broad, loose strokes somewhat like the handling here. But Turner is still concerned to render the particular even if, as in *Fishermen at Sea*, he deploys a bold scheme of lighting to unify the design. We are made to feel familiar with every fold of these obscurely-seen hills, even with the convolutions of the slowly unwinding veil of mist that hides them. Again the artist's intention is

pointed by a quotation, this time from Milton himself: lines which Turner remembered when he was preparing his lecture on Reflections in about 1810:

> Ye mists and exhalations that now rise,
> From hill or streaming lake, dusky or gray,
> Till the sun paints your fleecy skirts with gold,
> In honour to the world's great Author, rise.[60]

At the time he was exploring the north of England, Turner also became acquainted with north Wales, where he went in search simultaneously of grand subject-matter and the birthplace of Wilson.[61] Wilson's influence on his method of painting increased during the late 1790s, and he produced several pictures of Welsh subjects at that time. They culminated in the canvas that he submitted to the Academy as his Diploma picture on his election as full Academician in 1802 – a moment of great importance in his career. This picture (FIG. X), exhibited in 1800, shows *Dolbadern Castle, North Wales*,[62] and exemplifies the progress of his style towards the greater generalisation which the Academy approved. It bears witness to an awareness not only of Wilson, but of the even more sublime Salvator Rosa. The rather delicate colouring of *Coniston Fells* has given way to broad and powerful masses articulated by sharper and more dramatic tonal contrasts. Instead of presenting an intricate pattern of interrelating natural phenomena, Turner gives a single bold idea: the lonely stump of the castle's ruined tower presides over a beetling cliff, at the base of which two figures are dwarfed by the high rocks. Restless clouds press down on the design from a fitfully lit sky. Technically, the picture could hardly be further removed from the suave finish and sharp detail of *Fishermen at Sea*, although the two works are linked by their mood of uneasy, threatening repose. There is another difference, too: whereas the canvas of 1796 is allowed to speak for itself, the *Dolbadern* has the lines of verse that were now permitted to appear in the catalogue. Incidentally, it is noteworthy that during these years, when a citation of verse is almost *de rigeur* for Turner, the sea-pieces are always without them. This is perhaps a reflection on the state of nautical poetry at the time; though Turner was later to borrow from Thomson and others in connection with certain of his marines. The lines quoted with the title of *Dolbadern* are as follows:

> How awful is the silence of the waste,
> Where nature lifts her mountains to the sky.
> Majestic solitude, behold the tower
> Where hopeless OWEN, long imprison'd, pin'd,
> And wrung his hands for Liberty, in vain.

It is thought that these are the first lines of Turner's own poetry to be used by him in an Academy catalogue. Once again, they bring together the group of ideas that 'belong' to the subject and leave us in no doubt as to the effect that Turner seeks. The 'awful silence' is a typical element of the sublime – an element that the artist could not incorporate visually – and had been noted by Burke as a type of 'Privation', along with Vacuity, Darkness, and Solitude.[63] 'Majestic solitude' is evoked two lines later. 'Darkness, vacuity, silence, and all other absolute privations of the same kind,' says Payne Knight, 'may also be sublime by partaking of infinity: which is equally a privation or negative existence: for infinity is that which is without bounds, as darkness is that which is without light, vacuity that which is without substance, and silence that which is without sound. In contemplating each, the mind expands itself in the same manner; and, in expanding itself, will of course conceive grand and sublime ideas, if the imagination be in any degree susceptible of grandeur and sublimity.'[64] All the qualities of the natural scene at Dolbadern are given additional force by being related to the experience of a specific human being – 'hopeless Owen' – with whom

FIG. X
J. M. W. Turner, *Dolbadern Castle*, 1800, oil on canvas. Royal Academy of Arts, London

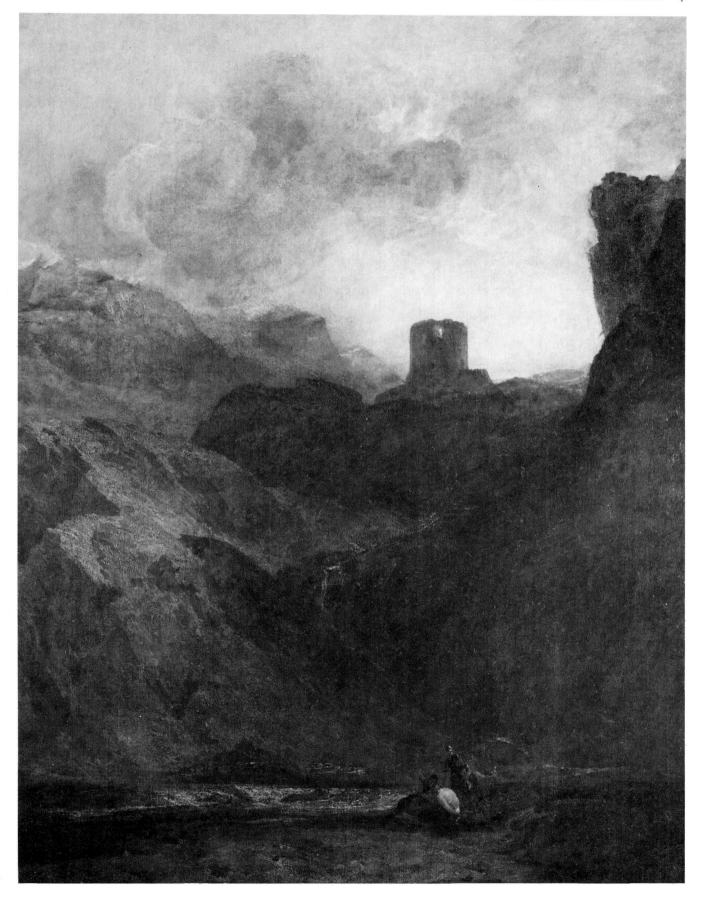

we can identify, and who, though unseen, takes the part of protagonist in the natural drama. This is Thomson's principle of human reference reapplied in a visual context, and of course the idea of historical association leading to the contemplation of heroic virtue and suffering is essential to the full sublime experience. The idea had been stated as a principle of Taste by John Gilbert Cooper in 1755:

> . . . even the Ruins of an old Castle properly dispos'd, or the Simplicity of a rough-hewn Hermitage in a Rock, enliven a Prospect, by recalling the Moral Images of *Valor* and *Wisdom* . . . amiable Images, belonging to the Divine Family of Truth . . .[65]

In *Dolbadern Castle* the specific 'Moral Image' is Liberty, a subject dealt with at length by Thomson in his poem of that title,[66] and treated by Turner in some later canvases.[67] The simultaneous suggestion of a hero and a universal ideal in the context of the gloomy Welsh mountains creates a complex play of ideas visual, moral and political which Turner may well have considered worthy of the attention of his fellow academicians.

With rather similar intentions, he worked on another north Welsh subject,[68] showing the army of Edward I marching through the foothills of Snowdon, on its mission of subduing the country and extirpating Welsh culture in the persons of its bardic priests. This act of suppression had been the theme of Gray's poem *The Bard* of 1757, a work which immediately entered the canon of sublime literature, and which lent itself with peculiar aptness to the use of painters specialising in the landscape sublime, more particularly since they could easily visit and study the scenery in which the story is set. Reynolds set the imprimatur of his approval on the poem in his fifteenth Discourse, when he referred to 'our great lyric poet, when he conceived his sublime idea of the indignant Welsh Bard . . .'[69] and several artists took inspiration from the subject.

> Ruin seize thee, ruthless king!
> Confusion on thy banners wait,
> Though fann'd by conquest's crimson wing
> They mock the air with idle state.
> Helm, nor hauberk's twisted mail,
> Nor e'en thy virtues, tyrant, shall avail
> To save thy secret soul from nightly fears,
> From Cambria's curse, from Cambria's tears!
> Such were the sounds, that o'er the crested pride
> Of the first Edward scatter'd wild dismay,
> As down the steep of Snowdon's shaggy side
> He wound with toilsome march his long array.[70]

It is the last two lines of this stanza that Turner illustrates. The work was never finished, and all that we have of it are a few studies, one or two of which are in watercolour on very large sheets of paper. For the finished picture was planned as a watercolour, not as an oil painting. Watercolour was a further means by which Turner could approach the problem of achieving serious art. It was a medium in which, at the time, limitless possibilities of technical advance were opening up. The experiments that Turner himself had been making during the 1790s were paralleled by developments in the work of contemporaries as dissimilar as Thomas Girtin (1775–1802), Richard Westall (1765–1836) and William Blake (1757–1827). The last two both attempted to give watercolour the density and power necessary for grand statements of 'historical' subjects, Westall trying with rich resonant colours reinforced by gum arabic to reproduce as exactly as he could the effect of his (much larger) oil paintings; Blake experimenting with his 'fresco' (tempera) and colour printing techniques to broaden the basis of watercolour. Girtin, who worked closely with Turner in the mid-1790s, confined himself almost exclusively to landscape, and

hardly modified his watercolour medium at all, but achieved a breadth and warmth in his use of it that contemporaries found impressive. He rarely needed to work on a large scale, having solved the problem of relative scale by his own subtly refined system of composition and colouring, which seems to have influenced Turner to some extent. But since both artists were pursuing a similar objective, the infusion of emotional force into the landscape watercolour, some of their solutions were likely to coincide in any case. In practice, their work turned out very different. Turner, for instance, was willing to paint his watercolours on enormous sheets of paper. In doing so, he was perhaps obeying a 'rule' of the sublime – that great size is conducive to grandeur.[71] Several of the watercolours that he submitted to the Academy exhibitions in the late 1790s and early 1800s follow this rule. There were other reasons, of course: in a public display of mixed works, watercolours needed to attract attention away from the paintings which all too easily monopolised the interest of visitors. Turner, unlike Girtin, had a mastery of oil which made it strictly unnecessary for him to paint in watercolour; but, as I have suggested, the technical potential of watercolour seemed immense. The studies for the *Bard* picture indicate the wonderful evocative power with which he could infuse the medium, and there are finished works of the same period which confirm this impression. For instance, another treatment of the theme of the Bard appeared as a finished watercolour on the Academy's walls in 1800 (the year of *Dolbadern Castle*). It is a much less dramatic subject, in which mountain grandeur plays no part:[72] Turner's model is Claude, and the Bard is seated beneath a graceful tree, singing to a small group of listeners. Beyond, a sunlit landscape of great beauty stretches away to the towers of Caernarvon Castle in the distance. Only the verses, probably by Turner, which appear in the catalogue, hint at the gruesome fate that the Bard will suffer:

> And now on Arvon's haughty tow'rs
> The Bard the song of pity pours,
> For oft on Mona's distant hills he sighs,
> Where jealous of the minstrel band,
> The tyrant drench'd with blood the land,
> And charm'd with horror, triumph'd in their cries.
> The swains of Arvon round him throng,
> And join the sorrows of his song.

Another watercolour view of Caernarvon Castle had been shown at the Academy in the previous year.[73] This too is a reminiscence of Claude, though the mood is greatly heightened by a sunset which suffuses the scene with golden light. No figures supply a 'historical' connotation; but the picture is nevertheless a translation into visual terms of a typical 'sublime' subject. One of the many tourists who visited the region had provided what might almost be the literary source for Turner's watercolour:

The solemn turrets of Caernarvon Castle, contrasted with the gay scenery of ships and villas in its neighbourhood, formed the foreground; to the left appeared the dark precipices of the Rivals, three mountains of great bulk, and immense height, which were now in the shade; and beyond them, the ocean, glittering with the rays of the departing sun, stretched as far as the vision extended. Nothing could exceed the glory of his setting; as he approached the waves, his radiance became more tolerable, and his form more distinct, exhibiting the appearance of an immense ball of fire. When he reached the ocean, he seemed to rest upon a throne, for a moment, and then buried his splendid rotundity in its waters; reminding us of that beautiful apostrophe to the orb of light, and sublime description, in the father of Erse poetry:

Hast thou left thy blue course in heaven, golden-haired son of the sky! The west has opened its gates; the bed of thy repose is there. The waves come to behold thy beauty.

They lift their trembling heads. They see thee lovely in thy sleep; they shrink away with fear. Rest in thy shadowy cave, O sun! Let thy return be with joy.

This must be our sole sample of the 'poetry' of Ossian, who, as the passage indicates, had considerably influenced people's way of looking at the mountainous regions of Britain. Turner himself produced only one work directly inspired by Ossian – a picture now lost which appeared at the Academy in 1802 with the title: *Ben Lomond Mountain, Scotland: The Traveller, vide Ossian's War of Caros*.[74] The traveller of our quotation is the Rev. Richard Warner, whose *Walk through Wales* came out in 1798,[75] and was followed a year later by *A Second Walk through Wales*. Warner's excited descriptions marvellously suggest the landscape of Snowdonia, and, in particular, convey the *scale* of the scenery, which was the element that caused artists most problems. He thus recounts his descent of Snowdon:

> We accordingly proceeded through the gloom, following the steps of our conductor, who walked immediately before us, as we literally could not see the distance of a dozen feet. The situation was new to us, and brought to our recollection the noble passage with which a prophecy of Joel magnificently begins: 'A day of darkness and gloominess, a day of clouds and of thick darkness, as the morning spread upon the mountains'; it produced however, an effect that was very sublime. Occasional gusts of wind, which now roared around us, swept away for a moment, the pitchy cloud that involved particular spots of the mountain, and discovered immediately below us, hugh rocks, abrupt precipices, and profound hollows, exciting emotions of astonishment and awe in the mind, which the eye, darting from an immense descent of vacuity and horror, conveyed to it under the dreadful image of inevitable destruction.[76]

Once again we have a literary parallel, this time from the Bible; and note the ritual succession of predictable adjectives and nouns: Gray's spontaneous awe, Thoresby's equally spontaneous terror, are now elements in a prescribed response; though it is not for that reason necessarily insincere, simply that the language for articulating the response is now fully forged. For Turner, the forging of a suitable language was still in progress. How, within the dimensions of even the largest sheet of paper, to present with forcible conviction the immensity of space which is the vehicle by which landscape operates upon our feelings? It was not, as Turner knew, simply a matter of drawing mountains and valleys and colouring them with suitably sumptuous tints. The whole composition had to embody that physical vastness which takes the breath away when we are confronted with it. This could be achieved partly by adjustments of scale; the tiny figures of the soldiers straggling along the valley in the view of Snowdon, humanity dwarfed by nature: that is one way to suggest vastness. But the vastness of Turner's landscapes had to be more palpable than that, much more a quality inherent in the way they were painted. He had seen that it could be done in the watercolour views of John Robert Cozens (1752–97), Alexander Cozens's more inspired son, many of whose compositions Turner copied (as did Girtin). He would have been able to see how Cozens, choosing subjects whose principal interest was the immensity of their scale, refined on the traditional techniques of watercolour to create a fully realised spatial dimension – vistas that recede into infinity, skies that are immeasurably deep, mountains that soar to immense heights, defining valleys of wonderful grandeur. To attain this remarkable power of atmospheric evocation, Cozens first of all restricted his colour range to a few greys, greens and blues, and secondly developed the natural distinction in watercolour between small, densely hatched strokes and broad washes. By deploying these to construct, respectively, solidly formed masses and ethereal spaces he translated, as it were, the opposing qualities of mass and space which he found in nature, into a literal equivalent in pigment on paper. Simple though this process sounds, it is tremendously effective. Turner understood it thoroughly, even if he never used it quite as Cozens did. He

exploited the delicacy of finely hatched touches to build up the concrete detail of a view, while flooding the sheet at the same time with bold sweeps of coloured wash to suggest space and light. A landscape is always constructed out of two elements: the physical forms of which it is composed, and the space between those forms. Before Cozens, landscape artists had generally left the space to look after itself – a wash of blue for a sky, a few formalised clouds, and a neat suggestion of sunlight falling on particular objects, were all that was required. It was a revised understanding of the reality of natural phenomena which prompted this change of approach: far from being more fantastic, Cozens and Turner aimed at a more comprehensive realism in conveying the grandeur of nature. After all, that grandeur was *there*; it did not need to be invented – it only had to be imitated adequately. This is what Diderot meant when he commended the 'terrible' Vernet for his 'truth'.

Vernet, however, was limited in what he could perform by the academic restrictions of his technique. By 1800 Turner had liberated himself from technical restrictions, as we have seen, by greatly expanding the capacity of watercolour, and by teaching himself to paint in a manner expressively consistent with his subject-matter. It was no doubt Reynolds who gave him the hint as to the advantages of a flexible oil technique: in his Discourses he had pointed to the consistency of style and content in Poussin and Salvator,[77] and Turner must have been alive to the value of this idea. And although he seems to have set himself to make watercolour do exactly what he required of it without recourse to extraneous media – gum, or bodycolour (gouache),[78] for instance – he did some experiments with more elaborate materials. His view of Gordale Scar (no. 30) is an instance of this experimentation: on a huge sheet of paper, it is a drawing in pencil over which Turner seems to have used watercolour, bodycolour and gum to create a texture close to that of oil paint.[79] This is only a study, once again, but it has all the force of an oil sketch. Gordale Scar was a phenomenon absolutely typical of the landscape sublime. It was a place where 'The rocks dart their bold and rugged fronts to the heavens, and impending fearfully over the head of the spectator, seem to threaten his immediate destruction.'[80] It was subsequently recorded unforgettably by James Ward in his enormous canvas[81] of the identical view, where the 'threat' is conveyed almost literally. Ward's choice of such a vast scale for his picture illustrates the compulsion exerted on artists by the landscape sublime to approximate to the actual scale of nature in their views. Needless to say, it was rarely attempted, though it was typical of Ward that he tried.

The impressive size of Turner's Gordale study is alone enough to indicate that in making it he was pursuing ends rather different from those he had in mind while drawing Melincourt waterfall in 1795. Picturesqueness is no longer a consideration; it is the sheer power of the scene that is the overriding factor. This is a new manifestation of the landscape sublime – the 'terrific': a category that comes into existence when the element of human danger is introduced. The historical themes of the works connected with the Bards or with 'hopeless Owen' thus directly contribute to the change of mood from one of agreeable, mainly aesthetic contemplation, to one of active involvement giving rise to a state of awe or fear. In the *Gordale Scar* historical figures are dispensed with, and even the representation of contemporary ones is superfluous – the spectator is the protagonist. Similarly in Switzerland, to which the sublime compulsion irresistibly led Turner along with many other artists, over-whelmingly grand statements are constructed out of individual features of the scene. The great fall of the Reichenbach, for example, inspired a large watercolour which is a revision of the composition of *Coniston Fells*.[82] It is upright, with the river falling down a cleft in the centre of the design. But instead of the assiduously suggested mist and obscurity of the earlier essay in the Picturesque Sublime, this drawing presents its subject with remarkable clarity. The details of dead trees, tumbled rocks, and blown spray are shown with scrupulous regard for vivid exactness. The grandeur of the

subject lies in the sheer size of the waterfall, in the scale that Turner creates on his sheet of paper, and in its immediacy. His technique enables him to render with fidelity a wide range of natural effects, forms and textures, a multitude of incidents compiled into a monumental image of great simplicity and directness. The human figure is absent, as so often in these early Alpine watercolours: this is the stark and inhospitable reality of the mountains brought vividly before us so that we can enjoy the *frisson* of horror that they give us. But the force of these Swiss views is more the result of confident directness than of an elaborately created atmosphere. Turner acknowledges the power of literal truth in the workings of the sublime.

'What are the scenes of nature that elevate the mind in the highest degree, and produce the sublime sensation? Not the gay landscape, the flowery field, or the flourishing city; but the hoary mountain, and the solitary lake, the aged forest, and the torrent falling over the rock. Hence, too, night-scenes are commonly the most sublime.' Hugh Blair's crisp definitions[83] of sublimity in landscape describe very accurately the preoccupations apparent in Turner's early work. But there is a further class of subjects that is prominent among his exhibited pictures, and which we have as yet barely touched upon: the marines. 'The idea of *literal sublimity*,' Dugald Stewart asserts, is 'inseparably combined with that of the sea, from the stupendous spectacle it exhibits when agitated by a storm.'[84] 'The excessive Grandeur . . . of the Ocean', says Blair, arises 'not from its extent alone, but from the perpetual motion and irresistible force of that mass of Waters.'[85]

Scholars of the sublime pointed out that there was an immediate connection between our responses to the ocean and to mountains: we speak quite naturally of 'mountain billows', Stewart observes, and conversely we talk of 'a tempestuous sea of mountains'.[86] It was therefore appropriate that Turner should study both these 'immensities' of nature together, and choose his subjects alternately from each. His first exhibited painting, as we know, was a sea-piece, and a night-scene into the bargain. But, as with his landscapes, he did not broach the most high-flown sublimities immediately. By a series of essays, progressively more ambitious, he explored gradually the technical problem of representing the sea, and the in-terrelationship between the sea and human beings. It is significant that many of the criticisms levelled against his early marines attacked his unrealistic depiction of water; this must have distressed him, since he attached such importance to literal truth in establishing the language of his dramas. Unfortunately, the criticism was to follow him throughout his career, although he modified his procedures considerably, as we shall see. The point that the critics were making was nevertheless important: they asserted (and Turner would have agreed with the premise) that if a picture of the sea is to impress us with awe, horror, or sympathy with its victims, then the painter must convince us that it is the sea we are looking at. The struggle to attain this conviction is evident in the sequence of his paintings: not all the subjects are dramas of human survival, but those which are show a steady intensification of dramatic excitement not only in handling and incident but also in broad conception. The progression from *Dutch Boats in a gale: fishermen endeavouring to put their fish on board* of 1801, to the *Shipwreck* of 1805, to the *Wreck of a Transport Ship* of about 1810[87] is one of gradually increasing involvement of the spectator in the scenes depicted. In the first a minor incident at sea is presented objectively as an external event; in the second a more serious incident is shown, the composition catching us up in a swirl of water and rocking vessels. The third is no longer an external event at all: the spectator is wholly absorbed into what is happening, actually in the water which reels and towers about him, a victim of the catastrophe that he witnesses. A visitor to Turner's studio thought it 'one of the most sublime and awful pictures that ever came from mortal hand . . . the dread reality seems before us'.[88] The old dilemma of the known artificiality of what we are supposed to respond to as if it were real is resolved by

masterly design and vivid realism of presentation. Gray might well have felt that in this picture the reality of the terror militated against the pleasure of beholding it. The dictum of Lucretius that defines this brand of enjoyment no longer applies:

> Suave mari magno turbantibus aequora ventis,
> E terra magnum alterius spectare laborem.[89]

This detachment, the detachment that makes it possible to distinguish between what other people experience and what we experience ourselves, while aesthetically pleasurable, is in a sense a fallacious basis for serious art. The landscape sublime relied on the contrary pulls of dread and enjoyment, the titillation of a fear that we cannot really feel. To evoke that sensation was no doubt agreeable enough; but it could have little to do with an art which set itself seriously and profoundly to treat of the eternal verities of human existence. This was merely playing with 'truth', and shirking the consequences. Turner, who saw more deeply into Reynolds's reasons for admiring Michelangelo than a simple effects-monger could, wanted to use his chosen medium of landscape for more important purposes.

NOTES TO CHAPTER TWO

1. As early as 1789 it was concluded that 'the Greeks had no Thomsons because they had no Claudes'. See Lindsay, *op. cit.*, p. 62; also Jean H. Hagstrum, *The Sister Arts*, Chicago 1958, pp. 251–2.
2. J. T. Atkyns, *Iter Boreale*, Yale Center for British Art, MS 1732.
3. William Mason, ed., *The Poems and Letters of Thomas Gray*, London 1820, p. 62.
4. *Ibid.*, p. 70, The passage from Livy translates: 'the mountain snows almost touching the sky, wretched huts placed on cliff-tops, cattle and animals shivering with cold, squalid and brutal people; everything animate and inanimate stiff with frost . . .'
5. See below, p.72.
6. D. H. Atkinson, *Ralph Thoresby, The Topographer, his Town and Times*, 2 vols, 1885–7, Vol. I, p. 129.
7. Immanuel Kant, *Critique of Judgement* (*Kritik der Urteilskraft*, Berlin 1790), trans. J. H. Bernard, London 1931, p. 124.
8. The etymology of the word has been hotly debated. The OED gives: Lat. sub + limen = lintel. 'Sub' has the force of 'over' or 'above' rather than 'below'; See Stewart, *op. cit.*, Appendix, p. 606–15.
9. Payne Knight, *op. cit.*, p. 332.
10. I. U. [Usher], *Clio; or Discourse on Taste, Addressed to a Young Lady*, 2nd ed., London 1769; p. 103.
11. Aristotle, *Poetics*, II, 13.
12. Payne Knight, *op. cit.*, pp. 328–9.
13. Coleridge, *Biographia Literaria*, ed. cit., p. 169.
14. David Hume, *Treatise of Human Nature*, 1739, ed. L. A. Selby-Bigge, 1888, Bk II, p. 298–9.
15. *Spectator*, No. 412, 23 June 1712.
16. Burke, *Philosophical Enquiry . . .*, London 1757, p. 13.
17. Kames, *op. cit.*, p. 264.
18. Kant, *op. cit.*, p. 136.
19. Kant, *op. cit.*, p. 125.
20. Stewart, *op. cit.*, p. 390.
21. *Spectator*, No. 417, 28 June 1712.
22. In his *Essay on the Pleasures of the Imagination* Elsewhere he discusses the sublime of Milton at length. See *Spectator*, Nos 267 (Saturday, 5 January 1712) etc.; an essay on *Paradise Lost*.
23. *Spectator*, No. 417, 28 June 1712.
24. Archibald Alison, *Essays on the Nature and Principles of Taste*, 4th ed., Edinburgh 1815, Vol. I, p. 121.
25. I. U., *Clio* . . . pp. 107–8.
26. Joseph Cradock, *An Account . . .*, London 1777, p. 1.
27. Gilpin's 'picturesque' was not strictly his own invention. The Abbé du Bos, in his *Reflexions Critiques sur la Poésie et sur la Peinture*, 1719, had already summarised many of the ideas Gilpin was to explore: J'appelle composition pittoresque, l'arrangement des objets qui doivent entrer dans un tableau par rapport à l'effet général du tableau. Une bonne composition pittoresque est celle dont le coup d'oeil fait un grand effet . . . Il faut pour cela que le tableau me soit point embarassé par les figures quoi qu'il y en ait assez pour remplir la toile. Il faut que les objets s'y démêlent facilement . . . que les groupes soient bien composés, . . .' etc.
28. *Spectator*, No. 414, 25 June 1712.
29. William Gilpin, *Three Essays: On Picturesque Beauty; On Picturesque Travel; and On Sketching Landscape* . . . 2nd ed., London 1794, p. 6.
30. Gilpin, *Observations relative chiefly to Picturesque Beauty, made in the year 1772, on Several Parts of England, Particularly the Mountains, and Lakes of Cumberland, and Westmoreland*, 2 vols, London 1786, vol. I, p. 3.
31. Horace Walpole's response to the Alps which he visited in the same year as Gray, 1739, is well known: 'Precipices, mountains, torrents, wolves, rumblings, Salvator Rosa –' (letter to Richard West, 28 September 1739).
32. Thomson, *The Castle of Indolence*; Canto I, xxxviii, ll. 8–9.
33. Gilpin, 1786, pp. 119–20.
34. TB I, D, H.
35. William Sotheby, *A Tour through Parts of Wales*, Sonnets, Odes and other Poems, London 1794, p. 16, and plate facing p. 17. Smith's dates are 1749–1831.
36. See nos 35 and 28.
37. See John Gage, 'Turner and the Picturesque', *Burlington Magazine*, CVII, January 1965, pp. 16–26 and February, pp. 75–81.
38. Butlin & Joll 7.
39. Farington, *Diary*, 5 January 1798. The critic was John Hoppner, RA, who said the picture showed 'a timid man afraid to venture'.
40. Thomson, *Spring*, ll. 88–9, 191–2, 193, 203–4.
41. TB XXXV, f. 84.
42. Butlin & Joll 6.
43. Butlin & Joll 126.
44. *Winter*, ll. 41–9. For comment on Turner's admiration for Thomson see Jack Lindsay, *JMW Turner*, 1966, pp. 58–62.
45. Butlin & Joll 86.
46. Butlin & Joll 140. The quotation is from *Summer*, ll. 1401–8.
47. Ms N, f. 8 verso. The lines Turner quotes are from *Summer*, ll. 804–21.
48. See T. Wright, *op. cit.*, p. 62.
49. Butlin & Joll 1.
50. For example, Wright's *Lighthouse in the Mediterranean*, Nicolson, pl. 312.
51. TB XXXVII, 104–5. rep. Wilton 1979, pl. 32.
52. Diderot, *Oeuvres Esthétiques*, Paris 1959, p. 574.
53. Diderot, *op. cit.*, p. 574.
54. Diderot, *op. cit.*, p. 564.
55. Diderot, *op. cit.*, p. 568.

56. Diderot, *op. cit.*, p. 575.
57. Butlin & Joll 137.
58. Butlin & Joll 360, see no. 73.
59. Butlin & Joll 5.
60. *Paradise Lost*, Bk v, ll. 185–8. ('Streaming' is a misprint for 'steaming'.) See Turner's MS Perspective Lecture, British Library Add. Ms 46151, H, f. 45.
61. See a letter of 27 December 1847, quoted by Finberg, *Life*, p. 419.
62. Butlin & Joll 12.
63. Burke, *op. cit.*, pp. 50–1.
64. Payne Knight, *op cit*., p. 363.
65. John Gilbert Cooper, *Letters concerning Taste*, London 1755, p. 13.
66. Published in 1735–6.
67. See Butlin & Joll 374, 375.
68. No. 41.
69. *Discourses*, Wark ed., p. 271.
70. Thomas Gray, *The Bard*, 1757, stanza 1.
71. Burke, *op. cit.*, p. 51: 'Greatness of dimension is a powerful cause of the sublime.' Sir George Stewart MacKenzie was of the opinion that 'Sheer size is not conducive to sublimity.' (*An Essay on Some Subjects connected with Taste*, Edinburgh 1817, p. 90.) In attempting to 'reproduce' on paper the scale of the mountains, Turner seems already to understand something broader by the sublime than the Burkean school of theorists.
72. Wilton 263, pl. 52.
73. Wilton 254, pl. 47.
74. Thought to have been a watercolour: see Wilton 346.
75. The quotation is from pp. 133–4.
76. Warner, *op. cit.*, p. 128.
77. See *Discourse V*, Wark ed., pp. 85, 87.
78. Turner is reported to have despised bodycolour: 'If you fellows continue to use that beastly stuff you will destroy the art of watercolour painting in our country.' See J. C. Horsley, *Recollections of a Royal Academician*, London 1903, p. 241.
79. Finberg considered that the medium is oil paint. He is possibly right.
80. *The Works of the late Edward Dayes*, London 1805, p. 62.
81. In the Tate Gallery, no. 1043.
82. Wilton 367; repr. in colour in *Turner in Switzerland*, p. 64.
83. Blair, *op. cit.*, p. 62.
84. Stewart, *op. cit.*, p. 422.
85. Blair, *op. cit.*, p. 58.
86. Stewart, *loc. cit.*
87. Butlin & Joll 14, 54, 210.
88. *Selections from the Literary and Artistic Remains of Pauline Lady Trevelyan*, ed. D. Wooster, London 1879, p. 117–18.
89. Lucretius, *De Rerum Natura*, II, ll. 1,2. The lines can be translated: 'It is sweet when on the great sea the winds trouble the waters, to behold from land another's deep distress.'

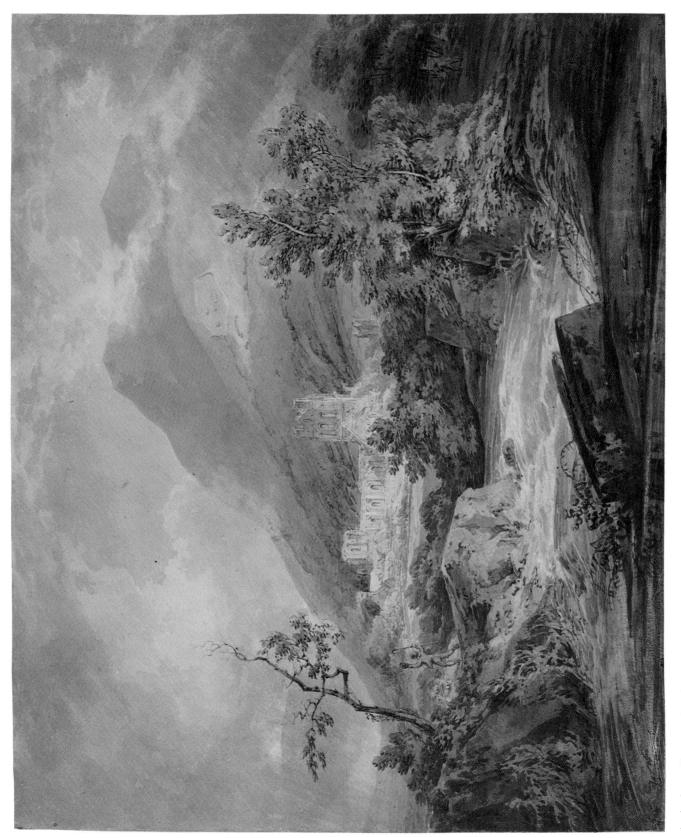

1 Llanthony Abbey, 1794 (no. 1)

2 *Evening Landscape with Castle and Bridge*, 1798–9 (no. 2)
3 *Norham Castle: Study, c.* 1798 (no. 3)

4 A view in North Wales, c. 1799 (no. 4)

5 Dolbadern and the pass of Llanberis, c. 1799 (no. 5)

6 *River with cattle and mountains beyond, c.* 1799 (no. 6)

7 *Pembroke-castle: Clearing up of a thunder-storm*, 1806 (no. 8)

8 Illustration to a lecture on Perspective:
Interior of a Prison, c. 1810 (no. 15)

9 *Rome: The Interior of the Colosseum: Moonlight*, 1819 (no. 17)

10 *The Hospice of the Great St Bernard*, (?) *c.* 1806 (no. 23)

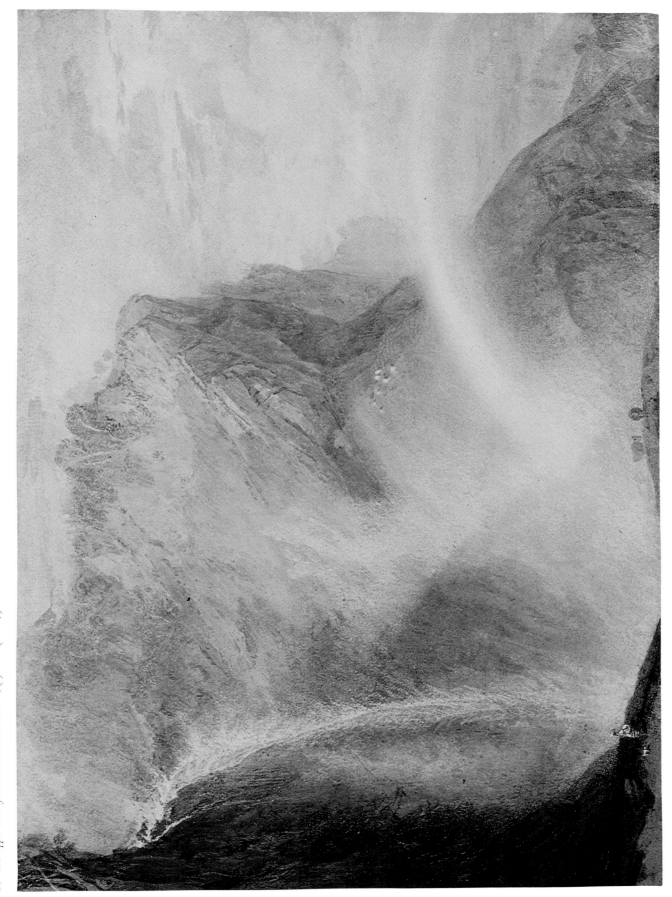

11 *The Upper Fall of the Reichenbach: rainbow*, (?) 1810 (no. 27)

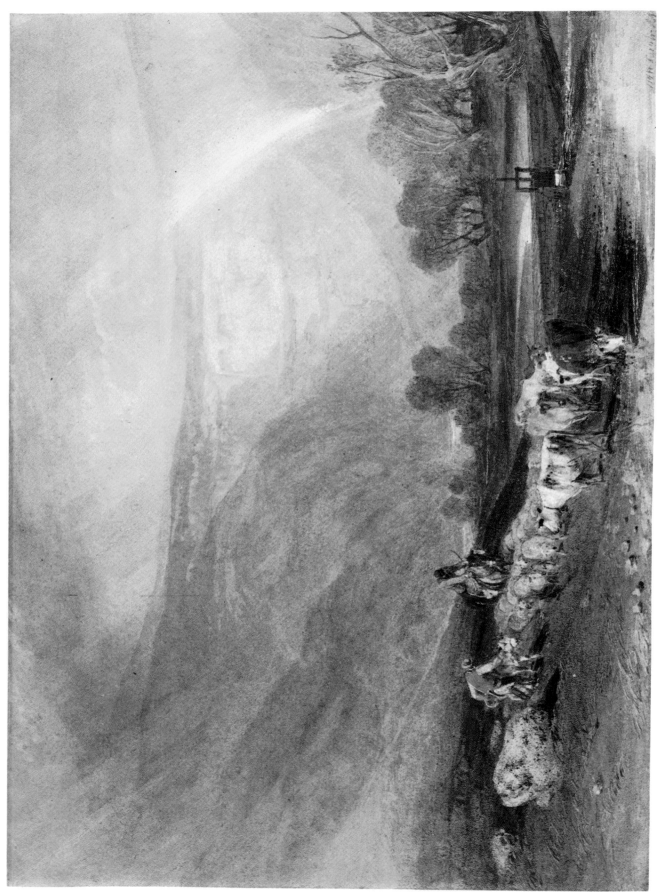

12 *Malham Cove, c. 1810 (no. 28)*

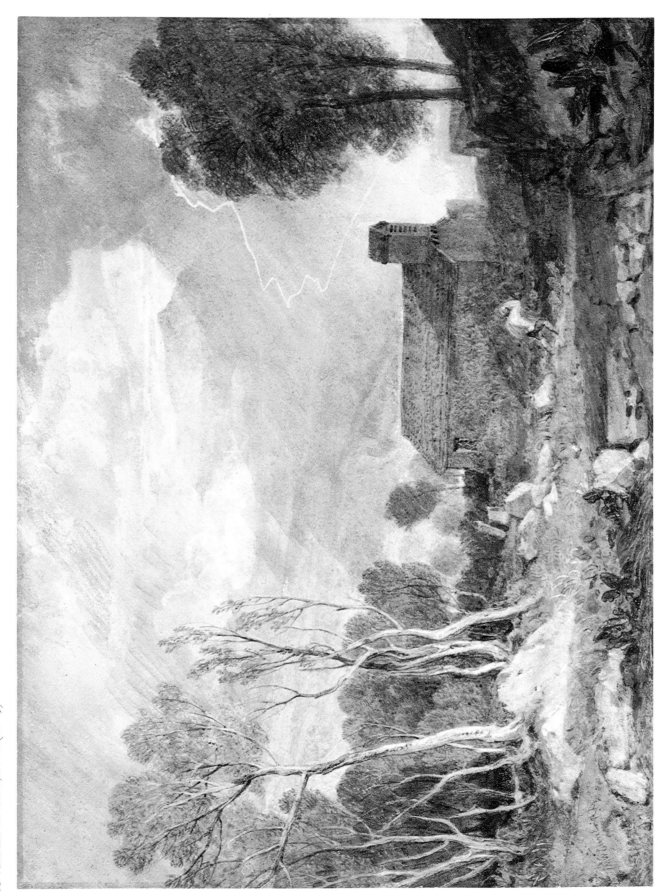

13 Patterdale Old Church, c. 1810 (no. 29)

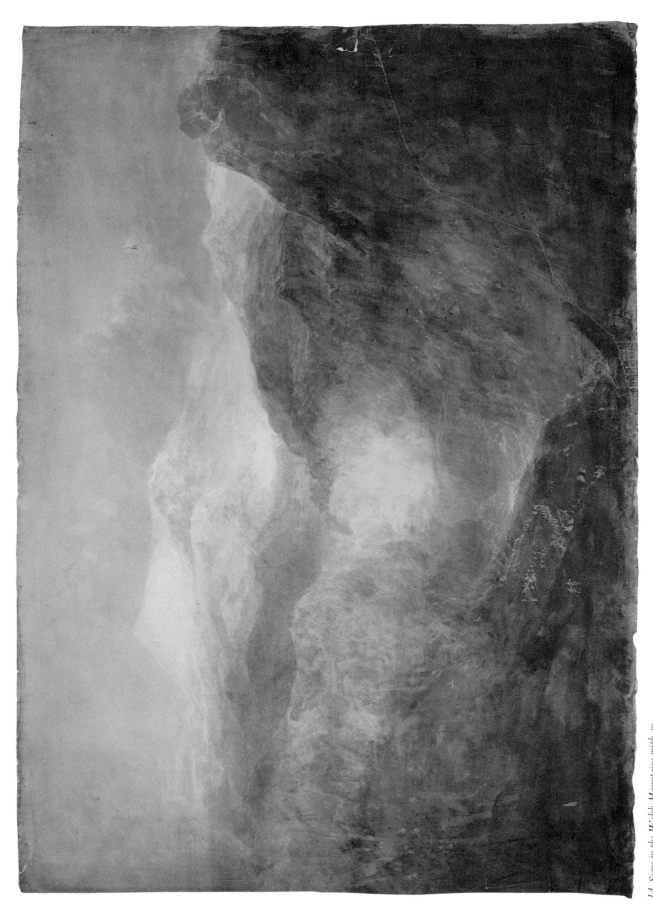

14 *Scene in the Welsh Mountains with an army on the march*, c. 1800 (no. 41)

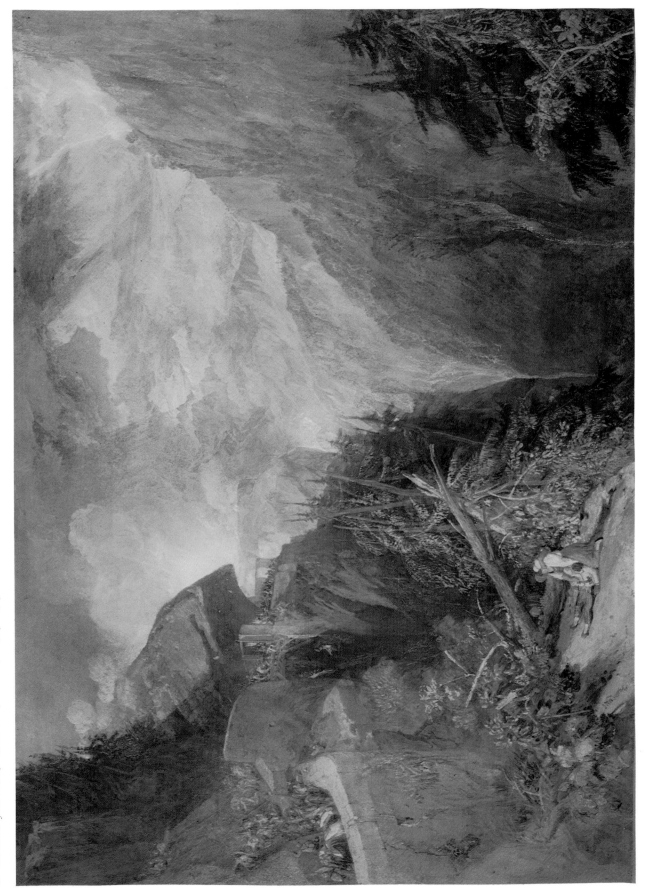

15 *The Battle of Fort Rock, Val d'Aouste, Piedmont*, 1815 (no. 51)

16 The Whale, c. 1845 (no. 69)

THE TURNERIAN SUBLIME

Distinguish with exactness, if you mean to know yourself and others, what is so often mistaken – the SINGULAR, the ORIGINAL, the EXTRAORDINARY, the GREAT, and the SUBLIME man: the SUBLIME alone unites the singular, original, extraordinary, and great, with his own uniformity and simplicity: the GREAT, with many powers, and uniformity of ends, is destitute of that superior calmness and inward harmony which soars above the atmosphere of praise . . .

JOHANN CASPAR LAVATER, *Aphorisms on Man*, (Aphorism 600), 1787

Tis not the giant of unwieldy size,
Piling up hills on hills to scale the skies,
That gives an image of the true sublime,
Or the best subject for the lofty rhyme;
But nature's common works, by genius dress'd,
With art selected, and with taste express'd;
Where sympathy with terror is combin'd,
To move, to melt, and elevate the mind.

RICHARD PAYNE KNIGHT: *Landscape. A Poem*, 1794

The branch of art to which Turner was initially trained was not of the most elevated, even in the field of landscape: from childhood until the age of about twenty he was a topographical draughtsman, making views of antiquarian interest for the popular magazines, in which they were rather inadequately engraved, or on commission for private clients. He also showed his watercolours regularly at the Academy, and, as we have noted, he attended the Academy's Schools where, in 1790, he listened to Reynolds's last Discourse.

That event must have impressed itself vividly on his memory, and the injunctions of the President been borne home to him in good earnest, for he frequently referred to Reynolds when he himself came to give lectures to the students in his capacity as Professor of Perspective. The assiduity with which he tried to discharge this office, and the pride with which he often signed his works 'R.A.P.P.' (for Royal Academician and Professor of Perspective) indicate his great dedication to the Academy and its function as preceptor to young artists. At the outset of his first lecture he reminded his listeners of Reynolds, 'whose Discourses must be yet warm in many a recollection'; and he devoted some space to a panegyric of the late President:

His worth as a man and his abilities as an artist were of the most conspicuous kind, whose constant attention to the interest of this establishment deserves all our thanks: whose whole life did prove by deeds 'the hardest lesson which his precepts taught' and which all prove unquestionably the greatness of his mind; and who, so far from vindicating the line of pursuit he had adopted (but which his works irrefrangibly prove exclusively to be his own), yet boldly stept forth, and recommended with his last words in this seat the study of Michael Angelo, to regard the energetic conceptions of his thoughts, the dignified manner of his expressing and embodying these thoughts; and to attend unto the lofty workings of his mind through all his works.[1]

It may well be that Turner felt the parallel between himself and Sir Joshua: both of them were there to teach disciplines to which in their professional capacities they had not entirely adhered. Like Reynolds, Turner tried to inculcate the elevated notion of the 'grand style' founded as much on a careful study of the great masters as on the observation of nature. He may have proposed methods from which he exempted himself on the ground that his own field was perforce an inferior one; but just as we nonetheless attribute to Reynolds himself the ideas he promulgated in his Discourses, so we may fairly assume that Turner believed wholeheartedly in what he told his audiences. Besides, he, like Reynolds, did not confine his activities to the one field in which he excelled: with even greater pertinacity than Reynolds he produced works in other genres. But unlike Reynolds, he never really considered his own an inferior field, and modified it to embrace an altogether broader concept of art.

With such ideas, it is not surprising that the genre of topographical view-painting, in which he began his career, should have provided Turner with a basis for a much more sophisticated form of communication. Buildings, which he learnt at an early age to draw with accuracy, were in fact repositories of a good deal of inherent sublimity. Often it was for this very quality that they were drawn; but topographers did not traditionally attempt to convert their antiquarian records into works of art – that is, they were not concerned with interpreting what they saw, or with creating atmosphere in their drawings. As a natural consequence of the vogue for the landscape sublime, architecture was accorded more weight in this context. Any building might be the focus of serious ideas if it was sufficiently ancient; castles, like Dolbadern or Caernarvon, were inherently grand because of their size and age; often they connoted particular historical events involving military prowess or the drama and terror of war. A cathedral connoted ideas of the grandeur of human achievements: 'In looking up to the vaulted roof of a Gothic Cathedral, our feelings differ, in one remarkable circumstance, from those excited by torrents and cataracts; that whereas, in the latter instances, we see the *momentum* of falling masses actually exhibited to our senses; in the former, we see the triumph of human art, in rendering the law of gravitation subservient to the suspension of its own ordinary effects.'[2]

But over and above these considerations, a cathedral embodied the religious sublime, and was the most impressive of all buildings by virtue of its direct connotations of the Deity. Addison did not much approve of the Gothic style, but he acknowledged the force of religious awe:

> We are obliged to devotion for the noblest buildings that have adorned the several countries of the world. It is this which has set men at work on temples and public places of worship, not only that they might, by the magnificence of the building, invite the Deity to reside within it, but that such stupendous works might, at the same time, open the mind to vast conceptions, and fit it to converse with the divinity of the place. For every thing that is majestic imprints an awfulness and reverence on the mind of the beholder, and strikes it with the natural greatness of the soul.[3]

In his great works in the mode of the 'architectural sublime' Turner strove not merely to inform the viewer of the appearance of the edifice he portrayed; he sought to imbue him with the same awe that he would experience in the building itself. Hence it was appropriate to make these watercolours on a large scale, as he did his landscapes of the same period. The views of Ely and Salisbury[4] that he produced in the decade around 1800 convey the grandeur of these great cathedrals by sheer scale, rather as the large Swiss watercolours of a little later present us starkly with the natural grandeur of the mountains. The use of sombre colour to suggest age-old interiors of dimly-lit stone is the equivalent of the palette employed to convey the rugged barrenness of the Alps, or the sullen storms of the Welsh mountains. All conform to the rule laid down by Burke:

Among colours, such as are soft or cheerful (except perhaps a strong red which is cheerful) are unfit to produce a grand image. An immense mountain covered with a shining green turf is nothing, in this respect, to one dark and gloomy; the cloudy sky is more grand than the blue; and night more sublime and solemn than day. Therefore, in historical painting, a gay or gaudy drapery can never have a happy effect; and in buildings, when the highest degree of the sublime is intended, the materials and ornaments ought neither to be white, nor green, nor yellow, nor blue, nor of a pale red, nor violet, nor spotted, but of sad and fuscous colours, as black, or brown, or deep purple, and the like . . .[5]

Colour is indeed a key element in these early watercolours, for it alone renders them quite separate in intention from the architectural or topographical tradition from which they spring. It proclaims the artist's wish to sway the emotions rather than to inform the mind: a radical change of role for the traditional topographical watercolour.

But studies of individual structures remarkable for their architectural and associational grandeur did not by any means comprehend all that Turner performed in the way of topography. In his view of the *Cathedral Church at Lincoln* of 1795 (FIG. XI) the

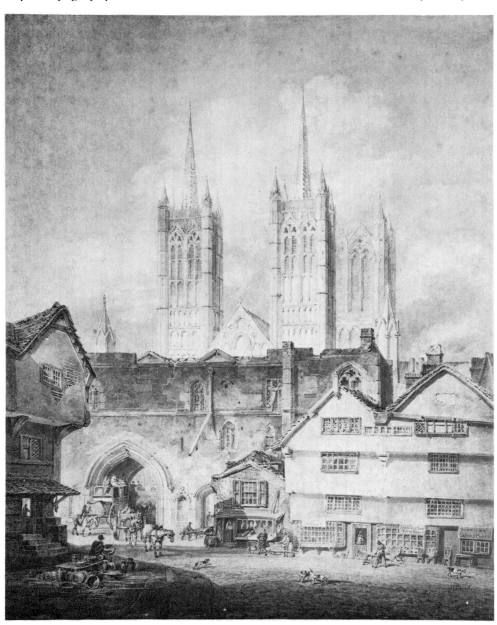

FIG. XI
J. M. W. Turner, *Lincoln Cathedral*, 1795, pencil and watercolour, British Museum, London

soaring towers and spires of the cathedral itself are not permitted to engross our interest; the foreground street scene with its backdrop of picturesque houses and walls is just as important to his purpose. The art of inventing appropriate figures to occupy the foreground of a view was one in which every topographer of any merit was skilled. Turner, in the years when such work occupied him almost exclusively – that is, until about 1795 – proved himself exceptionally adept in this. As the *Lincoln Cathedral* drawing shows, the foreground was not merely a space to be suitably filled with 'staffage': it was the stage on which much of the action of his design took place. For his view is not simply a cold statement of certain architectural facts. It is a picture of Lincoln, where architecture is only one element in a complex of interrelated facts about the city and its inhabitants. There is no large romantic 'message', only a full, lively and sympathetic account of the world Turner finds around him – the traditional 'economic' approach. Other topographical works of the 1790s carry the possibilities of that approach still further. The brilliant, bustling fair at *Wolverhampton*[6] of 1796 incorporates a wealth of human character, surveying the occupations of a wide variety of men and women in a provincial market town with something of a novelist's love of detail. A view of the west front of *Llandaff Cathedral*[7] drawn in the same year, at first glance a purely architectural study, contains a group of two girls dancing to a fiddler on a tombstone, touchingly suggestive of the larger issues that are raised by the subject. Imaginative human colour of this kind raises Turner's topography to a level of thought that is already considerably more sophisticated than that of the commonplace view.

What we are witnessing in these watercolours is the application of Thomson's principle of the interaction of human life and its environment. As we have seen, Turner was as ready to pair his watercolours with verses as he was his oils. Executed in the richer, more full-bodied palette Turner had evolved by this date, the drawings of the late 1790s convey far more of a sense of atmosphere than their predecessors of mid-decade, and there is a tendency for Turner deliberately to suppress the human element, for, as we know, he was pursuing the ideal of the landscape sublime, in which the brooding hostility of nature to man is a dominant note. The verses that he selected to accompany the 1799 *Warkworth Castle, Northumberland*,[8] from *Summer*, typify the mood:

> Behold slow settling o'er the lurid grove
> Unusual darkness broods; and growing, gains
> The full possession of the sky; and yon baleful cloud
> A redd'ning gloom, a magazine of fate,
> Ferment.[9]

But we have also noticed that the human element could be reintroduced, as it were, by oblique allusion: by bringing forward the latent associations of the spot recorded, as in *Dolbadern Castle*. Another of the watercolours shown in 1799, now unfortunately lost, does so in a particularly interesting way. It was entitled *Morning, from Dr Langhorne's Visions of Fancy*, and the catalogue supplied these verses from John Langhorne's *Elegy IV*:

> Life's morning landscape gilt with orient light,
> Where Hope and Joy, and Fancy hold their reign,
> The grove's green wave, the blue stream sparkling bright,
> The blythe hours dancing round Hyperion's wain.
>
> In radiant colours Youth's free hand pourtrays,
> Then holds the flattering tablet to his eye;
> Nor thinks how soon the vernal grove decays,
> Nor sees the dark cloud gathering o'er the sky.
>
> Mirror of life, thy glories thus depart.[10]

As in the *Dolbadern Castle* (FIG. X), the verses introduce a 'Moral Idea' which expands the sense of the picture and builds a group of connotations round it. Langhorne's poem is of special interest since it treats of a theme that Turner was to make his own: the Fallacy of Hope.

> Oh! yet, ye dear, deluding visions stay!
> Fond Hopes, of Innocence and Fancy born!
> For you I'll cast these waking thoughts away,
> For one wild dream of Life's romantic morn:
>
> Ah! no: the sunshine o'er each object spread
> By flattering Hope, the flowers that blew so fair;
> Like the gay gardens of Armida fled,
> And vanish'd from the powerful rod of care.[11]

When Turner began regularly to affix his own verses to his exhibited pictures, in 1812, it was a fragmentary 'Manuscript Poem' called *Fallacies of Hope* which provided the quotations. He continued to use this 'source' until the end of his life, and by its means gave literary interpretations to many pictures which seem to us to stand perfectly satisfactorily without them. His adherence to the eighteenth-century notion of *Ut pictura poesis* was staunch and lasting.

An amusing illustration of this is the pair of drawings that he made in his early thirties, satirically comparing an unsuccessful poet and an amateur painter.[12] The first is seen at his lucubrations in a garret scattered with 'Hints on an epic poem' and other papers, and beseeching his muse to 'finish well my long-sought line'. The other (no. 50) pores gloatingly over a newly completed canvas; the sheet is cluttered with notes on 'sublime' effects, and lists of historical subjects. Both aspire to the highest branch of their art, and while one is 'sublimely unaware' of his shortcomings, the other struggles against them, enlisting the aid of his muse. Turner's own struggles to write poetry are reflected in the *Garreteer's Petition*; his sense of the dangers of an inflated notion of one's own abilities as a painter emerges from the other drawing. Perhaps he asks us to draw the moral that we must adapt our notions of the sublime to suit our own capacities and abilities, rather than forcing ourselves into an ill-fitting mould.

But if he was diffident about his literary talents, he was not really in any doubt as to his powers as an artist, and the first decade of the new century saw him vying as earnestly as any student of Reynolds with the great masters of the past: Titian, Poussin, Backhuisen, Rembrandt, Salvator, Claude – all were used as models for pictures which explicitly set out to do what they had done. Even before he visited the Louvre he experimented with a grandiose history piece, exhibited in 1800, which he called the *Fifth Plague of Egypt* (see no. 43).[13] This embraces a much wider range of influences and associations than the *Dolbadern Castle* (FIG. X) of the same year, borrowing its combination of classical architecture and tempestuous landscape from Poussin, its wild paintwork and emotionally charged detail from Salvator, and its figures from Wilson. Later, influences are explored in a more disciplined way – the *Tenth Plague of Egypt* (see no. 44) aims at the unified tragic mood of Poussin, while *Jason* (see no. 42) imitates Salvator and *Macon* Claude.[14]

These subjects were to provide material for the early issues of Turner's *Liber Studiorum* which began to appear in 1807, and which in publishing his major pictures quite explicitly allocates them to their proper 'departments' of art: The *Plagues of Egypt* and *Jason* are, of course, 'Historical'; *Macon* was not used for the publication, but we know how Turner would have classified it, for his system is a typically eighteenth-century scheme for ordering and categorising, and the whole of the *Liber Studiorum* is, apart from being a means of disseminating his work, a sort of check-list of the various kinds of art at which he had tried his hand. He discriminates between the

'Historical' and the 'Mountainous Sublime' of course, and gives separate classifi-
cations to Architecture and Marine subjects; but he also makes distinctions between
the 'Pastoral' and the 'Elevated Pastoral', drawing attention to a most interesting
application of his system: most of the plates that are labelled 'P' for Pastoral treat of
informal, homely subjects – farmyards, children's games (the 'Puerile'?) and so on;
while 'E.P.' clearly denotes a more stately and splendid type of subject-matter; a
subject-matter that, in its own calm and expansive way, belongs as much to the
regions of the sublime as do rough seas and mountains. This is a matter about which
we shall have more to say later. Turner's use of the term 'Elevated Pastoral' (and
although it is not certain, there is every reason, including his own fondness for the
word 'elevated' in association with landscape, to believe that the 'E.P.' does mean
that)[15] affords important evidence of the development by this early date of his
personal interpretation of the 'hierarchy' of his own paintings.

This great series of mezzotints after his pictures perfectly illustrates Turner's
concern for the values that the eighteenth century had instilled in him. They reflect
the spirit of healthy rivalry with the greatest of his predecessors which Reynolds had
tried to inculcate, and a characteristically didactic attitude to his relations with the
public at large. He approached the old masters with Reynoldsian eagerness to learn,
but was equally eager to convey their teachings to others. The notebook that he filled
with observations on the paintings he saw in the Louvre on his continental visit of
1802,[16] and the jottings that he made in preparation for his lectures, contain many
thoughtful analyses and reflections on techniques, styles and idioms, which he
absorbed into his own practice and tried to pass on to his students.

His teaching of perspective was unorthodox, for he combined it with lectures on
the history of landscape painting and general observations on technical problems. He
was accused of talking off the point, but for him all these things were of central
importance, and to isolate the theory of perspective and teach it dryly as a 'pure'
discipline would have been absurd. He went so far as to admit that in itself the study
of perspective was boring: 'however arduous, however depressing the subject may
prove; however trite, complex or indefinite . . . however trammeled with the turgid
and too often repelling recourance of mechanical rules, yet those duties must be
pursued and altho they have not the charms or wear the same flattering habiliments of
taste as Painting, Sculpture or Architecture, yet they are to the full as usefull and
perhaps more so for without the aid of Perspective Art totters on its very foun-
dation.'[17] He reiterated with almost platitudinous firmness the importance of rules:
'True rules are the means, nature the end,' he said.[18]

As a landscape painter he was perhaps not the obvious choice for a teacher of the
Rules of Perspective as propounded by Malton, Kirby, Brook Taylor and the rest.
But as a trained architectural topographer he was well qualified for the task and he
thoroughly acquainted himself with the technical literature in preparing his course.[19]
He recognised that the laws of perspective are essential to the achievement of that
verisimilitude which the painter needs to attain in order to make any effect
emotionally valid. 'Parallel lines carry with them no idea of height,' he explained in
his first lecture, 'while the oblique line may rise to infinity. Consequently Perspective
and not geometrical drawings can produce an appearance [of] altitude, elevation or
size of form, which must be the feelings of the mind; the association of Ideas upon
viewing a fragment only of the Athenian Temples, a grain, a part of a whole, or before
the massy remnant of the Temple of Jupiter Stator without being impressed into ideas
of Grandeur by the mere recurrence of thought, the accompanying power of man's
intellectual capacity in supporting its extent of front or elevated entablature, but can
he, however colossal in intellect, for a moment think he is so in the scale of form or of
height equal to the fragments; how can it then be possible that a representation
Geometrically considered as to lines can give by any indulgence of effect the least idea

of the extent, the impression of height, dignity and towering majesty of architecture . . .'[20] The basic laws of perspective bear directly on our ability to communicate the grandest ideas. The point was fully borne out by the comments of a critic on Turner's *Decline of Carthage*[21] when it appeared in 1817: 'It is impossible to pass over the execution of the architectural parts of this picture: they are drawn with purity and correctness; the Grecian orders are carefully preserved, and the arrangement of the buildings in perspective is formed with so much adherence to geometrical rule, that the eye is carried through the immense range of magnificent edifices with such rapidity, that we entirely forget the artist, and merely dwell on the historic vision.'[22] Turner had already demonstrated the principle in his studies in the 'architectural sublime'; and he believed that no aspect of his art was so far outside the pale that it could not be elevated likewise:

> To select, combine and concentrate what is beautiful in nature and admirable in art is as much the business of the Landscape painter in his Line as in the other departments of art; and from the early drawings of nature in the work [of] Pietro Perugino can be traced the value of attending to method which each Master established for himself . . . by combining what was to them remarkable in nature . . . with the highest qualities of the Historic school.[23]

This states the principle on which Wilson constructed his landscapes in the grand manner – *Niobe, Celadon and Amelia, Solitude,* or *Cicero at his Villa*. When he came to discuss 'the immortal Wilson' in his lecture on Landscape, Turner cited these works as examples of his achievement. He pointed to the display of 'contending elements' in the *Celadon and Amelia,* and commended the 'dignified or more than solemn *Solitude*'.[24] It is no accident that the pictures that attracted Turner most, and which prompted the longest and most effusive of his commentaries, were two which achieved in a pre-eminent degree the combination of the 'remarkable in nature' with the 'highest qualities of the Historic school': Titian's *Death of St Peter Martyr* and Poussin's *Deluge*.[25] The first of these he called 'the standard of his [Titian's] powers of Landscape'. 'The high honour that Landscape Painting receives from the hands of Titian proves how highly he considered its value not only in employing the varieties of contrast, color and dignity in most of his Historical Pictures, but the triumph even of Landscape may be safely said to exist in his divine picture of St Peter Martyr. Even over History he felt not those puerile thoughts of making it subservient . . .'[26] The picture inspired Turner to ecstasies of poetic description: '. . . the sublimity of the arrangement of lines by its unshackled obliquity obtains the associated feelings of free continuity that rushes like the ignited spark struggling as the ascending Rocket with the Elements from Earth towards Heaven; and when no more propelled by the force it scatters around its falling glories, ignited embers, seeking again its Earthly bourne, while diffusing around its mellow radiance in the descending cherub with the palm of Beatitude sheds the mellow glow of Gold through the dark embrowned foliage to the dying Martyr.'[27] In his *Louvre* sketchbook he noted: 'This picture is an instance of his great power as to conception and sublimity of intellect – the characters are finely contrasted, the composition is beyond all system, the landscape tho natural is heroic, the figure wonderfully expressive of surprise and its concomitant fear . . . Surely the sublimity of the whole lies in the simplicity of its parts and not in the historical color . . .'[28]

On the other hand, it was the colour of Poussin's *Deluge* which Turner found 'sublime'. He thought it 'natural – it is what a creative mind must be imprest with by sympathy and horror'.[29] Turner follows Sir Joshua closely in using the word 'sublime' in connection with Poussin almost as a matter of course – endorsing the eighteenth-century judgment that the greatest sublimities are those associated with

the mind. Once more he attempts to marshal words to form a literary parallel to the picture: 'let us consider [a picture] where she [Nature] has ceased to place a barrier to the overwhelming waters of the Deluge swamping and bearing only one tone[,] the residue of Earthy matter . . . For its color it is admirable, impressive, awfully appropriate, just fitted to every imaginative conjecture of such an event . . . Deficient in every requisite of line so ably displayed in his other work, inconsistent in the coloring of the figures, for they are positively red, blue and yellow, while the sick and wan sun is not allowed to shed one ray but Tears.'[30] Another picture of Poussin's, *Landscape with Pyramus and Thisbe* (FIG. XII), called forth an equally rapt response: 'To the proofs of his abilities of Grandeur and pastoral subjects we possess another truly sublime in the Picture at Ashburnham House of Pyramus and Thisbe. Whether we look upon the dark dark sky illumined at the right hand corner by lightning rushing behind the bending trees and at last awfully gleaming its dying efforts upon some antique buildings on the left, while all beneath amid scattered foliage and broken tombs lies the dying figure of Pyramus; and [in] the depth of darkness all is lost but returning Thisbe.'[31]

This is to interpret painting as drama in the fullest sense: the man capable of these intense, involved responses to Titian, Poussin or Wilson was himself advocating an art to which such responses were appropriate, and there can be little doubt that he expected the public to view his own pictures in the same spirit.

Accordingly, he chose subjects that contained in themselves moving human incidents, and invented landscape settings in which those incidents found a sympathetic place. From the overt imitations of old masters that he produced in the first decade of the century he moved on to a more personal style of historical landscape, in which the lessons he had learned were amalgamated into a new unity. In 1811 he could still paint a more or less direct pastiche of Salvator, the *Apollo and Python*,[32] which is perhaps the last of his paintings to be couched unequivocally in the mode of the landscape sublime. It shows a rocky gully among the mountains, in which torn trees contribute to an atmosphere of desolation: the god, though he irradiates the bright beams of his solar responsibility, cannot illuminate the black cavern in which Python lurks. Apollo is conceived as a classical hero contending against the powers of darkness in a traditional opposition of light and shade, good and evil.

This is a simplistic view of the world that the mature Turner increasingly rejected. His next historical work is utterly different in conception. It treats of a hero, certainly; but the hero is a man, whose relationship with his surroundings is real and palpable – he does not float, like Apollo, in a circle of his own light, magically protected from reality. Hannibal crosses the Alps (FIG. XIII) in a blinding tumult of snow and storm that makes his perilous passage the more arduous. The literary source is precisely that passage from Livy quoted by Gray in his letter of 1739.[33] Gray once suggested that the subject should have been treated by Salvator Rosa: 'Hannibal passing the Alps; the mountaineers rolling down rocks upon his army; elephants tumbling down the precipices.'[34] But such an interpretation is no longer adequate to Turner's purpose. The crisp precision of his earlier delineations of the Alps is replaced by a vast blur of involved and battered fragments of the air in which the landscape is disintegrated. Does he thereby sacrifice that crucial 'truth' which he has all along recognised as the key to meaning? On the contrary. The conditions that he needs to describe are more vividly and accurately rendered like this than by any nice attention to minutiae. Here indistinctness is the essence of the sublime, the essence indeed of realism. 'Many images,' Gilpin had declared, 'owe their sublimity to their *indistinctness*; and frequently what we call sublime is the effect of that heat and fermentation, which ensues in the imagination from its ineffectual efforts to conceive some dark, obtuse idea beyond its grasp. Bring the same within the compass of its comprehension, and it may continue *great*; but it will cease to be *sublime* . . . In general,

FIG. XII
Nicolas Poussin, *Landscape with Pyramus and Thisbe*, c. 1651, oil on canvas. Städelsches Kunstinstitut, Frankfurt am Main

FIG. XIII
J. M. W. Turner, *Snow storm: Hannibal and his army crossing the Alps*, 1812, oil on canvas. Tate Gallery, London

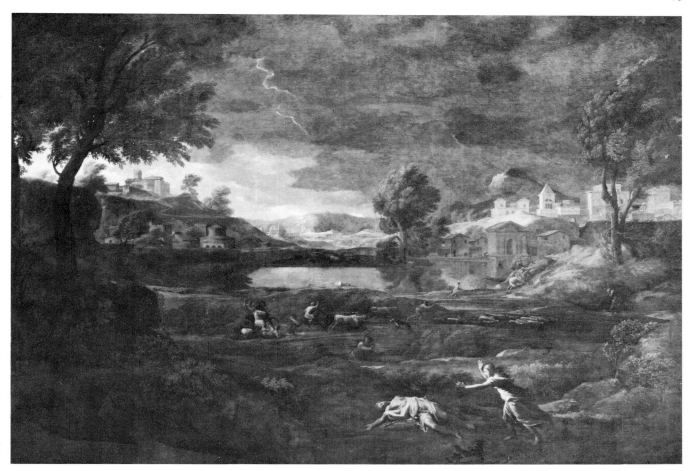

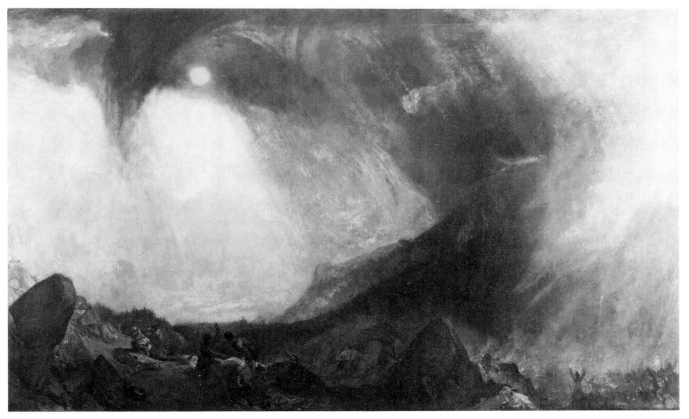

the poet has great advantages over the painter, in the process of *Sublimication*, if the term may be allowed. The business of the former is only to *excite ideas*; that of the latter, to *represent* them.'[35]

The contrast which critics had so often made between the expressive flexibility of poetry and the representational precision of painting had for generations inhibited painters from grasping the sublime bull by the horns. Reynolds had pointed in the right direction; but the generalisation he looked for was closely allied to the depiction of the human figure and the manipulation of facial expression in order to show emotion, and so could not help the landscape painter with his rather different problems. The dilemma reveals itself in the criticism of Wilson's *Niobe* which he made in his fourteenth Discourse (1788):

> Our late ingenious academician, Wilson, has, I fear, been guilty, like many of his predecessors, of introducing gods and goddesses, ideal beings, into scenes which were by no means prepared to receive such personages. His landskips were in reality too near common nature to admit supernatural objects. In consequence of this mistake, in a very admirable picture of a storm, which I have seen of his hand, many figures are introduced in the fore-ground, some in apparent distress, and some struck dead, as a spectator would naturally suppose, by the lightning; had not the painter injudiciously (as I think) rather chosen that their death should be imputed to a little Apollo, who appears in the sky, with his bent bow, and that those figures should be considered as the children of Niobe.[36]

This seems to destroy at a blow the whole argument of the 'Historical Landscape' school. If a convincing presentation of natural phenomena could not be combined with a heroic subject, what *could* one paint? But Reynolds had already pointed to Poussin as the model and stated categorically that his success derived from his self-consistency. Wilson had attempted two different sorts of 'truth' simultaneously and had failed to marry them. He needed to have a 'mind thrown back two thousand years, and, as it were, naturalised in antiquity'[37] to succeed. Turner's answer, after some years of thought and experiment, was an astonishing compromise. He chose natural phenomena of such grandeur or splendour that they were inherently 'universal' on account of their rare power and scale; and he proceeded to paint them as grandly and splendidly as his medium would allow. In a sense, he painted 'realistically'; but he had perceived, as we know, that realism does not necessarily reside in tightness and fine finish: it would be absurd to paint a snowstorm or a sunset like that. As Blair put it: 'it is one thing to make an idea clear, and another to make it affecting to the imagination; and the imagination may be strongly affected, and, in fact, often is too, by objects of which we have no clear conception.'[38] The absurdity of misapplied definition was to be demonstrated a very few years after the appearance of *Hannibal*, for Turner's picture inspired many of John Martin's apocalyptic subjects (FIG. XIV), in which cataclysms are rendered on huge canvases with painstaking attention to the details of rending granite and screaming women.[39] The effect is nearly always closer to the sensational or even the ridiculous than to the sublime.

Martin's crisply delineated multitudes of agonised human beings have their precursors in the blindly struggling armies of Hannibal. Turner does not attempt, like a club bore, to recount endless little incidents in detail. He invents figures just sufficient to convey the horror of the situation he describes. Ambush, rape, looting and murder are dimly suggested; the grim battles of men with each other and with the storm that envelopes them are evoked by mere indications: agitated mobs of half-lit figures shrouded in haze. The hero himself is nowhere to be seen. Turner tells his grand story of classical strength and human weakness in terms of the nameless men who composed Hannibal's forces. He rarely envisaged a hero without summoning to mind the effect of his actions on the human condition generally. Perhaps he saw a parallel with himself, heroic as a creative artist, materially altering the world in which

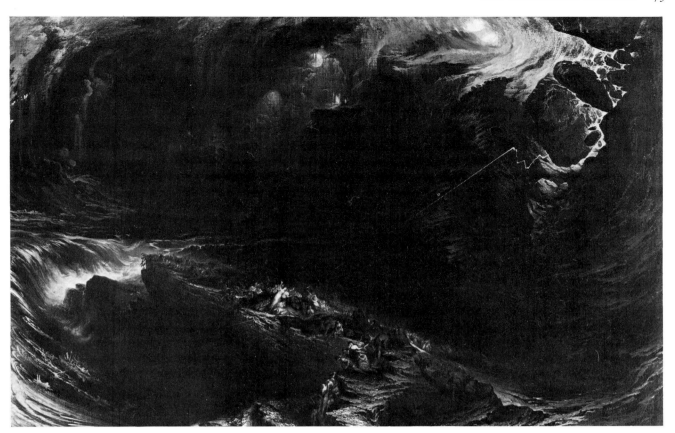

FIG. XIV
John Martin, *The Deluge*, 1834,
oil on canvas. Yale Center for
British Art, Paul Mellon
Collection

his fellow men lived.[40] So he was inclined not to place his protagonists at the centre of the stage, but to immerse them in the multitudinous crowds whose fate they controlled. This is in itself an extension of the sublime concept of the great man – a compelling restatement of his greatness in terms not of his appearance but of his power over men. It is a universality far more real and vital than the imagined features or gestures of an individual.

The identification of the actions of leaders and heroes with those of the men they led or controlled was an important development in his art which, as we shall see, was a necessary step in the integration of the two principal fields of his practice: the historical and the topographical. A striking example of the process in watercolour is his revision in 1815 of an earlier view of *Mont Blanc from Fort Rock in the Val d'Aosta*. The first version of the subject is a magnificent specimen of the landscape sublime,[41] in which the *frisson* created by a deep gorge among towering mountains is beautifully conveyed in the expressions and gestures of three girls who stand at a parapet. Their astonishment is apparent, their delighted terror embodies what we all feel before such a view. In the later version (*colour 15*) the girls are replaced by a woman holding a baby, who tends a wounded man lying on a bare shoulder of rock beneath the narrow mountain road on which a fierce battle is in progress. Napoleon's army is invading Italy, and, like Hannibal's, involved in a bloody skirmish among the mountains. The most conspicuous figures represent not the grand designs of Napoleon himself, but the remote effects of those designs on the common man.

In the same way, the paintings of *Dido building Carthage* and the *Decline of the Carthaginian Empire*[42] tell the tale of a whole society rather than recounting the exploits of one person. It is typical of Turner's progressing thought that the first subject focuses on a single character and purports to illustrate an epic poem, the *Aeneid*, while the second brings the story from mythology into history, supposes the triumphs and disasters of Hannibal's campaigns over, and presents a leaderless people

'enervated', as the catalogue title says, in their anxiety for peace, consenting 'to give up even their arms and their children'.

The two episodes of Carthaginian history are set in golden harbours of the type that Turner deliberately borrowed from Claude. But the scale of these harbours is grander than anything conceived by Claude: Turner uses his chosen model as the springboard for a communication that is unequivocally sublime. The drama of human affairs that he narrates is itself a powerful one, and his setting is calculated to enhance it. The splendour of Dido's city is a reflection of the nobility of her accomplishment, and all the more tragic a loss when it sinks into decay. The glorious sunrise in which it dawns, the 'ensanguin'd sun' that 'sets portentous'[43] over its decline – these are reinforcements of the theme at the level of direct symbolism. But they carry with them their own expressive force, as described by Dugald Stewart:

> There is a fourth [circumstance] which conspires, in no inconsiderable degree, in imparting an allegorical or typical character to literal *sublimity*. I allude to the Rising, Culminating, and Setting of the heavenly bodies; more particularly to the Rising, Culminating, and Setting of the Sun; accompanied with a corresponding increase and decrease in the heat and splendour of its rays. It is impossible to enumerate all the various analogies which these familiar appearances suggest to the fancy. I shall mention their obvious analogy to the Morning, Noon, and Evening of life; and to the short interval of Meridian Glory, which, after a gradual advance to the summit, has so often presaged the approaching decline of human greatness.[44]

Turner used this symbolism again very literally in his painting of 1842, *War. The exile and the rock limpet* (FIG. XV), which shows Napoleon in exile on St Helena. The sky

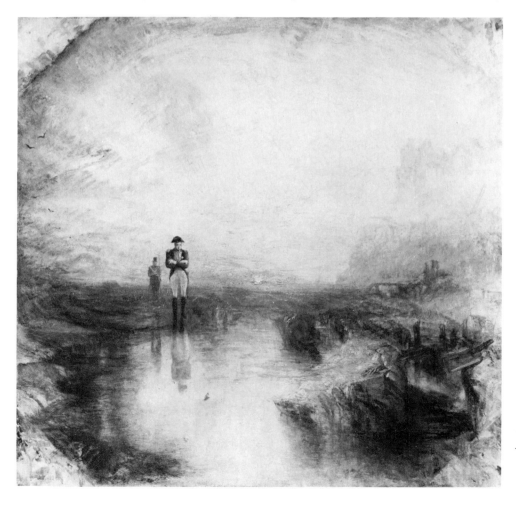

FIG. XV
J. M. W. Turner, *War. The Exile and the Rock Limpet*, 1842, oil on canvas. Tate Gallery, London

behind the solitary figure is of a deep and unmistakably bloody red, taking up an image that had been used by Byron in his *Ode to Napoléon*:

> – who would soar the solar height,
> To set in such a starless night?[45]

The opposition of night to day which sunset naturally implies greatly increases its emotional effect. And the symbol has a double meaning since it refers not only to the fallen hero, but to his sanguinary career. Although we see him alone, the lives and fates of his armies and all those who were sacrificed to his ambition are remembered. Turner's verses, in which Napoleon apostrophises the limpet, poignantly contrast his loneliness with the relative happiness of the humble soldier who can enjoy the company of his fellows:

> Ah! Thy tent-formed shell is like
> The soldier's nightly bivouac, alone
> Amidst a sea of blood –
> – but you can join your comrades.

This bitter opposition of fame and power to loneliness and decline was much on Turner's mind, and on the mind of the romantic generation that witnessed the fall of Napoleon. Beethoven had of course already celebrated the optimism that he inspired during his rise to power. His career gave him a rare historical status, coloured with a grandeur that seemed to involve the whole gamut of the sublime. A younger contemporary of Turner's brought many of these strands together in an essay *Sur la Mort de Napoléon* composed in 1843:

> Napoléon naquit en Corse et mourut à St. Hélène. Entre ces deux îles rien qu'un vaste et brûlant désert et l'océan immense. Il naquit fils d'un simple gentilhomme, et mourut empereur, mais sans couronne et dans les fers. . . . Sa vie, c'est l'arc en ciel; les deux points touchent la terre; la comble lumineuse mesure les cieux . . . sur son lit de mort Napoléon est seul; plus de mère, ni de frère, ni de soeur, ni de femme, ni d'enfant! . . . Il est là, exilé et captif, enchaîné sur un écueil. Nouveau Prométhée il subit le châtiment de son orgueil! Prométhée avait voulu être Dieu et Créateur; il déroba le feu du ciel pour animer le corps qu'il avait formé. Et lui, Bonaparte, il a voulu créer, non pas un homme, mais un empire . . . Jupiter indigné de l'impiété de Prométhée le riva vivant à la cime du Caucase. Ainsi, pour punir l'ambition rapace de Bonaparte, la Providence l'a enchaîné jusqu'à ce que la mort s'ensuivit, sur un roc isolé de l'Atlantique. . . . Sans doute d'autres conquérants ont hésité dans leur carrière de gloire . . . lui, jamais! Il n'eut pas besoin, comme Ulysse, de se lier au mât du navire, ni de se boucher les oreilles avec de la cire; il ne redoutait pas le chant des Sirènes – il le dédaignait; il se fit marbre et fer pour exécuter ses grands projets.[46]

In this piece of prose, almost contemporary with Turner's picture of Napoleon, a wealth of sublime imagery is clustered round the central figure of the fallen hero. Burning deserts, immense oceans, rainbows, Prometheus, Ulysses, marble, iron – all are suggested, not so much by the actual circumstances of Napoleon's death, but by the mere fact of his heroic stature in the history of the world. Turner's choice of subject implied for his audience just such an infrastructure of sublime reference; what is surprising is his insistence, which we see to be consistent with his other pictures about heroes, on the reverse, as it were, of the coin: the unremembered and not very sublime human beings whose suffering makes heroism possible.

Turner had already commemorated the men who died at Waterloo in his painting of that battle exhibited in 1818 (see no. 71), to which he appended a stanza of Byron's *Childe Harold* that dwells on the humanity and individuality of those who are killed. Waterloo was itself a subject eminently suited to the sublime: 'Nothing,' says Blair, 'is more sublime than mighty power and strength . . . the engagement of two great armies, as it is the highest exertion of human might, combines a variety of sources of

the Sublime . . .'[47] We have noticed that war is a subject that easily loses its sublimity and becomes merely sensational; Turner, following the literary lead given him by Byron, reformulates the message to emphasise neither the heroics nor the horror of the subject, but its broad human significance. While Napoleon broods in exile under a blood-red sunset, his soldiers at Waterloo lie – 'Rider and horse, – friend, foe, – in one red burial blent!' – already entombed in the darkness of night.

An earlier example of this process of transferring the actions of a hero to the swarming ranks in his command is the illustration to Gray's *Bard* which we have discussed. Here neither Bard nor 'ruthless king' appears, but only the army which is the instrument of tyranny, itself dominated almost to annihilation by the vastness of the mountains. It may be that to transfer historical significance from the leader to his people, his armies or his subjects, was something that had been suggested to Turner by his work as a topographer. That profession had taught him to embody the meaning of any landscape subject in the figures that belonged to it. As Archibald Alison observed, 'the occupations of men' are 'so important in determining, or in heighten-ing the characters of Nature . . . and afford [the painter] the means of producing both greater strength, and greater unity of expression, than is to be found either in the rude, or in the embellished state of real scenery.'[48] Art can concentrate and intensify by judicious selection what is often apparent only by implication in nature itself. Turner evolved his mature topographical style on this principle. For he certainly did not abandon his practice in that field when he acquired fame and wealth. But he could not help infusing it with ideas he had developed as a painter of 'heroic landscape'.

He gradually diverged, for instance, from the strict and literal recording of facts that characterised his earliest views. His successful essays in the architectural sublime of the late 1790s showed that there was a new public for expressive and atmospheric topography designed to stimulate a romantic mood rather than gratify curiosity about scientific facts. So although the nineteenth century began with a continuation of the demand for views, it witnessed a change in the nature of topography, for which Turner was largely responsible. Thanks to his highly sophisticated watercolour technique, developed by his repeated exercises in depicting the mountains first of Wales, then of Scotland and Switzerland, he was able to present, even on the modest scale of a small sheet of paper, a vividly convincing likeness of immense spaces, panoramic views and infinitely receding vistas seen in all kinds of atmospheric conditions. He could afford to choose for his subject-matter scenery and natural effects that had previously been beyond the range of even the most proficient technicians. If the place to be depicted did not admit of such theatrical treatment, he would nevertheless endow it with those qualities of light, air and space which all scenery possesses in reality, thereby rendering the most commonplace spots grand: simply as representations of the plain truth of the hitherto inexpressible elements of nature his watercolour drawings were breathtaking. And he would not hesitate to add drama to a view by breaking a violent storm over it, or arching a rainbow in the air above it. Air, sunshine, shadow, storm, clouds, the wind itself, he could render; not, as we should expect, by the free use of a wet brush, spreading broad washes across the paper, but by carefully building up the very substance of these insubstantialities with minute touches of a fine brush. He still employed the alternative of a free wash as Cozens had suggested to him, but now the wash and the fine hatched strokes were so intricately interwoven that the old clear opposition of the one technique to the other no longer appeared. By a strange contrariety of matter, in order to obtain effects on a small sheet of paper which on canvas he would get by means of breadth, he needed to apply a miniature touch to every separate part of the composition.

By doing so, he could simultaneously increase the relative scale of his paper (crowding many thousands of tiny strokes onto a sheet that would take only a few dozen broad ones), and control his effects from millimetre to millimetre of the surface

of the design. He could also say far more in a confined space, as indeed he had to. For these reasons, he was able to abandon large sheets of paper: grandeur of effect was a matter of relative scale and not of absolute size. At the same time he raised the colour key of his drawings – rather as he was doing with his oil paintings over the same period. These technical developments were intimately related to the heightened perception of natural phenomena that demanded other variations on the traditional language of landscape. It may have been the influence of Burke's theory of the 'terrific' sublime that initially encouraged Turner to distort the geographical details of what he saw to express more forcibly such ideas as height, depth and distance. These modifications of reality to achieve a more significant and essential reality in landscape quickly became a crucial element in Turner's heroic pictorial language. An example is his artificial treatment of recession in 'subsidiary perspectives', a common feature of his compositions, particularly those with a classical basis. Views through arcades, avenues of trees, tunnels of rock, even vortices of dust or storm, create an arrow-like retreat through the picture-space that is often at odds with the calmer perspective of the principal view.[49] These distortions are devised to increase the dynamic of landscape, not simply to reconstruct as vividly as possible in two dimensions the spatial complexities of the actual scene, but to impose a dramatic mode of vision upon the viewer, who is compelled to enact with the eye leaps and plunges, ascents, penetrations and progressions that plot for him the three-dimensional presence of the perceived landscape. The 'unnaturalness' of these devices is evident, and they are largely responsible for our sense that Turner is a theatrical, and not a naturalistic painter; yet they are employed primarily in order to convey certain fundamental truths about the physical world and as such are the artist's literal equivalents to what he experiences. And such distortions were entirely permissible to the theorists of the sublime. They were indeed inevitable in the processes of heightened communication: 'Longinus maintains,' as an eighteenth-century commentator noted, 'that a high degree of sublimity is utterly inconsistent with accuracy of imagination; and that Authors of the most elevated Genius, at the same time that they are capable of rising to the greatest excellencies, are likewise most apt to commit trivial faults.'[50] By the early 1820s, though we are conscious of these sometimes extreme exaggerations of space and form in Turner's work, we rarely feel that our susceptibility to fear is being played upon. It is far more often a sense of the overwhelming splendour of the world that emerges from the watercolours of this central period in his career.

Their impressiveness is not simply a consequence of their depicting grand scenery. His old fascination with the human life of the places he drew developed alongside the other aspects of his art to become a vital element in the heightened topography of his maturity. He began to conceive his views, not as a topographer, but as the great master of romantic landscape that he had become. And just as nature itself was imbued with new power, so the human 'staffage' gained in weight and significance, to become the same heroic multitudes that embody the moral purpose of his epic canvases. There is no need in the watercolours of the *Picturesque Views in England and Wales* (1825–37) to look for a named hero: man himself, the ordinary inhabitant of the scenes depicted, is the protagonist of these splendid dramas. And, as we have seen in the operation of the sublime elsewhere, a certain degree of detailed precision gives the verisimilitude that brings us into immediate contact with the experience that Turner is trying to communicate: the horror of a sea storm is the more appalling when we watch men vomiting up salt water as they drown, or slipping on wet sand as they try to salvage wreckage from the surf (nos 62, 64). The magic of a summer evening is palpable if we can identify with people who have stripped off their clothes to plunge into the warm still water of a quiet pool.[51] The bleakness of Penmaenmawr (no. 38) is appreciable more readily if we can see a stage-coach drawn at top speed across it by frightened horses galloping through a ferocious downpour of rain. The individual

effects of these watercolours may well (and frequently do) partake of the sublime fear we have discussed; the *Penmaenmawr* last mentioned clearly does so; though not in the crude, archaic way that emerges from, say, a travel guide account of 1757, which records that Penmaenmawr 'hangs perpendicularly over the Sea, at so vast a Height, that it makes most spectators giddy who venture to look down the dreadful Steep; and in the narrow passage to the other Side, the ventrous Traveller is threatened, every Moment to be crushed to Atoms, with the Fall of impending Rocks.'[52] Turner is not afraid to use devices that evoke this kind of horror, when his subject merits such treatment; but his overriding object in these watercolours is to impress us first with the grandeur of nature, and second with the reality of that grandeur as experienced by human beings like ourselves, who live out their lives in the conditions he presents. This is the point that Ruskin makes when, in discussing the great watercolour of *The Pass of Faido* of 1843 (*colour 24*), he concentrates not so much on the wild confusion of the scene as on the postchaise that Turner introduces on the road that winds through the pass. Blair observed that disorder 'is very compatible with grandeur; nay, frequently heightens it . . . A great mass of rocks, thrown together by the hand of nature with wildness and confusion, strike the mind with more grandeur, than if they had been adjusted to one another with the most accurate symmetry.'[53] And certainly the scene that Turner recreates in the *Faido* is sublime in this sense; it is one of his most grandiose evocations of the rugged and hostile scenery of the Alps, achieved on a small scale by means of an extraordinarily flexible and varied technique. As Ruskin observes, many people might be content with this, enjoying the primitive horrors of the landscape sublime, and feeling that to introduce even the most insignificant element of human life is to dilute 'the majesty of its desolation'. But Ruskin realised that for Turner it was not the emptiness of the scene alone, nor its hostility to human life, that needed to be stressed: the pass of Faido was one of the great natural events of the traveller's journey through the Alps to Italy, and could only be approached and understood in that context, in the traveller's state of mind, and through the medium of the road: 'in no other wise could we have come than by the coach road. One of the great elements of sensation, all the day long, has been that extraordinary road, and its goings on, and gettings about . . . so smoothly and safely, that it is not merely great diligences, going in a caravannish manner, with whole teams of horses, that can traverse it, but little postchaises with small postboys, and a pair of ponies . . .'[54] By the same token, the two panoramic views of Zurich that also came from Turner's brush in the 1840s take full cognisance of the fact that Zurich is a thriving city: however expansive and ecstatic the broad vision of the rising sun, the town is incomplete without its thronging inhabitants going about their affairs, or gathering for a day of civic revelry (see no. 93).

These watercolours proclaim what had long been evident in Turner's output, that the urban view is as capable of embodying grandeur as the wildest natural landscape. It is true that Blair had expressed the opinion that 'the flourishing city' was not conducive to elevation of the mind; but there are recurrent passages in the Tours of the period in which a panorama filled with varied evidence of human activity is described as sublime. Sometimes cities take only a subordinate place in a more general vista, as in Richard Warner's account of the view from Cader Idris: '. . . the vast unbounded prospect lay before us, unobscured by cloud, vapour or any other interruption to the astonished and delighted eye; which threw its glance over a varied scene, including a circumference of at least five hundred miles . . . Numberless mountains, of different forms, appearances, and elevation, rise in all directions around us; which, with the various harbours, lakes and rivers, towns, villages, and seats, scattered over the extensive prospect, combine to form a scene inexpressibly august, diversified, and impressive.'[55]

17 *Study of an Industrial Town at Sunset, c. 1830 (no. 85)*

18 *Luxembourg, c.* 1825–34 (no. 88)
19 *Lausanne, Sunset,* (?) 1841 (no. 90)

20 *The Moselle Bridge, Coblenz, c.* 1842 (no. 91)

21 *Heidelberg: looking west with a low sun,* 1844 (no. 92)

22 *Among the mountains*, (?) *c.* 1835 (no. 97)

23 *The Glacier des Bosons,* (?) 1836 (no. 99)

24 *The Pass of Faido*, 1843 (no. 104)
25 *Goldau with the Lake of Zug in the distance*, 1841–2 (no. 105)

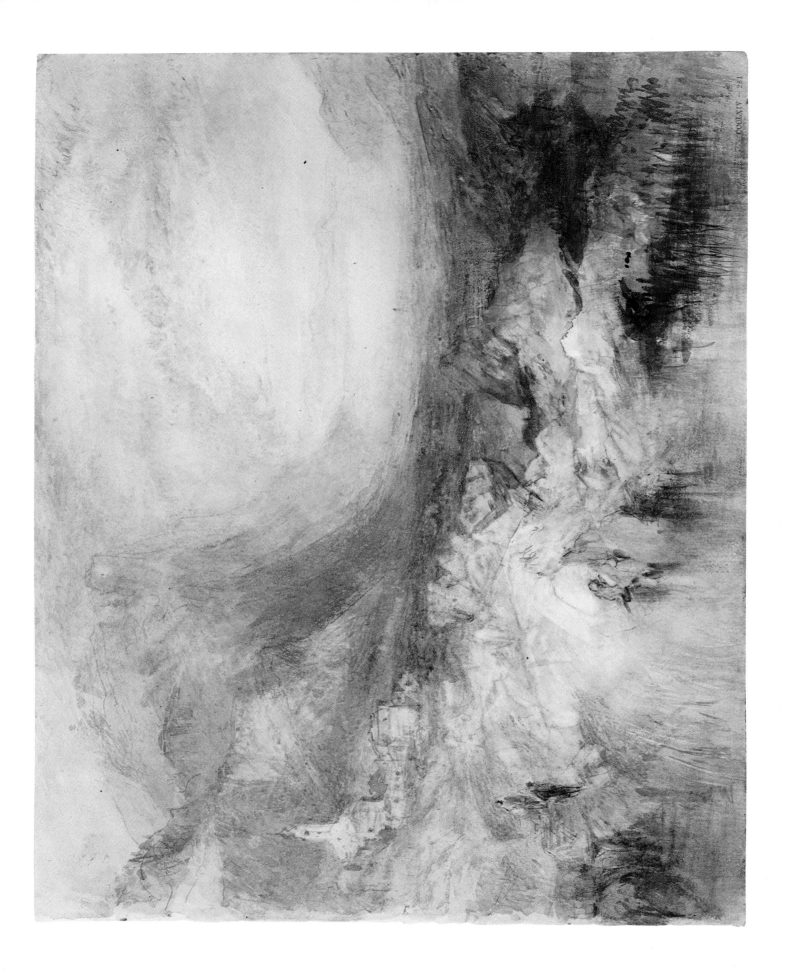

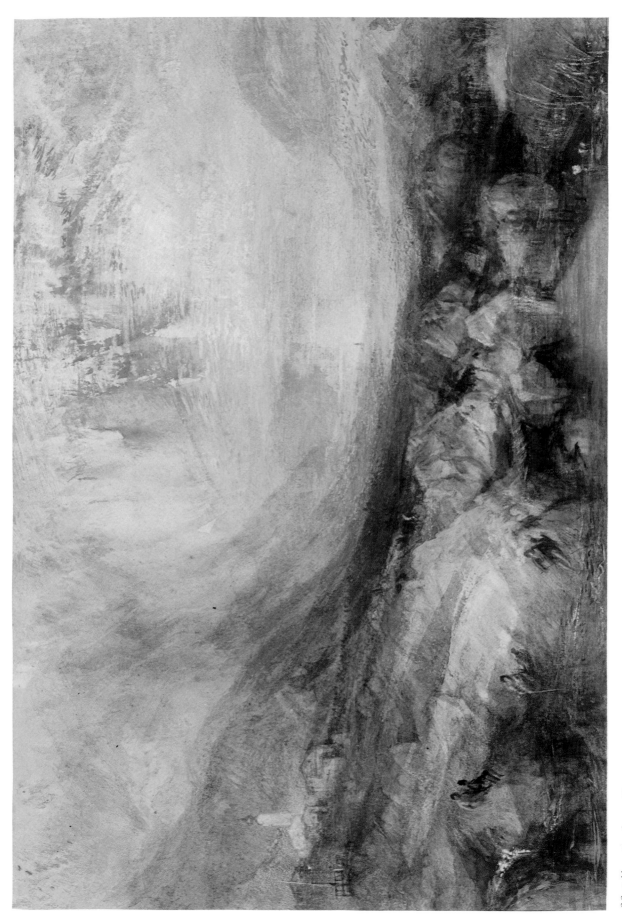

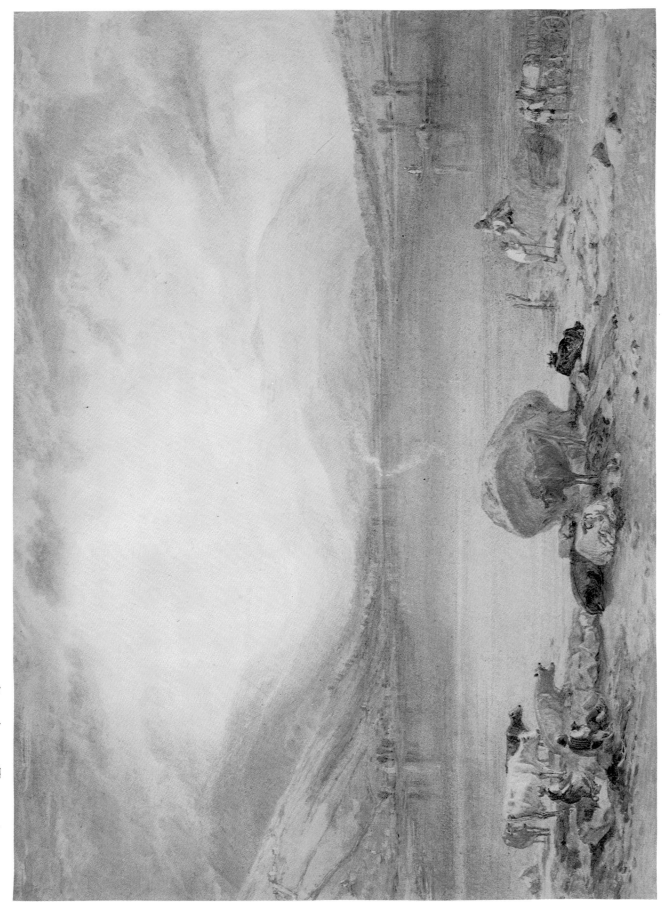

27 *Simmer Lake, near Askrigg, c.* 1818 (no. 109)

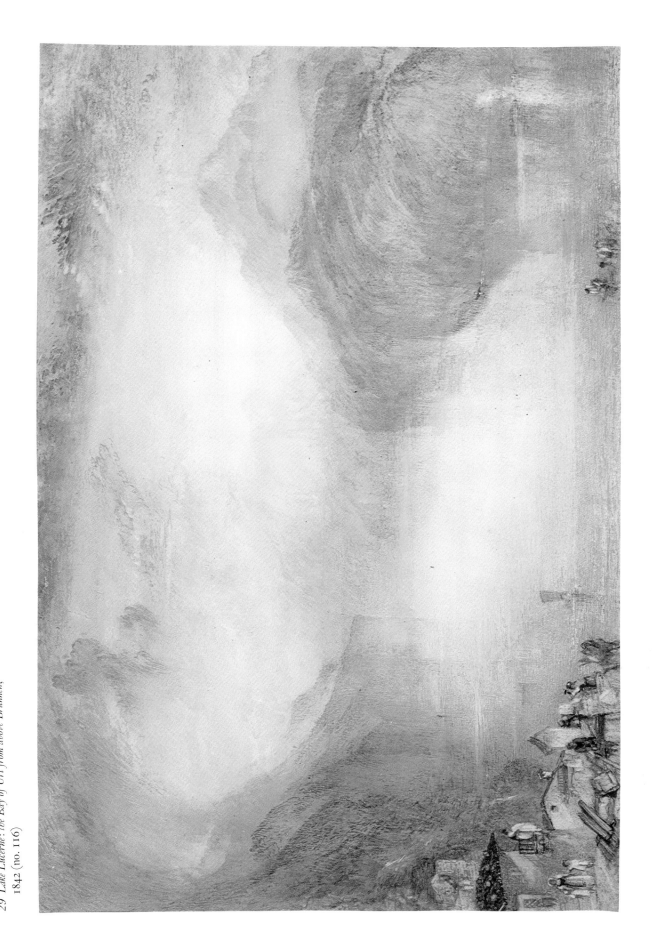

28 *The Bay of Uri from Brunnen*, c. 1841 (no. 115)
29 *Lake Lucerne: the Bay of Uri from above Brunnen*, 1842 (no. 116)

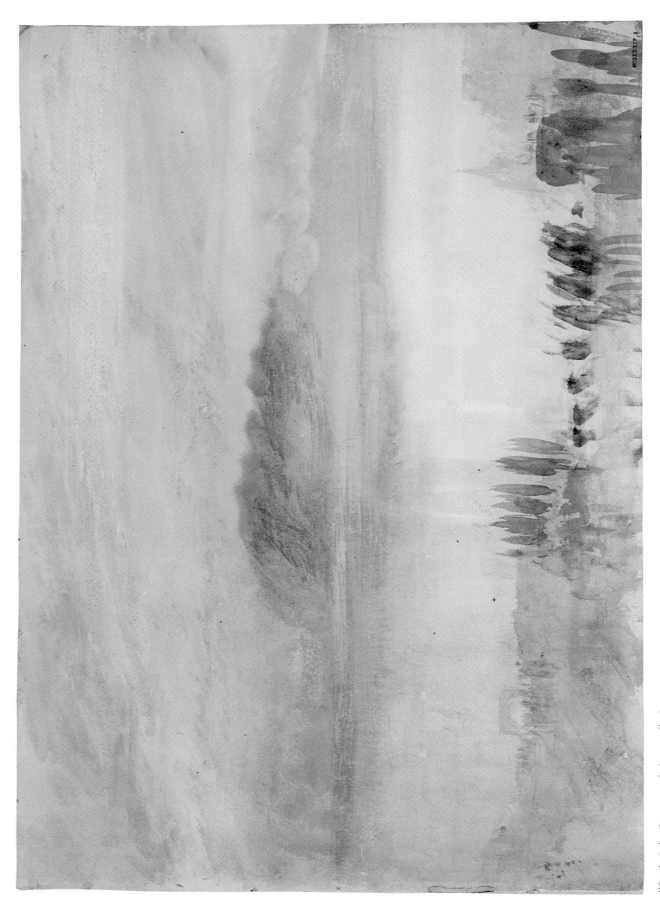

30 *The Lake of Geneva with the Dent d'Oche, from Lausanne: a funeral*, 1841 (no. 117)

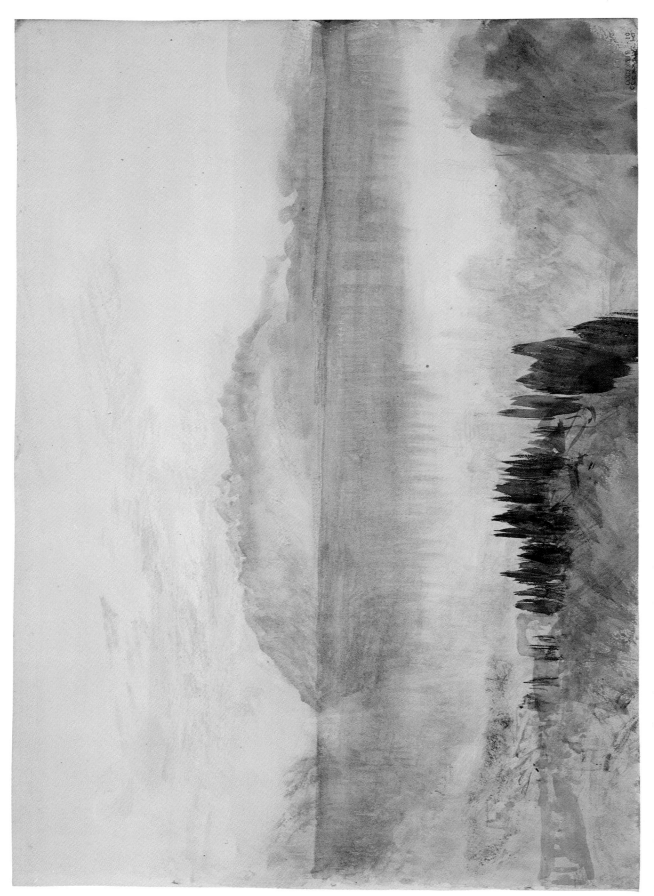

31 The Lake of Geneva with the Dent d'Oche, from Lausanne, 1841 (no. 119)

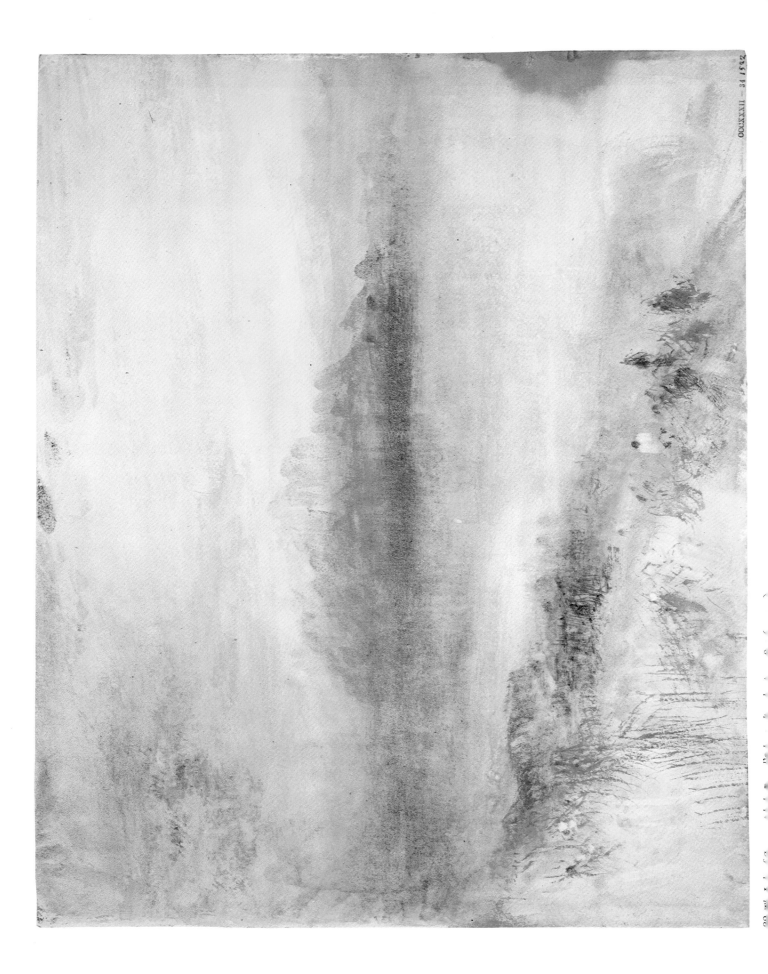

Turner's views of cities are usually more compressed than this. They are topographical in the sense that they present the appearance of a single defined place, with more or less of its neighbouring countryside. But even the most factual of them provide such a broad sweep of informative matter that they transcend the prosaic boundaries of ordinary topography. Climate, architecture, trades, entertainments, everything that modifies or colours the local life, play a part in his comprehensive 'economic' vision. On occasion these 'town portraits' reflect that excitement with the progress of the industrial revolution which many artists and writers felt at the time. It was not only Blake who compared the factory towns with Milton's inferno, though the 'dark satanic mills' of his account[56] seem less attractive than the grandiose and atmospheric scenes that some people found in them.[57] Turner's all-embracing fascination with the conditions in which men live, his sense of the intrinsic grandeur of man and his affairs, enabled him to infuse the sublime as readily into his city views as into his historical canvases.

The sweeping comprehensiveness of the Zurich subjects, for all their expressive splendour, is still rooted in the topographer's concern for the richness and multiplicity of human activity which enlivened even Turner's earliest watercolours. It is not only the rarefied products of wild nature but mankind itself in its endless and often humdrum patterns of existence which is truly impressive: Wordsworth's 'sense sublime of something far more deeply interfused' apprehended 'a motion and a spirit that impels All thinking things, all objects of all thought.'[58] There is no boundary beyond which things animate and inanimate no longer qualify as sublime: sublimity is the elevated thought and inspired perception that resides in the mind of the beholder, and suffuses everything it touches with grandeur.

The 'topographical sublime' with its strong overtones of the 'economic' view of landscape is not confined to the watercolours, however. There are numerous examples of similar themes treated as oil paintings; some with specific topographical reference, such as the two views of the *Burning of the Houses of Parliament*[59] exhibited in 1835, which exploit a popular 'sensation' – a big conflagration – with the grandest results; or the canvas shown in the same year, *The Bright Stone of Honour (Ehrenbreitstein) and the Tomb of Marceau, from Byron's 'Childe Harold'*,[60] where a purely topographical subject is provided with sublime overtones by its association with a great general – a military hero[61] – and with Byron's poem, which, superseding Thomson, provided Turner with a new literary source almost from the moment that it was published.[62] Other pictures are less precise as to location, but equally firmly yoke a sublime phenomenon with the lives of men. The late paintings of whalers are characteristic: whales had always been recognised as 'sublime' on account of their enormous size and their association with the dangers of the sea.[63] They form a very appropriate theme for the last of Turner's sea pictures (*colour 16*). The sketches he made[64] are in themselves evocative of the grandeur of the animal as it flounders in water rendered perilous by its lashing movements. The paintings, however, lay a strong emphasis on the activities of whalers themselves, on the hardships and dangers they undergo, as well as on the pleasures of the chase. Even if the canvases are little more than vivid presentations of the arctic conditions in which these men work, their titles betray Turner's interest: *Hurrah for the Whaler Erebus! Another Fish!*, *Whalers (boiling blubber) entangled in flaw ice, endeavouring to extricate themselves*[65] and suggest that the painter had joined a whaling ship in order to understand its activities and the lives of its men; but he acquired his knowledge only from books. Nevertheless, his interest was deep, his sympathy far-reaching, and his imaginative perception of the whaler's existence dependent on no mere generalisations.

In some of the greatest of his late paintings, then, Turner is to be found still balancing the demands of topography as he had learnt it in his youth with the requirements of High Art. The relationship between men and their surroundings that

Thomson illustrated is now explored on an altogether wider front; but the basic preoccupation is much the same. There is even one important late painting that seems to be based directly on a passage from the *Seasons*, showing that Turner kept Thomson in mind to the end: the *Slavers throwing overboard the dead and dying – Typhoon coming on* (FIG. XVI), is now recognised as being a sumptuous visual equivalent to a long passage in *Summer* describing the 'mighty tempest' that 'musters its force' while 'the direful shark' surges round a slave ship:

> . . . he rushing cuts the briny flood
> Swift as the gale can bear the ship along;
> And from the partners of that cruel trade
> Which spoils unhappy Guinea of her sons,
> Demands his share of prey – demands themselves.[66]

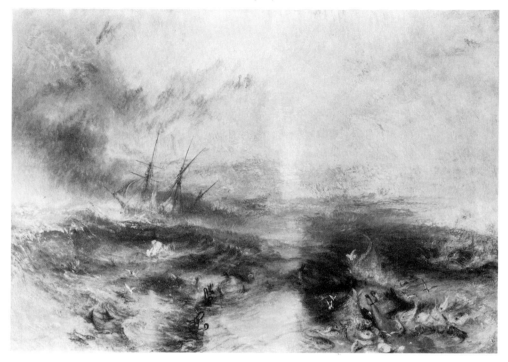

There can be no doubt here of the human significance of the subject. But no protagonist of the drama appears in the picture: the direct presentation of life is reduced to an expressive minimum, the overpowering atmosphere achieved by the most emphatic statement of the natural effects of sunset and brooding stormcloud. Turner aims unambiguously at the sublime, reproducing with all his skill a stupendous natural phenomenon in order to impress us with the larger argument of his picture.

FIG. XVI
J. M. W. Turner, *Slavers throwing overboard the dead and dying – Typhoon coming on*, 1841, oil on canvas. Museum of Fine Arts, Boston

The process is even more pronounced in one of the greatest of the late Swiss watercolours – that of *Goldau (colour 26)*, a work of 1843 which commemorates the disastrous fall of the Rossberg on the village of Goldau in 1806. Turner had already treated the subject of an avalanche in his painting of the *Fall of an Avalanche in the Grisons* of 1810, which, like the *Slavers*, relies on a passage from Thomson's *Seasons* for its literary basis.[67] The basis of Goldau is an actual historical event. As in the *Slavers* and the *Fall of an Avalanche*, the tragic idea is concentrated in a single immense image of natural power: a vast sunset floods the whole sheet with its scarlet light. Of figures there are practically none; only a few boys fishing from the huge rocks that crushed the village a generation earlier. This is the reduction of landscape to that universal and compelling simplicity that Reynolds demanded for the true sublime.

How do these images of natural grandeur differ from the 'terrific' landscape

sublime of Turner's youth? Many of the same elements are present. The *Fall of an Avalanche* (really quite an early work) is, on one level, a fairly conventional evocation of the physical terror we expect from such subjects. But it seeks to go beyond the local and individual both technically and conceptually. Unlike say, de Loutherbourg's picture of an Avalanche painted in 1803,[68] which Turner knew well, this avoids depicting a specific event, by the elimination of figures (de Loutherbourg's are conspicuously theatrical and unreal as well as being all too elegantly delineated), and at the same time achieves stunning conviction by the mixture of two opposed styles of painting – the vividly precise, in the details of the cottage and falling rock; and the expressionistically indistinct, in the surrounding blur of violent movement. By this means the eye is both engaged and confused in a way analogous to the visual effect of the event itself, and thus accepts the essential truth of what it is told.

Turner thereby avoids the merely theatrical, which few artists of the landscape sublime managed to do, and yet attains the realism essential to his purpose. The result of this virtuoso balancing act is a universalised presentation of an event that can only be appreciated as a specific one, though its real meaning is general. In the other works we have discussed the same balance is maintained, though by rather different means, depending on the nature of the subject-matter. As we have said, the only way to make a sunset emotionally effective is to make it convincingly real; and yet sunsets by their very nature allow the artist a good deal of expressive freedom in inventing and developing the language of reality. What distinguishes Turner's sunsets from any others is his constant reference to the human experience which is our only means of approaching them. Even in his most 'abstract' studies of natural phenomena we feel the vital response of the human mind and emotions. By his sheer technique in painting, say, a wave, Turner informs us of the subtlety and depth of his own feelings about the sea. As Archibald Alison put it, speaking of the new school of landscape painters generally: 'It is not the art, but the Genius of the Painter, which now gives value to his compositions; and the language he employs is found not only to speak to the eye, but to affect the imagination and the heart. It is not now a simple copy which we see, nor is our Emotion limited to the cold pleasure which arises from the perception of accurate Imitation. It is a creation of Fancy with which the artist presents us, in which only the greater expressions of Nature are retained, and where more interesting emotions are awakened, than those which we experience from the usual tameness of common scenery.'[69] So the very force of Turner's brush strokes enables us to identify with the imagination that has contemplated the sea, and to understand its significance in the lives of men. So Turner's great *Snow storm: steam boat off a harbour's mouth* of 1842 is the supreme example in all his art of that sublime realism which accurately records a natural event as perceived by a profoundly receptive mind. In lashing himself to the mast of the steamship *Ariel*[70] in order to observe this storm, as Turner said he had done, he was following the example of the great masters still: both Vernet and Backhuisen had made similar experiments in the interest of infusing greater realism into their art. But whereas these two men succeeded only in conveying an approximation in paint, limited by their narrow conception of realism and their restrictive technique, Turner was able, as he claimed, to 'show what such a scene was like'. He did not, as he irritably told an enquirer, 'paint it to be understood',[71] because his meaning was in the experience itself, and his object was to present the experience as totally and overwhelmingly as his art would allow. He proclaims clearly that the sublime is accessible to us all, that it is indeed a common property of the human mind, given the wonders with which nature surrounds us. A later artist, Gustave Courbet (1819–77), would paint the expanse of open sea, unencumbered with storms or other climatic effects, unvaried by figures or shipping, and call his picture *L'immensité*.[72] Turner eshews this kind of abstraction, retaining in all but his roughest studies a firmly perceived framework of human reference. He

appreciates and communicates what Stewart calls 'the sympathetic dread associated with the perilous fortunes of those who trust themselves to that inconstant and treacherous element [the ocean]'. Stewart goes on: 'It is owing to this, that, in its most placid form, its temporary effect in soothing or composing the spirits is blended with feelings somewhat analogous to what are excited by the sleep of a lion; the calmness of its surface pleasing chiefly, from the contrast it exhibits to the terrors which it naturally inspires.' And Stewart adds, in a footnote, that 'Gray had manifestly this analogy in his view when he wrote the following lines':

> Unmindful of the sweeping whirlwind's sway
> That hush'd in grim repose expects its evening prey.[73]

This very quotation from the *Bard* was used by Turner to make the same point about the sea in his painting of 1843, *The Sun of Venice going to Sea*. He did not acknowledge Gray as its author, but redrafted the passage and ascribed the verses to his own *Fallacies of Hope*. Gray had written:

> Fair laughs the morn, and soft the zephyr blows,
> While proudly riding o'er the azure realm
> In gallant trim the gilded vessel goes;
> Youth on the prow, and Pleasure at the helm;
> Regardless of the sweeping whirlwind's sway,
> That, hush'd in grim repose, expects his evening prey.[74]

Turner printed in the Academy catalogue:

> Fair shines the morn, and soft the zephyrs blow,
> Venetia's fisher spreads her painted sail so gay,
> Nor heeds the demon that in grim repose
> Expects his evening prey.

Gray's lines were so well known that Turner cannot have imagined that his thin disguise would deceive anyone. He deliberately invoked the 'sublime idea' of Gray's *Bard*, and a passage of the poem that had been cited as particularly expressive of a certain type of sublimity, in order to underscore the point of his otherwise light-hearted and joyful picture. It was, of course, the purpose of the *Fallacies of Hope* to tell us that joy is transient: after the calm comes the storm.

But Turner was not practising an art which could at best only illustrate literature. His intention was to raise landscape painting to a level of seriousness and universality that had previously been thought impossible. He did this both by bringing his profound contemplations to bear on the works of nature and on man's condition, and by developing his technical skills to a pitch at which they could, for the first time in the history of art, overcome the barriers of space and light, of immensity and obscurity and darkness, to describe with breathtaking realism the particular incidents by which these great themes manifest themselves.

Hence it was possible for him to paint landscapes from which violence, agitation and danger are totally absent, but which yet convey the most exalted sense of sublimity. And if Switzerland could yield subjects like the 'wildness and confusion' of Faido, or the tragic reminiscence of Goldau, it was also a source of scenery that was grand without any connotations beyond its own serenity and splendour. When Turner drew his long series of views of Lake Lucerne and Lake Geneva (see nos 114–23) he focused his meditations on the sheer amplitude of their vistas and the infinite calm of their waters at dawn or sunset. He did not lose sight of the surrounding world: in one of his most ecstatic views of the Rigi at sunrise the vast silence is broken by a small dog barking as it jumps off a boat into the water.[75] There are no heroic associations; even the views of the Bay of Uri do not invoke the shade of William Tell, though they do show the daily work of the steam ferry that takes passengers from one end of the lake to the other. The mood in these late Swiss lake

scenes is a return to the sanctified calm of John Robert Cozens, a faintly elegiac absorption of the mind and spirit in the grandeur of creation. The Rigi subjects are a far cry indeed from an earlier view of a mountain across water, *Vesuvius in eruption* of 1817 (no. 33), in which the crisp precision of the landscape sublime vividly conveys a violent natural upheaval, prompting a reaction of astonishment and terror. Even the relatively late painting of *Snowstorm, Avalanche and Inundation – a scene in the upper part of the Val d'Aosta* (1837)[76] seems overburdened with incident by comparison, and piles catastrophes one upon another so that its purpose is almost defeated. On the Swiss lakes Turner could dispense altogether with the trappings of 'horror' to distil the essence of the true sublime from his own soul in harmony with those spaces whose vastness Gilpin had dismissed as both unpaintable and uninteresting. In them land and sky, earth, air and water, are wrought into a fluid medium of colour and light: the space that intervenes between the eye and the object now becomes the real subject of the work. At the same time, the old symbolisms of sunrise and sunset take on a fresh and personal meaning, a significance which relates neither to a hero nor to the common man, but to the artist himself, who is both.

Turner knew that the phenomenon of sunset exercises a powerful influence over us. It elicits a vigorous response by virtue of its stupendous grandeur, and because it is one of the most immediately impressive of our glimpses of the vast realms of space. Theorists of the sublime attached much importance to the associational significance of the sky, and usually placed the night sky full of stars at the head of their list of its sublimities; but the sun is the heavenly body most intimately associated with our livelihood, the star capable of the most immediate grandeur. Burke actually preferred darkness to light for sublime power – he quoted Milton's description of Death in Book II of *Paradise Lost*, where, he says, 'all is dark, uncertain, confused, terrible, and sublime to the last degree';[77] and he listed Darkness among the 'privations' which, as we have seen, are specially conducive to the sublime. 'Darkness is more productive of sublime ideas than light.' 'Mere light,' he says, 'is too common a thing to make a strong impression on the mind, and without a strong impression nothing can be sublime. But such a light as the sun, immediately exerted on the eye as it overpowers the sense, is a very great idea.'[78] Burke's preference for darkness is typical of his whole understanding of the sublime as an emotion dependent on fear: 'Terror is, in all cases whatsoever, either more openly or latently, the ruling principle of the sublime.'[79] Other writers, as we have seen, attributed the sublime principle to grandeur, to energy, or to the Deity Himself. If some of Turner's works, in particular the earlier ones, adopt the language of Burke and the landscape sublime, it is clear that in his maturity he took a broader view. There are examples, of course, in which darkness is made the dominant theme; sometimes a whole suite of works, such as the 'Sequel to the Liber Studiorum' or 'Little Liber' (see nos 74–8), pursues the motif of darkness deliberately; in this case, the medium of mezzotint seems to have dictated the choice of theme, and prompted some of the most intensely felt night-scenes in Turner's art or anyone else's. But in general, he preferred to invest his pictures with the sublimity of brilliant sunlight 'immediately exerted on the eye'. A painting like the *Regulus* (see no. 54) is a vortex that revolves round a central hub, the sun at its most irradiantly dazzling. Some critics have thought it to be no coincidence that Regulus was a hero who suffered the punishment of having his eyelids cut off so that he was actually blinded by the sun. This is a conception that presents the idea of brilliant light and total darkness as necessary and complementary opposites. In works such as this, as much as in the late Swiss watercolours, Turner transcends the technical problems that traditionally beset the painter of grand effects. For him the complaint of a later artist was irrelevant: 'It is the "material" difficulty that forever vexes the soul of the painter. Is not white lead the only material we have with which to express the divine light of heaven?'[80]

Turner's famous remark, supposedly the last words he spoke, to the effect that 'the sun is god'[81] may or may not be authentic, but it sums up very well the impression that is overwhelmingly given by much of his output: sunlight, in its power to illuminate the world we live in, and in the inherent grandeur of its effects, is a supremely moving force, a force that is often felt in his paintings and watercolours to have a divine strength and beauty. Turner is generally considered to have been a pessimist, and to have had no religion – Ruskin, who knew him well in later life, and Thornbury, his first biographer, seem agreed on the point.[82] But the symbolism of his views of *Salisbury* and *Stonehenge*, made in the 1820s (see no. 83), if it is correctly interpreted by Ruskin,[83] strongly suggests that he shared with most of his contemporaries certain deep-seated assumptions about the validity of Christianity in contrast to other religions. It is quite possible that, with no very strong intellectual commitment, he subscribed to a vaguely deistic version of Christianity such as was common enough in England in the late eighteenth century. In any case, that he painted with no sense of religion is denied by his works. The numinous power of nature is repeatedly celebrated in them, and the omnipotent energy and saving grace of the sun constantly hymned. This was for Turner the religious sublime – far from being pessimistic his work often ecstatically exults in the consciousness of a superhuman force working in and through the natural world to the good of men.

Turner succeeded in breaking through the barrier of reality by pursuing many of the principles of realism in the painting of nature to their logical conclusion. Perhaps the idea that his latest works were in any sense 'realist' will be scouted as absurd. The confusion and irritation that his critics experienced in front of his pictures is surely an indication that he had gone beyond mere reality? Of course, in a sense he had. But their notion of realism in painting was still bounded by what Vernet understood by the term. Turner, as we have discovered, saw the need for a new and broader realism that would accurately describe phenomena of greater emotional power than any that had been painted in the past: a realism that would open up the imagination to deeper insights into the real world. If he had no followers in this it was because only a genius of his stature could master such a potent language. But there were contemporaries for whom it was, apparently, axiomatic that Turner, even the late Turner, was a realist. In 1849, two years before Turner's death, Charles Kingsley wrote in his novel *Yeast*: '. . . follow in the steps of your Turners, and Landseers, and Stanfields, and Creswicks, and add your contribution to the present noble school of naturalist painters . . . These men's patient, reverent faith in nature as they see her, their knowledge that the ideal is neither to be invented nor abstracted, but found and left where God has put it, and where alone it can be represented, in actual and individual phenomena – in these lies an honest development of the true idea of Protestantism . . .'[84]

It was of course Ruskin who, in *Modern Painters*, had promulgated the idea that Turner was a realist, whose power rests on truth to nature. He did not link him so glibly with Stanfield[85] and the rest of the successful and superficial generation that followed Turner, but he would have wholeheartedly endorsed Kingsley's view that Turner did not invent or abstract. It is a question of degree: Stanfield could adequately describe the 'littlenesses' of nature – the shape of clouds and the colour of the sea. But he could not begin to depict with convincing accuracy the height and breadth and depth of the sky, or the incalculable movement of the ocean. He could draw a mountain, but not convey its true height and its distance from the eye in terms that the heart could feel as well as the mind could understand. He could delineate the achievements of men, but not impress us with their grandeur. Above all, though he could scatter groups of well-posed figures across his landscapes, he could not make them, as Turner did, the focus of his subject, the heroic protagonists of the eternal drama of life.

NOTES TO CHAPTER THREE

1. Ms. C, ff. 3–4.
 Quotations from Turner's lecture notes (British Museum, Add Ms. 46151, A–88) are transcribed directly from the Mss, but irregularities of spelling, punctuation, and occasionally phrasing, have been amended to make for clarity and ease of reading. An exact rendering of what Turner actually wrote is, in any case, not always possible on account of the illegibility and fragmentary nature of many of his jottings.

2. Stewart, *op. cit.*, p. 411.

3. *Spectator*, no. 415, 26 June 1712.

4. See Wilton 193–203.

5. Burke, *op. cit.*, p. 64.

6. Wilton 139 and pl. 23.

7. Wilton 143 and pl. 24.

8. Wilton 256, the full title is: *Warkworth Castle, Northumberland – thunder storm approaching at sun-set.*

9. *Summer*, ll. 1103–5; 1111–13.

10. Stanzas 6 and 7. The final line seems to have been added by Turner himself.

11. Langhorne, *Elegy IV*, stanzas 1 and 2.

12. See no. 50.

13. Butlin & Joll 13.

14. Butlin & Joll 17, 19, 47.

15. There is a long discussion of the precise meaning of the letters 'E. P.' in J. L. Roget and J. Pye, *Notes and Memoranda respecting the Liber Studiorum by J.M.W. Turner*, London 1879, pp. 26, ff. Roget and Pye concluded that they stood for 'Epic Pastoral'; the significance is almost identical. 'Elegant Pastoral' is a less satisfactory alternative proposal.

16. TB LXXII.

17. Ms. C, f. 2.

18. Ms. E, f. 19.

19. See Gage, 1969, chapter 6.

20. Ms. K, f. 11 verso.

21. Butlin & Joll 135.

22. *Repository of Arts*, June 1817, quoted in Butlin & Joll.

23. Ms. I, f. 1 verso.

24. Ms. I, f. 21. Turner's admiration for subjects engraved after Wilson by William Woollett, including *Niobe* and *Celadon and Amelia*, is recorded in a letter from him to the print publishers Hurst and Robinson, 28 June 1822 (printed in Thornbury, p. 342).

25. Both were works that he had seen in the Louvre in 1802. The Titian was destroyed by fire in 1867, but is reproduced in several copies and in an engraving by M. Rota (repr. Wilton, 1979, pl. 78); the Poussin *Deluge* is Blunt, pl. 245.

26. Ms. I, f. 4 verso.

27. Ms. G, f. 27.

28. TB LXXII, pp. 28 verso, 28 recto.

29. TB LXXII, p. 42.

30. Ms I, ff. 16 verso, 17.

31. Ms I, f. 16.

32. Butlin & Joll 115.

33. Livy, *History of Rome*, XXI, 31.

34. Mason ed., *Gray*, p. 302.

35. Gilpin, *Remarks on Forest Scenery*, 1791, vol. I, p. 252. Compare the theory of Kant summarised on p. 29. Burke had stressed the importance of obscurity for the sublime, *op. cit.*, pp. 43–49.

36. *Discourse XIV*, 1788, Wark ed., p. 255.

37. *Ibid.*, p. 256.

38. Blair, *op. cit.*, p. 62. See note 35.

39. No doubt earlier works by Turner, such as the *Destruction of Sodom* of 1805 (Butlin & Joll 56) were influential on Martin, who may also have known *The Army of the Medes destroyed in the Desert by a Whirlwind*, now lost, but exhibited at the RA in 1801 (Butlin & Joll 15).

40. He may also have noticed that the theorists recognised sublimity in individuals as a function of their character and achievements, not of their stature; Lord Kames noted (*op. cit.*, p. 280) that 'the Scythians, impressed with the fame of Alexander, were astonished when they found him a little man.' To one of Turner's unprepossessing appearance, such ideas would have been important.

41. Wilton 369, repr. pl. 104.

42. Butlin & Joll 131, 135.

43. See the verses by Turner appended to the R.A. catalogue entry for the *Decline of Carthage*.

44. Stewart, *op. cit.*, p. 384.

45. Byron, *Ode to Napoleon*, stanza II, ll. 8, 9.

46. Charlotte Brontë, quoted by Mrs. Gaskell, *The Life of Charlotte Brontë* (1857), Everyman ed., p. 173.

47. Blair, *op. cit.*, p. 59.

48. Alison, *op. cit.*, vol. I, p. 126.

49. Examples of this dynamic perspective are to be found in *Calais Pier* of 1803, *Frosty Morning* of 1813, *Rome from the Vatican* of 1820, and *Hero and Leander* of 1831 (Butlin & Joll 48, 127, 228, 370) among the paintings, and in numerous watercolours of all periods.

50. William Duff, *An Essay on Original Genius, and its varied modes of exertion in Philosophy and the Fine Arts, particularly in Poetry*, London 1767, p. 166, note.

51. See *Caernarvon Castle*, Wilton 857; Shanes 65.

52. *The Beauties of England: or, a Comprehensive View of the Public Structures, the Seats of the Nobility and Gentry, the two Universities, the Cities, Market Towns, Antiquities and Curiosities, natural and artificial, for which this Island is remarkable*, London 1757, p. 339.

53. Blair, *op. cit.*, p. 65.

54. John Ruskin, *Modern Painters*, Pt V; *Works*, VI, pp. 38–9.

55. Warner, *op. cit.*, p. 97.

56. Blake, *Milton*, 1804, pl. 1.

57. See the often-quoted description of Coalbrookdale by Arthur Young, 1771: 'the noise of the forges, mills, etc., with all their vast machinery, the flames bursting from the furnaces with the burning of the coal and the smoak of the lime kilns, are altogether sublime, and would unite very well with craggy and bare rocks . . .' Quoted in Francis D. Klingender, *Art and the Industrial Revolution* (1947) revised ed., 1968, p. 89; and see pp. 88–103.

58. See Albert O. Wlecke, *Wordsworth and the Sublime*, Berkeley 1973, *passim*, and especially pp. 47 ff.

59. Butlin & Joll 359, 364.

60. Butlin & Joll 361.

61. Turner depicts the monumental pyramid under which Marceau's ashes were placed; it was designed by his colleague General Kléber, who is thus both military hero and artist.

62. The first two Cantos of *Childe Harold* appeared in 1812, the third in 1816 and the fourth in 1818.

63. *The Surprizing Miracles of Nature and Art* (see above, p. 29) includes whales among the astonishing phenomena it lists (e.g. p. 162: 'In 1658, a great Whale came up to Greenwich near London, a thing seldom known before.')

64. TB CCCLVII–6, and Wilton 1141 and 1142.

65. Butlin & Joll 423, 426.

66. The whole passage is ll. 980–1025. See T. S. R. Boase, 'Shipwrecks in English Romantic Painting', *Journal of the Warburg and Courtauld Institutes*, 1959, pp. 332–46.

67. *Winter*, ll. 414–423. See Jack Lindsay, *J.M.W. Turner*, 1966, p. 107.

68. The two Avalanche pictures are reproduced side by side in Wilton, 1979, pls 101, 102. De Loutherbourg's version hung in the collection of Sir John Fleming Leicester, at Tabley House, which Turner visited in 1808, two years before the exhibition of his own avalanche subject.

69. Alison, *op. cit.*, vol. II, p. 128.

70. Is Turner's choice of name for the ship itself a kind of 'historical' allusion? The *Ariel* was the vessel in which Prince Albert of Saxe-Coburg came to England to marry Queen Victoria in 1840.

71. Ruskin, *Works*, VII, p. 445, note.

72. Courbet's *L'Immensité* (c. 1865) is in the Victoria and Albert Museum, Ionides Collection.

73. Stewart, *op. cit.*, p. 422.

74. *The Bard*, pt II, stanza 2, ll. 9–14.

75. Wilton 1524.

76. Butlin & Joll 371.

77. Burke, *op. cit.*, p. 45. The passage of Milton's *Paradise Lost*, Book II, ll. 666–673.

78. Burke, *op. cit.*, p. 62.

79. Burke, *op. cit.*, 2nd ed., 1759, II, 2.

80. J. C. Horsley, *op. cit.*, p. 168.

81. Ruskin, *Works*, XXVIII, p. 147.

82. Thornbury, p. 303.

83. Ruskin, *Works*, VII, pp. 190–1.

84. Charles Kingsley, *Yeast*, Everyman ed., p. 228.

85. Clarkson Stanfield, 1793–1867.

CONCLUSION

I love all waste
And solitary places; where we taste
The pleasure of believing what we see
Is boundless, as we wish our souls to be.

P. B. SHELLEY: *Julian and Maddalo*, 1824

Landscape photography which successfully captures the scale of nature can often make the creations of man seem insignificant. But even when people and their dwellings are dwarfed by the scenery or excluded from the picture altogether, it would be a mistake to think that human interest is lacking. What gives a good landscape picture its appeal is its ability to reflect human emotions and to express ideas about the relationship between man and nature. If a view of a mountain or an area of countryside is sufficiently spectacular, you may be content simply to record it, but you are likely to be disappointed with the results unless the photograph succeeds in capturing not only what you saw but also what you felt.

JOHN HEDGECOE, *Introductory Photography Course*, 1979

When Turner was an old man he visited the American photographer J. J. E. Mayall in London and spent many hours questioning him about his procedures and the physical laws governing photography. 'He came again and again, always with some new notion about light', Mayall recalled for the benefit of Thornbury. 'He wished me to copy my views of Niagara – then a novelty in London – and enquired of me about the effect of the rainbow spanning the great falls. I was fortunate in having seized one of these fleeting shadows when I was there, and I showed it to him. He wished to buy the plate . . . He told me he should like to see Niagara, as it was the greatest wonder in Nature; he was never tired of my descriptions of it.'[1]

It was no accident that the school which took up Turner's ideas with the greatest enthusiasm and conviction was that of the American 'Hudson River' painters, who responded to the immensity and grandeur of the North American continent by producing pictures of great size and exploiting the most grandiose effects of storm, sunlight and vast space. In such a landscape as theirs it was hardly possible to avoid the sublime. James Fenimore Cooper's remarks at the beginning of *The Pathfinder* were both necessary and inevitable. It is touching that Turner himself, at the end of his life, was able to glimpse something of the sublime possibilities of America, and appropriate that he should have done so through the eminently 'realistic' medium of photography.

The Hudson River school took the New World as they found it and instinctively created works of art on a grand scale. They were far enough from Europe to be unconcerned about the more elevated aspirations of Academic landscape artists, and were content to inspire and uplift by the faithful rendering of nature in all her splendour. They introduced into American culture a love of the vast, the magnificent and the overpowering that has been an essential part of it ever since. It is largely through the medium of the American imagination that we still savour the sublime

today. For in spite of a perhaps inevitable debasement of its significance, sublimity remains a potent element in our consciousness, whether we use the word itself or not. We continue to be awed by the enormous, the very high, the immensely vast, the imponderably great, and we may still feel that these qualities in natural phenomena suggest the presence of a power that cannot be expressed in material terms. North America is peculiarly rich in such phenomena both natural and man-made. Hollywood's 'epic' movies are the 'sensational' art of our age, the natural successors of John Martin's cataclysms. The Empire State Building, the World Trade Center, the CN Tower at Toronto, are tourist attractions for no other reason than that they are 'productive of the sublime' – even if we should hesitate to say that they are sublime in themselves. They are the modern counterparts of the Temple of Jupiter Belus at Babylon, which was a mile high, and, as Addison says, for that reason alone sublime. Addison also refers to 'the huge rock that was cut into the figure of Semiramis, with the smaller rocks that lay by it in the shape of tributary kings',[2] which was surely only an earlier version of Mount Rushmore. The illimitable deserts and boundless forests so much beloved by the theorists of the sublime are a visitable reality in the United States and Canada. Even the achievement of taking men to the moon is strictly classifiable as a sublime attainment of the human mind, of human energy and heroism. And it has been possible for one of the leaders of the modern American school of abstraction to speak of its work as embodying 'a modern Stonehenge, with a sense of the sublime and the tragic that had not existed since Goya and Turner'.[3]

As human beings we cannot avoid being responsive to the sublime in nature and in the works of man. We must still be responsive to it in works of art. This instinctive human response is what prompts much of our admiration for Turner. He did not, of course, paint only in the sublime mode. He has moods of lyric tenderness, of pastoral calm and domestic jollity; he is as much a recorder of the quiet ordinariness of daily life as of its storms and passions. But there can be no doubt that he gauged his own most serious and powerful works by the notion of the sublime as it had been so fully and elaborately formulated by the theorists of the period. Just because that formulation is not so readily available to us now, or because we have other, perhaps more sophisticated reasons for appreciating him, we should not fail to respond to his art as he certainly intended us to.

NOTES

1. Thornbury, *op. cit.*, p. 349.
2. *Spectator*, no. 915, 26 June 1712.
3. Robert Motherwell, 1965, quoted in Frances Carey and Anthony Griffiths, *American Prints 1879–1979*, London 1980, p. 18.

Notes to the catalogue

The catalogue is divided into nine sections. These are not intended to include every aspect of the sublime, which lends itself to categorisations of many kinds. They are to suggest, rather, some of the principal ways in which theories of the sublime make themselves apparent in various types of works. For instance, 'Darkness' is only one of several 'abstract' categories (such as infinity, vastness, emptiness, etc.), and there are included in it examples which might also be catalogued as, say, 'Historical' (no. 71) or 'Industrial Sublime' (no. 73). These inclusions illustrate how an abstraction associated with the sublime could be applied to subjects with other characteristics, sublime or not. The Industrial Sublime itself, really a derivative of the Picturesque Sublime, has been incorporated into the section of 'Cities', a broader category that comprehends Turner's developments of other themes – the 'Topographical Sublime' or even the sublime of brilliant sunlight.

The arrangement of the sections is somewhat arbitrary, but it is hoped that a sense of development will be conveyed, and that the individual catalogue entries will be read against the general background of argument provided by the main text. The 'Picturesque Sublime', for instance, played a role of diminishing importance in Turner's paintings after about 1800, but continued to shape his approach to many watercolour subjects as late as the 1830s. The 'Terrific' was a mode that he radically modified for his own purposes so that his later views of mountain scenery have a very different mood. Hence they appear in a separate section. Whatever the disadvantages of the arrangement, Turner would perhaps have sympathised with the wish to order and categorise his works, since he was so much inclined to do so himself.

Items are catalogued in roughly chronological order within sections, and dimensions are given in inches and millimetres, height preceding width. The support is assumed to be white wove paper unless otherwise stated.

The following abbreviations are used in the catalogue entries:

BM 1975	Wilton, Andrew, *Turner in the British Museum*, London 1975
Butlin & Joll	Butlin, Martin and Joll, Evelyn, *The Paintings of J. M. W. Turner*, 2 vols, London 1977
Finberg	Finberg, A. J., *Life of J. M. W. Turner*, 2nd ed., 1961
R.	*either* Rawlinson, W. G. *The engraved work of J. M. W. Turner*, London 1908
	or Rawlinson, W. G., *Turner's Liber Studiorum*, 2nd ed., London 1906
RA 1974	Royal Academy, Turner Bicentenary Exhibition
Ruskin, *Works*	Cook, E. T. and Wedderburn, A. (eds), *The Works of John Ruskin*, 39 vols, London 1903–12
Shanes	Shanes, Eric, *Turner's Picturesque Views in England and Wales*, London 1979
TB	Turner Bequest (numbers in A. J. Finberg, *Inventory of the Drawings in the Turner Bequest . . .*)
Thornbury	Thornbury, Walter, *Life and Correspondence of J. M. W. Turner* revised ed., 1877
Turner in Switzerland	Russell, John and Wilton, Andrew, *Turner in Switzerland*, Zurich 1976
Wilton	Wilton, Andrew, *The Life and Work of J. M. W. Turner*, London 1979

CATALOGUE

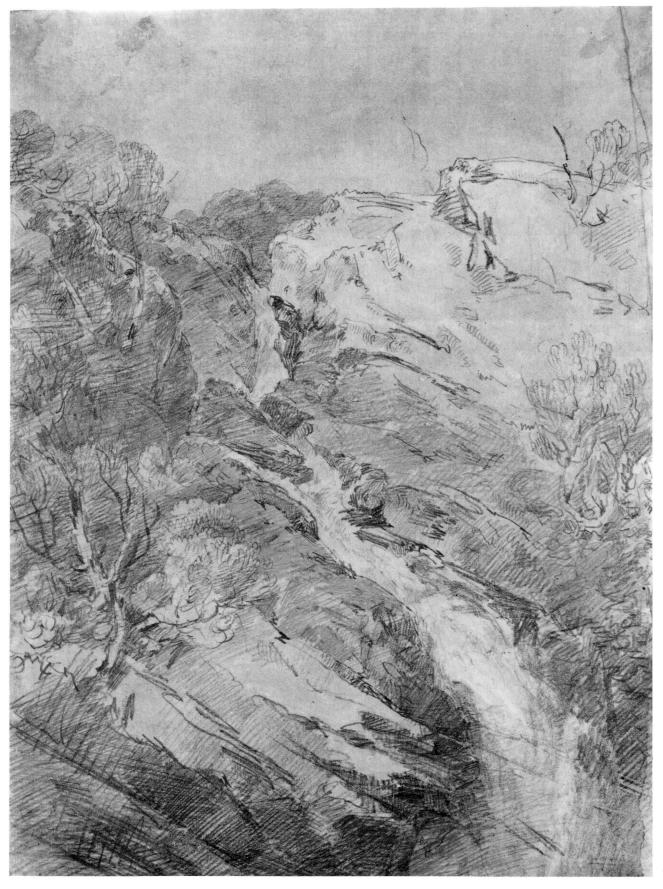

7

THE PICTURESQUE SUBLIME

1 Llanthony Abbey 1794

Pencil and watercolour, $12\frac{7}{8} \times 16\frac{11}{16}$ (327 × 424)
Inscr: lower left *1794 W Turner*
TB XXVII − R, RA 1964 (11), Wilton 65
Colour plate 1

This is the grandest of the subjects that Turner gleaned from his trip to South Wales in 1792,[1] combining the fascination of a venerable ruin with the drama of the Black Mountains and an approaching rainstorm: a concatenation of historical, natural and climatic ideas that Turner was to use repeatedly all his life, especially in topographical work but also in many paintings of broader intention. The reinterpretation of the subject that makes its appearance in the *England and Wales* series (see no. 11) shows how flexible the formula could become in his hands. This first version of the theme achieves atmospheric unity by means of a restricted palette of greys and blue-greens which Turner found in the work of other artists of the Picturesque − Edward Dayes (1763−1804) and Thomas Hearne (1744−1806) in particular. He also had in mind, no doubt, the more impressive performances of John Robert Cozens, who specialised in wild mountainous subjects that attain to a misty grandeur which Turner seems to be emulating here.

1. It is based on a pencil drawing, TB XII−F.

2 Evening Landscape with Castle and Bridge *c.* 1798−9

Watercolour, $7\frac{7}{16} \times 10\frac{1}{2}$ (189 × 226)
Yale Center for British Art, Paul Mellon Collection, B1977.14.5380,
Wilton 250
Colour plate 2

Nothing marks Turner's development from the early 1790s to the later years of the decade more distinctively than the change that came over his colouring. His work in oil no doubt had much to do with this, but his experiments in both media were inspired by the same wish to create more powerful and impressive statements than before. It was in the course of these experiments that he developed the habit of making colour sketches for his watercolour compositions, rather as he might lay in a canvas for a subject in oil. This sheet is a rather unusual example, being smaller than the expansive 'colour-beginnings' he often made around 1800 (see no. 3). It probably comes from a sketchbook, but was evidently not drawn in front of the subject: it concentrates certain aspects of Turner's idea in an intense, brooding image which is the generalised basis for a finished work − though no known watercolour relates to it directly.

3 Norham Castle: Study *c.* 1798

Pencil and watercolour, $26\frac{1}{8} \times 33\frac{1}{16}$ (663 × 840)
TB L−B, RA 1974 (639)
Colour plate 3

Turner exhibited a powerful, sombre watercolour view of Norham at the RA in 1798 (no. 353), and repeated the subject shortly afterwards.[1] Both versions are based on a pencil sketch made on the spot in 1797,[2] and may have made use of this colour-beginning and another similar one,[3] which exploit Turner's new technical skills to create an atmosphere of great intensity. Watercolour is laid on in broad washes which are then partially blotted away, to reveal either a different wash beneath, or the white of the paper. Some-

times the resulting effects are similar to those achieved by oil paint, but the fluidity and integrity of the watercolour medium is maintained in the bold and free handling of these elaborate devices. This view of Norham was one of the subjects which at the end of his career Turner reinterpreted to express his conception of the sublimity of sunlight as opposed to that of gloom (see no. 9).[4]

1. Wilton 225, 226.
2. TB XXXIV−57.
3. TB L−C.
4. Butlin & Joll 512. Others in the series are generally taken from *Liber Studiorum* subjects. (See Butlin & Joll 509−21.)

4 A View in North Wales *c.* 1799

Watercolour, $21\frac{3}{4} \times 30\frac{3}{8}$ (553 × 772)
TB LX(a)−A, BM 1975(19)
Colour plate 4

5 Dolbadern and the pass of Llanberis *c.* 1799

Watercolour and stopping-out, $21\frac{7}{8} \times 29\frac{7}{8}$ (555 × 758)
TB LXX−Z
Colour plate 5

6 River with cattle and mountains beyond *c.* 1799

Watercolour and stopping-out with some bodycolour, $21 \times 30\frac{1}{16}$ (533 × 780)
TB LXX−b
Colour plate 6

These three studies form part of a group of large drawings that resulted from Turner's tour of north Wales in 1799.[1] In scale and mood they are similar to some finished watercolours of about that time,[2] although they are not in themselves exhibitable works. They are a close visual equivalent of the descriptions published in the fashionable tours of the period − that of Richard Warner, for instance (see pp. 43−4). In them the notion of the sublime as emotionally charged, gloomy and grandiose reaches full maturity; but already we sense Turner's desire to expand the terms of reference of the sublime, to comprehend a wider range of feeling than the merely 'astonishing'.

1. These are all in the Turner Bequest: TB LX(a) was originally catalogued by Finberg as a series of scenes in the Lake District, done in about 1801; he later (*Life*, pp. 159−60) redated them to 1809. They must in fact belong to the earlier period, and are all, apparently, scenes in north Wales.
2. E.g. Wilton 252−4, 259.

7 A Mountain Torrent 1801

Pencil, watercolour and white bodycolour on a buff prepared ground,
$19 \times 13\frac{9}{16}$ (483 × 344)
TB LVIII−34

One of the series of sixty large studies made during Turner's Scottish tour of 1801.[1] He worked on a ground tone mixed from 'india ink and tobacco water',[2] using the pencil with a force and experimental freedom new in his work. The expansive landscapes of the Highlands seem to have acted as a stimulus, almost as a challenge: how is the artist to persuade his audience of the scale of such scenery with the aid of one monochrome implement? The deliberate restriction of means, the penetrating search for significance, are reminiscent of John Robert Cozens's understated yet

passionate accounts of the Alps. These Scottish drawings give the first hint that Turner was beginning to understand what Cozens had to teach the painter of mountain grandeur. They constitute an exercise, a discipline that was to stand Turner in good stead when he went to Switzerland in the following year.

1. TB LVIII: they were christened by Ruskin 'Scottish Pencils'.
2. Joseph Farington, *Diary*, 6 February 1802.

8 Pembroke-castle: Clearing up of a thunder-storm
1806

Watercolour and bodycolour over pencil, with some scraping-out, $26\frac{3}{8} \times 41\frac{1}{8}$ (670 × 1045)
Art Gallery of Ontario, Toronto (on loan from the Governing Council of the University of Toronto), Wilton 281
Colour plate 7

This watercolour is one of two showing Pembroke Castle seen from a similar angle and in stormy conditions. The other was exhibited at the Royal Academy in 1801 as *Pembroke Castle, South Wales: thunder storm approaching*.[1] This one was shown in 1806 with the title given here. Until recently the titles had been allocated to the wrong subjects, as it had not been noticed how carefully Turner distinguishes the meteorological effects that he specifies. Whereas in the other work only a fitful gleam of sunlight penetrates thick clouds, here there is a real 'clearing up' of the sky to the right, while boats which had previously huddled inshore for shelter now strike out across the sound once more. Such careful observations always underlie the general dramatic statements made by Turner's pictures. Even so, it is odd that he should have shown two such similar works at the Academy. He had done the same thing a few years before when, in 1796 and 1797, he exhibited almost identical views of the interior of Ely cathedral,[2] differing only in the direction of the sunlight that falls through the windows: a subtle reflection on the power of light to alter our experience of things, even when we are indoors and least conscious of it. So in the *Pembroke Castle* pair Turner seems to be saying that nothing is ever the same on different occasions, for time and climate constantly alter our perception, and indeed the reality itself, of what we see.

1. Wilton 280.
2. Wilton 194, 195.

J. M. W. Turner and Charles Turner (1773–1857), after J. M. W. Turner

9 Falls of the Clyde (*Liber Studiorum*) 1809

Etching and mezzotint, printed in brown ink, first published state (R. 18), subject: $7\frac{3}{16} \times 10\frac{3}{8}$ (182 × 264); plate: $8\frac{1}{4} \times 11\frac{7}{16}$ (209 × 291)
Inscr. above: *E. P.*; below: *Drawing of the CLYDE. In the possession of J. M. W. Turner.* with measurements (3ft 4in. × 2ft 3in.); and: *Drawn & Etched by J. M. W. Turner Esqr R.A.P.P.* and: *Engraved by C. Turner*; bottom: *London, Published March 29. 1809. by C. Turner, No. 50, Warren Street, Fitzroy Square.*
Yale Center for British Art, Paul Mellon Collection, B1977.14.8120

Turner made several studies of the fall of Cora Linn on the Clyde during his tour to Scotland in 1801;[1] from these he worked up a large watercolour of the fall[2] which he exhibited at the Royal Academy in the following year, with a reference in the catalogue to Mark Akenside's *Hymn to the Naiads* of 1746. Akenside explained[3] that his poem was about the 'Nymphs who preside over springs

and rivulets' giving 'motion to the air, and exciting summer breezes; . . . nourishing and beautifying the vegetable creation.' The *Liber Studiorum* subject is a considerably modified version of the original design, giving greater prominence to the depth of the fall, which is caught in a slanting beam of light that also spills across the scene through the trees at the left. This creates a sustained diagonal that lends a breadth to the scale of the plate in keeping with its 'Elevated Pastoral' status. When Turner returned to the subject for one of his last paintings,[4] these formal devices were abandoned in favour of an altogether more experimental use of diffused and iridescent light, perhaps, as has been suggested,[5] a further gloss on Akenside's theme, in which the personification of 'the elemental forces of nature' as nymphs, which the early versions share with the eighteenth-century poem, is replaced by a more direct expression of the inner meaning of the landscape.

1. Wilton 322–4.
2. Wilton 343; and see James Holloway and Lindsay Errington, *The Discovery of Scotland*, Edinburgh 1978, pp. 47–55.
3. In the 'Argument' which prefaces the poem.
4. *The Fall of the Clyde*, Butlin & Joll 510.
5. By John Gage, *Colour in Turner*, 1969, p. 143.

J. M. W. Turner and Robert Dunkarton (1744–c. 1811), after J. M. W. Turner

10 Hind Head Hill On the Portsmouth Road (*Liber Studiorum*) 1811

Etching and mezzotint, printed in brown ink, first published state (R. 25), subject: $7 \times 10\frac{3}{16}$ (177 × 259); plate: $8\frac{1}{8} \times 11\frac{3}{8}$ (207 × 289)
Inscr. above: *M*; below: with title and: *Drawn & Etched by J. M. W. Turner, R.A.P.P.*, and: *Engraved by R. Dunkarton*, and: *Published Janr 1. 1811, by Mr Turner, Queen Ann Street West.*
Yale Center for British Art, Paul Mellon Collection, B1977.14.8131

This plate reminds us that the countryside of southwest Surrey is among the most dramatic in England, possessing many of the attributes of the landscape sublime. It is overlooked nowadays as being too close, probably, to London to be of interest, and Turner's categorisation of 'Mountainous' would seem surprising. He passed this way on his route to make drawings at Portsmouth and Spithead in October, 1807, and sketched the hill in a book that also contains some verses scribbled by him on the subject of 'Hindhead the cloud-capt',[1] a demonstration of the way that sublime scenery of all sorts roused his responses not only visual but literary. The hill shown by Turner is now known as Gibbet Hill, and is 894 feet high; the gibbet was removed early in the nineteenth century and, as Rawlinson records, was replaced by a stone cross inscribed *Post Tenebras Lux*, which is, in a sense, the theme of this survey of Turner's work. The original drawing for this plate is TB CXVII–C.

1. The *Spithead* sketchbook, TB C. The verses are on the inside cover; drawings of Hindhead Hill are on ff. 20–3 and 70 verso. The sketch for the *Liber* subject is on f. 49 verso.

James Tibbitts Willmore (1800–63), after J. M. W. Turner

11 Llanthony Abbey, Monmouthshire (*England and Wales*) 1836

Engraving, progress proof(b), touched by Turner with pencil and white bodycolour (R. 287), subject: $6\frac{5}{8} \times 9\frac{7}{16}$ (168 × 240); plate: $9\frac{1}{2} \times 12\frac{1}{8}$ (242 × 309)
Yale Center for British Art, Paul Mellon Collection, B1977.14.7086

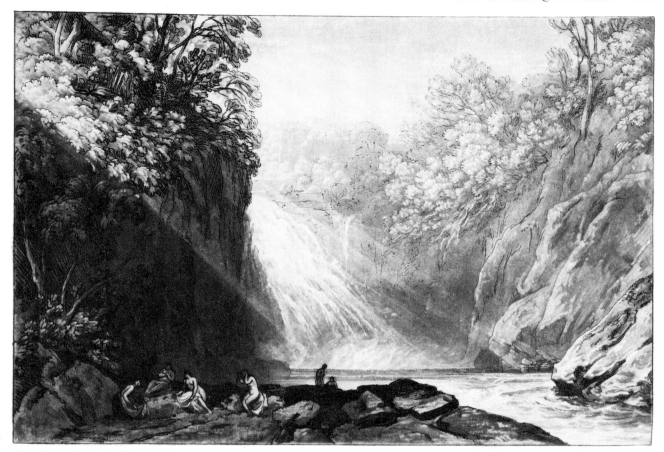

9

10

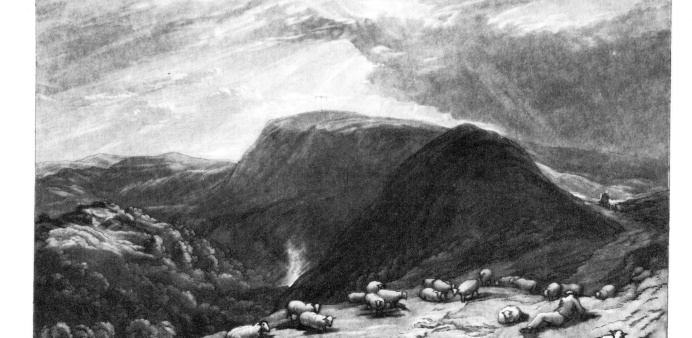

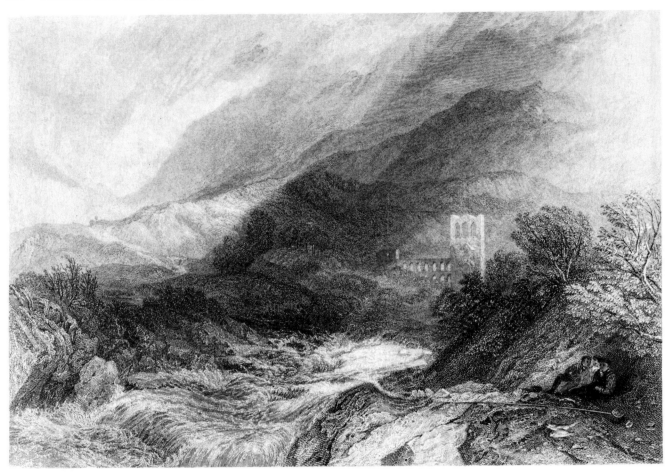

11

A return to the subject of a watercolour of 1794 (no. 1), in which the unstable, tumbling diagonal of the mountainside is reinforced by new diagonals in the very air itself: shafts of light that beat across the scene, binding its various elements together in an exhilarating 'downpour' that is both topographical and climatic. Similar uses of light and shadow to create compositional structures that reinforce, but are independent of, the geography of the land-scape, can be found in nos 39 and 110. Ruskin, who spoke of the drawing[1] as a 'noble work', confirmed the accuracy with which it portrays weather conditions: 'The shower is here half exhausted, half passed by, the last drops are rattling faintly through the glimmering hazel boughs, the white torrent, swelled by the sudden storm, flings up its hasty jets of springing spray to meet the returning light; and these, as if the heaven regretted what it had given, and were taking it back, pass as they leap, into vapour, and fall not again, but vanish in the shafts of the sunlight; hurrying, fitful, wind-woven sunlight, which glides through the thick leaves, and paces along the pale rocks like rain; half conquering, half quenched by the very mists which it summons itself from the lighted pastures as it passes, and gathers out of the drooping herbage and from the steaming crags; sending them with messages of peace to the far summits of the yet unveiled mountains, whose silence is still broken by the sound of the rushing rain.'[2]

1. Wilton 863; Shanes 71.
2. Ruskin, *Works*, III, p. 402.

12 View through the columns of St Peter's Piazza,
Rome *c.* 1795

Pencil and grey wash, $15\frac{3}{4} \times 17\frac{1}{16}$ (400 \times 433)
TB CCCLXXV–7

This drawing has been thought to be by some other hand than
Turner's,[1] for it is executed in a style which he shared, briefly, with
other artists in the mid-1790s. It is perhaps the work of his
colleague Thomas Girtin; but on balance seems more likely to be by
Turner himself, and reflects his bold sense of scale. It no doubt
derives from a study made in Italy by another artist – many
drawings by J. R. Cozens were adapted by Turner and Girtin in
this way – but shows signs of having been thought out afresh, with
its small figures in historic costume, which suggest that Bernini's
columns belong to some colossal temple of antiquity, much vaster
than they are in reality. A piece of direct topographical recording is

converted by these simple means into a classical fantasy in the
spirit of artists like Pannini and Piranesi.

1. See Finberg, *Inventory*, vol. II, p. 1234.

13 The Octagon, Ely Cathedral 1794

Pencil, $30\frac{3}{8} \times 23\frac{1}{8}$ (772 \times 588)
TB XXII–P, RA 1974(12)

This study, made on the spot during a tour of 1794, was used by
Turner as the basis for two watercolours shown at the Royal
Academy (see no. 8). It is typical of the careful and accurate
architectural record-taking in which Turner became so proficient
during the early 1790s. But it betrays in its sheer size an intention
far beyond the usual topographical exercise. We hardly need the
addition of colour to be impressed by the huge and soaring struc-

12

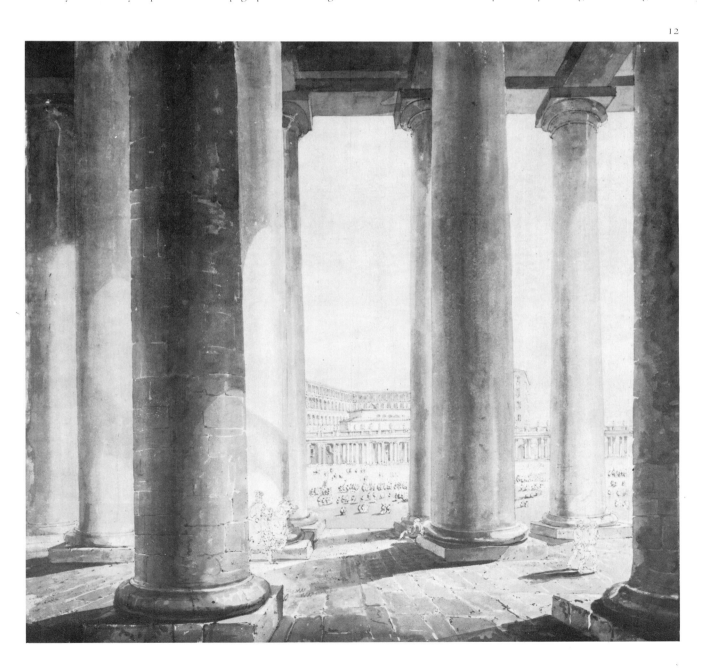

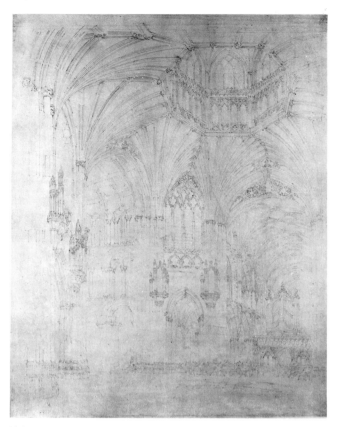

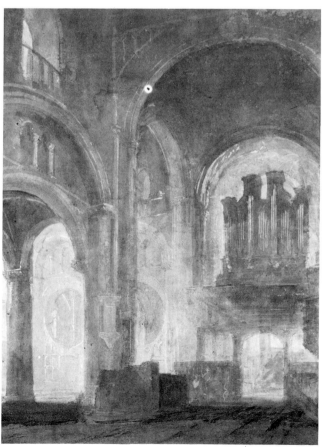

13△ ▽ 14

ture that Turner brings before us here. It is remarkable that he should have pursued his interest in large-scale watercolours to the extreme of actually making a full-size drawing on the spot, and still more remarkable that in this drawing he anticipates his practice of making such gigantic watercolours by about two years. It is a matter of some importance to determine whether Turner had a large-scale watercolour in mind when the drawing was made. He had certainly never produced anything on such a scale at that date, though one or two other topographers had set a precedent for work of this kind – Edward Dayes, for instance, had drawn the exterior of Ely in 1792 on a sheet measuring 680 × 925.[1] In Turner's own output, this is the first firm evidence we have for the interest in large works that was to preoccupy him for a decade or more.

1. In the Victoria and Albert Museum (FA 674) repr. Andrew Wilton, *British Watercolours, 1750–1850*, Oxford 1977, pl. 26.

14 Interior of Christ Church Cathedral, Oxford, *c.* 1799

Pencil, watercolour and stopping-out, touched with bodycolour, $26\frac{3}{4} \times 19\frac{3}{4}$ (680 × 501)
TB L–G

It was Sir Richard Colt Hoare of Stourhead in Wiltshire who first gave Turner commissions to make watercolour drawings of architectural interiors – in particular, the interior of Salisbury Cathedral, of which Turner made several large finished watercolours between 1796 and about 1802. In addition, there are two views of the interior of Ely cathedral, and one of Westminster Abbey, all belonging to the same years.[1] No. 13 is a pencil study of one of these subjects. Colt Hoare's own collection of watercolours included works by the French artist Abraham-Louis-Rodolphe Ducros (1748–1810), which exhibited a range of effects unknown to English artists in the mid-1790s;[2] in his work for Colt Hoare, then, Turner set himself to vie with the strength and dramatic immediacy of Ducros's views, and it is in the Salisbury interiors especially that he achieves the grandeur and power that he aimed for. This study of another interior, that of Christ Church cathedral, is perhaps an indication of how these highly wrought drawings looked when half finished. The system of stopping-out colour that Turner had developed by this date is in evidence (compare the study of Norham Castle of about the same time, *Colour 3*). The atmosphere of the old church is rendered in a rich chiaroscuro, shafts of light reinforcing the compositional thrust of the steep perspective.

1. Wilton 138; 194–203.
2. For an account of Turner's relations with Colt Hoare, and reproductions of Hoare's drawings by Ducros, see Kenneth Woodbridge, *Landscape and Antiquity*, 1970, pt II, chap. 14.

15 Illustration to a lecture on Perspective: Interior of a Prison *c.* 1810

Pencil, watercolour and bodycolour, $19\frac{1}{8} \times 27$ (486 × 686)
Inscr. upper left: *65*
TB CXCV–120, RA 1974(B54)
Colour plate 8

Turner's course of lectures on Perspective was first delivered in January, 1811, after more than three years' delay: he had been appointed Professor of Perspective at the Royal Academy in 1807.

He illustrated his talks with drawings carefully prepared by himself, often, like this one, of great beauty and brought to a high degree of finish. This sheet is one of a small group of studies[1] based on an etching of Giovanni Battista Piranesi (1720–78), plate 2 of the *Prima Parte di Architettura e Prospettive* which appeared in 1743. Piranesi was another master whose work Turner had been able to study in the collection of Sir Richard Colt Hoare (see no. 14), and his magnificent architectural fantasies played a large part in forming Turner's style as an artist of the architectural sublime.[2] Here the rigid demonstration of a perspective system in no way hinders him from producing a grand effect of tenebrous and slightly sinister gloom. His interest in architecture is well documented, and we know that he himself was responsible for more than one building scheme, including the design of his own picture gallery and a small house in Twickenham.[3] He was also a friend of Sir John Soane (1753–1837), whose neo-classical designs may have had some influence on the appearance of this drawing. It is possible that some of Turner's later, more ambiguous paintings of architectural interiors draw inspiration from Soane's work.[4]

1. Others are TB CXCV–121, 128.
2. See Woodbridge, *op. cit.*
3. Another of Turner's architectural projects was a gate lodge at Farnley; his own drawing of this is Wilton 589.
4. See Wilton, 1979, p. 210, and Butlin & Joll, pp. 445–50.

16 Rome: The Portico of St Peter's with the Entrance to the Via Sagrestia 1819

Pencil and watercolour with bodycolour on white paper prepared with a grey wash, $14\frac{3}{8} \times 9\frac{1}{4}$ (369 × 232)
TB CLXXXIX–6, BM 1975(68)

Just as, in drawings of 1819 like nos 17 and 82, Turner seems to have been reminded by his experiences in Rome of the art of Ducros whom he had admired in the 1790s, this study recalls another of the great influences of those years – Piranesi (see no. 15). It was indeed difficult not to see Rome through the eyes of artists, and it is surprising that, in general, Turner's view of it was so fresh, uncluttered by the prepossessions that he certainly took with him to Italy. Here, despite a Piranesian sense of scale, the vision is entirely original and direct, a masterly and personal response to the architecture of St Peter's, the scale of which is greatly exaggerated by the tiny figure beside it. He was to pursue the theme further in a finished watercolour of 1821 showing the interior of the basilica,[1] a brilliant Renaissance variant on the shadowy gothic interiors of Ely and Salisbury of the 1790s.

1. Wilton 724, pl. 159.

17 Rome: The Interior of the Colosseum: Moonlight 1819

Pencil, watercolour and bodycolour on white paper prepared with a grey wash, $9\frac{1}{16} \times 14\frac{9}{16}$ (231 × 369)
TB CLXXXIX–13, BM 1975(70)
Colour plate 9

Apart from the sweeping panoramas of Rome with which Turner filled many pages of his Italian sketchbooks, there are a number of studies of individual buildings, usually monuments of great size and historical significance like the Colosseum or the Vatican (see no. 16), which are presented in close-up, crowding in on the

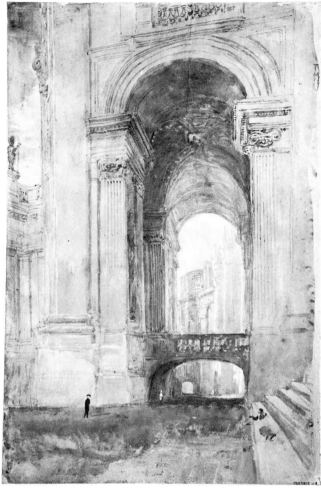

16

spectator as gigantic and awe-inspiring piles of masonry.[1] In this sense, they continue the tradition of the architectural sublime that Turner had established in the 1790s. The drawings of 1819, however, do not make use of large sheets of paper, and achieve their effect by understatement. This sheet and no. 82 are exceptional among the many colour studies that Turner made during his first visit to Rome, in that they subordinate the grandeur of ancient buildings to climatic or atmospheric effects. It was usual, for instance, to show the interior of the Colosseum peopled with the contemporary inhabitants of Rome, listening to monks preaching or taking part in religious processions. Turner dispenses with these formalities of 'grand tour' topography, substituting his own associations, which perhaps hark back to the imagery of Ducros that he had seen at Stourhead (see no. 14). This drawing might be a design for the setting of the climax to Henry James's tale of *Daisy Miller* (1879).

1. A finished watercolour of the exterior of the Colosseum, in which the height of the structure is deliberately increased to tower off the edge of the paper, is in the British Museum, Lloyd Bequest (Wilton 723).

18 Ben Arthur 1801

Pencil and white bodycolour on a buff ground, $11\frac{1}{2} \times 16\frac{7}{8}$
(293 × 428)
TB LVIII—5

One of the 'Scottish Pencils' of Turner's tour of 1801 (see no. 7), this spare, brooding study exemplifies the economy of means by which Turner taught himself to note accurately the essentials of mountain scenery. Concentrating as it does on the forms of the rocks alone, the composition already contains something of the writhing energy of Turner's last masterpiece of the mountainous sublime – the *Faido* of 1843 (no. 104). Ben Arthur was to be used as the subject-matter for one of the latest of the published *Liber Studiorum* plates (no. 32). Rapid pencil studies of Ben Arthur occur in the *Tummel Bridge* sketchbook, and this sheet seems to have been worked up subsequently from one of them.[1]

1. TB LVII, 13 verso, 14.

19 The Devil's Bridge, Pass of St Gothard 1802

Pencil, watercolour and bodycolour with scraping-out on white paper prepared with a grey wash, $18\frac{9}{16} \times 12\frac{1}{2}$ (471 × 318)
TB LXXV—34, BM 1975(32)

The St Gothard pass, from Lucerne and Altdorf to Bellinzona, was one of the chief routes over the Alps for travellers of Turner's day, and the Devil's Bridge was its most celebrated *Sehenswürdigkeit*. It was frequently drawn, though rarely by English artists before Turner. One exception was William Pars (1742–82), who made a watercolour of it for his patron Lord Palmerston in 1770.[1] Pars brought to the subject an eighteenth-century desire for accuracy that almost completely overrides any sense of excitement in the grandeur of the spot; careful delineation of form, allied to an insistent horizontal stress, make for stability and reassurance, whereas Turner's loose washes and powerful vertical, where both the cliff tops and the bottom of the chasm are out of sight, create a mood of dizzying instability. The theme was one that he was to repeat often, bringing it to a peak of expressive force in the *Battle of Fort Rock (colour 15)*. Another study of the gorge, taken from the bridge itself,[2] was used for a large finished watercolour of 1804.[3] A similar watercolour based on this view of the bridge is recorded, but untraced.[4] Turner executed oil paintings of both subjects,[5] and used this one for a 'Mountainous' plate in the *Liber Studiorum* (no. 26).

1. In the British Museum, 1870–5–14–1221. See Andrew Wilton, *William Pars: Journey through the Alps*, Zurich 1979, p. 45. Pars's drawing was engraved by William Woollett in 1773 (Fagan LXXVII).
2. TB LXXV—33. The two studies are reproduced side by side in *Turner in Switzerland*, pp. 62–3.
3. Wilton 366.
4. Wilton 368, repr. Frederick Wedmore, *Turner and Ruskin*, 2 vols, London 1900, vol. II, p. 256.
5. Butlin & Joll 146, 147.

18

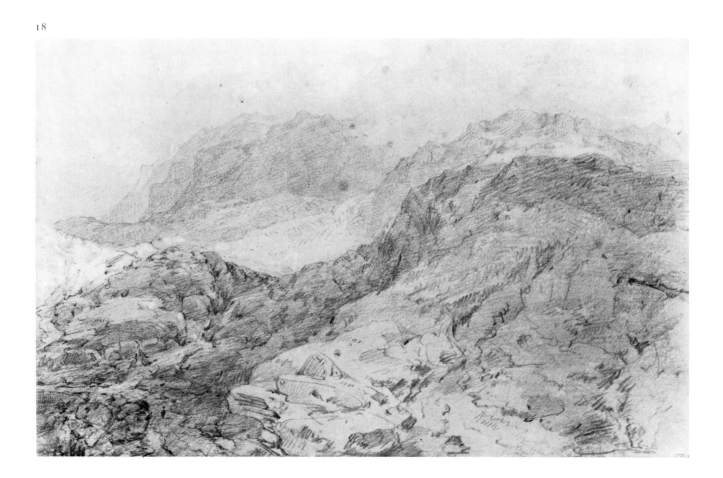

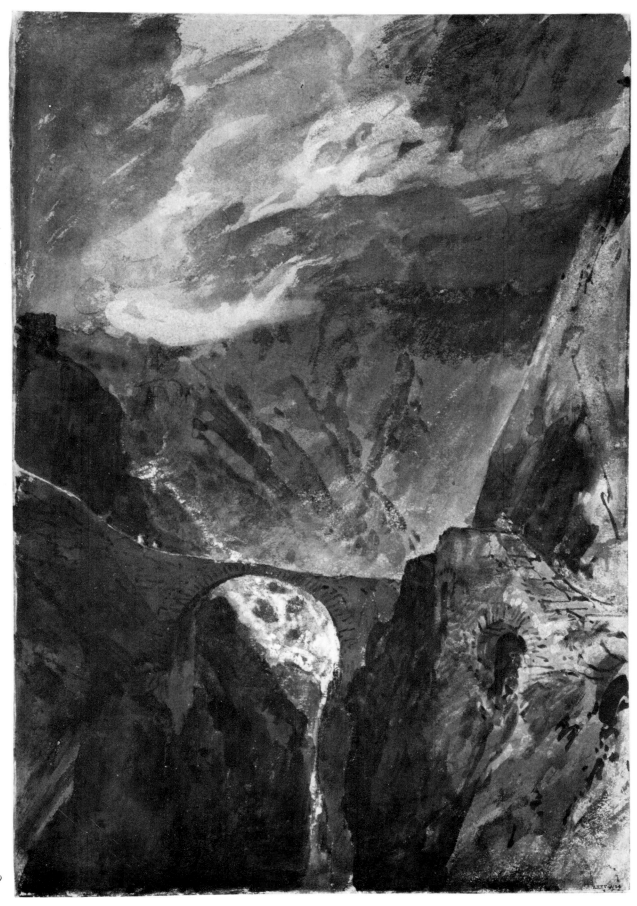

19

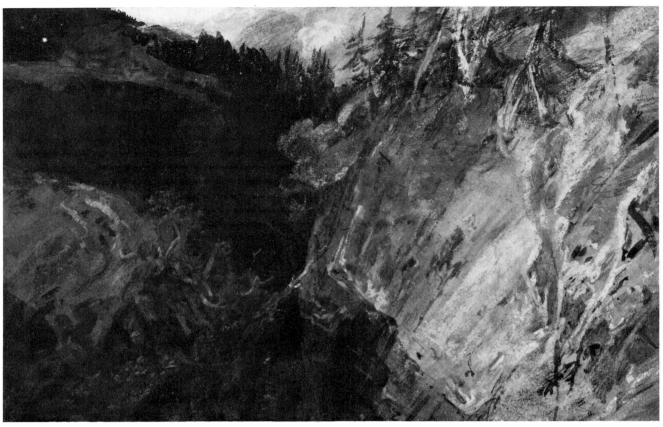

20

20 A ravine on the pass of St Gothard 1802

Pencil and watercolour with bodycolour and scraping-out on white
paper prepared with a grey wash, $12\frac{1}{2} \times 18\frac{11}{16}$ (318×475)
TB LXXV−35, BM 1975(30)

An elaborately worked up study from the *St Gothard and Mont Blanc*
sketchbook of 1802, which embodies many of the salient ideas
associated with the landscape sublime: brooding shadow, tree-
grown crags and steep cliffs dropping into chasms. It is perhaps
surprising that no finished watercolour was developed from this;
but the sequence of drawings of Fort Rock in the Val d'Aosta
contain many of the same elements (see *colour 15*).

21 The Mer de Glace, Chamonix 1802

Pencil, watercolour and bodycolour on white paper prepared with a
grey wash, $12\frac{3}{8} \times 18\frac{5}{16}$ (314×468)
TB LXXV−23, BM 1975(31)

Turner made this drawing on a leaf of his *St Gothard and Mont Blanc*
sketchbook, and although he did not use it as the basis for any of
the finished watercolours that resulted from his Swiss tour of 1802,
he adapted it for a plate of the *Liber Studiorum* published in 1812, in
the 'Mountainous' category.[1] The monochrome greys of the ice
and rock create the impression of a rough sea frozen into immo-
bility; a perfect demonstration of the contention of the theorists of
the sublime that mountain peaks and rough seas are closely related
visually.[2] The bleakness of the subject perhaps discouraged Turner
from developing it into a finished work: in a sense, this direct and
spontaneous study needs no elaboration. Life is alien in such a
setting, and to add figures and other details for the sake of a

complete composition would have been inconsistent with the
mood and meaning of the place represented. The 'privation' of the
scene is expressed as much in the limited means used to convey it as
in any formal design of Turner's.

1. R. 50.
2. See p. 46; and *Turner in Switzerland*, p. 48.

22 The Hospice of the Great St Bernard 1802

Black and white chalks on grey paper, $8\frac{7}{16} \times 11\frac{3}{16}$ (215×284)
TB LXXIV−55

Turner's technique in this drawing owes much to the exercises he
had accomplished in Scotland in the previous year (nos 7 and 18),
and like those, the sheet may not be a record made on the spot, but
a more carefully wrought development of a slight out-of-doors
sketch, for the purpose of concentrating and refining an idea that
might subsequently be used for a picture. We have evidence that
Turner did indeed intend to make a finished watercolour of the
scene, for there is a study that explores the composition in broad
masses of colour (*colour 10*). No finished work is known, however.
The dramatic possibilities of the Great St Bernard with its famous
Hospice (which appears in Dickens's *Little Dorrit*)[1] were explored
by Turner in two vignette designs that he made for Samuel Rogers
in the late 1820s. In these, dogs prowl through the snow, and
cowled men carry the body of a victim of the mountain on a
stretcher.[2]

1. 1857; Bk II, Chapter 1.
2. The vignettes were published in Roger's *Italy*, 1830 (R. 351, 352); Wilton 1155,
 1156.

THE 'TERRIFIC' · 119

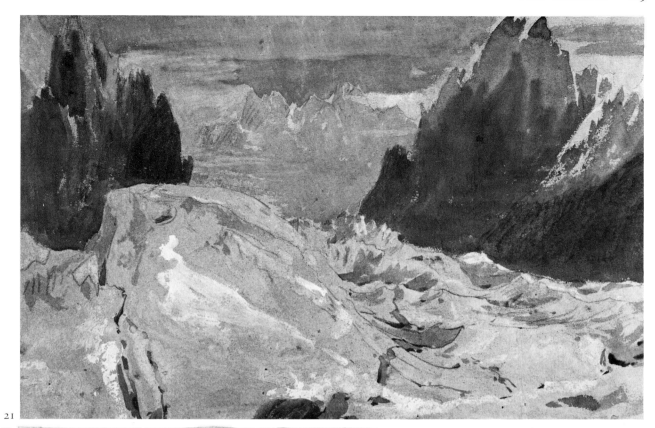

21

22

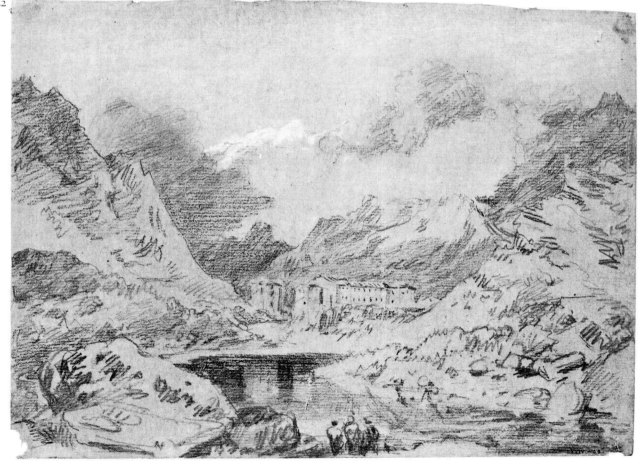

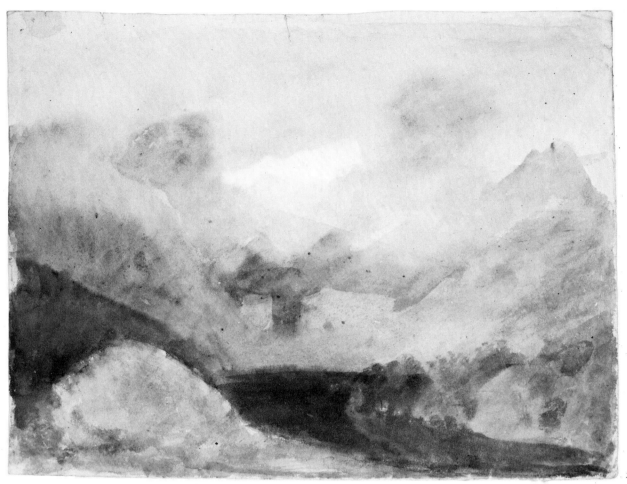

23
24
25 ▷

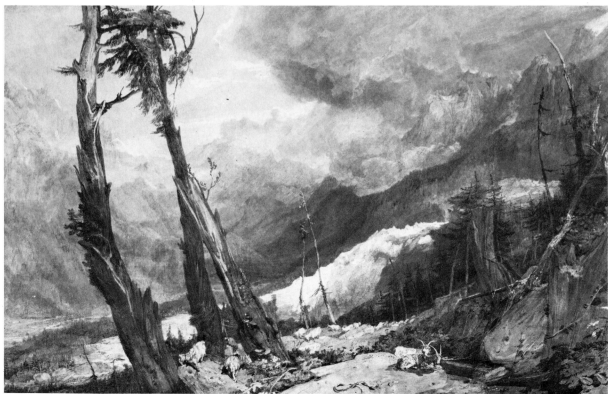

23 The Hospice of the Great St Bernard: colour study

(?)*c.* 1806

Watercolour over traces of pencil, $13\frac{3}{8} \times 16\frac{3}{4}$ (340×425)
TB CCLXIII—195, BM 1975(71)
Colour plate 10

A meditation in pure colour on the subject of a drawing from Turner's *Grenoble* sketchbook (no. 22), this study is evidently a preliminary 'structure' for a fully worked out watercolour which was never completed. It affords an opportunity to examine, unalloyed by local detail, the broad scheme of a work of the early sublime type, in which Burke's 'sad and fuscous' colours play a dominant part (see p. 67).

24 Glacier and Source of the Arveiron, going up to the Mer de Glace 1803

Watercolour, 27×40 (685×1015)
Yale Center for British Art, Paul Mellon Collection, B1977.14.4650, Wilton 365

Of all the subjects that Turner gathered during his tour of Switzerland in 1802, the views along the Valley of Chamonix from near the Mer de Glace were among the most fruitful. Apart from the austere drawing of the glacier and its surrounding peaks (no. 21), he made several other studies in the same area, including a rough chalk drawing[1] of the view which was used as the basis for this large watercolour. No less than three other finished drawings make use of a similar motif:[2] the sharp diagonal, which Turner had first experimented with in his *Llanthony Abbey* of 1794 (no. 1), now embodies all the mobility and contrast of full-scale mountain

scenery. The sharply slanting line is more than a mere equivalent on paper of the side of a mountain. It is the 'oblique line' that 'may rise to infinity', which Turner discussed in his lectures.[3] It links the placid tranquillity of the valley with the harsh energy of the cloudy peaks, and imbues the whole design with the unsteady rhythm of the rocky, unsure goat-paths and the avalanche-invaded forest. Human influences on this wild landscape are few: a solitary goatherd is dwarfed by his surroundings, and a snake coiled on a rock suggests that man is not welcome here. Watercolour technique is stretched to its utmost to describe the great variety of forms and effects in this comprehensive survey of the grandeur and ugliness of Alpine scenery. A final version of the subject appeared in the form of a plate for Part XII of the *Liber Studiorum* in 1816, categorised as 'Mountainous'.[4]

1. TB LXXIX—L
2. Wilton 383, 387, 389.
3. See p. 70.
4. R. 60.

J. M. W. Turner and Charles Turner (1773–1857), after J. M. W. Turner

25 Mount St Gothard (*Liber Studiorum*) 1808

Etching and mezzotint, printed in black-brown ink, first published state (R.9), subject: $7 \times 10\frac{3}{16}$ (178×259); plate: $8\frac{1}{8} \times 11\frac{3}{8}$ (207×289)
Inscr. above: *M. S*; below: *M.̊ S.̊ Gothard.* and *Drawn & Etchd by J.M.W. Turner Esq.̊ R. A. P. P.* and *Engraved by Cha.̊ Turner* and bottom: *London Published Feb.̊ 20, 1808, by C. Turner N.̊ 50, Warren Street Fitzroy Square.*
Yale Center for British Art, Paul Mellon Collection, B1977.14.8106

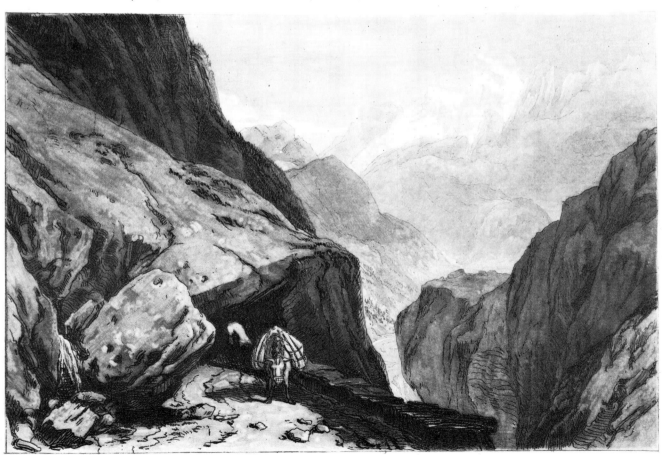

Turner's use of initial letters to denote the various categories of landscape included in the *Liber Studiorum* is sometimes erratic. Apart from the well-known uncertainty attached to the letters 'E.P.' which he sometimes uses instead of 'P' for Pastoral, there is some ambiguity attending the heading to this plate. Rawlinson notes[1] that Turner occasionally gives 'Ms' rather than simply 'M' for Mountainous, to distinguish the category from Marine, which is also denoted by 'M.' In this plate the dot between the two capital letters 'M.S' suggests that they stand, like 'E.P' for two separate words. Presumably the category is the 'Mountainous Sublime'. This is in fact the first 'mountainous' plate of the series, and Turner did not use the form again;[2] perhaps because he felt that the phrase was tautologous: mountainous scenery is by its nature sublime. Pastoral scenery is not; hence his need to emphasise the 'elevated' nature of many of the more serene subjects by adding the letter 'E' to the plain 'P'.[3]

1. Rawlinson, *Liber Studiorum*, 1878, p. v.
2. The next 'mountainous' plate is the *Lake of Thun*, R. 15 (see no. 108), designated as 'M.'. All subsequent examples of the category are 'M' except the *Little Devil's Bridge* of 1809, R. 19 (see no. 26) which is headed 'Ms.'.
3. See p. 70.

J. M. W. Turner and Charles Turner (1773–1857), after J. M. W. Turner

26 Little Devil's Bridge over the Reuss above Altdorf (*Liber Studiorum*) 1809

Etching and mezzotint, printed in brown ink, engraver's proof(f) (R. 19), subject: $7 \times 10\frac{3}{16}$ (177 × 258); plate: $8\frac{3}{16} \times 11\frac{3}{8}$ (208 × 289)

Inscr. below: *Little Devils Bridge over the Russ above Alldorft Swiss.d* and: *Drawn & Etched by J. M. W. Turner Esq.r R.A.P.P.* and: *Engraved by Cha.t Turner.* bottom: *London Published March 29. 1809. by C. Turner, No 50. Warren Street Fitzroy Square.*
Yale Center for British Art, Paul Mellon Collection, B1977.14.8123

The subject is derived from a drawing in the *St Gothard and Mont Blanc* sketchbook (no. 19). Turner remodels the emphatically vertical composition of that study in the horizontal format of the *Liber* plate, deliberately giving prominence to the horizontal formed by the parapet of the bridge, and substituting for the vertical depth of the original a new depth of recession through the arch, with strong contrasts of tone giving a sense of great space beyond what we glimpse of the river gorge. The inhospitable landscape is made bleaker by the presence of bleaching bones near the blasted tree in the foreground. No. 25 is another *Liber* plate showing the same route; and the *Faido* of 1843 (*colour 24*) is Turner's final statement on the theme of this difficult mountain road.[1]

1. Ruskin insisted that it was the road, a vital link for travellers between north and south (more specifically between England and Italy), which gave the place its peculiar attraction for Turner. See *Works*, VII, p. 435, note.

27 The Upper Fall of the Reichenbach: rainbow (?) 1810

Watercolour and bodycolour with scraping-out over pencil, $10\frac{7}{8} \times 15\frac{1}{2}$ (276 × 394)
Yale Center for British Art, Paul Mellon Collection, B1977.14.4702, Wilton 396
Colour plate 11

26

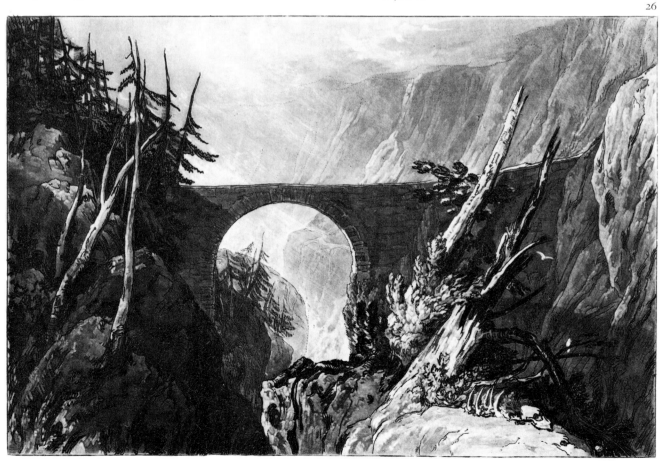

The fall of the Reichenbach, near Meiringen in Haslital, was a sublime phenomenon that had been consecrated by John Robert Cozens, who made several drawings of it in 1776.[1] Two impressive studies of it occur in Turner's *St Gothard and Mont Blanc* sketchbook of 1802,[2] and these were used as sources for two finished works, the large *Great Fall of the Reichenbach* now at Bedford[3] and this smaller view of the cascade seen from the side. The most famous literary association of this spot is with Conan Doyle's Sherlock Holmes, who plunged over the fall with Moriarty to his death.[4] Even though that 'event' occurred many decades later, it underlines the suggestive force of the subject as one lending itself naturally to drama – or melodrama. As in the *Glacier and Source of the Arveiron* (no. 24), and the other early Swiss subjects, there is an overriding concern with technical precision in this drawing: effects of mist, spray, rainbow or hazy distance are rendered not by impressionistic washes but by minutely calculated adjustments of colour and tone from one stroke to the next. Turner's virtuosity in scraping the surface of his drawings is realised to the full: the windblown spray of the fall, in which much of its majestic effect lies, is entirely achieved by scratching and rubbing away the painted surface.

1. C. F. Bell and T. Girtin, 'The Drawings and Sketches of John Robert Cozens', *Walpole Society* vol. XXIII, 1934–5, nos 20–6.
2. Wilton 361, 362.
3. Wilton 367, repr. in colour, *Turner in Switzerland*, p. 64.
4. A. Conan Doyle, *The Memoirs of Sherlock Holmes*, 1894.

28 Malham Cove *c.* 1810

Watercolour and scraping-out, $11 \times 15\frac{5}{8}$ (279 × 396)
Inscr. lower right: *I M W Turner RA*
British Museum, Salting Bequest, 1910–2–12–277, Wilton 533
Colour plate 12

Malham, says a writer of the 1820s, is a village 'situate in a deep and verdant dale' and 'chiefly remarkable on account of an immense cragg of limestone, called Malham Cove. It is 286 feet high, stretching in the shape of the segment of a large circle across the whole valley, and forming a termination at once so august and tremendous, that the imagination can scarcely figure any form or scale of rock within the bounds of probability that shall go beyond it.'[1]

The similarity of both the size and the handling of this sheet with *Patterdale Old Church (colour 13)* strongly suggests that they were executed as a pair, if not as members of a longer series of related views in the north of England. They bear some resemblance to a group of watercolours executed for Sir Henry Pilkington in about 1813–15,[2] and were perhaps done for him, but there is no record of his having owned them. Turner made a pencil study of Malham Cove, which he used for this watercolour, in a sketchbook of about 1808.[3] As in the view of Patterdale, he presents a quiet scene of rustic life among grand scenery, which becomes the backdrop for a sudden change from sunshine to storm. Both are restatements of his old interest in the picturesque sublime in the light of his experience of Switzerland and in terms of his increasingly flexible technique. Although this is not one of Turner's best-known subjects, and was never engraved, it has been traditionally associated with him, at least in Yorkshire, just as Gordale Scar is associated with James Ward (1769–1859).[4]

1. Thomas Allen, *A New and Complete History of the County of York*, 3 vols, London 1828–31, vol. III, p. 354.
2. Wilton 534–6, 538, and possibly others of the Yorkshire views of the period.
3. The *Tabley No. 1* sketchbook, TB CIII–10.
4. See William Rothenstein, *Men and Memories*, London 1931, pp. 14–15.

29 Patterdale Old Church *c.* 1810

Watercolour and scraping-out, $11\frac{3}{8} \times 15\frac{9}{16}$ (279 × 395)
Inscr. lower left: *J M W Turner RA PP*
Yale Center for British Art, Paul Mellon Collection, B1975.4.1618, Wilton 547
Colour plate 13

After his return from Switzerland, Turner was well equipped with sublime material on which to work; he sought contrast in the more pastoral aspects of English scenery, and many of his watercolours of the first decade of the century are gentler in mood than the grandiose Swiss subjects he was producing. But after his first stay at Farnley in Yorkshire, which probably took place in 1810, he approached the wilder landscapes of England with a new interest, a vision modified by what he had seen abroad. As Ruskin noticed (see no. 70), he recorded a greater warmth of understanding in the face of British wildnesses than he could yet muster for continental ones, and there is a tenderness and grace about even such violent subjects as this one, which allies them to the picturesque tradition which had formulated so effective a language for the interpretation of English scenery. Even so, the breadth of his handling of the electric storm that suddenly drenches these Westmorland mountains is superb. The sharp gusts of driving wind and rain are suggested by bold diagonal strokes of the brush in the sky and in objects near at hand – the wind-tossed tree to the left of the church, for instance. While it is not known whether Turner had any particular patron in mind when he made this drawing, it is possible that he intended it to form one of a series of north-country subjects, of which another is perhaps the *Malham Cove (colour 12)*. An earlier drawing of Patterdale, showing the new church,[1] was engraved in 1805 for Mawman's *Excursion to the Highlands and English Lakes*;[2] it is now lost, but the engraving is a staid affair with none of the brooding drama of this later watercolour.

1. Wilton 229. It is referred to in a list of watercolours jotted by Turner on a leaf of the album into which the 'Scottish Pencils' were pasted; see Finberg, *Inventory*, vol. I, p. 153.
2. R. 75.

30 Gordale Scar *c.* 1816

Pencil, watercolour, bodycolour and gum, $21\frac{5}{8} \times 29\frac{7}{8}$ (550 × 760)
TB CLIV–O

Gordale Scar is 'one of the most stupendous scenes in Yorkshire, immensity and horror being its inseparable companions uniting together to form subjects of the most awful cast. The rocks are of extraordinary height, being not less than 300 feet, and in some places projecting more than ten yards over their base. An opening was formed in this limestone rock by a great body of water, which collected in a sudden thunderstorm in about 1730, and now forms a highly romantic cascade of twenty or thirty yards in height.'[1]

The medium in which this study is executed has been thought to be oil colour, applied thinly over pencil underdrawing. There is no reason, however, why Turner should have worked in oil on such a sketch, since the projected picture was almost certainly to have been in watercolour. A note of the title appears with the names of other watercolours that Turner was preparing for his patron Walter Fawkes, listed in the *Greenwich* sketchbook.[2] His pencil study on the spot for this subject occurs in one of the Yorkshire sketchbooks of about 1816.[3] No finished work is known. A number of the Yorkshire studies of this period are on large sheets like this, but few exploit the size of the paper in quite this way to achieve a physical sense of awe and terror. This is in fact a rather late

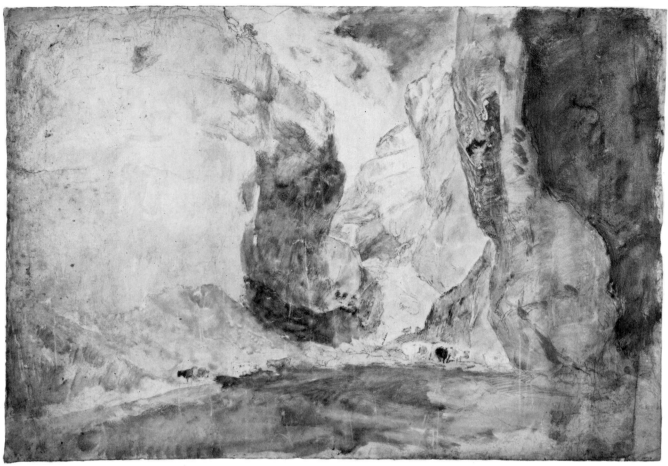

30

specimen of Turner's use of the large scale for such purposes, and the study is closer in mood to his Welsh mountain views of about 1799 (*colour 4, 5, 6*) than to his characteristic work of the 1810s. Nevertheless, it succeeds in its intention of conveying the rugged grandeur of the Scar, paralleling James Ward's attempt to achieve the same end on an enormous canvas.[4]

1. Thomas Allen, *op. cit.*, Vol. III, p. 355.
2. TB CII, inside front cover and p. 52.
3. TB CXLV, 167–8.
4. Tate Gallery, no. 1043.

31 Mill near the Grande Chartreuse, Dauphiny *c.* 1815

Pen and brown ink and wash, $9\frac{1}{16} \times 9\frac{1}{2}$ (230 × 241)
TB CXVIII–B

This is the drawing of a *Liber Studiorum* plate engraved by Henry Dawe and issued in 1816. It has been supposed that Turner himself took some hand in applying the mezzotint.[1] He categorised the subject as 'mountainous'. The Grand Chartreuse occupied a central place in the consciousness of early searchers for the sublime among the Alps. Long before Gray passed that way in 1739, travellers had visited it and been struck with 'that strange solitude where the grand Chartreuse is scituated', and with 'such precipices as would affright any eye to look downe upon them'.[2] Turner confines himself to expressing the primitive power of the spot by simple means; Ruskin, who admired the *Liber Studiorum* print enormously, sums up its import in terms of basic elements that had been cited

for two hundred years: Turner 'painted the mill in the valley. Precipices overhanging it, and wildness of dark forests round; blind rage and strength of mountain torrent rolled beneath it, – calm sunset above, but fading from the glen, leaving it to its roar of passionate waters and sighing pine-branches in the night.'[3]

1. R. 54.
2. Richard Colebrand, *Journal*, 12 September 1659, Yale University Library, Osborne Collection, MS b266.
3. Ruskin, *Works* VII, p. 433.

J. M. W. Turner and Thomas Goff Lupton (1791–1873), after J. M. W. Turner

32 Ben Arthur, Scotland (*Liber Studiorum*) 1819

Etching and mezzotint, printed in brown ink, first published state (R. 69), subject: $7\frac{3}{16} \times 10\frac{9}{16}$ (183 × 268); plate: $8\frac{1}{4} \times 11\frac{7}{16}$ (209 × 291)
Inscr. above: *M*; below: with title, and *Drawn and Etched by J. M. W. Turner Esq. R.A.P.P. and Engraved by T. Lutton.* [sic]; and: *London, Pub. Jan 1. 1819. by I. M. W. Turner Queen Ann Str West.*
Yale Center for British Art, Paul Mellon Collection, B1977.14.8189

Turner made sketches of Ben Arthur on the spot, and worked up some of these into more elaborate drawings in the 'Scottish Pencils' series (see no. 18). He returned to the subject much later when looking for motifs for a late issue of the *Liber Studiorum*. The impressive curving line that dominates the design is reminiscent of

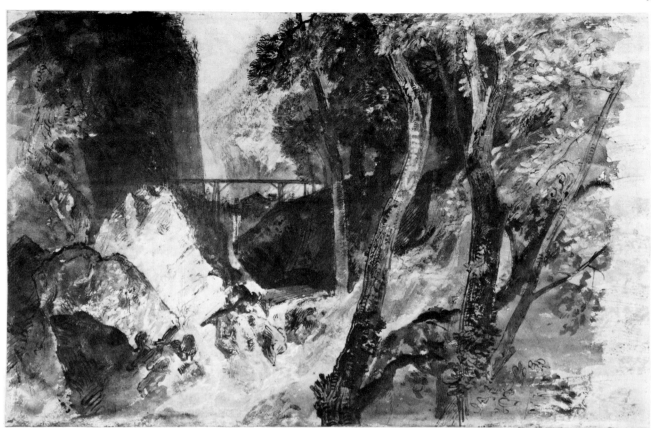

31△ ▽32

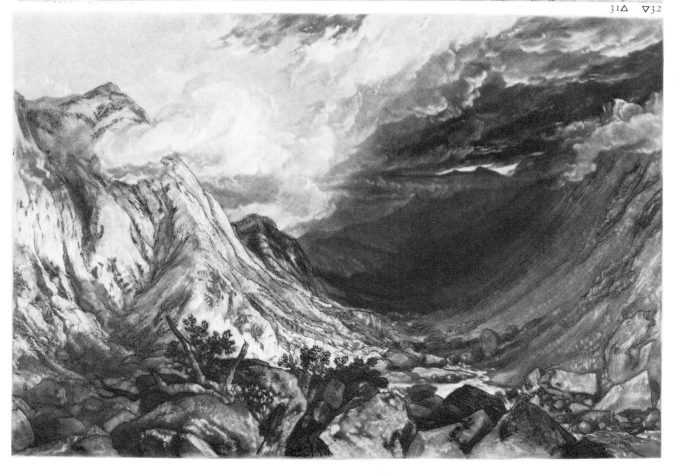

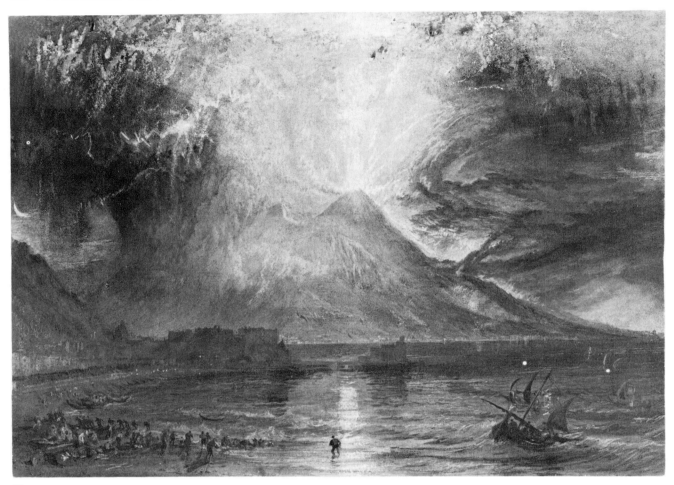

33

the movement of breakers in a high swell at sea; compare the less fluid rhythms of the 'waves' created by the aiguilles at Chamonix (no. 21). Turner reverted to the same wave-like rhythms, though they take a more violent form, in his small drawing of *Loch Coriskin* for the *Poetical Works* of Scott of about 1832.[1] Rawlinson considered this *Liber* plate exceptionally impressive, maintaining even that 'were all Turner's other works lost, upon the strength of it alone, his pre-eminent fame as a landscape draughtsman might safely rest. Whose hand but his could have so drawn those sweeping mountain curves, could have so wedged in the loose array of stones at their base, could have given that grand gloom to the storm at the head of the ravine, or the grace to the fleecy clouds which cling about the hill-tops?'

1. Wilton 1088.

33 Eruption of Vesuvius 1817

Watercolour and scraping-out, $11\frac{1}{4} \times 15\frac{5}{8}$ (286 × 397)
Inscr. verso: *Mount Vesuvius in Eruption JMW Turner RA 1817*
Yale Center for British Art, Paul Mellon Collection, B1975.4.1857,
Wilton 697

The sublimities of Italy were not all engrossed by the achievements of man: Vesuvius was perhaps the most celebrated of volcanoes, and one whose activities had been recorded in the writings of a classical author, the younger Pliny, whose account of the destruction of Pompeii and Herculaneum[1] had comparatively re-

cently acquired new interest and importance from the discovery of the remains of those towns on the southern slopes of the mountain.[2] The sensational appeal of volcanic eruptions was perennial; Vesuvius had provided matter for innumerable modern accounts as well as that of Pliny. The early masters of the landscape sublime had revelled in depictions of it: Joseph Wright painted its performances often.[3] Turner made three views of the volcano before his first visit to Italy in 1819; two show an eruption.[4] They must have been based on drawings by some other artist, perhaps John Robert Cozens,[5] or perhaps James Hakewill, who supplied pencil outlines from which Turner worked up eighteen watercolours for Hakewill's *Picturesque Tour in Italy* published in 1818–20.[6] He had shown a painting of a volcano in eruption at the Academy in 1815:[7] *The eruption of the Souffrier Mountains, in the Island of St Vincent, at midnight, on the 30th of April, 1812* (a title characteristically circumstantial and concrete; see no. 57). This too was dependent upon the sketch of an amateur. He wrote these lines to accompany the picture in the catalogue:

Then in stupendous horror grew
The red volcano to the view
And shook in thunders of its own,
While the blaz'd hill in lightnings shone,
Scattering their arrows round.
As down its sides of liquid flame
The devastating cataract came,
With melting rocks, and crackling woods,
And mingled roar of boiling floods,
And roll'd along the ground!

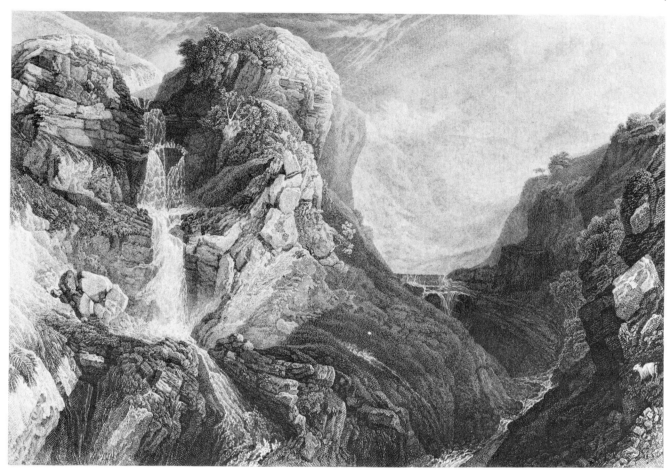

34

In realising for himself the eruption of Vesuvius, Turner gave full reign to his technical inventiveness, creating one of his most exuberant and exciting watercolours, a fantasy of fire and night, in which fear is replaced by a more positive emotion – one of wondering delight in the extravagant beauty of a natural cataclysm.

1. Pliny the younger, *Letters*, VI, 16 (to Cornelius Tacitus).
2. Excavations at Herculaneum had begun in 1711, and at Pompeii in 1733.
3. Nicholson, *Wright*, pls 163, 165, 167–70.
4. Wilton 697–9.
5. No drawing by Cozens of Vesuvius from this viewpoint is known, however.
6. Wilton 700–17.
7. Butlin & Joll 132.

Samuel Middiman (1750–1831), after J. M. W. Turner

34 Moss Dale Fall (*History of Richmondshire*) 1822

Engraving, progress proof (b), printed on india paper (R. 181), subject: $7\frac{1}{2} \times 11$ (190 × 268); plate: $11\frac{3}{8} \times 16\frac{5}{8}$ (290 × 422)
Inscr. below, right: *Engᵈ by S. Middiman 1822*
Yale Center for British Art, Paul Mellon Collection, B1977.14.6814

John Pye (1782–1874), after J. M. W. Turner

35 Hardraw Fall (*History of Richmondshire*) 1818

Engraving, printed on india paper, first published state (R. 182), subject: $7\frac{1}{2} \times 10\frac{3}{4}$ (190 × 273); plate: $11\frac{1}{4} \times 17\frac{1}{2}$ (285 × 445)

Inscr. below: with names of artist and engraver; centre: *Etched by S. Middiman.* and with title, and: *Published by Longman, Hurst, Rees, Orme & Browne, London, and Robinson, Son & Holdsworth, Leeds Octᵣ. 1. 1818*[1]
Yale Center for British Art, Paul Mellon Collection, B1977.14.13282

John Landseer (1769–1852), after J. M. W. Turner

36 High Force or Fall of Tees (*History of Richmondshire*) 1822

Engraving, printed on india paper, first published state (R. 173), subject: $7\frac{5}{8} \times 10\frac{5}{8}$ (194 × 270); plate: $11\frac{9}{16} \times 17\frac{7}{16}$ (293 × 442)
Inscr. below: with names of artist and engraver, and with title; lower right: *Printed by H. Triggs*; bottom: *Published by Longman & Cᵒ. Paternoster Row, and Hurst, Robinson, & Cᵒ. Cheapside, London. Septᵣ. 12. 1821.*
Yale Center for British Art, Paul Mellon Collection, B1977.14.1329

T. D. Whitaker's *History of Richmondshire* afforded Turner an opportunity to design an extensive series of views in the north of England,[2] including many views of the grand natural scenery for which the region is famous, and which he had already drawn on for subject-matter (as in nos 28 and 30). These three plates are typical of the sublime topography required for Whitaker's sumptuous volumes. They are accompanied by descriptive text:
'From Meerbeck [in Wensleydale] upwards the appearances of fertility and verdure gradually diminish: there is little alluvial land; long and sweeping surfaces of mountain pasture range from the

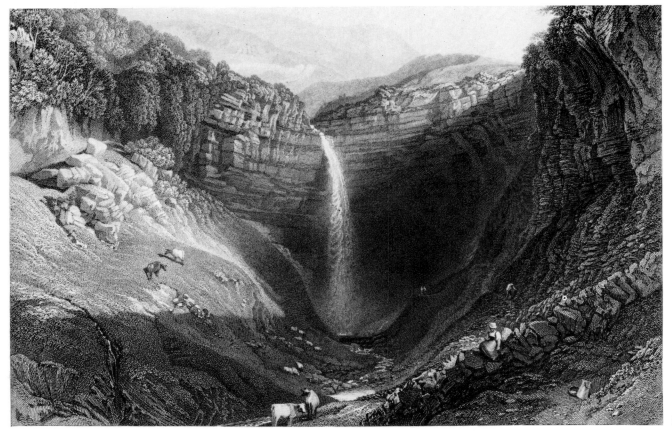

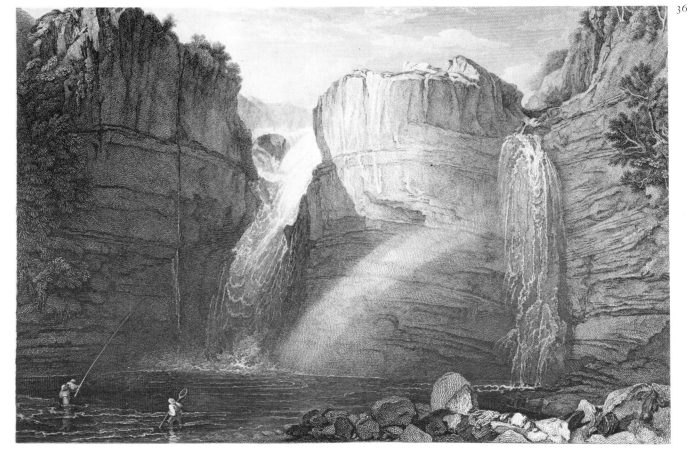

35

36

immediate vicinity of the Ure to the foot of the highest fells; the river diminishes to a beck, and the beck to a sike. The collateral features shrink in proportion, and the traveller finds himself on a level peatmoss, suddenly appalled by a dreadful and perpendicular disruption in the rock, where a stream is heard to murmur at a vast depth beneath. This is Hellgill, the Stygian rivulet of Camden, which forms a striking natural boundry to the counties of York and Westmorland. Yet is this not like some of the Lancashire forests, a mere unfeatured scene of desolation. The junction of the Ure with Mossdale Beck exhibits two waterfalls, one in each stream, seen from the same point, and enclosed within noble boundaries of dell and rock, happily uniting at an oblique angle to the eye.' Turner has taken his drawing of Mossdale Fall from the position described by Whitaker.

'At Hardraw is another waterfall of a character almost peculiar to itself. It is a grand column of water projected from the edge of a rock, so as to detach itself completely from the strata beneath, and to plunge without dispersion or interruption into a black and boiling cauldron below. This singular and happy effect has been produced by two causes: first, the bed of the torrent above is a stratum of rock, broken off at the point from which the projection takes place, so hard that the perpetual attrition of a violently agitated current has made little impression upon its edge. And secondly, the strata beneath are schistus, perpetually decompounding by the action of the air, and widening the interval between the face of the rock and this vast column of liquid crystal, which may easily be surrounded and viewed in its ever varying refractions on every side.'[3] This kind of description, partly lyrical, partly scien-

tific, anticipates the spirit of Ruskin's analyses in *Modern Painters*, where Turner's watercolours themselves are submitted to the same scrutiny, and found to yield the same satisfaction both to the geologist and to the poet. Ruskin seems to have learned some of his characteristic methods from Whitaker: his love of categorising natural phenomena, for instance (whether the old eighteenth-century philosophical categorisation, or a newer scientific type it would perhaps be hard to say), is foreshadowed in this discussion of the *Fall of the Tees*; which 'is one of the finest cataracts in the island, whose roar is audible long before it is perceptible to the eye. Its character is that of the falls of Aysgarth [of which Turner also made a drawing],[1] but the scale is beyond comparison more magnificent, the projection much deeper, the mass of water more entire, and equally precipitous. Cataracts in this country may be divided into two classes, first, the falls of considerable rivers, of which the expanse is necessarily grand, while the depth is seldom very great, because their course has ceased to be very precipitous before they acquire so great a bulk of water. The second consists of mountain torrents of no ample dimensions, but precipitated down the abrupt and often perpendicular chasms of glens and gullies, with a force and to a depth which amply compensates for their narrowness. Of the former kind the falls of Aysgarth and Tees stand perhaps unrivalled in Britain.'[5]

1. Rawlinson prints 1815 in error.
2. Wilton 559–81.
3. T. D. Whitaker, *History of Richmondshire*, vol. I, p. 413.
4. Wilton 570.
5. Whitaker, *op. cit.*, vol. I, p. 142.

37

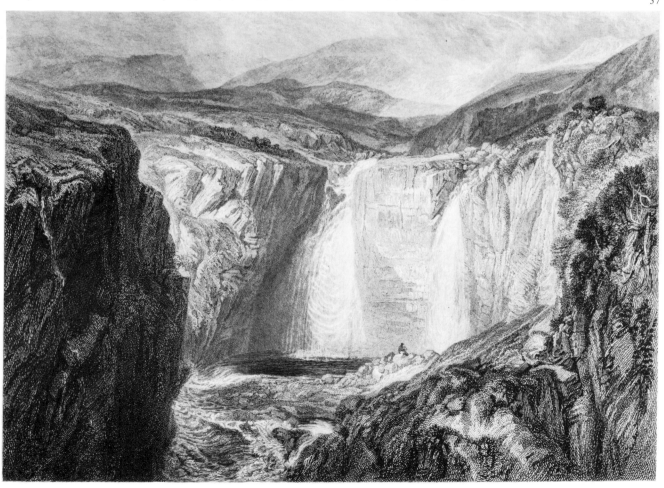

Edward Goodall (1795–1870), after J. M. W. Turner

37 Fall of the Tees, Yorkshire (*England and Wales*) 1827

Engraving, third state (R. 214), subject: $6\frac{7}{16} \times 8\frac{13}{16}$ (163 × 224); plate: $9\frac{11}{16} \times 11\frac{15}{16}$ (246 × 303)
Inscr. below: with names of artist and engraver with title: lower right: *Printed by M^c Queen*; bottom: *Published June 1. 1827, for the Proprietor, by Robert Jennings, Poultry.*
Yale Center for British Art, Paul Mellon Collection, B1977.14.13311

A comparison of this subject with the view of the *Fall of the Tees* made for Whitaker's *Richmondshire* less than a decade earlier (no. 36) indicates the extent to which Turner's conception of the landscape sublime had moved away from sheer physical terror to a more expansive sense of the vastness and variety of natural phenomena. He contemplates mountains and hills in infinite recession rather as Addison ponders the interminable and incalculable occurrence of planet after planet in the universe. In doing so, he gives emphasis to the great spaces between objects – or between objects and the eye, rather than on the magnitude of the objects themselves. As a result, this view of the fall, though less 'stunning', is ultimately grander.

James Tibbitts Willmore (1800–63) after J. M. W. Turner

38 Penmaen Mawr, Caernarvonshire (*England and Wales*) 1832

Engraving, india proof before all letters (R. 276), subject: $6\frac{1}{2} \times 8\frac{15}{16}$ (164 × 228); plate: $10 \times 12\frac{1}{2}$ (255 × 318)
Yale Center for British Art, Paul Mellon Collection, B1977.14.7061

Henry Wigstead, in his *Remarks on a Tour to North and South Wales, in the year 1799*, records: 'From *Conway* to *Caernarvon* is twenty-four miles. The road is at first uninteresting; but, at about four miles, the scenery becomes really terrific. *Penman Ross*, on the right hand, awfully raises its aspiring head, and intercepts the beams of the sun in his highest elevation; while *Penman-maur*, on the left, seems, from its desolated and rocky summit, to threaten the traveller with instant annihilation. The road runs round near the base of the mountain one hundred yards above the sea: the whole height of this terrific and barren elevation is 1545 feet. This road ... is flanked by a stone wall on the side towards the sea. This is about three feet high, over which the water and the distant isle of *Anglesea* are seen. On the other side, the surface of the mountain, which is very steep, is covered with tremendous masses of stone, which seem ready to slide from their slippery base, and overwhelm the passenger in inevitable destruction. – From the almost incessant rain we had experienced for some time before, and the rapidity of the land-springs, which poured down on every side from the very summit, we were very much alarmed in our passage, lest one of these masses should arrest us; particularly as the wall had been driven in several parts down the precipice into the sea by similar accident . . .'[1] It is the vivid experiences of the traveller that Turner makes the focus of his drawing: he recasts the 'terrific' sublime in terms of the human response which makes it terrific.[2] As so often in his scenes of mountain and storm for the *England and Wales* series he binds his composition together with an emphatic diagonal stress.[3] Compare nos 11 and 39.

1. Wigstead, *op. cit.*, London 1800, pp. 26–7.
2. Compare comments on *Faido*, no. 104.
3. The original watercolour is in the British Museum, Lloyd Bequest; Wilton 852; Shanes 61.

W. R. Smith (fl. *c.* 1832–51), after J. M. W. Turner

39 Chain Bridge over the River Tees (*England and Wales*) 1838

Engraving, second state printed on india paper (R. 302), subject: $6\frac{1}{2} \times 9\frac{7}{8}$ (165 × 251); plate: $9\frac{1}{2} \times 12\frac{7}{8}$ (242 × 327)
Inscr. below: with title and names of artist and engraver; lower right: *Printed by M^c Queen*; bottom: *London, Published 1838 for the Proprietor, by Longman & C^o Paternoster Row.*
Yale Center for British Art, Paul Mellon Collection, B1977.14.13415

In his work on the *Picturesque Views in England and Wales* Turner attempted a variety almost as studied as that of the *Liber Studiorum*;[1] but he rarely included a subject as 'mountainous' as this. The sheer vertiginous excitement of this close-up view of a waterfall reverts to the mood and methods of the 'terrific'; but its vigorous rhythms look forward to the great *Faido* of 1843, (*colour 24*). It is worth noting how Turner has unobtrusively pointed up the impassability of the torrent by placing the sportsman on one side of it and his quarry, a nest of grouse, on the other.[2]

1. See Shanes, p. 16, and Wilton 1979, p. 178.
2. The original watercolour is Wilton 878; Shanes 84.

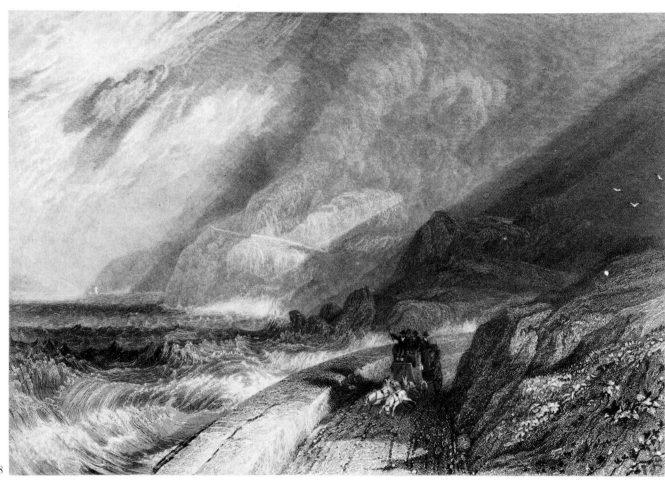

38

39

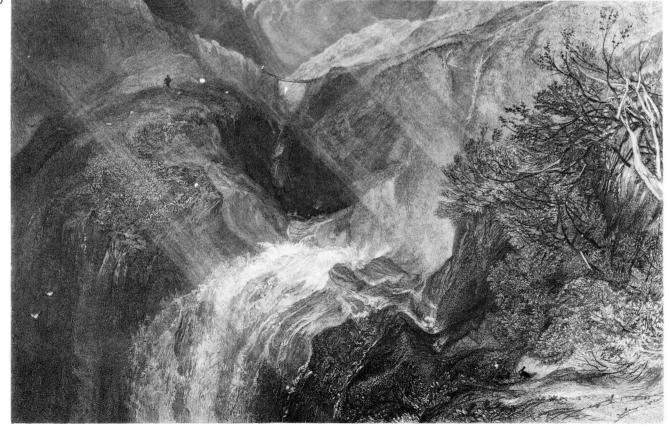

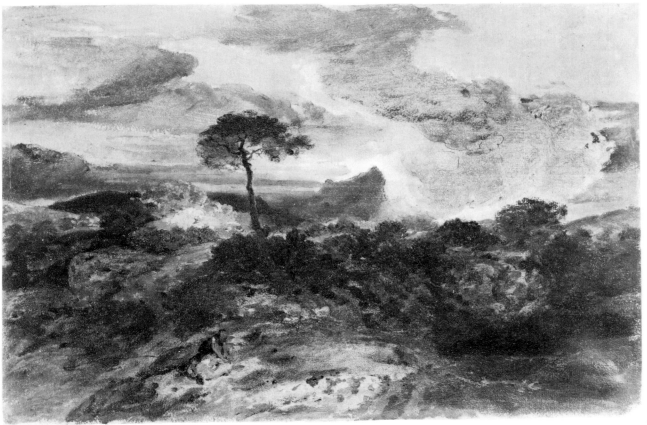

40

42

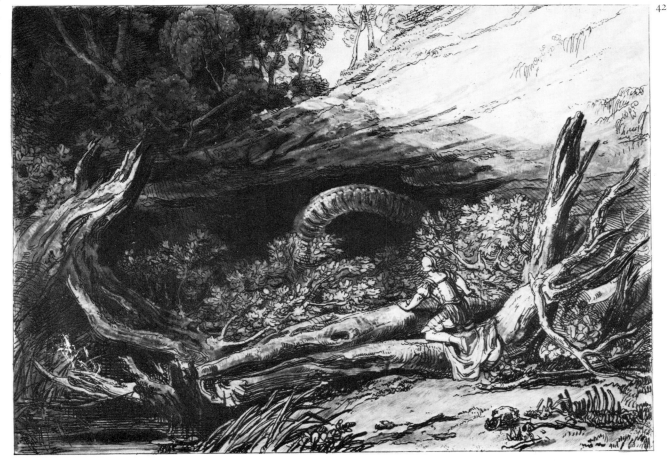

40 A wild Landscape, with Figures, at Sunset

c. 1799–1800

Oil with some pen and ink on paper, $10\frac{1}{4} \times 15\frac{1}{4}$ (261 \times 388)
TB XCV(a)–G, Butlin & Joll 35

Although he made small oil sketches for various purposes at all stages of his career, Turner rarely planned a formal composition for an oil painting, in oil on a sheet of paper like this. The precise nature of the subject here is a little obscure, but there seems to be no doubt that the scene is a contrived one such as Turner would have used for a painting, and not a record of a particular spot. The two figures in the foreground have every appearance of being a group of the Good Samaritan, for one, clothed, tends the other, who lies naked on the ground. This is therefore in all probability one of Turner's first exercises in painting a Biblical subject. It did not result in a finished picture, but some of its ideas may have been used in the untraced picture of *Ben Lomond Mountains, Scotland: The Traveller*, exhibited in 1802. This has been thought to be an oil painting but seems more probably to have been a watercolour.[1]

1. Wilton 346.

41 Scene in the Welsh Mountains with an army on the march *c.* 1800

Watercolour with stopping-out, $27\frac{1}{16} \times 39\frac{1}{4}$ (687 \times 996)
TB LXX–Q
Colour plate 14

This enormous sheet is either an elaborate preliminary study for one of the large watercolours that Turner was exhibiting about 1800, or is actually an unfinished work of that type. The view up a long valley towards snowy peaks anticipates the composition of *The Battle of Fort Rock (colour 15)*, with which it shares a similar theme: an army presses its way through bleakly hostile mountains to carry out its work of murder and devastation. Just as Napoleon's troops were to submit 'fair Italy' to ravage and plunder, so this army is bent on subduing a civilisation by force. Various other drawings in the Turner Bequest inform us that Turner was interested at this date in the story of the Welsh bards who were exterminated by Edward I,[1] and in 1800 he exhibited at the Royal Academy a finished watercolour[2] depicting a bard in his rightful place, singing to a peaceful audience in a sunny landscape. The verses he composed to accompany that work speak more of the 'tyrant' who 'drench'd with blood the land' than of the happier aspects of the subject, and it is possible that Turner intended this to be a companion picture, giving the other side of the story. Such a pairing would have been especially poignant if, as seems to be the case, Turner planned deliberately to omit the figure of a bard from this wild landscape: the resulting contrast between the searching army and the innocent, unprotected singer and his followers would have been vividly reinforced by the different landscape of the two works.[3]

1. e.g. LXX–N.
2. Wilton 263; repr. in colour in RA 1974, p. 17.
3. For further comment on the place of this work in Turner's development, and especially as it relates to *Hannibal*, see Lynn Matteson, 'The Poetics and Politics of Alpine Passage: Turner's Snowstorm: Hannibal and his army crossing the Alps,' *The Art Bulletin*, September 1980.

J. M. W. Turner and Charles Turner, after J. M. W. Turner

42 Jason (*Liber Studiorum*) 1807

Etching and mezzotint, printed in brown ink, first published state (R. 6), subject: $7\frac{1}{4} \times 10\frac{1}{8}$ (184 \times 257); plate: $8\frac{3}{16} \times 11\frac{3}{8}$ (207 \times 289)
Inscr. above: H; below: with title and: *Drawn & Etched by J.M.W. Turner R.A.* and *Engraved by C. Turner.*; bottom: *Published as the Act directs by J.M.W. Turner Harley Street.*
Yale Center for British Art, Paul Mellon Collection, B1977.14.8101

Turner's painting of this subject was shown at the Academy in 1802, with the title *Jason, from Ovid's Metamorphosis*.[1] It is one of his most conscious imitations of Salvator Rosa, though de Loutherbourg's *Jason enchanting the Dragon* may also have been in his mind.[2] The subject belongs to a series of mythological works executed in the first few years of the century, including *The Goddess of discord choosing the apple of contention in the garden of the Hesperides*,[3] exhibited in 1806, and *Apollo and Python*[4] of 1811. All these works seem to treat of the opposition of good and evil; in each case a heroic or idealised state is contrasted with the baseness of corrupt forms of life – dragons and snakes representing the flaw in the created world as the serpent does in *Genesis*. Turner frequently used the snake in his non-historical works to intimate the hostility of nature to man; see for example no. 24.[5]

1. Butlin & Joll 19.
2. Not exhibited at the R.A., but easily accessible in the London collection of Michael Bryan (author of the *Biographical Dictionary of Painters and Engravers*) until it was sold in 1798.
3. Butlin & Joll 57.
4. Butlin & Joll 115; for further comment on *Apollo and Python* see p. 72.
5. For a discussion of these paintings, see Gage, 1969, pp. 137–40.

J. M. W. Turner and Charles Turner, after J. M. W. Turner

43 The Fifth Plague of Egypt (*Liber Studiorum*) 1808

Etching and mezzotint, printed in brown ink, first published state (R. 16), subject: $7\frac{1}{16} \times 10\frac{1}{8}$ (179 \times 257); plate: $8\frac{1}{4} \times 11\frac{3}{8}$ (209 \times 289)
Inscr. above: H; below: *Drawn & Etched by J.M.W. Turner Esq. R.A.P.*; *Engraved by C. Turner* and with title: *The 5ᵗʰ Plague of Egypt the Picture late in the possession of W. Beckford Esq.*; lower left: *Proof*; bottom: *London Published June 10, 1808. by C. Turner Nº 50, Warren Street, Fitzroy Square.*
Yale Center for British Art, Paul Mellon Collection, B1977.14.8118

Although Turner gave his picture[1] the title that appears on his *Liber Studiorum* print when it was originally exhibited at the Academy in 1800, he published in the catalogue a quotation which shows that his subject is really the seventh plague: 'And Moses stretched forth his hands toward heaven, and the Lord sent thunder and hail, and the fire ran along the ground. Exodus, chapter ix verse 23.' This was the first full-scale historical work to come from Turner's brush, and announced him clearly as a major subject-painter, drawing his inspiration from Poussin among the old masters, and from Wilson among the moderns. By subduing the light that falls, in the painting, on the central group of blasted trees, and in other ways modifying the composition, the print gives greater emphasis to the horizontal stress of the landscape – a surprising feature in so dramatic a work. It draws attention to the fact that the dynamic turbulence of the picture is derived almost entirely from the handling of chiaroscuro and the suggestion of atmospheric disturbance that fills the scene with intense but intangible unease.

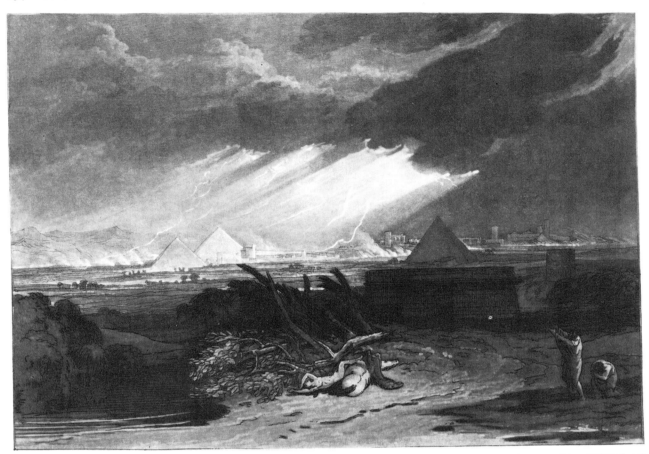

43

44

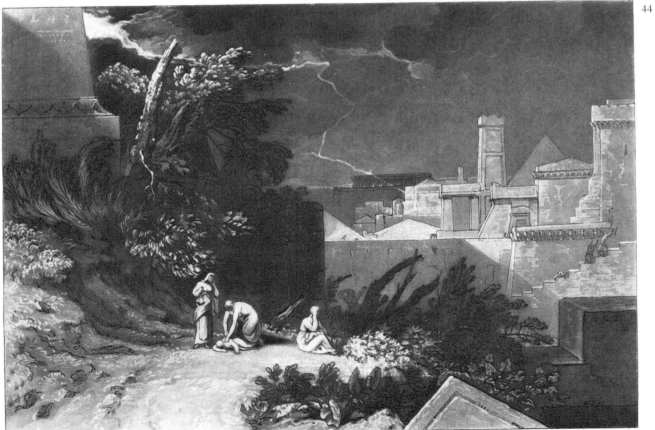

The print, on the other hand, exploits mezzotint to present powerful contrasts of tone across a flat landscape that looks forward to some of the industrial subjects of a later period.[2]

1. Butlin & Joll 13.
2. Ruskin disapprovingly likened the pyramids to 'brick kilns' (*Works*, III, p 240); surely not an inappropriate connotation given the occupation of the Israelites in Egypt – making bricks.

J. M. W. Turner and William Say (1768–1834), after J. M. W. Turner

44 Tenth Plague of Egypt (*Liber Studiorum*) 1816

Etching and mezzotint, printed in reddish-brown ink, first published state (R. 61), subject: $7\frac{1}{8} \times 10\frac{3}{16}$ (179 × 259); plate: $8\frac{3}{16} \times 11\frac{5}{16}$ (208 × 288)
Inscr. above: *H*; below: with title and *Drawn & etched by I.M.W. Turner Esq RA* and *Engraved by W Say Engraver to H R H the Duke of Gloucester*; and *Published Jan 1. 1816 by I M W Turner, Queen Ann Street West.*
Yale Center for British Art, Paul Mellon Collection, B1977.14.8178

The painting from which this subject derives was exhibited at the Royal Academy in 1802.[1] It was therefore completed before Turner's continental journey of that year, but it evidently makes use of ideas gleaned from works by Poussin which he had seen in England – including, perhaps, the *Landscape with Pyramus and Thisbe* in Lord Ashburnham's collection on which he commented in his Perspective Lecture on Landscape.[2] In its bleak grandeur it is one of the most thoroughgoing of all Turner's attempts to reconstruct the language of Poussin, which, as he said (echoing Reynolds), depends on a deep sympathy with ancient art: 'his love for the antique prompted his exertion and that love emanates thro all his works: it clothes his figures rears his Buildings disposes his materials ar-rainges his landscapes and gives a color that removes his works from truth'.[3] The print that Turner published in the *Liber Studiorum* manages to convey much of the gloomy weight of the canvas itself. Rawlinson could say of it: 'In early and fine impressions . . . there seems to me a striking sense of horror and terror, giving it much more impressiveness than the *Fifth Plague of Egypt* . . . you cannot doubt but that the painter has meant you to feel that there is here something beyond any mere physical cause of terror and awe. This, but this alone, prevents its being a melodramatic and wholly inadequate rendering of one of the most sublimely-told tragedies of any literature . . .'

1. Butlin & Joll 17.
2. See p. 70.
3. Add. ms. 46151 1, f. 13.

45

45 Study for a Historical Composition: the Egyptian Host in the Red Sea(?) *c.* 1800

Pen and brown ink and wash with white bodycolour on rough grey paper, $10\frac{13}{16} \times 13\frac{1}{4}$ (275 × 336), irregular
TB CXIX—R

When Turner first launched into History painting proper, he noted down a mass of ideas for subjects, many of which were never used. At first the Bible seems to have been a prime inspiration, though it was later superseded by Homer, Virgil and other sources. The *Fifth* and *Tenth Plagues of Egypt* (see nos 43 and 44) and the *Destruction of Sodom*,[1] together with a possible treatment of the Good Samaritan subject,[2] are all recorded. *The army of the Medes destroyed in the desert by a whirlwind*, illustrating a prophecy of Jeremiah, was shown at the Academy in 1801, though the picture is now lost.[3] This scrap may belong to the same series of ideas. It is, at any rate, a variant on the Deluge theme that Turner found so fascinating (see nos 46–49). Whether the men floundering in the waves here are indeed Pharoah's host is uncertain. Possibly we can read in Turner's hasty pen marks the prows of Roman galleys – some classical sea-fight may be in train. The basic theme, however, is clear: with a few strong washes Turner suggests the depth and power of the sea, and the helplessness of men against it.

1. Butlin & Joll 56.
2. See no. 40.
3. Butlin & Joll 15.

46 Study for 'The Deluge' *c.* 1804

Pen and brown ink with pencil on grey paper, $16\frac{1}{8} \times 23$ (410 × 585)
Verso: another study for the same subject
TB CXX—X

The two sketches on this sheet are characteristic of the elaborate studies Turner made in preparation for the large historical pictures that he exhibited in the first decade of the century. They are concerned principally with the organisation of figures in the picture-space, often with complex groups of interwoven bodies – an aspect of pictorial design that he had not had to tackle previously. *The Deluge* is thought to have been shown at Turner's own gallery in 1805 (see no. 49), and is among the most elaborate of these exercises in the deployment of the human form in the whole of his art. These studies, therefore, are important documents of his response to the central problems posed by the historical sublime; problems that had been solved by Raphael, and resolved by Poussin, but which still dominated the conception of great art, and its execution, throughout Turner's life. In this drawing there are indications of a background of classical architecture like that of the *Tenth Plague of Egypt* (no. 44), but almost all traces of this are suppressed in the final painting, where the other elements of the sketch are also almost entirely reorganised. Another study is in the *Calais Pier* sketchbook.[1]

1. TB LXXXI, 120–121.

46

47 The Deluge *c.* 1815

Pen and brown ink and wash with scraping-out over pencil,
$7\frac{7}{16} \times 10\frac{9}{16}$ (188 × 268)
TB CXVIII–X, Vaughan Bequest

A design for the *Liber Studiorum* which was never published, though
Turner himself worked on a mezzotint plate of it (no. 48). The
subject is scarcely recognisable as an adaptation of the large *Deluge*
picture of about 1805 (see no. 49), but elements such as the
windblown tree and the cliffs at the right, together with the general
surge of water from right to left, are common to both. In this
economical drawing a mood of desolation worthy of Poussin[1] is
evoked by fragmented yet rhythmic lines and sombre washes; the
figures, only schematically suggested, nevertheless embody the
hopelessness of the whole subject.

1. See Turner's comments on Poussin's painting of the Deluge, p. 71.

48 The Deluge (*Liber Studiorum*, unpublished)

c. 1815–20

Mezzotint, printed in dark brown ink (R. 88), impression taken in
the 1870s, subject: $7\frac{15}{16} \times 10\frac{7}{8}$ (201 × 276); plate: $8\frac{13}{16} \times 11\frac{13}{16}$
(224 × 300)
Yale Center for British Art, Paul Mellon Collection, B1977.14.13967

Turner's drawing for this subject (no. 47) only hints at the
grandeur of the mezzotint itself, in which the subject of the
painting (see no. 49) has been further modified and simplified so
that a single powerful statement is made. As Rawlinson observed,
'The "fountains of the great deep" are indeed "broken up", and the
"windows of heaven opened"' (*Genesis*, vi, 11).

J. P. Quilley (fl. 1812–42), after J. M. W. Turner

49 The Deluge 1828

Mezzotint, printed in black ink, proof (R. 794), subject:
$14\frac{15}{16} \times 22\frac{11}{16}$ (380 × 576); plate: $18\frac{1}{16} \times 24\frac{3}{4}$ (459 × 629)
Inscr. below: *To the Right Honorable (the late) Earl of Carysfort,
K.P./This Plate of THE DELUGE, in grateful remembrance/Is most
Respectfully Inscribed by J. M. W. Turner R.A.*; with the names of
painter and engraver, and lower right: *Printed by J. Lahee*; lower
left: *Proof/Picture 4ft 6 by 7ft 10*; bottom centre: *London, Published
June 24, 1828, by Moon, Boys & Graves, Printsellers to the King,
6, Pall Mall.*
Yale Center for British Art, Paul Mellon Collection, B1977.14.8338

Although Rawlinson lists this as the published state of the plate, he
records uncertainty as to whether the print was ever actually
published, but see *Field of Waterloo* (no. 71). The picture itself[1] had
been painted several years earlier, and was probably shown in
Turner's gallery in 1805.
Exhibited again at the RA in 1813, it was accompanied in the
catalogue by these lines from *Paradise Lost*:[2]

Meanwhile the south wind rose, and with black wings
Wide hovering, all the clouds together drove

47

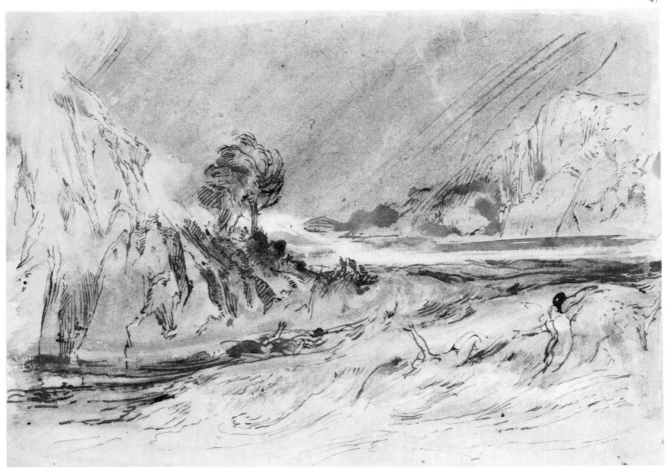

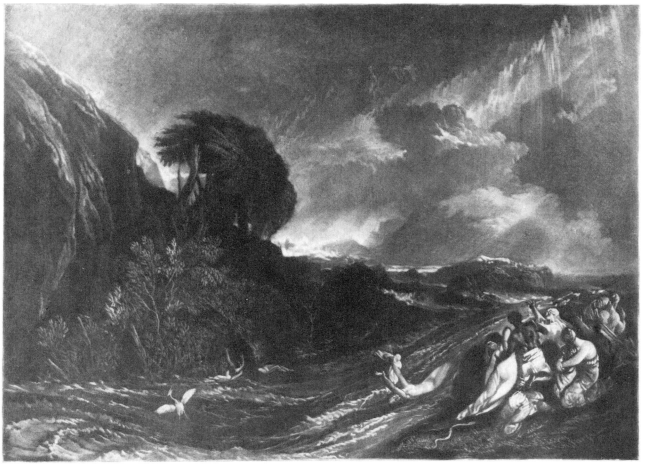

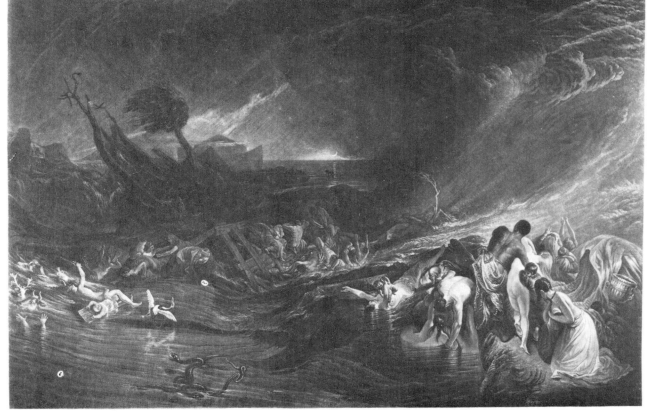

48

49

From under heaven –
– the thicken'd sky
Like a dark ceiling stood, down rush'd the rain
Impetuous, and continual, till the earth
No more was seen.

This is, then, an illustration to Milton, and not to the Bible – an English equivalent of the canvas by Poussin which had so stirred Turner when he saw it in the Louvre in 1802. Another of his early Poussin-inspired canvases, *The Garden of the Hesperides* of 1806[3] was engraved by Quilley at about the same time.[4] It is interesting that he should have wished to exhibit it again in 1813, especially after the showing of his own *Hannibal* in the previous year; but it was in 1812 that John Martin first entered the Academic lists as a painter of the sublime (with his *Sadak in search of the Waters of Oblivion*)[5] and Turner may have felt a need to assert his supremacy in this department. A similar reason may lie behind the production of this print at an even later date: it was in the mid-1820s that an 'apocalyptic' painter rather akin to Martin, Francis Danby (1793–1861), began to show his Biblical subjects at the Academy – *The delivery of Israel out of Egypt* appeared there in 1825; and his *Sunset at Sea after a storm* shown in 1824 may have inspired Turner to work on his 'Little Liber' prints at about the same time (see nos 72, 74, 78). Turner's subject of the *Deluge* foreshadows much of what Danby had to say in the 1820s, and Turner perhaps wanted to remind the public that he had been the first in the field. The print includes much crisply wrought detail that is absent from the original painting, and, again, Turner may have wished to demonstrate that he could invent with the same crisp immediacy as Danby. The free application of paint in the picture itself, however, is more exciting, and anticipates the emancipated handling of the *Fall of an Avalanche in the Grisons* of 1810. Turner was to explore the subject again in his great pair of 1843 *Shade and Darkness – The Evening of the Deluge* and *Light and Colour (Goethe's Theory) – The Morning after the Deluge.*[6]

There is a certain mystery surrounding the dedication of the plate. John James Proby, 1st Baron Carysfort, had died just before it was published, on 7 April 1828. It was therefore quite appropriate that he should be commemorated in this way, and Turner may have had a particular respect for him – he was an outspoken abolitionist and reformist, and his political views would have chimed in with Turner's own, if, as some have done, we interpret the pictures of the *Slavers* (FIG. XVI) and the *Burning of the Houses of Parliament* as liberal political statements.[7] But Turner often dedicated his prints to patrons with whom he was on especially good terms – Sir John Swinburne, for instance, received the dedication of Cousen's plate of *Mercury and Herse*[8] for he was the picture's first owner; and for the same reason B. G. Windus was the dedicatee of Willmore's plate of *Oberwesel*;[9] see also the *Lake of Lucerne* (no. 123). Lord Carysfort did not own a picture of Turner's, but just at the time when Turner was working on the *Deluge*, in about 1804, he entered Lord Carysfort's name in a list of patrons jotted in the *Academies* sketchbook.[10] There, his lordship is down as having commissioned a 'Historical' work – that one word is the only indication of the type of picture concerned, except that a figure of '300' (pounds?) is written beside the name. It is possible that the *Deluge* was intended for Lord Carysfort, but that for some reason it never entered his possession.

1. Butlin & Joll 55.
2. Book XI, ll. 738–40; 742–5.
3. Butlin & Joll 57.
4. R. 793.
5. Repr. Christopher Johnstone, *John Martin*, London 1974, p. 41.
6. Butlin & Joll 404, 405.
7. By e.g. Prof. John McCoubrey in an unpublished lecture on the *Houses of Parliament* paintings; and by Jack Lindsay, *op. cit.*, pp. 189–90.
8. R. 655; Butlin & Joll 114.
9. R. 660; Wilton 1380.
10. TB LXXXIV, 67 verso.

50

50 The Amateur Artist *c.* 1808

Pen and brown ink and wash with some watercolour and scraping-out, $7\frac{1}{4} \times 11\frac{7}{8}$ (185 × 302)

Inscr. recto: Pictures either { *Judgment of Paris*
{ *Forbidden Fruit*
*Old Masters scattered over y*e *floor*
Stolen hints from celebrated Pictures Phials/Crucibles retorts.
label'd bottles . . . [illegible] *varnish quiz*

verso: *Please* [*d*] *with his Work he views it o'er and o'er*
And finds fresh Beauties never seen before
The Tyro mind another feast controuls
. . . [several lines of draft]
The Master loves his art, the Tyro butter'd rolls

TB CXXI–B, RA 1974(121)

This is one of a pair of drawings which Turner probably executed under the influence of David Wilkie (1785–1841) and Hogarth in the first decade of the century. The other subject[1] corresponds to that of a painting exhibited at the Academy in 1809 with the title *The garreteer's petition*;[2] it deals explicitly with the problems of the unsuccessful poet – a character with whom Turner may have identified. His notes on the sketch for it mention Vida's *Art of Poetry* and *Hints on an Epic Poem*, indicating the high-flying ambitions of the garreteer. This drawing seems to make a similar point about a 'tyro' artist, who seeks inspiration in 'Old Masters', using 'Stolen hints from celebrated Pictures'. The lesson is that of Reynolds, but it is misapplied: no amount of self-satisfaction can turn a feeble work into an inspired one. Turner's comment on the nature of inspiration is a wry one, for he was aware that, if a 'master' of painting, he himself was a 'tyro' in poetry.

1. TB CXXI–A.
2. Butlin & Joll 100.

51 The Battle of Fort Rock, Val d'Aouste, Piedmont 1796 1815

Watercolour with scraping-out, $27\frac{3}{8} \times 39\frac{3}{4}$ (695 × 1010)
Inscr. lower left: *I M W Turner 1815*
TB LXXX–G, BM 1975(43), Wilton 399
Colour plate 15

The landscape setting for this subject was recorded by Turner in a monochrome study of 1802;[1] he later produced a large finished watercolour of *Mont Blanc, from Fort Rock, in the Val d'Aosta*, with figures expressive of awe and astonishment in the spirit of the picturesque or terrific sublime.[2] This version followed in 1815, in which year Turner showed it at the Royal Academy with verses composed by himself in the catalogue:

The snow-capt mountain, and huge towers of ice,
Thrust forth their dreary barriers in vain;
Onward the van progressive forc'd its way,
Propelled; as the wild Reuss, by native glaciers fed,
Rolls on impetuous, with ev'ry check gains force
By the constraint uprais'd; till, to its gathering powers
All yielding, down the pass wide devastation pours
Her own destructive course. Thus rapine stalked
Triumphant; and plundering hordes, exulting, strew'd,
Fair Italy, thy plains with woe.

These lines, which Turner stated were taken from his poem *Fallacies of Hope*, are written in a strongly Thomsonian vein; they comprise what is perhaps the most complete statement in the verse that he published of his sense of the destructive force of war. The hostile progress of the invading army is linked by a direct simile

with the devastating onset of the winter floods, as the swollen river pushes its way down the gorge. This is a development of the theme of the *Bard* drawing (*colour 14*) and of *Hannibal and his army crossing the Alps* (FIG. XIII). Man and nature are allied in savagery; and yet nature is also the enemy of man, halting his plans, barring his progress, separating people from people by vast barriers of mountains. And nature is greater than man: beyond the petty, vicious and futile struggles of ambitious men the serene Alps remain immutable; the empty cliffs and crags that occupy the right-hand half of this strangely bisected composition are totally unaffected by the bloody events of the battle. When Turner came back to this scenery in later life, he was concerned not with impermanence and transition, but with the enduring and eternal; men play a different and more sympathetic role. See nos 98 and 100.

1. In the Fitzwilliam Museum; Cormack 10.
2. In a private Scottish collection; Wilton 369. The three versions of the view are reproduced together in Wilton, 1979, pp. 102–3.

Edward Goodall (1795–1870), after J. M. W. Turner

52 The Fall of the Rebel Angels (*Milton's Poetical Works*) 1835

Engraving, proof (R. 599), subject (vignette): $4\frac{1}{2} \times 3\frac{3}{8}$ (115 × 85); plate: $8\frac{1}{2} \times 5\frac{7}{8}$ (215 × 149)
Inscr. below: with names of artist and engraver, and: *Printed by J. Yates*, and: *London, John Macrone, 3, St. James's Square, MDCCCXXXV*
Yale Center for British Art, Paul Mellon Collection, B1977.14.7926

Turner's drawing for this vignette is untraced.[1] The subject is taken from Book VI of *Paradise Lost*, and is one of Turner's very rare essays in the depiction of the Deity. For comment on this see no. 53. Rawlinson records that the engraver's son informed him that 'when his father was engraving this plate, Turner wrote across the upper part of the proof, "put me in innumerable figures here". These the engraver himself had to draw.' The idea that crowds of figures beyond computation conduce to a sublime effect is strongly present in many of Turner's late landscape subjects; here, the intention is directly related to the religious and Miltonic sublime that he illustrates. The swarming figures, as well as the oval shape of the design, recall Baroque ceiling decoration, which Turner was to make use of again in one of the great 'circular' paintings of the 1840s, *Light and Colour . . . The morning after the deluge.*[2]

1. Wilton 1265.
2. Butlin & Joll 405; and see Wilton 1979, p. 216.

Robert Wallis (1794–1878), after J. M. W. Turner

53 Sinai's Thunder (*Campbell's Poetical Works*) 1837

Engraving, India proof (R. 616), subject (vignette): $4\frac{1}{8} \times 2\frac{15}{16}$ (104 × 75); plate: $11\frac{9}{16} \times 6$ (294 × 153)
Inscr. below: *Turner, R. A.* and *Wallis Proof*
Yale Center for British Art, Paul Mellon Collection, B1977.14.7947

Turner indicated on his drawing for this subject[1] the lines from Campbell's *Pleasures of Hope* that are illustrated here: 'Like Sinai's Thunder, pealing from the cloud'. The figure of God appearing to Moses on Mount Sinai is more circumstantially drawn than the faint shadow in a burst of radiance that appears in *The Fall of the Rebel Angels* (no. 52). The convention of religious painters in representing the Deity amid clouds, accompanied by symbols of

52

eternity and the Trinity and sending out thunderbolts, is followed, but it is combined with Turner's more naturalistic (though still elaborately distorted) landscape. The combination of imagery in this illustration foreshadows the pair of paintings of 1843, *The evening of the deluge* and *The morning after the deluge*:[2] the former shows the ark, which appears in the left-hand distance in the Campbell illustration; the latter deals with 'Moses writing the book of Genesis' and depicts him seated in glory rather as God is shown here. That Turner chose to give so detailed an interpretation of the manifestation of God to men in this vignette is perhaps explained by the fact that Campbell's poem deals with a subject

that engrossed Turner's interest: Hope. Campbell, however, lays firm emphasis on the blessings provided by Hope, and not on its 'fallacies'.[3] Another rendering of the Israelites in the desert of Sinai was made for Finden's Bible a few years earlier than the Campbell illustrations.[4]

1. Wilton 1274.
2. Butlin & Joll 404, 405.
3. In particular, he speaks of the comforts of Hope at the approach of death: 'Unfading Hope! when life's last embers burn,/When soul to soul, and dust to dust return', etc.
4. Wilton 1238. The Campbell designs are Wilton 1271–90.

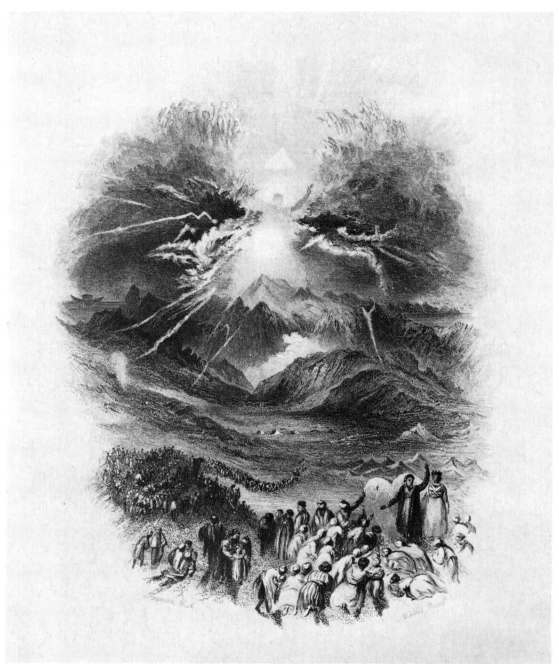

53

Daniel Wilson (fl. *c.* 1840), after J. M. W. Turner

54 Ancient Carthage – the Embarcation of Regulus
1840

Line engraving, india proof (R. 649), subject: $15\frac{7}{16} \times 22\frac{9}{16}$
(392×573); plate: $18\frac{1}{2} \times 26\frac{3}{8}$ (470×670)
Inscr. with names of artist and engraver, and with date
Yale Center for British Art, Paul Mellon Collection, B1977.14.8032

Turner exhibited his painting of this subject in Rome in 1828, and reworked it for showing in London at the British Institution in 1837, when it appeared with the simple title *Regulus*.[1] When this print was published, however, three years later, it had the longer and more explicit title given here. As one of the most powerful of all Turner's attempts to render the physical effect of brilliant sunlight it made a great impression when it was first shown. More recently, the effect has been given justification by reference to Regulus's punishment for failing to betray Rome to the Carthaginians, whose prisoner he was: his eyelids were cut off so that he was blinded by the sun. The whole picture can thus be interpreted as an evocation of the sun's most sublime attribute – its ability actually to deprive us of sight by its own strength. If we identify with Regulus in this way, Kant's definition of the sublime is stretched to its utmost, further even than in *The Wreck of a Transport Ship* (no. 57). No one in Turner's time seems to have read the picture like this – probably because it is a most unorthodox way of handling the relationship between viewer and canvas; so unorthodox indeed that Turner himself may not have intended it. The deliberate statement of the

title published with the print suggests that he had a more traditional programme in mind, and it appears that Regulus, who has been thought to be absent altogether, is depicted in the scene, descending the stairs to a waiting boat in the right middle-distance. Turner summed up the essence of the story in some verses of his own:

> Oh! powerful beings, hail! whose stubborn soul
> Even o'er itself to urge [?even] self-control.
> Thus Regulus, whom every torture did await,
> Denied himself admittance at the gate
> Because a captive to proud Carthage power,
> But his [fierce?] soul would not the Romans lower.
> Not wife or children dear, or self, could hold
> A moment's parley, – love made him bold,
> Love of his country; for not aught beside
> He loved, – but for that love he died.[2]

These lines suggest that Turner's ultimate source is Horace, who tells the story of Regulus in one of his Odes:[3]

> He on the Senate doubting long
> Unwearied press'd his Reasons strong;
> He gain'd at length their joint Consent
> To Counsel giv'n before by none;
> And thro' his weeping Friends he went
> A matchless Exile from the Town.
>
> He knew ev'n then the barb'rous kind
> Of Torture by the Foes design'd
> Yet through his kindred that enclos'd
> He bravely press'd without Delay;

> Remov'd the People that oppos'd,
> And back to Carthage urg'd his way.
>
> To horrid Racks severely great
> He pass'd, as to his Country Seat;
> As when, his Clients causes try'd,
> The *Forum*'s tedious Hurry o'er,
> He sought Venatrum's peaceful side
> Or fair Tarentum's pleasing shore.

Despite the title of the engraving, therefore, the picture must show the moment of Regulus's departure from Rome to certain punishment at Carthage. It exactly parallels another, equally splendid harbour scene of the same period, *Ancient Italy – Ovid banished from Rome*,[4] exhibited at the Academy in 1838. Although the reason for Ovid's banishment is obscure – it was traditionally ascribed to his publication of the *Ars Amatoria* – the parallel with *Regulus* is made plain by the similarity of the treatment, and even a complementary compositional layout. Turner was to explore the parallelism between the fate of artists and the fate of military heroes in his pair of 1841, *Peace – burial at sea* (the burial of David Wilkie) and *War. The exile and the rock limpet*.[5] In both cases, he celebrates the creative genius – the 'powerful being' – who can change the course of civilisation either physically or morally – the Aristotelian hero whose actions are significant for all mankind.

1. Butlin & Joll 294.
2. Thornbury, *Life*, rev. ed., p. 217.
3. Horace, III, od. 5, stanzas 11–14. T. Hare, *A Translation of the Odes and Epodes of Horace into English Verse*, London 1737.
4. Butlin & Joll 375.
5. Butlin & Joll 399, 400.

54

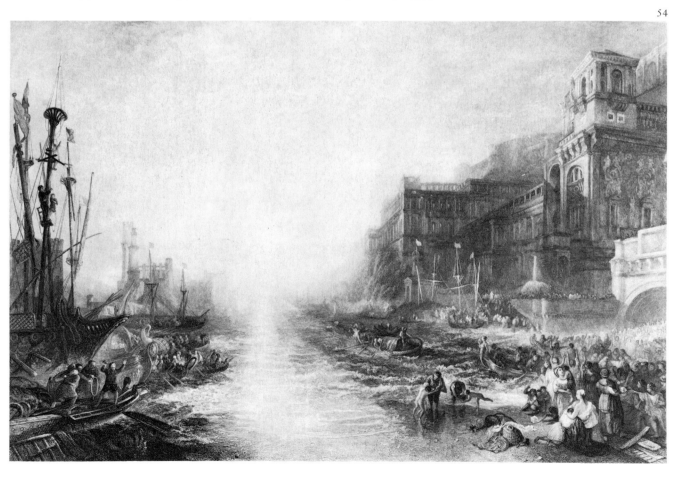

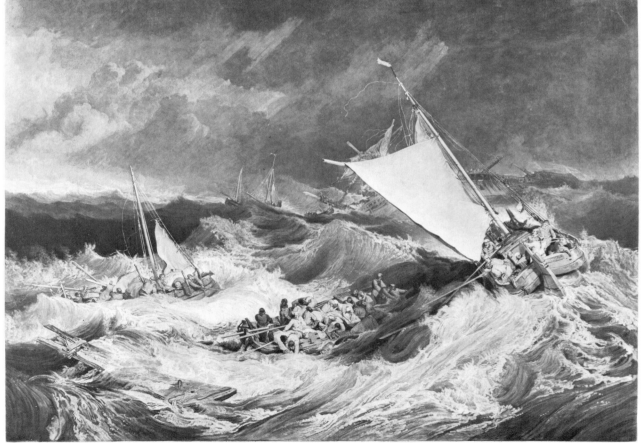

55

56

THE SEA

55 A Storm off Dover c. 1793

Pencil and watercolour, $10\frac{1}{16} \times 14\frac{1}{4}$ (256 × 362)
TB XVI–G, BM1975(2)

Turner's earliest experience of the grandeur and terror of the sea must have been on the coast of Kent, which he visited as a boy, and again in 1792 and 1793. It was a coast that was to attract him all his life, not only for the scenes of toil and danger in the daily lives of fishermen which he repeatedly painted, but for the sunsets to be seen from Margate, the most spectacular in the world, Turner thought.[1] In this early study the picturesque confusion of the weathered timbers of the pier (which he drew in another sketch without the stormy background)[2] seems about to be engulfed by the heaped waves and inky clouds. The ship too appears to be swamped. It is a precocious statement of the overwhelming and disintegrating force of elemental nature both in the context of men's lives and as a power that was to take Turner's art far beyond the niggling 'charm' of picturesqueness: the contrast of the pencil work in the foreground and the broad effects achieved by watercolour wash embodies the change that was to revolutionise his work within the decade.

1. Ruskin, *Works*, XXVII, p. 164.
2. TB XVI–D; other studies of the pier are XVI–E, F.

Charles Turner, after J. M. W. Turner

56 A Shipwreck 1806

Mezzotint, printed in dark brown ink, engraver's proof, touched in pencil by the artist (R. 751), plate: $22\frac{1}{16} \times 32\frac{13}{16}$ (560 × 833)
Inscr. bottom centre: *London Publ. July 1st 1806. by C.Turner Nº 50, Warren Str. Fitzroy Square.*
Yale Center for British Art, Paul Mellon Collection, B1977.14.8254

This print was undertaken by the engraver Charles Turner (no relation of the artist but a colleague of his from student days at the Academy Schools) as his own financial speculation. He advertised it in 1805 and it was completed, as in this impression, by the middle of 1806; but publication was delayed, and the final publication line reads *Jan. 1, 1807*. The appearance of the print marked an epoch in Turner's career. It was the first engraving to be made from one of his paintings,[1] and reflected not merely the interest of the engraver, but the enthusiasm of the general public: numerous influential members of the nobility as well as artists young and old subscribed to the plate.[2] This was also the first time that Turner had been able to see his work translated into mezzotint, and by 1807 Charles Turner was fully involved in the production of the mezzotint plates of the *Liber Studiorum*,[3] a project that was to continue until 1819, though after 1811 the artist replaced Charles Turner by other engravers, and executed more and more of the mezzotint work himself, completing several plates entirely unassisted before the series was discontinued. These experiments led him naturally into the 'Little Liber' prints of the 1820s, as well as to collaboration with Thomas Lupton and others over the *Rivers and Ports of England*.[4] The medium attracted him particularly for its atmospheric expressiveness, its ability to suggest vastness, uncertainty, night, obscurity and so on – all elements of the sublime for which he urgently needed an equivalent in one of the reproductive media. John Martin's adoption of mezzotint for his own visionary ideas must also have stimulated his interest in the method, and two of his most explicitly historical prints were produced by this means in the late 1820s (see nos 49 and 71). Among the many superlative qualities of this early plate, it should be noticed that great care is given to the differentiation of individual figures in the three foreground vessels: this is no generalised evocation of suffering, but a vividly presented and fully documented incident (though it is presumably entirely imaginary). Compare the still more compelling immediacy of no. 57, a painting of about five years later. It has been thought that Turner's 'inspiration' for choosing this subject was the republication in 1804 of William Falconer's poem *The Shipwreck*, which originally appeared in 1762, and enjoyed a considerable reputation as a marine epic of Thomsonian power.

1. Butlin & Joll 54. The picture was exhibited at Turner's gallery in 1805.
2. For an account of the production of the print, see Finberg, *Life*, pp. 118–19.
3. See pp. 69–70.
4. R. 752–68; 778–90; see no. 73.

Thomas Oldham Barlow (1824–89), after J. M. W. Turner

57 The Wreck of a Transport Ship c. 1856

Mezzotint, printed in brownish-black ink, on india paper, published state (R. 811), subject: $23\frac{1}{8} \times 32\frac{5}{16}$ (587 × 821);
plate: $26\frac{15}{16} \times 34\frac{7}{16}$ (684 × 875)
Inscr. below: with the arms of the Earl of Yarborough (the owner of the picture), and *Artist's copy from the plate presented by the Right Hon.ble the Earl of Yarborough to the Artists General Benevolent Institution*; and signed by the engraver, lower right.
Yale Center for British Art, Paul Mellon Collection, B1977.14.8364

This is one of two large plates mezzotinted by Barlow after subjects by Turner; the other is *The Vintage at Macon*, from the painting of 1803;[1] impressions are dated 1856, which may be the approximate date of this print as well. *Macon* was also a picture in Lord Yarborough's collection. This subject of a shipwreck[2] was exhibited in 1851 with the title *The Wreck of Minotaur*, by which name it has frequently been known, though it was shown in London in 1849 as *The Wreck of a Transport Ship*. Since the date of execution of the picture is uncertain, it is difficult to refer it to any specific historical event, but current opinion tends to doubt the accuracy of the association with the sinking of the Minotaur. This took place, as the 1851 catalogue states, on '22nd December 1810', and since Turner appears to have used sketches made before that year it seems unlikely that there can be a connection between the picture and the event. But the painting itself was probably not executed until about 1810, and although Turner's conception is largely imaginary, there is no reason why he should not have wanted to give his subject greater point and immediacy by identifying it with a specific wreck. This would be wholly in keeping with the overwhelming immediacy and conviction of the whole work. It is also characteristic of Turner to make such direct associations between his pictures and real occurrences, even if he sometimes suppressed the factual information when giving his works titles. The matter is of no great importance, but the mere fact that this powerfully documentary work should have attracted a title (whether given it by Turner or not) as precise as 'The Wreck of Minotaur, Seventy-four, on the Haak Sands, 22nd December 1810' is itself a tribute to the success of the piece as sheer realism.

1. Butlin & Joll 47.
2. Butlin & Joll 210.

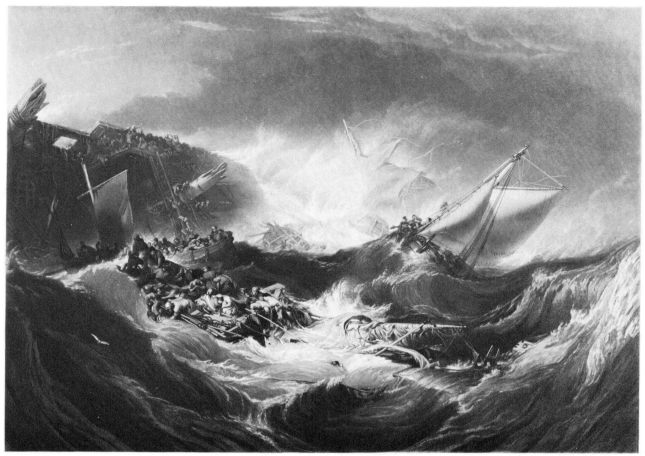

57

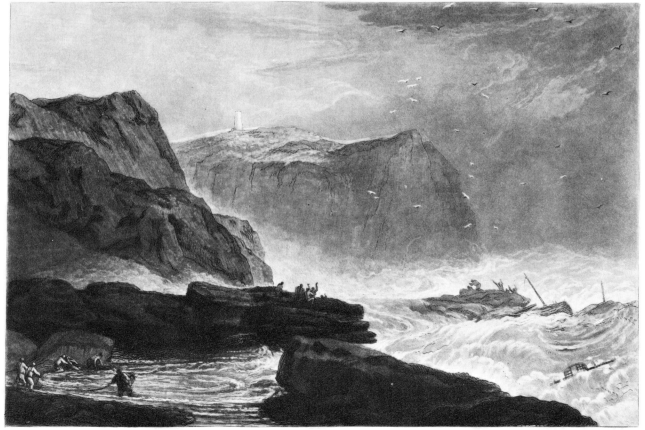

58

59

J. M. W. Turner and William Say (1768–1834),
after J. M. W. Turner

58 Coast of Yorkshire near Whitby (*Liber Studiorum*)
1811

Etching and mezzotint, printed in brown ink, first published state
(R. 24), subject: $7\frac{1}{16} \times 10\frac{5}{16}$ (180 × 262); plate: $8\frac{3}{16} \times 11\frac{3}{8}$
(208 × 290)
Inscr. above: *M*; below: *Drawn & Etched by J. M. W. Turner. R.A.*
and *Engraved by W Say Engraver to H.R.H. the Duke of Gloucester.*; and
with title, and *Published Jan! 1 1811, by M? Turner, Queen Ann Street
West*
Yale Center for British Art, Paul Mellon Collection, B1977.14.8130

A graphic early account of the violence with which sea meets land,
and of the dangers men face on rocky coasts. Compare later
treatments of the theme such as nos 62–65. The drawing for this
subject is in the Turner Bequest.[1]

1. TB CXVII–B

59 Study for the Loss of a Man o' War *c.* 1818

Watercolour, $12\frac{3}{16} \times 18\frac{1}{8}$ (310 × 460), watermark 1816
Inscr. lower left: *Begun for Dear Fawkes of (? or at) Farnley*
TB CXCVI–N, RA 1974(187)

The finished watercolour for which this is a study is in an English
private collection.[1] It shows many figures clinging to the ship's
sharply canted deck, which occupies the whole picture space. As an
essay in portraying the horror of a sea storm it is one of Turner's

most interesting experiments, for it concentrates on the plight of
the ship's crew almost to the exclusion of the sea itself. In another
marine subject of the same year, the *First-Rate taking in stores*,[2]
Turner is known to have attempted 'a drawing of the ordinary
dimensions that will give some idea of the size of a man of war'.
There, he contrasts the huge warship with the smaller shipping
around it, from a viewpoint low down in a small boat alongside.
Here, he seems to tackle the same theme, but quite differently: the
ship's size is appreciable from the minuteness of the figures on its
deck, and the proportion of it in relation to the whole sheet – but
despite its bulk the vessel is overwhelmed by the fury of the sea:
a vivid statement of a familiar sublime topic, influenced perhaps
by some famous painting of wrecks, like Northcote's *Loss of the
Halsewell*,[3] showing the sufferings of men and women crowded
onto a ship's deck which occupies most of the canvas.

1. Wilton 500.
2. Wilton 499.
3. Exhibited at the RA, 1786(240).

60 Storm over a rocky Coast *c.* 1815–20

Watercolour with some pencil, $14\frac{9}{16} \times 21\frac{9}{16}$ (370 × 547)
Inscr. lower right: *Stranded Vessel (?); Willow Paper*
TB CCLXIII–32, BM 1975(52)

The note of a *Stranded Vessel* on this sheet may refer to a particular
sight witnessed by Turner, but is perhaps a memorandum of an
idea for inclusion in a finished watercolour for which this sheet is a
preliminary study. Another sheet in the Turner Bequest, similarly

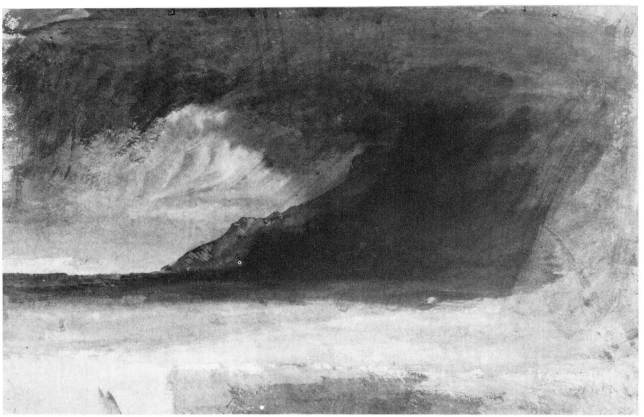

60

61

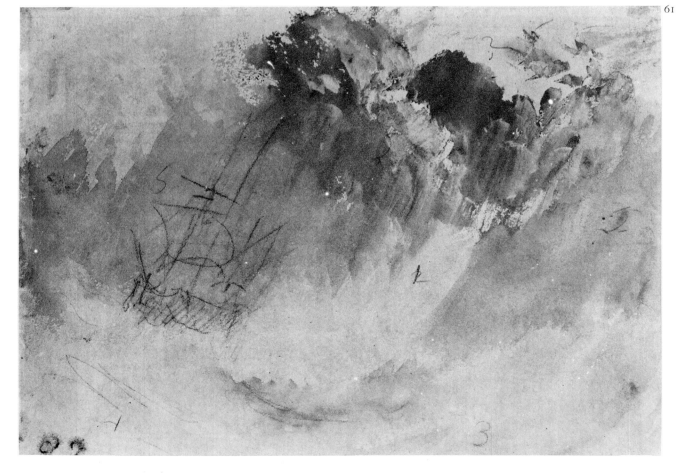

inscribed *Willow Paper* (he was evidently experimenting with a new surface) is annotated *Durham* so it is likely that both are the products of a tour in the north of England in the 1810s.

61 Ship in a Storm *c.* 1825

Pencil and watercolour, 8½ × 11⅜ (216 × 290)
Inscr.: in various parts of the sheet: *1, 2, 3, 4, 5*
TB CCLXIII–309(a), Wilton 772

Although he made elaborate pen and wash drawings for the *Liber Studiorum* plates that were to be mezzotinted by other artists, and even for those, like the *Stonehenge*, that he alone worked on, Turner adopted a different procedure when he was creating the series of 'sequels' to the *Liber*, in which the potential of mezzotint for rich effects of chiaroscuro is exploited more fully and dramatically than ever. For these subjects the merest hint was sometimes enough to provide a guide so that Turner could work directly onto the mezzotint plate. Here, for example, the two elements of the subject, ship and stormy sea, are indicated briefly in opposing media – pencil and watercolour – with a minimum of detail. This is an interesting development from the presentation of Dover pier in no. 55, which makes use of a similar opposition of techniques to

suggest the antagonism of man and the sea. The numerals scattered about the design are difficult to interpret, though they may indicate the principal tonal blocks into which the design divides itself. If they do, it is not clear what purpose they served, though we know that at this period – the early and mid-1820s – Turner was perfecting his method of watercolour composition by constructing his subjects from broad segments or patches of colour, over which specific detail was added. The loose washes of this sketch create a vivid sense of the fury of the sea, anticipating the motif and even the technique of the *Snow storm: steam boat off a harbour's mouth* of 1842. In the 'Little Liber' mezzotint[1] the tonality is darker and the mood one of greater horror.

1. R. 803.

W. R. Smith, after J. M. W. Turner

62 The Entrance to Fowey Harbour, Cornwall (*England and Wales*) 1829

Engraving, printed on india paper, first published state (R. 225), subject: 6⁷⁄₁₆ × 9¹⁄₁₆ (163 × 230); plate: 10³⁄₁₆ × 12½ (258 × 318)
Yale Center for British Art, Paul Mellon Collection, B1977.14.6919

62

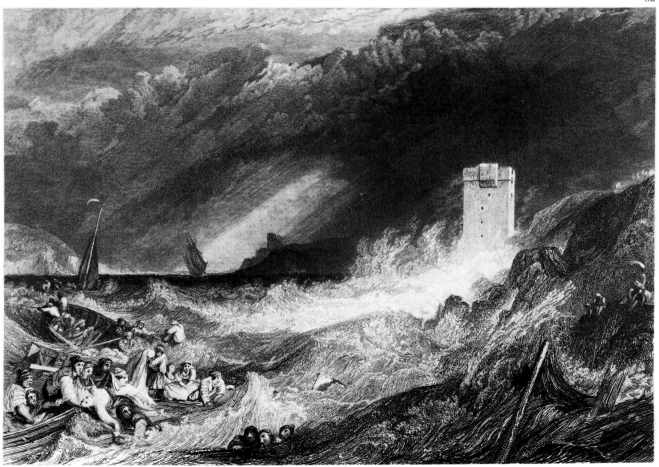

63

W. R. Smith, after J. M. W. Turner

63 Long-ships Light House, Lands End (*England and Wales*) 1836

Engraving, printed on india paper, first published state (names of artist and engraver only, partially erased), (R. 288), subject: $6\frac{7}{16} \times 9\frac{15}{16}$ (164 × 252); plate: 10 × $12\frac{15}{16}$ (253 × 328)
Yale Center for British Art, Paul Mellon Collection, B1977.14.7090

Thomas Jeavons (1816–67), after J. M. W. Turner

64 Lyme Regis, Dorset (*England and Wales*) 1836

Engraving, printed on india paper, first published state (R. 290), subject: $6\frac{1}{2} \times 10\frac{1}{16}$ (165 × 256); plate: $9\frac{7}{8} \times 12\frac{5}{8}$ (250 × 320)
Yale Center for British Art, Paul Mellon Collection, B1977.14.7094

W. R. Smith, after J. M. W. Turner

65 Lowestoffe, Suffolk (*England and Wales*) 1837

Engraving, third state (R. 293), subject: $6\frac{5}{16} \times 9\frac{3}{4}$ (160 × 248); plate: $9\frac{7}{8} \times 13$ (250 × 330)
Yale Center for British Art, Paul Mellon Collection, B1977.14.13442

All four of these plates from the *Picturesque Views in England and Wales*[1] are, like others in the series, concerned with the re-lationship of the sea to the land, and in particular with those aspects of that relationship which make life in such places hazardous to men. They vary in the degree of explicitness with which this theme is treated. The *Long-ships Light House* makes an indirect statement, using fragments of wreckage to present the effects of the destructive fury of the sea, which is so vividly shown in the subject;[2] while the *Lowestoffe* and *Lyme Regis* depict various aspects of the toil associated with a seafaring or coastal life. The latter was published with the mistaken title of 'Lyme Regis Norfolk', perhaps confusing the Dorset port with Yarmouth, the setting for some of Turner's grandest scenes of wreck and salvage (see no. 67). The most graphic of all these accounts, however, is the *Fowey Harbour*, which presents the horrors of the sea with brutal realism. This design is based on that showing the same view in the *Picturesque Views on the Southern Coast of England*, engraved by W. B. Cooke in 1820,[3] which also shows stormy weather, but does not suggest danger and death. Here these elements of the subject are given prominence, and the spectator witnesses a human tragedy as ferocious, in its less sensational way, as the wreck of the transport ship (no. 57).

1. The original drawings are Wilton 801, 864, 866, 869; Shanes 63, 73, 74, 76.
2. It seems to derive from the composition of *Ilfracombe* for the *Picturesque Views on the Southern Coast of England* (Wilton 462).
3. Wilton 466.

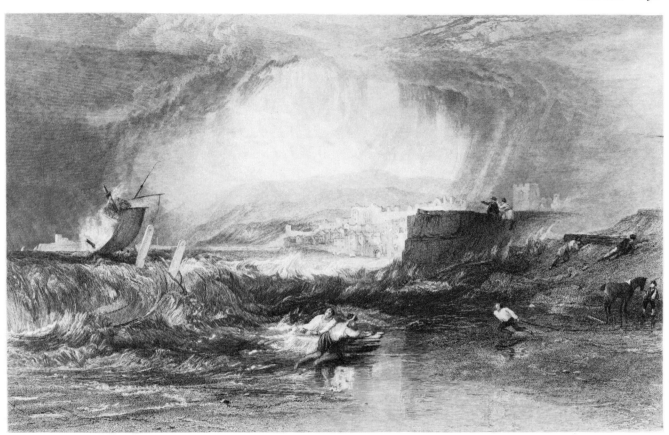

64△ ▽65

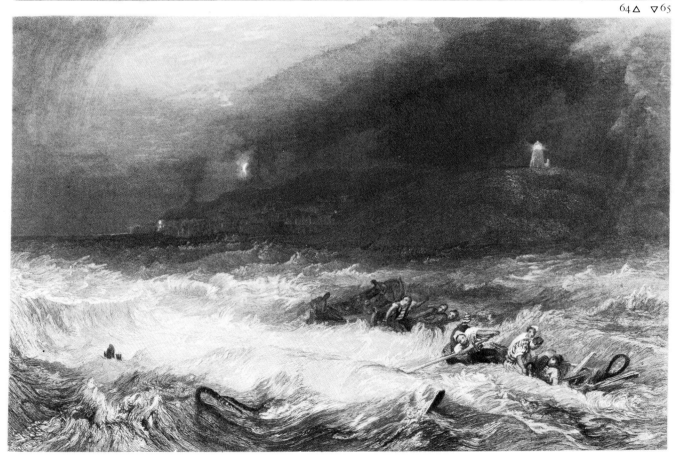

66 Stormy Sea *c.* 1830–35

Watercolour, $14\frac{3}{4} \times 21\frac{3}{4}$ (375 × 554)
TB CCCLXV–36

Colour studies like this one are difficult to place in Turner's output: were they, like many colour-beginnings, preliminary sketches for finished works, or have they a more independent existence as essays, experiments in portraying particular effects? If they belong to the former category, we must suppose that Turner saw them as only partial statements, which his eye filled out with the abundant detail and complex significance of a fully realised subject. If they are of the latter type, it is likely that they belong to a late period in his career — certainly after 1830 and perhaps after 1840. The washes of colour would then indicate, not the foundation on which a particular effect was to be built up, but a solution to the problem of conveying an effect — and not a unique or even a successful solution: late studies of this kind almost always exist in series, in which Turner returns again and again, rapidly, to one idea, without necessarily having a finished work in mind. Characteristics of both types of study may be present in this sheet, which does not, it seems, belong to a long series of similar sketches, but does not, either, relate to a finished watercolour. Stylistically it appears to be a study for the *England and Wales* series, and there are parallels between the treatment of the waves here and that in finished subjects like *Lowestoffe* (no. 65) or *Lyme Regis* (no. 64).

67 Yarmouth Sands (?)*c.* 1840

Watercolour with scraping-out, $9\frac{3}{4} \times 14\frac{1}{4}$ (248 × 362)
Yale Center for British Art, Paul Mellon Collection, B1975.4.1417,
Wilton 1406

One of a series of scenes on the shore, or just out at sea off Yarmouth, which Turner perhaps made about 1840,[1] and which relate to the subject-matter of his painting *Rockets and blue lights (close at hand) to warn steam-boats of shoal water*,[2] exhibited at the Academy in that year. Turner had been interested in the seashore at Yarmouth earlier than this, however: his *Life-boat and Manby apparatus going off to a stranded vessel making signals (blue lights) of distress*[3] is also set at Yarmouth, and was exhibited in 1831. The great freedom with which these watercolour studies are executed argues in favour of the later date. They precede by only a few years Dickens's famous description of the wreck of Steerforth's ship off Yarmouth in *David Copperfield*.[4]

1. Wilton 1405–10. Another drawing from the series is in the Tate Gallery, no. 5239.
2. Butlin & Joll 387.
3. Butlin & Joll 336.
4. Chapter 55. The novel first appeared in 1850.

68 Lost to all Hope . . . *c.* 1845–50

Pencil and watercolour, $8\frac{5}{8} \times 12\frac{3}{4}$ (220 × 324)
Inscr. at bottom: *Lost to all Hope she lies/each sea breaks over a derelict*[?]*/on an unknown shore the sea folk*[?]*/only sharing* [?] *the triumph*
Yale Center for British Art, Paul Mellon Collection, B1977.14.5378,
Wilton 1425

One of a group of bleak late watercolour studies to which Turner has appended tentative drafts of verses. Another sheet seems to have further lines from the same poem: *And Dolphins*[?] *play around the wreck*[?] *The man's hope holding all that hoped/Admits the work* [?*mark*] *of the almighty's hand failing*[?] *hope for sail.*[1] That drawing is also inscribed *Wreck on the Goodwin Sands*, and we may suppose that Turner made these studies at Margate, from which the Goodwin Sands are visible, on one of his visits there in the last years of his life. Some of the late oil studies of breakers and wrecks near the coast appear to be concerned with the same theme.[2] These rough sketches — for most of them are little more — give expression to a private mood of lonely despair, the introspective depression of old age, and are an extension of some of the themes that run through much of Turner's marine painting. But their message is not one that comes to the surface in his public utterances — the finished paintings and drawings. Broad moral points are made in his exhibited works, as, for instance, in *The Sun of Venice going to sea*,[3] which have been interpreted as personal reflections by Turner on his own condition.[4] But their mood is always very different from that of these studies. It is usually buoyant, if not exultant, at least as far as visual qualities are concerned, and pessimism is only apparent in the verses appended to them in the catalogues; just as these watercolour sketches derive most of their poignancy from the inscriptions. Is this the opposition of the painter, the confident master of his medium, to the anxious 'tyro' poet? (See no. 50.)[5]

1. Wilton 1426.
2. E.g. Butlin & Joll 459.
3. Butlin & Joll 402.
4. E.g. by Louis Hawes, 'Turner's Fighting Temeraire', *Art Quarterly*, Vol. XXXV, 1972, pp. 22–48.
5. And see Wilton, 1979, pp. 14–15.

69 The Whale *c.* 1845

Pencil and watercolour, $9\frac{5}{16} \times 13\frac{3}{16}$ (237 × 335)
Inscr. lower left: *I shall use this*
TB CCCLVII–6
Colour plate 16

This is a sheet from Turner's *Ambleteuse and Wimereux* sketchbook, used on his final visit to the continent in 1845. It is supposed that he saw the whale while crossing the Channel, but if so it is surprising that he did not make a more precise study of the creature's appearance. There is an atmosphere of fantasy about this sketch, in which the whale seems to materialise out of the waves as if conjured up by an effort of Turner's imagination. If he had been reading Beale's *Natural History of the Sperm Whale* and other works on whaling, as we know he did at this time, he may well have invented this subject rather than having relied on direct experience for it. The oil paintings that he produced in 1845 and 1846[1] are certainly works of the imagination, and Turner's titles refer specifically to Beale's book. It is of particular interest in this context that Turner should have taken up one of the archetypal motifs of the sublime — the vast, strange and elusive monster of the deep, Leviathan — as a final theme in his life-long exploration of the sea as a subject for his art.

1. Butlin & Joll 414, 415, 423, 426.

68

70

J. M. W. Turner and George Clint (1770–1859),
after J. M. W. Turner

70 Peat Bog, Scotland (*Liber Studiorum*) 1812

Etching and mezzotint, printed in brown ink, fifth state (R. 45),
subject: $7\frac{1}{16} \times 10\frac{1}{4}$ (180 × 260); plate: $8\frac{1}{4} \times 11\frac{1}{2}$ (210 × 292)
Inscr. above: *M*; below: with title and names of artist and engraver;
bottom: *Published April 23, 1812, by J.M.W. Turner, Queen Ann
Street West.*
Yale Center for British Art, Paul Mellon Collection, B1977.14.13996

This plate is recorded by Rawlinson as having deteriorated in later
stages, but this impression of the fifth state is of great richness and
strength, fully conveying the power of Turner's design, which
Ruskin referred to as 'the darkest' of his views of Scotland. He goes
on to suggest that it was the rugged scenery of Scotland that taught
Turner 'to despise the affections of Italian landscape and the
comforts of Dutch'.[1] More plausibly, perhaps, it was the Pictur-
esque that Turner finally abandoned as a consequence of his Scottish
tour of 1801. This subject is similar to some of his north country
scenes of the picturesque sublime – *Buttermere Lake* (FIG. VII), for
instance – but its mood is heightened, its drama more intense, and
there is no longer any wish on the artist's part to charm his
audience with the polite formalities of picture-making.

1. Ruskin, *Works*, XXI, p. 219.

Frederick Christian Lewis (1779–1856),
after J. M. W. Turner

71 Field of Waterloo 1830

Mezzotint, printed in black ink, second published state (R. 795),
subject: $13\frac{15}{16} \times 23$ (354 × 584); plate: $18\frac{1}{8} \times 25\frac{1}{2}$ (464 × 647)
Inscr. below: with title and: "- - - - - *heapd and pent / Rider and horse in one
red burial blent*"/*Byron's Childe Harold*; and with the names of painter
and engraver; lower right: *Proof*; bottom centre: *London, Published
May 1830, by J.M.W. Turner, R.A. 47, Queen Ann Street, West.*
Yale Center for British Art, Paul Mellon Collection, B1977.14.8339

Rawlinson doubted whether this, like the plate of the *Deluge* (no.
49), was ever actually published; but an earlier state with publi-
cation line and the date, July 1st 1829, is recorded, which suggests
that the print was issued. The lines from Byron that appear on the
plate are condensed from the verses that Turner quoted in the RA
exhibition catalogue when the painting[1] was shown there in 1818:

Last noon behold them full of lusty life;
Last eve in Beauty's circle proudly gay;
The midnight brought the signal – sound of strife;
The morn the marshalling of arms – the day,
Battle's magnificently stern array!
The thunder clouds close o'er it, which when rent
The earth is covered thick with other clay
Which her own clay shall cover, heaped and pent,
Rider and horse – friend, foe, in one red burial blent!

71

The subject, issued in a format similar to that of the *Deluge* of a year before, might be seen as a companion to that work – a modern historical piece in which Turner exploits even more dramatically the theme of darkness and firelight. Although it was painted several years before Danby's *Delivery of Israel out of Egypt* (1825), this work again seems to presage it, especially in the column of light in the air, which resembles Danby's pillar of fire. Turner made a watercolour showing the carnage at Waterloo at about the time he was working on the painting;[2] and he was to return to the subject for illustrations to Scott and Byron in the 1830s. None of these exploits the effect of darkness that is so unexpected a feature of this work. Night has overtaken the dead; time passes, the battle is lost and won, yet they remain impotent to affect the course of history or even their own existence any longer: 'Roll'd round in earth's diurnal course, With rocks, and stones, and trees';[4] these are ideas powerfully conveyed by the lighting which also lends the whole subject an apocalyptic quality entirely appropriate to its mood of hopeless loss and emptiness. It is thus also an entirely apt counterpart to the *Deluge* picture with which Turner seems to be comparing it.

1. Butlin & Joll 138.
2. Wilton 494.
3. Wilton 1097, 1116, 1229.
4. Wordsworth, *Lucy*, v, ll. 7, 8.

72 Stonehenge at daybreak (*Liber Studiorum, unpublished*) *c.* 1820

Mezzotint, printed in brown ink, late 19th-century impression from Turner's unfinished plate (R. 81), subject: $7\frac{5}{8} \times 10\frac{3}{8}$ (193 × 263); plate: $8\frac{3}{4} \times 11\frac{3}{8}$ (222 × 288)
Yale Center for British Art, Paul Mellon Collection, B1977.14.13969

Although associated by Rawlinson with the *Liber Studiorum*, this plate, entirely worked by Turner himself, belongs to a group of prints which lie between the *Liber* itself and the 'sequels' that he apparently made about 1825 (see no. 74).[1] In subject-matter and mood it is considerably closer to the works of the later series, and the drawing on which it is based[2] also seems to have moved technically towards the loose washes of those used in that project. The distinctive penwork of the *Liber Studiorum* drawings, which Turner translated into etched outline in the plates, has vanished, and the whole subject is expressed in tones of sepia ink – the equivalent of the mezzotint work of the print. Stonehenge was of course a monument of antiquity whose mystery and great age rendered it sublime (see also no. 79).

1. This group of plates in pure mezzotint by Turner himself are R. 81, 82, 84, 85, 86, 87, and 88.
2. In the Museum of Fine Arts, Boston, gift of Ellen T. Bullard, 59.795. It was formerly in the collection of J. E. Taylor and measures $7\frac{5}{8} \times 10\frac{9}{16}$ (194 × 268).

Charles Turner, after J. M. W. Turner

73 Shields, on the River Tyne (*Rivers of England*) 1823

Mezzotint, printed in black ink, second state (R. 752), subject: $6\frac{1}{8} \times 8\frac{5}{8}$ (156 × 219); plate: $7\frac{11}{16} \times 10\frac{1}{4}$ (195 × 260)
Inscr. below: with title and names of artist and engraver; bottom: *Rivers of England. Plate 1. Published June 2.d 1823. by W. B. Cooke 9. Soho Square.*
Yale Center for British Art, Paul Mellon Collection, B1977.14.8257

The *Rivers of England* series on which Turner worked in the early 1820s was conceived as a series of small-scale views with a remarkably wide range of landscape types and emotional moods.[1]

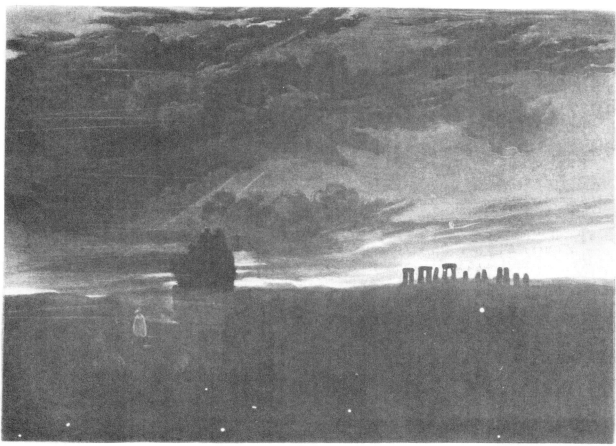

72

73

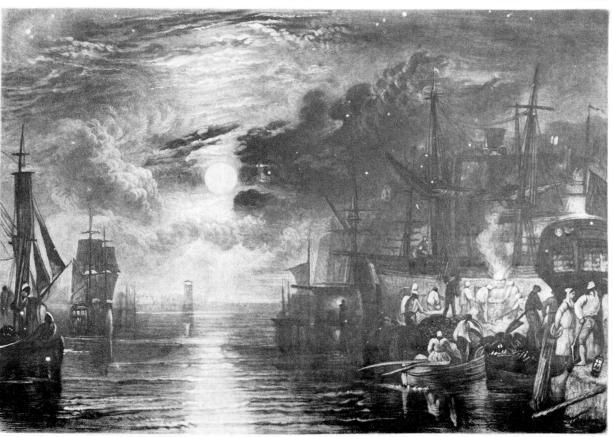

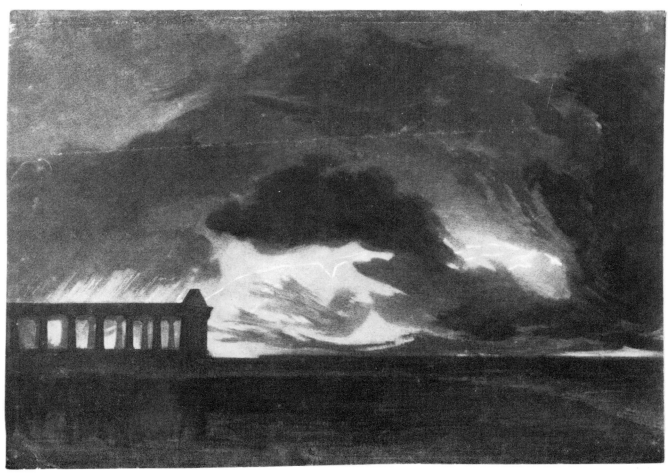

74

While some of the subjects are gently pastoral, there are also hilly panoramas, squally marines, and impressive cityscapes. One subject is actually taken directly from a large watercolour of Turner's early sublime period – a brooding view of Warkworth Castle.[2] This scene on the Tyne is the only night-piece, and it anticipates the beautiful nocturnes of the 'Little Liber' executed, probably, only a year or two later (see nos 74–8). It also provided the basis for an oil painting of 1835, *Keelmen heaving in coals by night*,[3] in which the 'industrial sublime' is elevated into a statement as serenely beautiful as a Claude.

1. The watercolour designs for the series are TB XCVI (Wilton, nos 732–48).
2. Wilton 256.
3. Butlin & Joll 360.

74 Paestum ('Little Liber') *c.* 1825

Mezzotint, printed in black ink, early trial proof, trimmed to the
edge of the subject (R. 799), 6 × 8½ (152 × 216)
Yale Center for British Art, Paul Mellon Collection, B1977.14.8348

This and nos 75–8 are plates from the series of twelve mezzotints scraped by Turner himself at some point after the conclusion of the

Liber Studiorum in 1819. A date around 1825 is considered likely; they cannot date from before the 1820s for stylistic reasons and because some are on steel plates, not introduced until about 1820. There seem to be connections between these designs and some of those for the *Rivers* and *Ports of England* on which Turner was engaged between about 1823 and 1828 (see no. 73). Although they form a distinct group, they were not published and their purpose remains obscure. Rawlinson attempted to prove that they were 'originally intended as studies of moonlight under various conditions' but abandoned this idea.[1] They are all linked, however, by a common preoccupation with exploiting the dramatic possibilities of mezzotint; hence their concentration on night scenes and scenes of strongly contrasted tones. Their importance in Turner's development as a colourist in the 1820s seems to be significant, though it has not been precisely defined.[2] The design of this subject is sketched in a sheet in the Turner Bequest (no. 75). Later impressions of the plate show a second temple to the right of the one visible in this proof, and a buffalo skeleton in the foreground. Compare the motif with that of the dead shepherd with his flock in the *Stonehenge* of the *England and Wales* series (no. 79).

1. Rawlinson, *Engravings*, Vol. I, pp. xliv, 385.
2. See White, 1977, p. 79, and Wilton, 1979, pp. 168–70.

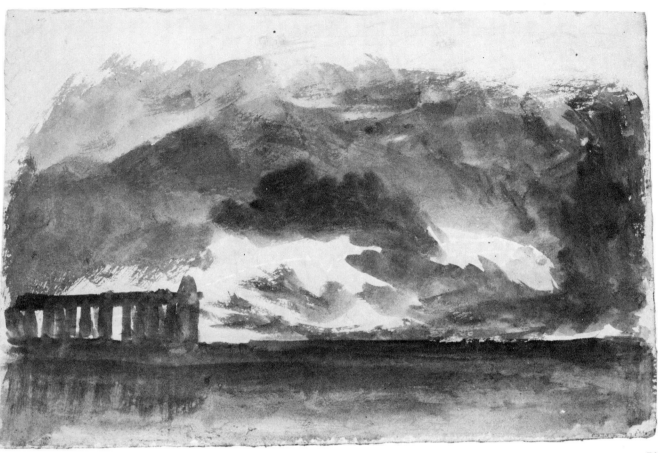

75

75 Paestum in a thunderstorm *c.* 1825

Watercolour with pencil, 8⅜ × 12 (213 × 305)
TB CCCLXIV – 224, Wilton 769

Like the towns of Herculaneum and Pompeii, the Greek temples at Paestum (Pesto) south of Naples were 'discovered' in the eighteenth century and contributed largely to the progress of Neoclassicism in Europe. They were magnificently engraved by Piranesi.[1] Turner visited them in 1819, making several drawings.[2] In 1824 Lady Blessington recorded her response to the temples as follows: '. . . the first view . . . must strike every beholder with admiration. Nor is this sentiment diminished on approaching them; for the beauty of their proportions, and the rich and warm hues stamped on them by time, as they stand out in bold relief against the blue sky, . . . render the spot, even independent of the classical associations with which it is fraught, one of the most sublime and interesting imaginable. The solitude and desolation of the country around, where naught but a wretched hovel, a short distance from the temples . . . breaks on the silent grandeur of the scene, adds to the sublime effect of it.'[3] This study appears to have been made with the intention that it should be translated into mezzotint, for it belongs to a group of stylistically similar drawings which all relate to the 'Little Liber' series which Turner scraped in the mid-1820s. The resulting print is no. 74. According to Ruskin, Turner commonly associated lightning with the monuments of dead religions; compare the view of *Stonehenge* (no. 79).[4]

1. Piranesi, *Différentes Vues de quelques Restes de trois grands Edifices de L'ancienne Ville de Pesto*, 1778–9.
2. In the *Naples, Paestum and Rome* sketchbook, TB CLXXXVI.
3. Edith Clay, ed., *Lady Blessington at Naples*, London 1979, p. 88.
4. Ruskin, *Works*, XXI, p. 223.

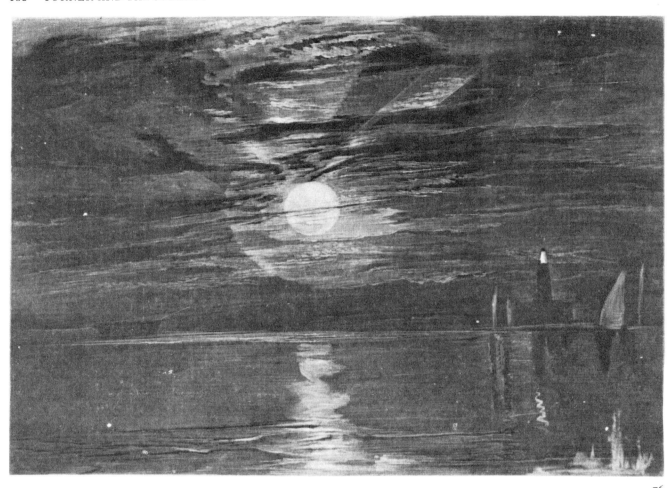

76

76 Shields Lighthouse ('Little Liber') *c.* 1825

Mezzotint, printed in black ink, trial proof(a) (R. 801), subject:
$5\frac{15}{16} \times 8\frac{3}{8}$ (151 × 212) trimmed inside plate-mark
Yale Center for British Art, Paul Mellon Collection, B1977.14.8351

A wash drawing related to this subject is in the Turner Bequest.[1]
Turner modified his design considerably as he proceeded with it; a
second proof at Yale[2] has the moonlight diffused in a haze of
radiance over the whole scene; later, the moon was reduced in size.
In this plate Turner completely dispels any association of darkness
with fear, while reaffirming that it is truly sublime. The stillness of
this moonlit night is one of his profoundest conceptions, executed
with great breadth and with a simplicity of touch that denotes the
mastery that Turner had acquired over this medium, which of all
the reproductive methods he made most his own.

1. TB CCLXIII–308.
2. Reproduced in Christopher White, *English Landscape 1630–1850*, Yale 1977, pl.
 CXXIX.

77a Catania, Sicily ('Little Liber') *c.* 1825

Mezzotint, printed in black-brown ink, touched by Turner in
pencil and (?) white chalk, trial proof(b), (R. 805), subject:

$6 \times 8\frac{7}{16}$ (153 × 215); plate: $7\frac{5}{8} \times 9\frac{15}{16}$ (193 × 252)
Yale Center for British Art, Paul Mellon Collection,
B1977.14.8355

77b Catania, Sicily ('Little Liber')

Mezzotint, printed in black (R. 805); impression taken by
Seymour Haden, 1872
Yale Center for British Art, Paul Mellon Collection,
B1977.14.8356

Turner's drawing of this subject is in the Boston Museum of Fine
Arts.[1] It was presumably made from a sketch by another artist,
since Turner never visited Sicily himself. In the trial proof, Turner
has indicated with touches of chalk the reflections from the water
which are realised in the final state. The felucca at the left is
pencilled in, and there is a smudge of white in the darkest part of
the thundercloud. This does not seem to have been incorporated
into the mezzotint, but the boat is added in the later state, as is the
distant outline of Mt Etna, with its plume of smoke. This is one of
the grandest of all Turner's lightning storms.

1. Wilton 774.

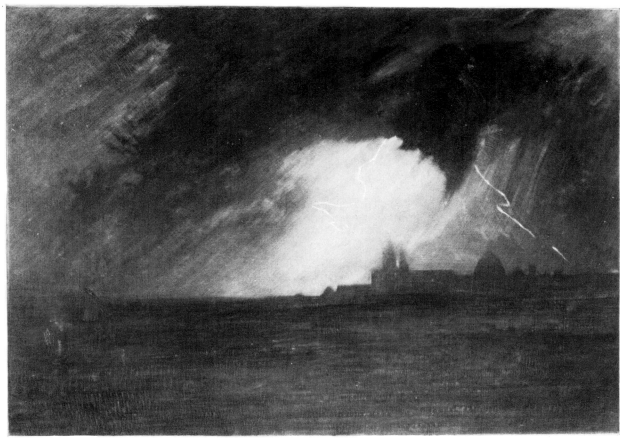

77a

77b

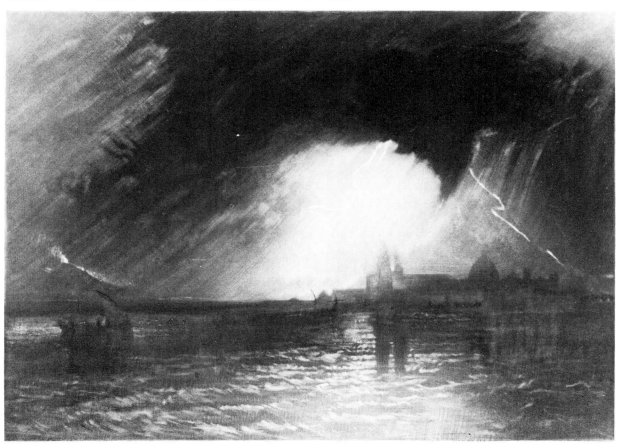

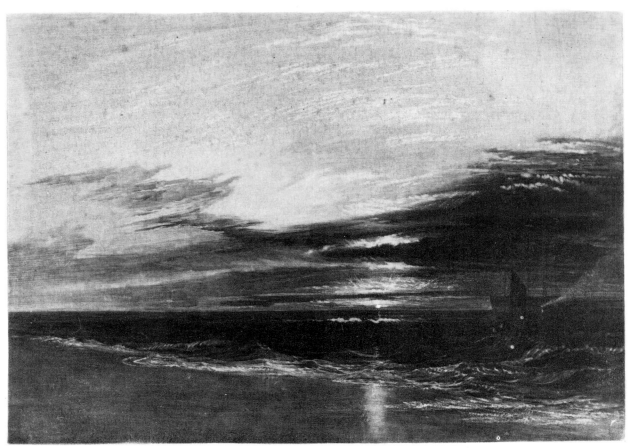

78

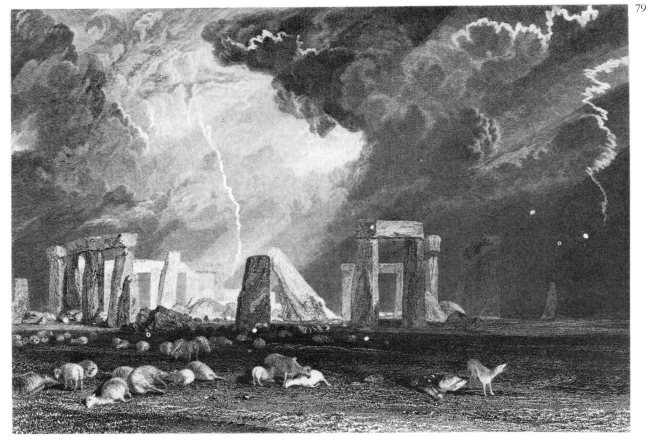

79

78 The Evening Gun ('Little Liber') *c.* 1825

Mezzotint, printed in black ink, trial proof(c), touched by Turner
(R. 800), subject: $5\frac{1}{16} \times 8\frac{3}{8}$ (151 × 212); plate: $7\frac{1}{2} \times 9\frac{3}{16}$
(190 × 233)
Yale Center for British Art, Paul Mellon Collection, B1977.14.8349

Turner's alterations to this proof consist of scraping-out of the
mezzotint tone with a sharp point in the upper sky, the rays of the
sun, and the foreground ripples.[1] If Turner had the work of Francis
Danby in mind when he made the 'Little Liber' plates, this subject
approaches closest to the spirit of Danby's paintings. Danby in fact
produced a picture with the same title which he exhibited in 1848.[2]

1. See S. Colvin, 'Turner's Evening Gun', *The Portfolio*, 1872, pp. 75–6.
2. At the Royal Academy, no. 595. Its full title was *The Evening Gun – a calm on the
 shore of England.*

Robert Wallis, after J. M. W. Turner

79 Stone Henge (*England and Wales*) 1829

Engraving, second state, on india paper (R. 235), subject: $6\frac{1}{2} \times 9\frac{1}{4}$
(165 × 234); plate: $9\frac{1}{16} \times 9\frac{1}{4}$ (252 × 310)
Inscr. below: with title and names of artist and engraver; lower
right: *Printed by M͟c Queen.*; bottom: *London, Published 1829, for the
Proprietor, by R. Jennings, Poultry, & by Giraldon Bovinet, Gallerie,
Vivienne, Paris.*
Yale Center for British Art, Paul Mellon Collection, B1977.14.13346

The neolithic circle of Stonehenge has always been recognised as
an object specially evocative of the sublime.[1] Even an antiquary
preoccupied with scientific description could write in 1740 that
'the yawning ruins' provoke 'an ecstatic *reverie*, which none can
describe';[2] and subsequently poets and tourists found inspiration
in its antiquity, mystery and desolate situation. As William Gilpin
said, 'Standing on so vast an area as Salisbury Plain, it was lost
in the immensity around it. As we approached, it gained more re-
spect . . . But when we arrived on the spot, it appeared aston-
ishing beyond conception. A train of wondering ideas immediately
crowded into the mind. Who brought these huge masses of rock
together? Whence were they brought? For what purpose? . . .'[3]
Burke considered that 'Stonehenge, neither for disposition nor
ornament, has anything admirable; but those huge rude masses of
stone, set on end, and piled each on other, turn the mind on the
immense force necessary for such a work. Nay the rudeness of the
work increases this cause of grandeur, as it precludes the idea of art,
and contrivance . . .'[4] Turner made a number of pencil studies of
the structure[5] and used it as the subject of a mezzotint (no. 72),
which suggests the bleakness of its setting. Here, by contrast, he
makes the monument a backdrop to a drama reminiscent of Thom-
son, in which a shepherd is struck dead by lightning in the middle
of the deserted plain. The sky is worked up into one of Turner's
most violent electric storms. Rawlinson relates that the President
of the Royal Meteorological Society was impressed by the artist's
rendering of the lightning. It is interesting to note that he was
determined on absolute accuracy here, while the actual positions of
the stones have been modified to suit his purposes in the design.[6]

1. For a survey of the place of Stonehenge in British romantic art see Louis Hawes,
 Constable's Stonehenge, Victoria and Albert Museum, London 1975.
2. William Stukeley, *Stonehenge, a Temple restor'd to the Druids*, 1740, p. 12.
3. William Gilpin, *Observations on the Western Parts of England, relative chiefly to
 Picturesque Beauty*, London 1798, p. 77.
4. Burke, *op. cit.*, p. 60.
5. e.g. TB LXIX 79, 80; TB CXXIII–211, 212.
6. The original watercolour is Wilton 811; Shanes 25.

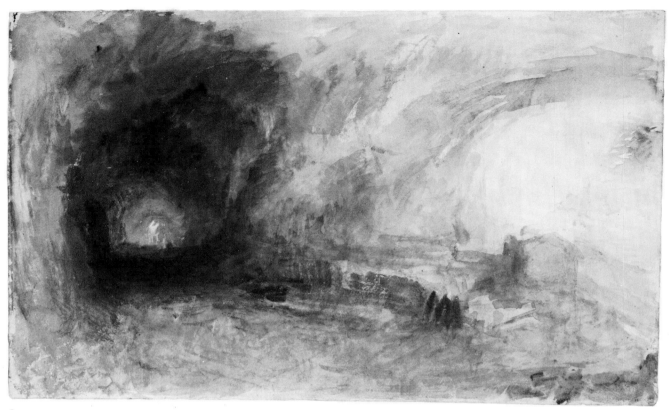

80

80 A Mountain Pass: night (?)c. 1830

Watercolour, $13\frac{3}{4} \times 19\frac{5}{16}$ (305 × 490)
TB CCLXIII–91

This enigmatic colour study may be connected with one of
Turner's watercolours showing incidents during his travels across
Europe in winter. The large scene of a diligence overturned in a
snowdrift which he exhibited in 1829 as *Messieurs les Voyageurs . . . in
a snowdrift upon Mount Tarrar*[1] is the most likely, though the
finished composition differs from this in most respects. The
contrast between the tunnel of darkness on the left and the area of
light at the right is typical of Turner's compositional organisation
in the 1830s, but it is impossible to be sure precisely what is
intended here: are we among the wilds of a bleak mountain pass, or
is the scene a more familiar one, with streets and houses, and
perhaps a torchlight procession? It would be appropriate to link the
study with the *England and Wales* subjects of the early 1830s, but no
obvious connection suggests itself. Compare, however, the tunnel-
like cutting at the right of Turner's view of *St Catharine's Hill,
Guildford*,[2] which has compositional analogies, though the design is
in reverse.

1. Wilton 405.
2. In the Yale Center for British Art, Wilton 837; Shanes 48.

81 Leeds 1816

Watercolour, $11\frac{3}{8} \times 16\frac{3}{4}$ (290 × 425)
Inscr. lower left: *J M W Turner RA 1816*
Engr. by J. D. Harding (lithograph), 1823
Yale Center for British Art, Paul Mellon Collection, Wilton 544

Although not a work in the sublime mode, this view of Leeds marks the point at which Turner's progress as a topographer began to reflect the breadth of reference and coherence of handling that he had achieved in meeting the technical challenges of the sea and the mountains. This sheet is dated to the year after Turner had painted *The Battle of Fort Rock (colour 15)*, and no topographical view could ever be the same after that experience.[1] Here, there is no sense of technical strain – perhaps precisely because so much effort had gone into the earlier work – and a wealth of information is incorporated into a lucidly organised and stably composed panorama. The inherent grandeur of the youthful industrial cities is celebrated in quiet enjoyment of the new atmospheric effects created by innumerable chimneys pouring their smoke into the broad sky. The proximity of country to town is presented even while we are made conscious of the long lines of new houses that straggle up the hills, the insidious outcrops of building that are just beginning to alter the landscape irrevocably. Turner does not, however, draw any tragic conclusions: he records objectively, but with fascination, the work of masons building a wall, the morning errands of butchers and farmers. Two men appear to be erecting a stall, for a fair or market, in a field where people are gathering mushrooms. Later, in the *England and Wales* series (compare especially no. 84), Turner was to invest such views with much greater drama; here he allows the sheer diversity of life to make its

own impression, and by doing so evokes almost unawares the spirit of the sublime.

1. Compare the breathtaking, but equally 'topographical' view of *Raby Castle*, an oil painting of 1818 now in the Walters Art Gallery, Baltimore (Butlin & Joll 136).

82 Rome: The Forum with a Rainbow 1819

Pencil, watercolour and bodycolour on white paper prepared with a grey wash, $9 \times 14\frac{5}{16}$ (229 × 367)
TB CLXXXIX–46, BM 1975 (67)

Turner's responses to Rome, 'the Eternal City', were inevitably coloured by the host of associations historical, literary and artistic, with which all Englishmen were equipped when they set out on the tour of Italy. His studies of it can be divided into two types: small pencil sketches recording details of architecture, and larger compositions, often in colour and usually executed on a prepared grey ground, which evoke aspects of the character of the city, and which have much of the expressive force of finished watercolours. This sheet is an unusually elaborate study, a page from the same sketchbook as no. 16, in which a sublime natural phenomenon is superimposed on the various antiquities of the Roman Forum. Buildings that appear in this somewhat rearranged view of the heart of the ancient empire include the Temple of Antoninus and Faustina, the three columns of the Temple of Castor and Pollux, the mass of the Basilica of Constantine, and above it, the church of S. Francesca Romana. Turner exhibited a large painting of the *Forum Romanum* at the Academy in 1826. It presents the various edifices of the site among a jumble of fragments of classical masonry

81

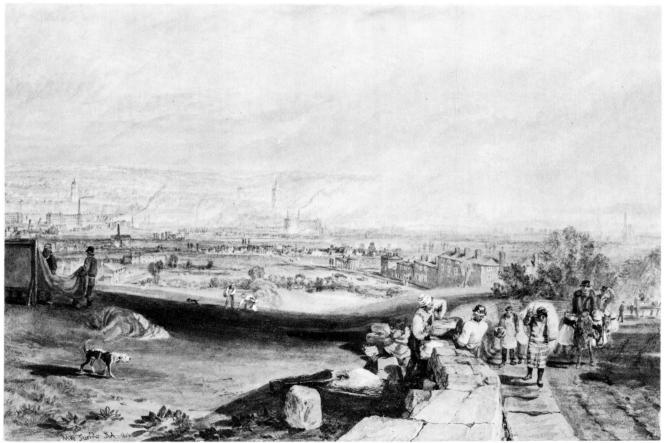

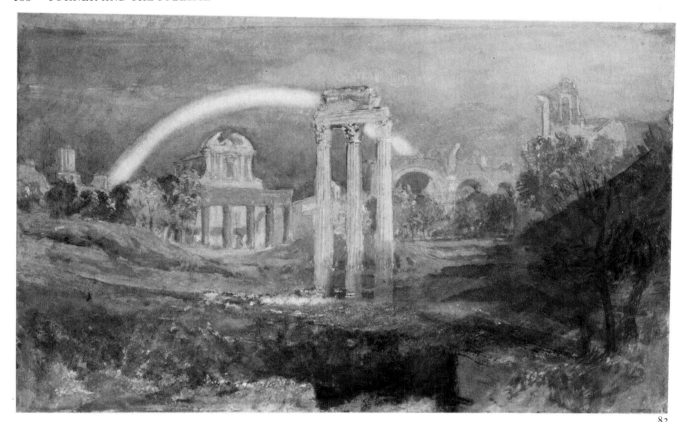

82

that give it something of the atmosphere of the architectural fantasies of Sir John Soane and his draughtsman Joseph Michael Gandy (1771–1843). It was perhaps Gandy's highly imaginative projections of buildings ancient and modern that Turner had in mind when he painted the picture, as its subtitle says, 'for Mr Soane's Museum'. The canvas never in fact entered Soane's collection.[1]

1. Butlin & Joll 233.

William Radclyffe (1780–1855), after J. M. W. Turner

83 Salisbury, Wiltshire (*England and Wales*) 1830

Engraving, first published state, printed on india paper (R. 260), subject: $6\frac{5}{8} \times 9\frac{1}{2}$ (169 × 242); plate: $9\frac{1}{2} \times 13\frac{13}{16}$ (242 × 351)
Inscr. below: with names of artist and engraver
Yale Center for British Art, Paul Mellon Collection, B1977.14.13382

While his view of Leeds (no. 81) is dominated by the chimneys of new industry and the smoke they generate, Turner's Salisbury is still, in the 1820s,[1] the city dominated by its great cathedral which he drew in the 1790s. The structure loses nothing of its majesty from being placed in the centre of a panorama instead of being isolated as a monument of the architectural sublime; just as Turner can stand back from the fall of the Tees (no. 37) and in doing so enlarge our sense of its grandeur, so in placing Salisbury cathedral in its context, he enhances its value as a cultural monument and religious symbol. As Ruskin noticed, that symbolism is carried out in the foreground group of shepherd with his flock, a parallel, couched in Biblical language, to the pastoral significance of the church. He compared this idea with the central motif of the *Stone Henge* (no. 79) in which 'the shepherd lies dead, his flock scattered'.[2]

1. Like most of the *England and Wales* drawings, the original watercolour probably dates from a year or two earlier than the print; about 1828 (Wilton 836; Shanes 24).
2. Ruskin, *Works* VII, pp. 190–1, see also *Works* XXI, p. 223.

S. Fisher (fl. 1831–44), after J. M. W. Turner

84 Coventry, Warwickshire (*England and Wales*) 1833

Engraving, printed on india paper, second published state (R. 273), subject: $6\frac{7}{16} \times 9\frac{5}{8}$ (164 × 245); plate: $9\frac{13}{16} \times 12\frac{9}{16}$ (250 × 319)
Inscr. below: with title and names of artist and engraver; lower right: *Printed by M.^r Queen*; bottom: *London, Published 1833, for the Proprietor, by Moon, Boys & Graves, 6, Pall Mall.*
Yale Center for British Art, Paul Mellon Collection, B1977.14.13394

A comparison of this subject with the *Leeds* of 1816 (no. 81) tells us much about the way in which Turner's topography had become imbued with the lessons of his more 'serious' painting. Both are expansive views of cities, seen from the rising country immediately outside them, and both communicate many details about the way of life of their inhabitants. But while the information given in the *Leeds* is allowed to accumulate unobtrusively until a complete picture is formed, Coventry bursts upon the eye as a revelation – an Elysian colony with its clustered houses and soaring spires brilliant in a burst of stormy light. The composition is not a gentle assemblage of parts, but a rapid and vivid *coup de théâtre*, dependent on a few salient stresses and tonal divisions. This is the rhetoric of 'high art', not the learned conversation of topography. And yet the elements are much the same as before: there is no sacrifice of immediacy or of truth. Indeed, the truth is now given to us with much greater immediacy than before, and we are conscious that it is a superior brand of truth – the rhetoric is perhaps couched in heroic couplets. The original watercolour is in the British Museum.[1]

1. Lloyd Bequest, 1958–7–12–434 (Wilton 849; Shanes 58).

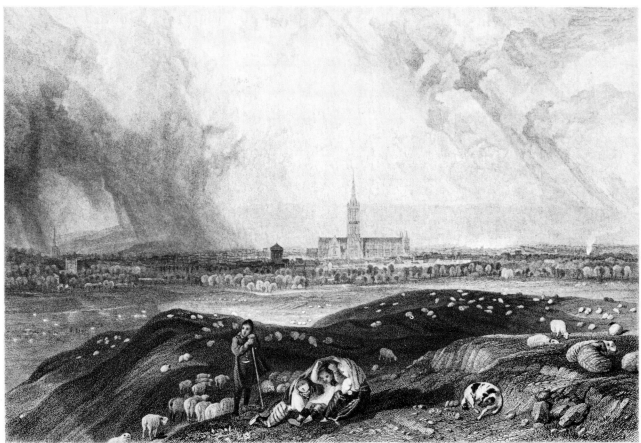

83

84

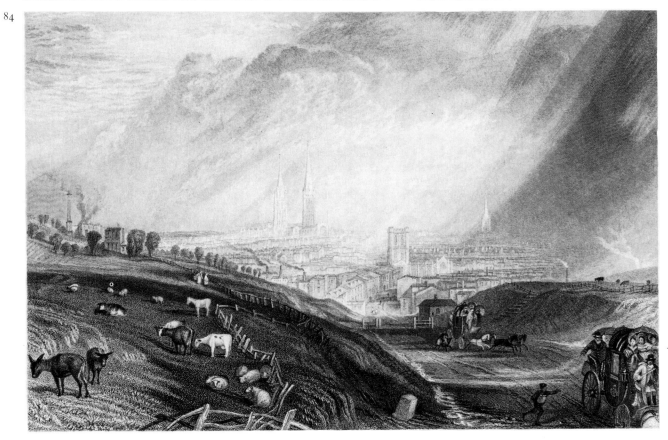

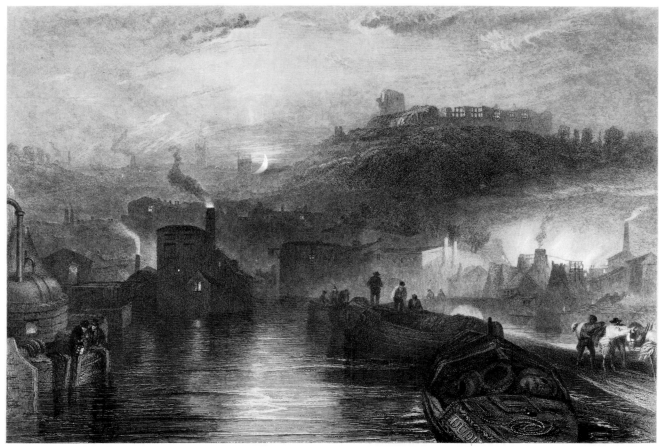

86

85 Study of an Industrial Town at Sunset *c.* 1830

Watercolour, $9\frac{5}{8} \times 19$ (244 × 483)
TB CCLXIII—128
Colour plate 17

This colour-beginning is apparently one of the numerous studies that Turner made for the series of *Picturesque Views in England and Wales*, and probably shows one of the industrial Midlands towns that he visited on a tour of 1830. A finished subject of this type is the view of *Dudley* (no. 86). This is not the same town, it seems, but the study presents many of the same ideas: obscurity and smoke hazily illuminated by the fires of industry; a spacious landscape crowded with the activity of men, obliterated by an atmosphere quite different from the mists and storms of the mountains, and lit by a sun diffused through an artificial fog. In spite of Ruskin's opinion that Turner felt the tragedy of the industrial revolution and its ravages of the English landscape, this drawing is unequivocally a poem of almost lyric enchantment with the new conditions in which the world assumed such grand forms – even if, perhaps, there is a hint of Milton's Hell in the combination of fire and darkness.

R. Wallis (1794–1848), after J. M. W. Turner

86 Dudley, Worcestershire (*England and Wales*) 1835

Engraving, third state (R. 282), subject: $6\frac{7}{16} \times 9\frac{7}{16}$ (163 × 240); plate: $9\frac{7}{8} \times 11\frac{15}{16}$ (251 × 304)

Inscr. below: with title and names of artist and engraver; lower right: *Printed by Mc Queen*; bottom: *London, Published 1835, for the Proprietor, by Longman & Co Paternoster Row.*
Yale Center for British Art, Paul Mellon Collection, B1977.14.13436

The history of criticism of this design provides interesting evidence of the influence of Ruskin's personal interpretation of Turner's art. Ruskin, distressed to the point of despair by the effects of industrialisation on English life and scenery, and moving towards a philosophical position close to that of his contemporary, Karl Marx, was unable to see the phenomena of the industrial revolution with the eyes of the earlier generation to which Turner belonged. He spoke of the watercolour of this subject[1] as 'One of Turner's first expressions of his full understanding of what England was to become,' and drew attention to the ruined castle and the church spires as 'emblems of the passing away of the baron and the monk'.[2] Rawlinson also calls attention to this contrast between past and present, 'so profoundly felt, so impressively rendered. The quiet, pathetic beauty of the once dominant, but now ruined feudal castle, is strikingly brought out by the forges and the busy life of the nineteenth century below.'[3] This just observation has been combined with Ruskin's in a recent comment to the effect that 'Gloom and ceaseless industry abound . . . the only romantic feature is that of the sun's last rays [*sic*: it is of course moonlight, as usual in Turner's oppositions of industrial to natural light; cf. no. 73] illuminating the ruined castle and Cluniac priory in regretful farewell.'[4] The 'regret' here is undoubtedly Ruskin's, transmitted unenfeebled through several generations. Turner's view of Dudley

itself does not convey any such mood. It is a work alive with activity, a fully-realised transcript of the life of industrial man as seen by the generation of artists for whom these scenes were novel and immensely stimulating experiences. Turner chooses night-time because it was by night that the industrial glare was most vivid, as Joseph Wright and others had done before him in the late eighteenth century.[5] The contrast of old and new is certainly here; as it is, for instance, in Turner's nocturnal view of *Stonehenge* (no. 72), where the ancient structure is passed by a modern stage coach.[6] Turner's fascination with the changes that society inevitably undergoes was by no means necessarily accompanied by dismay. On the contrary, as an artist, there is little doubt that he hailed the new with delight.[7] In fact, *Dudley* is one of the most complete of Turner's essays in the 'Industrial Sublime' which was quintessentially a department of the eighteenth-century 'Picturesque Sublime'.

1. Wilton 858.
2. Ruskin, *Works*, XIII, p. 435.
3. Rawlinson, vol. I, p. 158.
4. Shanes, p. 43, no. 66; and see p. 21.
5. e.g. Nicolson, *Wright*, cat. 198, pl. 104, or de Loutherbourg's *Coalbrookdale by night* (1801) in the Science Museum, London; and compare Turner's own *Limekiln at Coalbrookdale* in the Yale Center for British Art (Butlin & Joll 22).
6. See Rawlinson's comments on this subject, *Liber Studiorum*, no. 81.
7. See comments on Ruskin's opinion of the railways, no. 122.

87 Carlisle *c*. 1832

Watercolour, $3\frac{1}{4} \times 5\frac{5}{8}$ (83 × 142)
Engr. by E. Goodall for Scott's *Poetical Works*, 1833 (R. 493)
Yale Center for British Art, Paul Mellon Collection, B1975.4.966,
Wilton 1070

Turner's activities as an illustrator, which occupied him extensively in the late 1820s and the 1830s, have been found puzzling by some commentators: granted that he was eager to find a wider public for his work, and recognised the advantages of disseminating it by means of engravings, why, in addition to creating magnificent landscape designs for picturesque series like the *England and Wales*, or superintending the reproduction of his paintings (see nos 49, 56, 71), did he laboriously execute such quantities of small-scale plates and vignettes for books? The answer is to be found in the very names of the authors to whose works he paid this dedicated tribute. They are Scott, Byron, Campbell and Milton (as well as his friend Samuel Rogers, who is the only writer of the group who cannot be said to occupy a significant place in the literary hierarchy of Turner's day).[1] Milton's standing is clear; Scott and Byron were unquestionably the most celebrated figures in romantic literature – Scott, a writer who had given literary value to the whole of Scotland as well as to many parts of England, immortalising many places by giving them new 'historical' and dramatic associations. In making 'topographical' views of such spots, Turner was actually creating landscapes with a direct literary reference and with, often, connotations of romantic and passionate events. This view of Carlisle does not illustrate any specific episode, but, in its concentrated elaboration, conveys the range and variety of ideas that Turner wished to present in connection with the city. In such a drawing, the sheer virtuosity by which the artist controls his material to evoke so much in so little space is itself a manifestation of the sublime, an aspect of man's achievement comparable to the gravity-defying technology of a Gothic cathedral.

1. Though some contemporary critics thought highly of him, e.g. Sir James Mackintosh.

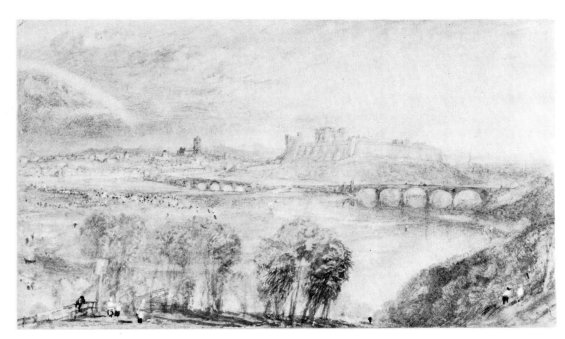

87

88 Luxembourg *c.* 1825–34

Bodycolour with some pen and chalk on buff paper, $5\frac{3}{8} \times 7\frac{7}{16}$
(135 × 189)
Yale Center for British Art, Paul Mellon Collection, B1975.4.963,
Wilton 1019
Colour plate 18

A study connected with Turner's ambitious project of views along
the 'Rivers of Europe', of which only the Loire and Seine series
were published (in 1833–5).[1] Here Turner sees the fortified city as
an extension of the rocky structure of the earth itself: a view of
man's achievements in building that corresponds to Turner's
frequent treatment of human beings themselves, as an integral part
of the ancient organic fabric of nature. Notice that he does in-
troduce figures even into this visionary sketch: a city is not a
desert, and is inseparable in conception from the idea of man and his
doings. Technically, this drawing is at the opposite pole from the
view of Carlisle (no. 87), a city view of quite a different type,
though executed on an equally small scale, and at about the same
date.

1. See Wilton 930–1051.

89 Fribourg 1841

Pencil, watercolour and some pen, $9\frac{3}{16} \times 13\frac{3}{16}$ (233 × 334)
TB CCCXXXV–12

Turner was strongly attracted to Fribourg, and made numerous
studies of it on a visit there in 1841.[1] He never made a finished
picture, either in oil or in watercolour, however, and his ideas
about the place are enshrined in drawings like this one. At Fri-
bourg, an ancient city is surrounded by high cliffs; small buildings
clustered together seem about to be engulfed by towering waves of
rock: the picturesqueness and historical interest of man's work is
always to be found in direct confrontation with the stark force of
nature. Many of the Fribourg studies express this opposition in
their very technique: delicate outlines in pencil and pen contrast
with broad washes of colour that convey the mass of the pre-
cipitous cliffs and their scale, as the light moves intangibly over
their surfaces. Compare the study of an *Alpine Gorge* (no. 100).

1. In various sketchbooks, e.g. the *Fribourg* sketchbook, TB CCCXXXV, from which
 this sheet comes. Turner made pencil sketches of the city in the *Lucerne and
 Berne* sketchbook, TB CCCXXVIII, especially f. 17, a panoramic view identified by
 Finberg as showing Lucerne, but undoubtedly a study at Fribourg.

89

90 Lausanne, Sunset (?)1841

Pencil and watercolour, $9\frac{7}{8} \times 14\frac{3}{8}$ (251×365)
TB CCCLXIV–350, BM 1975(265)
Colour plate 19

Whereas the two late views of Zurich (see no. 93) show the city in full daylight, this equally splendid vision of Lausanne sets off the skyline against a breathtaking sunset. As at Zurich, the thronging activities of the townspeople occupy the foreground of the view; this feature alone makes it very probable that Turner had it in mind to execute a finished watercolour based on this study; but there is no record that he did so. Nevertheless, much of the richness and fullness of content of a finished work is present here; and it is possible that he took the subject no further because he had compressed all that he wished to say into the sketch. The sense of excited expectancy that hangs over a crowd out of doors on a hot summer evening is marvellously suggested. Such summer promenades are among the commonest and oldest-established ways in which people signify their need to identify both with the natural world and with their fellow-men: hence the intensity of excitement that these informal rituals provoke. Here we feel that a form of communal sun-worship is taking place; every part of the drawing is pervaded with the warm brightness of the sunset light.

91 The Moselle Bridge, Coblenz *c.* 1842

Pencil and watercolour, $17\frac{7}{8} \times 23\frac{5}{16}$ (454×592)
Yale Center for British Art, Paul Mellon Collection, B1977.14.4651, Wilton 1520
Colour plate 20

Turner made a number of airy studies of this subject,[1] though none of the others is as large as this one. A more elaborate sketch, worked up into a 'sample' for Thomas Griffiths (see no. 103),[2] gave rise in 1842 to a finished watercolour of the Moselle Bridge at Coblenz which Ruskin owned.[3] It is known today only through copies by William Ward, whom Ruskin gave special permission to reproduce it.[4] It shows the bustle of life on both banks of the river, with the city beyond to the right and the fortress of Ehrenbreitstein in the left distance. Here those elements are indicated only by a few allusive touches, and Turner concentrates on the fall of light on the old bridge. For comment on the series of large colour studies to which this sheet belongs see no. 101.

1. TB CCCLXIV–336 is another (BM 1975, no. 282).
2. TB CCCLXIV–286; BM 1975, no. 283.
3. Wilton 1530.
4. A letter to Ward of 17 May 1882 declares Ruskin 'happy in putting it in your power to produce a facsimile of Turner's mighty drawing of the *Coblentz*'. (*Works* XIII, p. 577–8.)

92 Heidelberg: looking west with a low sun 1844

Pencil and watercolour with some pen and red and yellow colour, $9 \times 12\frac{7}{8}$ (228×327)
TB CCCLII–9, BM 1975(296)
Colour plate 21

Turner made three finished watercolours of Heidelberg in the last decade or so of his life;[1] they show the city from across the river Neckar, clothing the steep hill beyond the water with clusters of buildings and spires. The river bank in the foreground is crowded with figures. When he visited Heidelberg in 1844, during his last tour across Europe, he made a series of exquisitely luminous, sun-saturated studies[2] in which, more than in any other series of city views except those of Venice, the topography is dissolved in light. Forms are suggested by fragmentary outlines, touched in with a pen dipped in the colours of which the washes are pale tints. Turner was particularly alive to the historical associations of Heidelberg, one of the oldest university towns in Europe, and a city which had been severely handled in successive wars, bombarded, fired, and sacked on many occasions during the Thirty Years' War and the campaigns of Louis XIV. The castle, residence of the Electors Palatine of Bavaria, was ruined in a siege by the French in 1693; it was subsequently rebuilt but destroyed by a fire caused by lightning in 1764. When Turner painted a large picture of Heidelberg, probably in about 1845,[3] he showed it in a view roughly corresponding to that in this drawing. Its foreground is densely thronged with figures in historical dress – apparently that of the seventeenth century. After Turner's death this picture was engraved by T. A. Prior and published with the title *Heidelberg Castle in the Olden Time*.[4] It has been suggested that the festivities taking place are those celebrating the marriage of the Elector Frederick with Elizabeth of Bohemia, the 'Winter Queen', herself a figure doomed to a tragic life. The sunny optimism of the oil painting is therefore ironic. But the drawing, as it were, reverses the irony: Heidelberg, as it now is, rises serenely beautiful from its own tribulations, enduring and triumphing, while individuals like the Elector or his subjects cannot.

1. Wilton 1376, 1377, 1554, pls 245, 255.
2. In the *Heidelberg* sketchbook, TB CCCLII.
3. Butlin & Joll 440, where it is dated 1840–5. It seems likely, both on stylistic grounds and because of Turner's 1844 tour, that the picture was executed about the middle of the decade.
4. For the *Turner Gallery*, 1859–61 (R. 732).

T. A. Prior (1809–86), after J. M. W. Turner

93 Zurich 1854

Line engraving, first published state, india proof before all letters, (R. 672), subject: $11\frac{13}{16} \times 19\frac{1}{8}$ (300×486); plate: $16\frac{5}{8} \times 23\frac{1}{4}$ (422×590)
Inscr., lower right: in pencil, with engraver's signature; outside plate: *Zurich*. Bears Printsellers' Association stamp.
Yale Center for British Art, Paul Mellon Collection, B1977.14.8077

Like no. 123, this engraving reproduces one of the ten Swiss views of 1845,[1] and presents a subject which Turner had treated earlier in the decade. The 1842 view of Zurich is in the British Museum;[2] the original of this print, now in the Kunsthaus, Zurich, is known as *Zurich: fête, early morning*. Just as the views of Lake Lucerne from Brunnen display an increasing sense of air and space, so the two Zurich subjects mark a progress towards greater aerial freedom, allied to a gradually loosening technique (see *Fluelen: morning*, no. 122). This is indeed Turner's most ecstatic account of urban life, a life that revolves round a vortex of glistening water, radiant sky and distant mountains. Man and his achievements – thronging crowds, toiling horses, the spires and towers of churches, the clustered roofs of city buildings – are all involved in the whirling career of the natural universe. The mood, however, is one of tranquillity; Turner contemplates the wonders of human life with the same reverent ecstasy as when meditating on the still mountains and unruffled lake before dawn. This is his final important statement about the place of man in the cosmos, and it is an affirmative, indeed a joyous one.

1. Wilton 1548.
2. Lloyd Bequest; Wilton 1533.

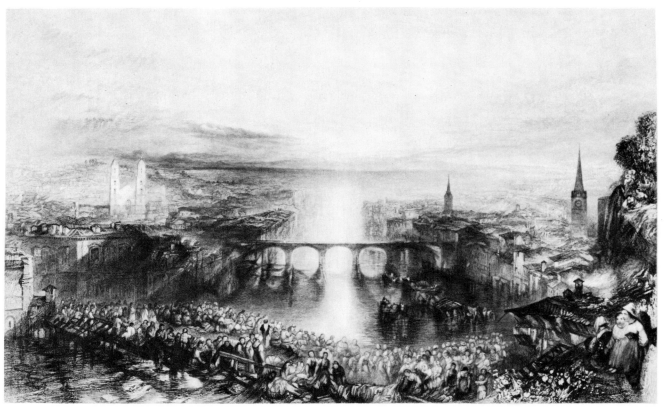

93

MOUNTAINS

94 Chain of Alps from Grenoble to Chamonix *c.* 1811

Pen and brown ink and wash with scraping-out, $8\frac{1}{8} \times 11\frac{1}{8}$
(203 × 282)
TB CXVII–Y

If a single mountain is sublime, a whole chain of mountains is infinitely more so. Yet to present the vastness of such a concept with concrete vividness is an almost superhuman task. Turner here[1] puts his subject into a context that is natural and proper – he shows the mountains as they appear in the distance to the excited traveller, across an intervening plain of cultivated land, with people engaged in their daily activities. It is not the actual scale of the mountains, but their promise of grandeur, that thrills us in this setting, as all English tourists first saw them. Turner's handling of the splendid recession of the flat landscape in the foreground and middle distance seems to owe something to the technique of John Robert Cozens. He may indeed have had a specific composition of Cozens in mind – his *View from Mirabella in the Euganean Hills* (Victoria and Albert Museum).[2]

1. This is Turner's drawing for a plate of the *Liber Studiorum*, published in 1812.
2. C. F. Bell and T. Girtin, 'The Drawings and Sketches of John Robert Cozens', *Walpole Society* vol. XXIII, 1934–5, no. 216, pl. XVIIIb.

95 Crichton Castle with a rainbow *c.* 1818

Watercolour with traces of pencil, $6\frac{13}{16} \times 9\frac{7}{16}$ (173 × 239)
Yale Center for British Art, Paul Mellon Collection, B1977.14.6299,
Wilton 1143

A study for one of Turner's illustrations to Sir Walter Scott's *Provincial Antiquities of Scotland*, a view of Crichton Castle engraved by George Cooke in 1819.[1] There is another colour-beginning for the same subject in the Turner Bequest.[2] The rainbow does not appear in the finished design.

1. Wilton 1059; R. 558.
2. TB CLXX–4.

96 Grey Mountains (?)*c.* 1835

Grey wash with some yellowish-brown colour, $7\frac{1}{2} \times 11$ (190 × 280)
TB CCLXIII–262

Both this sheet and no. 97 (*colour 22*) seem to belong to a group of related studies[1] of a mountainous subject unconnected with any finished work. All are very freely handled, and are evocative, not of any specific emotion such as awe or fear, as was the case with the earlier Alpine views, but of a mood of expansion and exaltation in the face of the ineffable and ungraspable reality of nature. It is difficult to date these studies; they may derive from one of Turner's journeys through Europe in the 1830s.

1. E.g. TB CCLXIII– 261, 263, 264, 265, 277, etc.

97 Among the mountains (?)*c.* 1835

Watercolour, $7\frac{1}{2} \times 10\frac{7}{8}$ (190 × 276)
TB CCLXIII–258
Colour plate 22

A variant of the subject of no. 96.

94

95

96

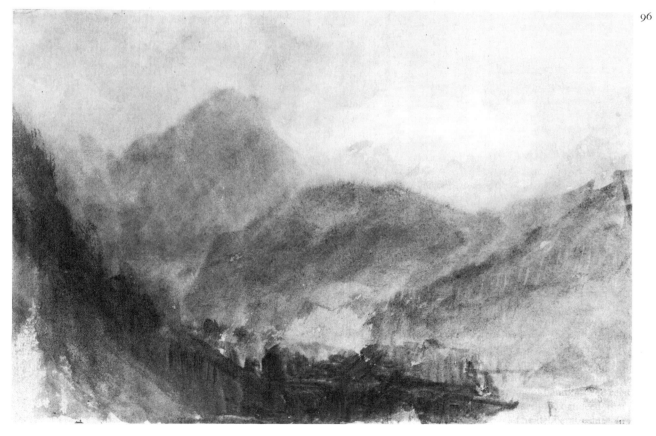

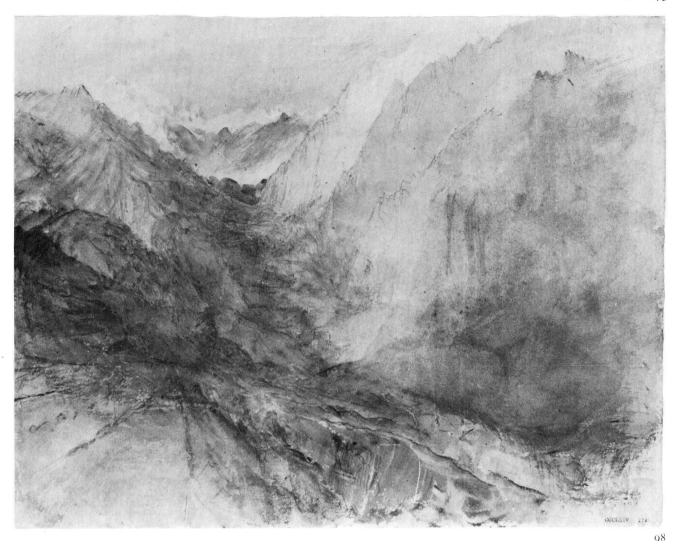

98

98 A Mountain Valley (?) 1836

Pencil and watercolour, $9\frac{1}{2} \times 11\frac{11}{16}$ (241 × 297)
TB CCCLXIV–276

The handling of watercolour in this study is reminiscent of the technique of some of Turner's views in the Val d'Aosta of 1836,[1] and it may be a sheet that once belonged to a sketchbook in use during that tour. It seems to be a view of the Allée Blanche looking towards the Col de la Seigne, and if this is the case then it almost certainly does stem from that journey. It is in fact a return to the region of *The Battle of Fort Rock (colour 15)*, in which the agitated sublimities of that drawing are subdued into a massively calm vision of peace. Watercolour wash is applied very broadly to convey mass and the play of light, while certain areas have been worked over with the blunt end of a brush, a procedure that Turner seems to have favoured particularly on the 1836 tour.

1. See Wilton 1430–56.

99 The Glacier des Bossons (?) 1836

Watercolour over traces of pencil, with some scratching-out, $8\frac{15}{16} \times 13$ (228 × 333)
British Museum, Sale Bequest 1915–3–13–49, Wilton 1440
Colour plate 23

Returning to the valley of Chamonix in later life, Turner again found himself impelled to give expression to its insistent diagonal slopes (see no. 24). Here the entire composition is resolved into a single sharply defined slanting line which separates two areas of contrasted tone. The drawing almost exactly mirrors the composition of Ruskin's monochrome study of the same glacier seen from the opposite side, now in the Ashmolean Museum,[1] though Ruskin's careful delineation of geological forms, woodland textures, and the cultivation and settlement of the valley produce a very different kind of work. Turner, for his part, suggests almost all of what Ruskin depicts with a few economical washes. The feathery delicacy of the touches used to render the huge mass of the mountainside vividly conveys the uplifted state of mind in which he contemplated it.

1. Repr. A. Wilton, *British Watercolours, 1750–1850*, pl. 140.

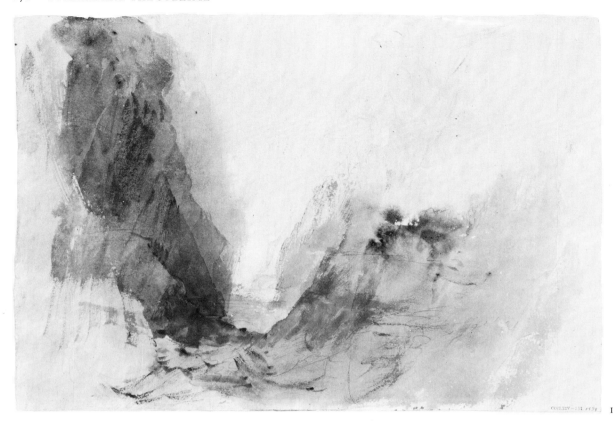

100

101

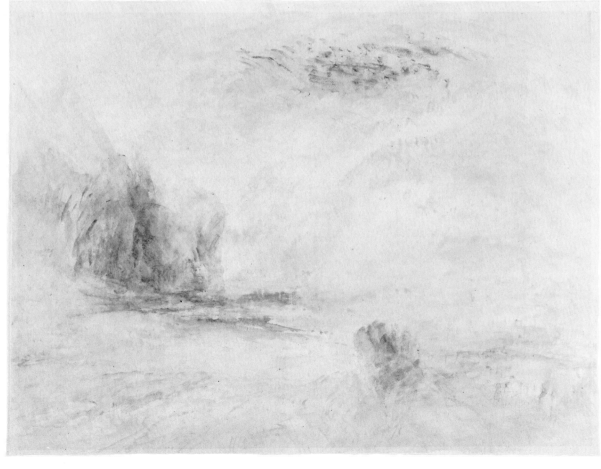

100 An Alpine Gorge 1836 or later

Pencil and watercolour, $9\frac{5}{8} \times 13\frac{3}{4}$ (243 × 347)
TB CCCLXIV–351

As in many of Turner's studies of the 1830s and 1840s, this sketch is the result of a coalescence of two distinct elements: the pencil drawing, which indicates here a stream and bridge, and some details of the rocks and plants nearby; and the watercolour wash, which describes independently the height and mass of the gorge, conveying simultaneously and in the same strokes such opposite things as a steep cliff and a dark shadow. As usual, Turner's observation is based on the particular, but it is expressed in terms that approach as near as possible to the universal and abstract. The study is 'about' sublime essences – height, steepness, danger – which are propounded with a minimum of specific reference. It is the virtuoso conciseness of Turner's mature technique that makes this possible.

101 Mountainous Landscape with a Lake *c.* 1842

Pencil and watercolour, $18\frac{1}{16} \times 23\frac{5}{16}$ (458 × 592)
Inscr. lower right: *2nd/Dark*(?)
Yale Center for British Art, Paul Mellon Collection,
B1977.14.6300, Wilton 1521

At the end of his life Turner produced a few colour studies that return to the scale of the Welsh studies made in about 1799 (*colour 4, 5* and *6*). It is not always possible to relate them to finished drawings, but this subject has some features in common with the *Pass of Faido* of 1843 (no. 104) and perhaps with another sheet from the same series of large studies, that at Leeds known as *The foot of the St Gothard*.[1] The 'lake' referred to in the title is more likely to be a river. These studies are characterised by their unrestrained generalisation, in which much is conveyed with almost total absence of detailed description; in both scale and approach to subject-matter they come closest of all the watercolours to Turner's very late studies in oil. It is typical, however, that this broad treatment is combined with the rapid note of figures and some detailed effect, added in pencil outline. Another example of the same series of drawings is no. 91.

1. Wilton 1522.

102 The Via Mala 1843

Pencil and watercolour with scraping-out, $9\frac{5}{8} \times 12$ (244 × 305)
TB CCCLXIV–362, BM 1975(290)

Murray's *Handbook* describes the Via Mala as 'perhaps the most sublime and tremendous defile in Switzerland', and goes on to

102

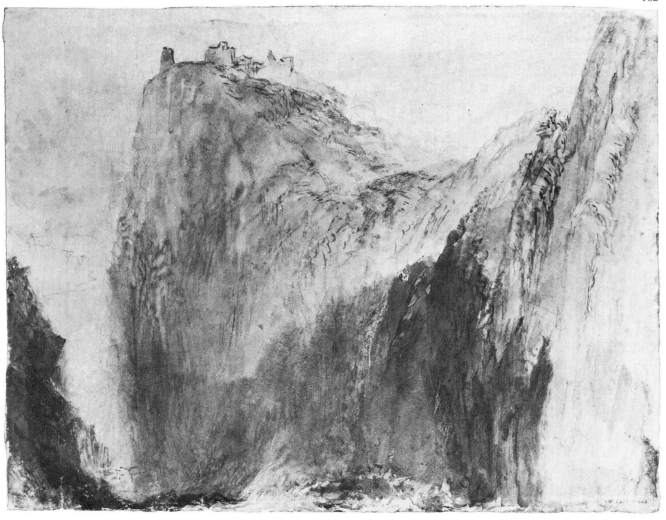

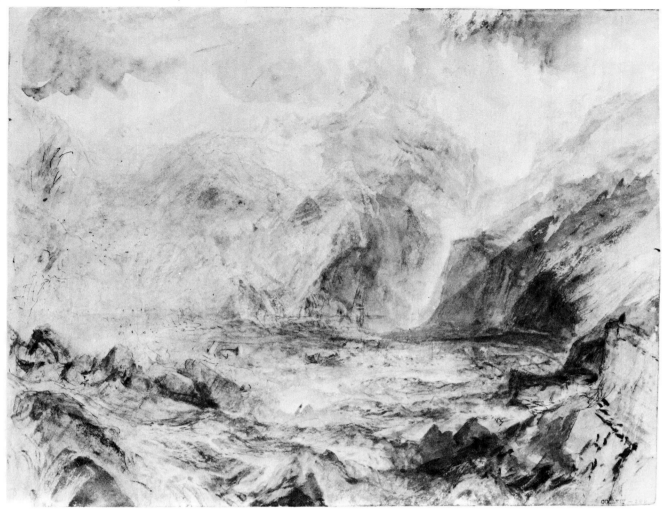

103

speak of it in terms of the fully-fledged 'terrific'.[1] Turner did not visit it in 1802, and when he saw it on the Splügen route to Italy in 1842 and 1843, made few drawings of it. One rather perfunctory chalk drawing shows the narrow chasm;[2] a rough colour sketch depicts the entrance to it from Thusis;[3] this sheet is the only one that is identified as a view within the gorge, and it is not designed to convey any sense of the threatening narrowness of the chasm. Turner had by this date outgrown the eighteenth-century love of horror, and sought in Switzerland for breadth rather than constriction. The splendour of this study lies in its evocation of sunlight falling onto the steep cliffs of hard rock, and in its sense of imminent release from the confinement of the valley.

1. Murray, *Handbook for Travellers in Switzerland, Savoy and Piedmont*, 7th ed., London 1856, pp. 244–5.
2. TB LXXIV–C; see *Turner in Switzerland*, p. 105.
3. TB CCCXXXVI–19, repr., *Turner in Switzerland*, p. 104.

103 The Pass of Faido: study 1842 or 1843

Pencil and watercolour with some pen, $11\frac{3}{16} \times 9$ (285 × 228)
Inscr. verso: *Pass Piolano Tessin No. 14*
TB CCCLXIV–209

A loose sheet in the Turner Bequest, from a dismembered sketchbook used during the tour of either 1842 or 1843, on both of which Turner crossed the Pass of St Gothard, following the river Tessin (Ticino) down towards the Italian lakes. The study was presented to Turner's agent, Thomas Griffith, as a 'sample' to indicate to clients the kind of subject that he might treat for them.[1] The watercolour that he worked up from it is no. 104. As in the case of *Goldau* (*colour 25* and *26*), the differences between study and finished drawing are considerable, but a great part of the intention of the final work is already present in this sketch of Faido.

1. See Ruskin, *Works* XIII, pp. 477–84.

104 The Pass of Faido 1843

Watercolour with scraping-out over pencil, $13\frac{3}{4} \times 18\frac{1}{2}$
(305 × 470)
Collection of Mr and Mrs Eugene V. Thaw, New York,
Wilton 1538
Colour plate 24

The study on which Turner based this watercolour is no. 103. While it was not unusual for him to make such a sketch, the working up of the idea into a finished watercolour results in a most unexpected subject. In general, the late Swiss views emphasise the expansive qualities of the Swiss landscape, taking the eye through immense vistas of light and space.[1] Here a sense of enclosure is the dominant note, a claustrophobic obsession with encircling cliffs that marks a return to the mood of the early Swiss subjects, or of *Gordale Scar* (no. 30). In his new relationship with the mountains, established after a lifetime of technical experiment, and affirming the liberation of spirit that they conferred upon him, he felt perhaps that one last full-scale tribute should be paid to the 'terrific' sublime of his youth. In the event he produced two important essays in this mode, the *Faido* and the *Goldau* (*colour 24* and *25*) which strike the most sombre note of all the late watercolours. But such is the metamorphosis of his vision by this date that the threatening rocks and roaring waters take on a new and more splendid significance: an exhilarating diversity and excitement, expressed in the swirling lines of the composition, carries us beyond the Burkean consideration of fear or the Kantian recollection of security to a complete and ecstatic identification with the elemental forces of nature, which are presented here raw and unsoftened, yet with a vigorous and compelling life of their own. It is not by accident that Turner, for once, introduces no figures into the foreground of the design: if *Regulus* (no. 54) brings the onlooker face to face with the scorching sun, this watercolour introduces us without intermediary to the wildness of the mountains: it is we who breathe the strong air and feel the spray on our face.[2] As Ruskin observed,[3] the quite unobtrusive suggestion of a carriage turning the corner on the rocky road is a sufficiently concrete touch to remind us that it is we who travel that way, and that the experience is our own. This emphatically personal inference is supported by Turner's own uncharacteristic comment that 'he liked the drawing'.[4]

Despite the expressive transformations which Turner wrought upon his subject-matter here, and which Ruskin analyses at length in *Modern Painters*, it was still possible for the critic to praise the work for its truth to nature; he noted that 'The warm colour given to the rocks is exactly right; they are gneiss, with decomposing garnets, giving them the brightest hues of red and yellow ochre.' Ruskin's editors add that he 'brought home an actual specimen of the rock, which he used to be fond of showing to visitors, in order that they might compare it with the drawing in his collection.'[5]

1. Ruskin's 'Mountain Glory' as opposed to 'Mountain Gloom'; see *Works*, IV, pp. 418ff.
2. See the comments of John Tracy Atkyns, p. 26.
3. Ruskin, *Works*, VI, p. 37 ff.
4. Ruskin, *ibid.*
5. Ruskin, *Works*, XIII, p. 207 and note.

105 Goldau with the Lake of Zug in the distance 1841–2

Pencil and watercolour with some pen, $9 \times 11\frac{3}{8}$ (228 × 288)
Inscr. verso: *Goldau – Rigi – and the Lake of Zug*
TB CCCLXIV–281
Colour plate 25

Like no. 103 this is one of the 'sample' studies presented by Turner to Thomas Griffiths to enable clients to form some idea of the subjects they might order from him. Ruskin was the patron who selected this scene, and even he must have been somewhat surprised by the extraordinary drawing that Turner produced for him (no. 106). It differs very considerably from the sketch, in which he saw a direct statement of recognisable weather conditions: 'after getting very wet at Schwyz, [we] are rewarded by seeing the clouds break as we reach the ridge of Goldau, and reveal the Lake of Zug under a golden sky.'[1] Turner's free interpretation of the scene is already, however, a statement of great grandeur, though it completely lacks the resonant overtones of the final watercolour.

1. Ruskin, *Works*, XIII, pp. 201–2.

106 Goldau 1843

Watercolour with scraping-out, $12 \times 18\frac{1}{2}$ (305 × 470)
Private Collection, U.S.A., Wilton 1537
Colour plate 26

One of the six Swiss drawings of 1843, this subject is derived from a study in the Turner Bequest (no. 105). The tragic connotations of this brilliant sunset sky have been compared to those of the sky in the *Slavers* of 1840 (FIG. XVI). Turner has chosen to commemorate here an Alpine catastrophe of 1806, when the mountain of the Rossberg buried the village of Goldau, killing 457 people.[1] A comparison with the *Avalanche in the Grisons* of 1810 points up the contrast between Turner's response to such 'terrific' subjects then and now. Whereas in the early part of his career he sought to express the Burkean emotion of fear by presenting with inescapable vividness a scene of natural violence actually taking place, he now transcends the horror of the subject to pour out a hymn of exaltation in the ultimate identification of man with the earth to which he belongs. He frequently depicted man as a kind of organic element in the landscape (see no. 88), but in no other work does he present us so forcibly with the very fact of burial, of the return of the body to the earth: under these huge boulders lie the people of Goldau, transformed into eternal participants in the cycle of nature. This is a vision that takes us a stage further than the heaped corpses on the battlefield of Waterloo (no. 71): their transmutation has not yet begun; here, after nearly forty years, the tragedy has become cause for a titanic and primeval rejoicing. There could be no act of devotion to nature more complete, absorbed and dedicated than that of fishing, Turner's favourite relaxation; hence the quiet, barely defined figures who passively accept fate as they wait among the boulders for fish to rise in the lake that reflects the sunset.

1. Graphic details of the disaster are supplied in Murray, *op. cit.*, pp. 43–7.

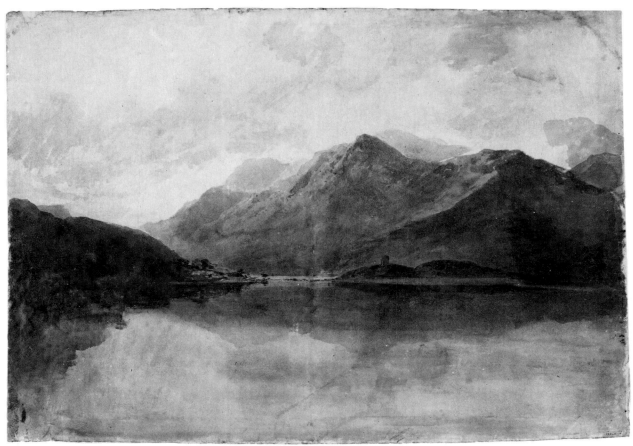

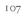

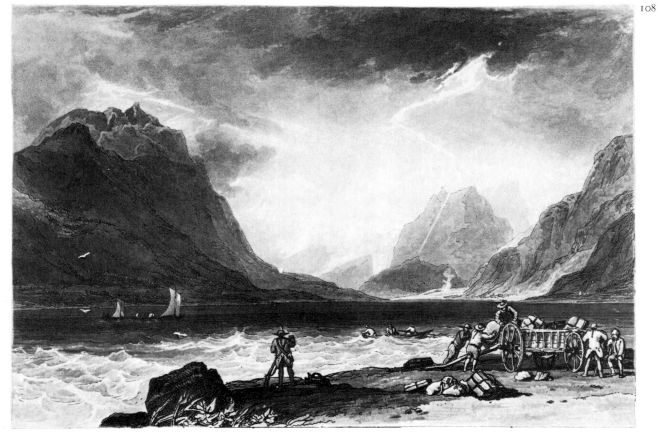

107 Lake Llanberis with Dolbadern Castle *c.* 1799

Pencil and watercolour, $21\frac{3}{4} \times 29\frac{15}{16}$ (553×761)
Inscr. lower right: 53
TB LXX–X, BM 1975(20)

Both Dolbadern Castle and Lake Llanberis were to prove recurrent inspirations to Turner in the course of his career. The castle was the subject of his Diploma picture, presented to the Royal Academy on his election as Academician in 1802 (see p. 40), and the lake provided one of the most dramatic of the *England and Wales* views of the early 1830s. Another early study of the castle, from above, is *colour 5*. In this expansive sheet Turner establishes one of the quintessential features of lake scenery: the sense of great space bounded by clearly defined masses of land, the surface of the water taking the eye easily and rapidly over a great distance. As Gilpin realised, the clarity with which the space is enclosed gives us a scale by which to measure its extent, while the uniformity of the still water creates a sense of vastness. Here, tranquillity actually contributes to the sublime mood, and Turner was to repeat the formula innumerable times during his life.

J. M. W. Turner and Charles Turner, after J. M. W. Turner

108 Lake of Thun, Swiss (*Liber Studiorum*) 1808

Etching and mezzotint, printed in brown ink, first published state (R. 15), subject: $7\frac{3}{16} \times 10\frac{5}{16}$ (182×262); plate: $8\frac{1}{4} \times 11\frac{3}{8}$ (209×290)
Inscr. above: *Proof.* and *M*; below: *Drawn & Etchd by J.M.W. Turner Esqr. R.A.P.P.* and *Engraved by C. Turner*; with title, and lower left: *Proof*; bottom: *London Published June 10.1808 by C. Turner No. 50 Warren Street Fitzroy Square.*
Yale Center for British Art, Paul Mellon Collection,
B1977.14.8117

Turner made a finished watercolour of this subject,[1] as well as his usual sepia drawing for the plate.[2] As Ruskin noticed, he retained in all his designs 'the confusion of packages on the shore, by which he had been startled on landing at Neuhaus'.[3] The sudden electric storms that descend on central Swiss lakes were to occupy him rarely in his later visits; though he made one splendid study of a steamer beating through a thundercloud on Lake Lucerne in about 1841 (no 113).

1. Wilton 373, pl. 96.
2. TB CXVI–R.
3. Ruskin, *Works*, XXI, p. 221.

109 Simmer Lake, near Askrigg *c.* 1818

Watercolour with scratching-out, $11\frac{5}{16} \times 16\frac{1}{4}$ (287×412)
Inscr. lower right: *I M W Turner RA 4*(?)
British Museum, Salting Bequest, 1910–2–12–280, Wilton 571
Colour plate 27

Turner's sense of the calm splendour of a windless lake here finds full mature expression. He was later to vary and develop the ideas presented here, but he continued to use compositions like this one all his life; compare *Ullswater* (no. 111) and *The Lake of Uri from Brunnen* (no. 121). The elements of foreground, lake and far hills arranged in strips across the sheet provide one of Turner's most stable designs, which is given intensity by the burst of light in the sky above, a radiant benediction on the humble activities that are precisely catalogued along the lake shore, and on its surface. The

numeral '4' which appears after Turner's signature is hard to explain. The drawing belongs to the series of illustrations to Dr Whitaker's *History of Richmondshire* which appeared in 1819–23, with twenty plates engraved after Turner (see nos 34–6). There is no apparent reason to associate the numeral with the project.

James Tibbitts Willmore (1800–63), after J. M. W. Turner

110 Llanberis Lake, Wales (*England and Wales*) 1834

Engraving, third state (R. 279), subject: $6\frac{1}{2} \times 9\frac{9}{16}$ (164×243); plate: $9\frac{15}{16} \times 12\frac{7}{16}$ (253×316)
Inscr. below: with names of artist and engraver, and title (as *Llanberis Lake*); lower right: *Printed by Mr Queen*; bottom: *London, Published 1834, by Moon, Boys & Graves, 6, Pall Mall.*
Yale Center for British Art, Paul Mellon Collection,
B1977.14.13398

This is a return to the subject of no. 107; like others of the *England and Wales* series, it presents its material more comprehensively than before, forging a mass of information about the landscape into coherence by means of sweeping structural lines: as in the *Llanthony Abbey* (no. 11) the very air itself seems to be broken into vast chunks, apparently by beams of sunlight which create overlapping planes of light and dark against which the topography is disposed in counterpoint. These beams of light fall almost horizontally across the design, giving it a stability that is otherwise absent: while Turner's lake views are usually of emphatic placidity, this is a scene in which the tranquil surface of the water is contrasted with the surging rhythms of the mountains and windblown trees.[1]

1. The original watercolour, in the National Galleries of Scotland, is Wilton 855; Shanes 64.

James Tibbitts Willmore (1800–63), after J. M. W. Turner

111 Ullswater, Cumberland (*England and Wales*) 1835

Engraving, printed on india paper, first published state (R. 284), subject: $6\frac{7}{16} \times 9\frac{9}{16}$ (164×243); plate: $8\frac{7}{8} \times 11\frac{5}{8}$ (225×295)
Yale Center for British Art, Paul Mellon Collection,
B1977.14.7079

The broad calm of Turner's late lake subjects is here established.[1] Gilpin expatiates at length on the view of Ullswater, 'the largest lake in this country, except Windermere; being eight miles long; and about two broad in the widest part; tho, in general, it rarely exceeds a mile in breadth . . . [descending from Matterdale] the whole scene of the lake opened before us; and such a scene, as almost drew from us the apostrophe of the inraptured bard,
 Visions of glory, spare my aching sight!
 Among all the *visions* of this inchanting country, we had seen nothing so beautifully sublime, so correctly picturesque as this. – . . . "The effect of the *sublime*, Mr Burke informs us, is *astonishment*; and the effect of beauty, is pleasure: but when the two ingredients mix, the effect, he says, is in a good measure destroyed in both . . ." This refined reasoning does not seem intirely grounded on experience. – I do not remember any scene in which beauty and sublimity, according to my ideas, are more blended than in this: and tho Mr Burke's ideas of beauty are perhaps more exceptionable, than his ideas of the sublime; yet it happens, that most of the qualities, which he predicates of both, unite also in this scene . . .'[2]

1. The original watercolour, in an English private collection, is Wilton 860; Shanes 68.
2. Gilpin, 1786, vol. II, pp. 50–4. The 'bard' is Gray's (III l, i).

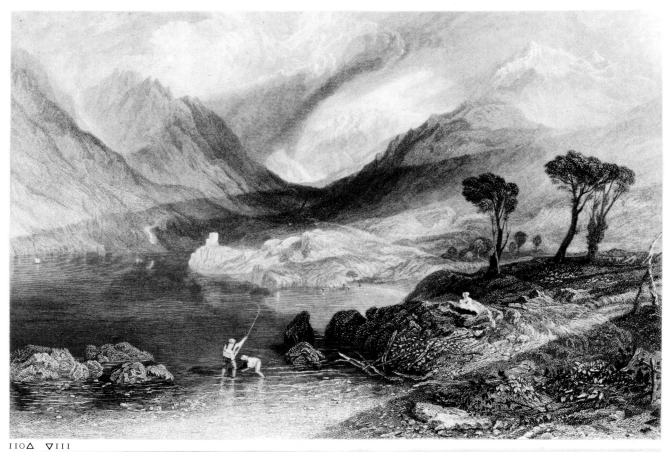

110△ ▽111

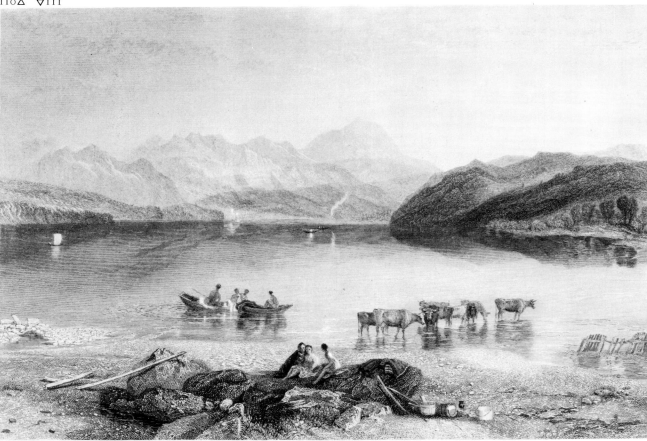

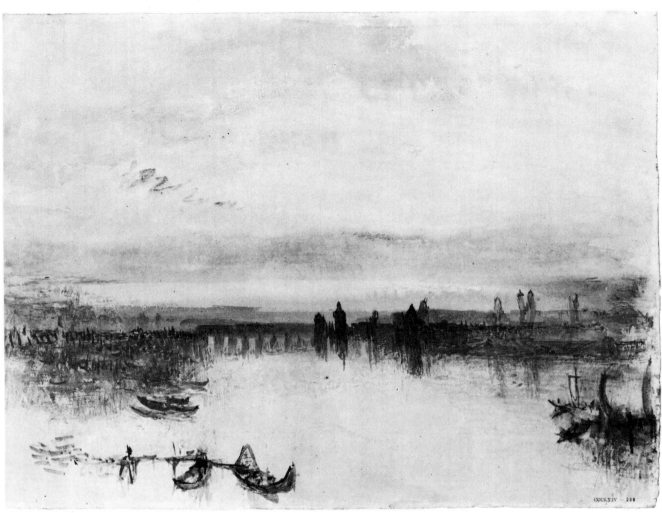

112

112　Constance 1841

Watercolour, $9\frac{5}{8} \times 12\frac{3}{16}$ (244 × 305)
TB CCCLXIV–288, BM 1975(281)

This subject exemplifies the openness of Turner's late continental drawings; its simple horizontal stress and its spaciousness perhaps reflect a deliberate search on Turner's part for the conditions that he had found in Venice in 1840. There, he had made a very large number of such studies in which the open expanse of the Bacino di S. Marco or the Lagoon plays an important part.[1] This view of Constance was submitted to Turner's agent, Thomas Griffith, at the end of 1841 and used as the basis of a finished watercolour,[2] one of the set of ten of 1842.

1. TB CCCXV, CCCXVI, CCCXVII, CCCXVIII. See RA 1947, pp. 154, 155 and BM 1975 nos 216–60.
2. Wilton 1531.

113　Steamboat in a storm (?)1841

Watercolour, $9\frac{1}{8} \times 11\frac{3}{8}$ (232 × 289)
Yale Center for British Art, Paul Mellon Collection,
B1977.14.4717, Wilton 1484

Although this drawing has not been identified as a lake scene, it corresponds closely in its colour and treatment to sheets from a sketchbook of 1841 in which Turner made studies on the Lake of Lucerne. These are now scattered in various collections: one shows *The first steamer on the Lake*,[1] another very atmospheric sheet the *Seelisberg by moonlight*;[2] the subject-matter of this drawing is therefore by no means out of place. Although the shores of the lake are not very apparent, there seems to be an indication of the twin-spired cathedral of Lucerne at the extreme left of the drawing; this would account for the absence of high hills, since the lake shore is comparatively flat at its northern (Lucerne) end. The flash of lightning indicated by a single scratch, partially covered by touches of watercolour, is one of Turner's boldest technical strokes. For an earlier representation of a Swiss lake storm see no. 108. See comments on the idea of sudden storm disturbing a calm sea, p. 100.

1. Wilton 1482.
2. Wilton 1479.

114　The Bay of Uri from Brunnen (?)1841

Watercolour over pencil, $9\frac{5}{8} \times 11\frac{11}{16}$ (244 × 298)
TB CCCLXIV–342

Possibly a sheet from the same dismembered sketchbook as no. 115. For further comment on these studies of Lake Lucerne, see no. 116.

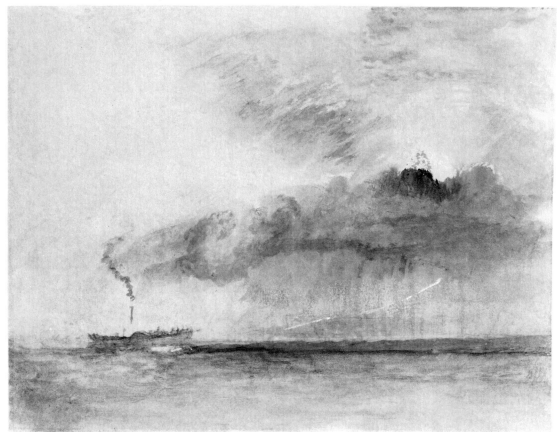

113

114

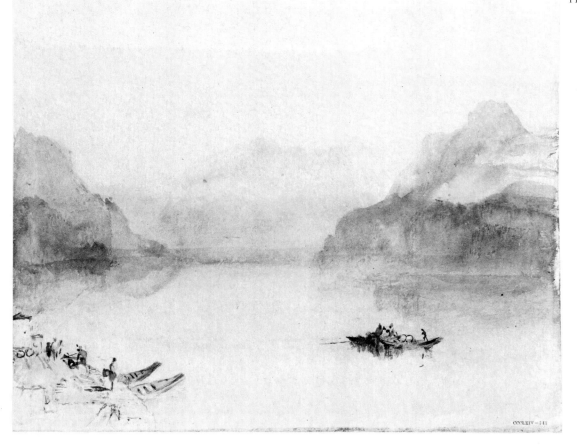

115 The Bay of Uri from Brunnen 1841

Watercolour, $9\frac{7}{16} \times 11\frac{9}{16}$ (240 × 294)
TB CCCLXIV–354
Colour plate 28

This is the study from which no. 116 (*colour 29*) was elaborated. For further comment on the subject-matter of the drawing, see the note to that work.

116 Lake Lucerne: the Bay of Uri from above Brunnen 1842

Watercolour over pencil, $11\frac{1}{2} \times 18$ (292 × 457)
Private Collection, U.S.A, Wilton 1526
Colour plate 29

The view over Lake Lucerne from above Brunnen was treated more often by Turner than any other Lucerne subject. He made numerous pencil and colour studies of it (see nos 114 and *colour 28*), and at least four finished watercolours between 1841 and 1845.[1] No. 123 is a print from one of the last of these to be completed, and no. 122 a view of the bay of Uri from the southern end. The view from Brunnen includes Grütli, the spot on the opposite shore of the lake where, in 1307, three men from Schwyz, Unterwalden and Uri met to swear fidelity to the idea of liberation from the oppression of the Hapsburg empire. But it is unlikely that Turner's fondness for the place had much to do with this historical association – the scenery itself corresponds precisely to the preoccupations that distinguish nearly all his late work. 'Opposite Brunnen, the lake of the Four Cantons changes at once its direction and its character. Along the bay of Uri . . . it stretches nearly N. and S. Its borders are perpendicular, and almost uninterrupted precipices; the basements and buttresses of colossal mountains, higher than any of those which overlook the other branches of the lake; and their snowy summits peer down from above the clouds, or through the gullies in their sides, upon the dark gulf below. . . On turning the corner of the promontory of Treib, a singular rock, called *Wytenstein*, rising like an obelisk out of the water, is passed, and the bay of Uri, in all its stupendous grandeur, bursts into view.'[2] Murray's handbook quotes Sir James Mackintosh as saying: 'The vast mountains rising on every side and closing at the end, with their rich clothing of wood, the sweet spots of verdant pasture scattered at their feet, and sometimes on their breast, and the expanse of water, unbroken by islands and almost undisturbed by any signs of living men, make an impression which it would be foolish to attempt to convey by words.'[3] The ineffability of the landscape is a quality that is, by contrast, fully conveyed by Turner's repeated essays in rendering it. This series of watercolours serves to remind us that the sublime was for Turner by no means an inevitably literary matter. It was always first and foremost a visual mode, capable of expressing itself without external references or allusion.

1. Wilton 1526, 1527, 1543, 1547.
2. Murray, *op. cit.*, p. 57.
3. *Memoirs of the Life of Sir James Mackintosh*, ed. Robert James Mackintosh, 2 vols, London, 1836, Vol. II, p. 307.

117 The Lake of Geneva with the Dent d'Oche, from Lausanne: a funeral 1841

Pencil and watercolour, $9\frac{1}{4} \times 13\frac{1}{8}$ (235 × 334)
TB CCCXXXIV–2
Colour plate 30

118

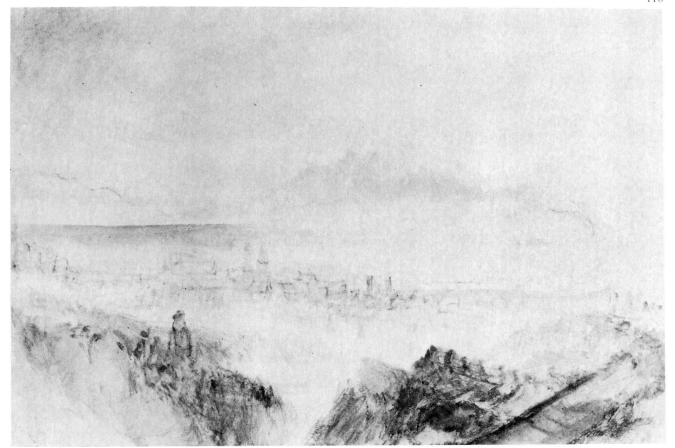

118 The Lake of Geneva with the Dent d'Oche, from
 above Lausanne 1841

Black chalk and watercolour, $9\frac{1}{4} \times 13\frac{1}{8}$ (235 × 334)
TB CCCXXXIV–7

119 The Lake of Geneva with the Dent d'Oche, from
 Lausanne 1841

Pencil and watercolour, $9\frac{1}{4} \times 13\frac{1}{8}$ (235 × 334)
TB CCCXXXIV–10
Colour plate 31

These are sheets from the *Lausanne* sketchbook, which probably dates from Turner's stay there in 1841. His fascination with Lake Geneva was hardly less marked than his love of Lake Lucerne, and just as there exist long sequences of drawings recording his meditations on the Rigi,[1] or at Brunnen (see no. 116), so there are an equally impressive group of studies made looking across to the mountains of France from Lausanne. These and nos 120 and 121 are five drawings of that view. They were not necessarily all done at the same time, but they all belong to the same profound and tranquil train of thought. Unlike Lake Lucerne, Lake Geneva does not seem ever to have been stormy for Turner: he saw it always – as indeed it frequently is – motionless, vast, stretching its length beyond reach of the eye in either direction, bounded, according to the climatic conditions of the moment, sometimes by haze, sometimes by the peaks of the Dent d'Oche and the Cornettes. Even here, the occupations of men and women have a place in his contemplations: a funeral passes, escorted by a division of soldiers (*colour 30*); or people tend the vines that grow along the terraces overhanging the lake (*colour 32*). Often, a complete panorama of the city is included in the prospect (no. 118). The mind wanders, entirely free of material trammellings, in a landscape immense and immutable, powerful yet benign, eternally energetic yet utterly at rest.

1. For reproductions of several Rigi subjects see *Turner in Switzerland*, pp. 86–91, 94–5.

120 The Lake of Geneva with the Dent d'Oche:
 tending the vines 1841

Watercolour, $9 \times 11\frac{7}{16}$ (228 × 291)
TB CCCXXXII–34, BM 1975(276)
Colour plate 32

Finberg identified this drawing, a leaf from the *Fribourg, Lausanne and Geneva* sketchbook, as a view of Mont Pilatus, opposite Lucerne,[1] but there seems little reason to doubt that it is in fact another of the series of studies looking out across the Lake of Geneva towards the Savoy Alps. For comment on this group, see nos 117–19.

1. This identification was followed in the British Museum 1975 catalogue.

121 The Lake of Geneva with the Dent d'Oche from
 above Lausanne (?)1841

Watercolour over pencil, $9 \times 12\frac{3}{4}$ (230 × 325)
TB CCCLXIV–274

No longer associated with any identified sketchbook, this loose sheet probably belongs to the same year as the other drawings of this view. But it is executed in a coarser technique than the rest, using stippling or hatching to suggest the thickening of light and air along the farther shore of the lake. Although such devices are common among the colour studies of the 1840s, the handling here is reminiscent of some of Turner's last finished watercolours,[1] and it is possible that this drawing belongs to the second half of the decade. For further comment see nos 117–119.

1. Wilton 1553–60.

122 Fluelen: morning (looking towards the lake) 1845

Watercolour with scraping-out, $11\frac{3}{4} \times 18\frac{15}{16}$ (299 × 481)
Engr: by John Ruskin (outline etching), published in *Works*, XIII, pl. XXIV
Yale Center for British Art, Paul Mellon Collection,
B1977.14.1715, Wilton 1541

Like the original of no. 123, this is a drawing from the set of ten Swiss views made in 1845. It is based on a study in the Turner Bequest.[1] As in other watercolours of this late date, Turner's distortions of scale are violent. The proportion of the little town of Fluelen to its overhanging cliff is much diminished: as in no. 123 the elements of the subject are flung apart by the expansive space between them so that the whole scene seems, as Ruskin put it, 'fading away into a mere dream of departing light'. Ruskin, who saw these late drawings as the valedictions of a pessimist, prophesied that with the 'cliff tunnelled now for the railway' the 'story of the "Sacred Lake, withdrawn among the hills"' would end.[2] Turner's drawing, for him, signals the end of Lake Lucerne, of beauty, of nature, of life; but that is surely not the spirit in which Turner revisited these favourite places so often in his late years. His drawings are certainly those of an old man, experienced, and perhaps saddened by much of life; but they affirm the continuance, not the demise of nature. Ruskin's attitude to the railway was wholly negative – so much so that he never wrote of Turner's masterpiece, *Rain, Steam and Speed*,[3] in all his copious effusions on his art; and when asked why Turner painted it, he replied that it was 'to show what he could do with so ugly a subject'.[4] Much of the pessimism with which Turner is credited is Ruskin's own, attributed by him to the artist because it was impossible for Ruskin to conceive of an alternative view of the world.

1. TB CCCLXIV–282; See Wilton 1540–9.
2. Ruskin's comments are in his 'Notes on his own drawings by Turner', *Works*, XIII, pp. 459–60.
3. Butlin & Joll 409.
4. *Works*, XXXV, p. 601, note.

Robert Wallis (1794–1878), after J. M. W. Turner

123 Lake of Lucerne 1854

Line engraving, india proof, second state (R. 671), subject: $11\frac{1}{2} \times 18\frac{5}{8}$ (292 × 473); plate: $16\frac{1}{2} \times 22\frac{13}{16}$ (420 × 580)
Inscr. below: with names of artist and engraver; centre: *London, Published May 27th 1854: by Henry Graves & Compl Printsellers in Ordinary to her Majesty and H.R.H. Prince Albert 6 Pall Mall.*; in pencil, outside plate-mark, probably in the engraver's hand: *Lucerne*; bears Printsellers' Association stamp.
Yale Center for British Art, Paul Mellon Collection, B1977.14.8076

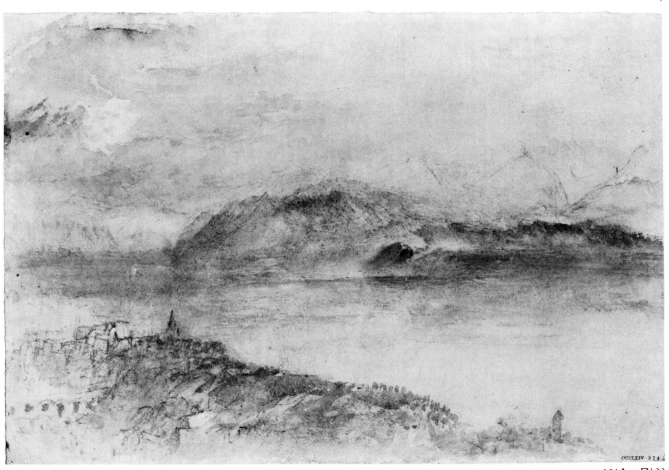

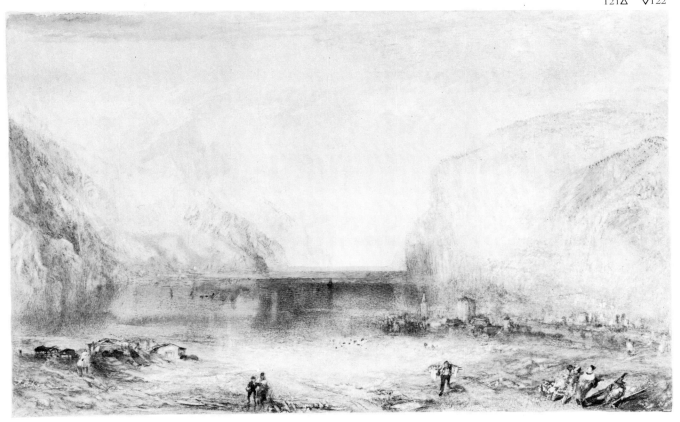

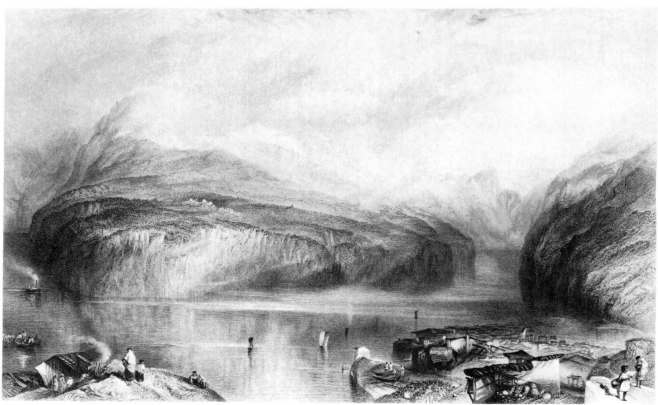

123

When published, this plate bore a dedication to B. G. Windus, the
first owner of the watercolour from which it is taken.[1] The original
drawing is unfortunately severely faded, and this print probably
conveys more accurately now the artist's intentions. Both this, the
Zurich (no. 93) and the watercolour no. 121 are subjects from the
1845 set of ten Swiss views. In all three, Turner revisits familiar
scenes to dilate more expansively than ever on a favourite theme.
The vast spaces of the Lake of Lucerne had attracted him as early as
1802, and a large watercolour made shortly after that first Swiss
tour[2] celebrates the grandeur of the high cliffs that rise from the
lake; their confining and constricting force is strongly presented
there, while in the late views it is the space between the mountains
that becomes the dominant element. In this subject, the viewpoint
is higher than before, and the landscape opened up so that the eye
travels deep into its recesses, swooping and darting across the
serene panorama like the moving sunbeams themselves. Turner
seems to be confirming the observation of another traveller, that
the Lucerne ferry, half-way across the lake, afforded 'a singular and
most beautiful view, composed of the mere elements of landscape –
of water combined with mountains melting into air'.[3]

1. Wilton 1547.
2. Wilton 378.
3. Sir James Mackintosh, *op. cit.*, p. 306.

SELECT BIBLIOGRAPHY

Addison, Joseph, 'On the Pleasures of the Imagination', *Spectator*, London, 21 June 1711 – 3 July 1712.

Alison, Archibald, *Essays on the Nature and Principles of Taste*, 2 vols, Edinburgh 1811.

Allen, Thomas, *A New and Complete History of the County of York*, 3rd ed., London 1831.

Barbier, C. P., *William Gilpin: his drawing, teaching and theory of the Picturesque*, Oxford 1963.

Blunt, Anthony, *Nicolas Poussin*, 2 vols, New York 1969.

Burke, Edmund, *An Enquiry into the Origin of our Ideas of the Sublime and Beautiful*, London 1757, 2nd ed., 1759. New ed. with introduction and notes by James T. Boulton, Notre Dame, Ind. 1958.

Butlin, Martin, and Joll, Evelyn, *The Paintings of J. M. W. Turner*, 2 vols, London 1977.

Diderot, Denis, *Oeuvres Esthétiques*, ed. Paul Vernière, Paris 1959.

Dobai, Johannes, *Die Kunstliteratur des Klassizismus und der Romantik in England*, 2 vols, Berne 1974, 1975.

Du Bos, Abbé Jean Baptiste, *Reflexions Critiques sur la Poésie et sur la Peinture*, 1719.

Finberg, A. J., *A Complete Inventory of the Drawings of the Turner Bequest*, 2 vols, London 1909.

Finberg, A. J., *Life of J.M.W. Turner*, 2nd ed., London 1961.

Finberg, A. J., *Turner's Sketches and Drawings*, 1910, new ed., New York 1968.

Finley, Gerald, 'The Genesis of Turner's "Landscape Sublime",' *Zeitschrift für Kunstgeschichte*, 42, 1979, pp. 141–65.

Friden, G., *James Fenimore Cooper and Ossian*, Cambridge 1949.

Gage, John, *Colour in Turner, Poetry and Truth*, London 1969.

Gage, John, 'Turner and the Picturesque', *Burlington Magazine*, CVII, January 1965, pp. 16–26.

Gilpin, William, *Observations relative Chiefly to Picturesque Beauty, Made in the Year 1772, on several parts of England; particularly the Mountains, and Lakes of Cumberland and Westmorland*, 2 vols, London 1786.

Hagstrum, Jean H., *The Sister Arts*, Chicago 1958.

Hamburg, Kunsthalle, *Ossian und die Kunst um 1800*, exhibition catalogue 1974.

Hawes, Louis, *Constable's Stonehenge*, Victoria & Albert Museum, London 1975.

Hipple, Walter, *The Beautiful, the Sublime, and the Picturesque in Eighteenth-Century British Aesthetic Theory*, Carbondale, Ill. 1957.

Hume, David, *Treatise of Human Nature*, 1739, ed. L. A. Selby-Bigge, Oxford 1888.

Kant, Immanuel, *Critique of Judgement* (*Kritik der Urteilskraft*, Berlin 1790), trans. J. H. Bernard, London 1931.

Klingender, Francis D., *Art and the Industrial Revolution*, 1947, new ed. [London] 1968.

Knight, Richard Payne, *An Analytical Inquiry into the Principles of Taste*, London 1805.

Lindsay, Jack, *J.M.W. Turner, His Life and Work, A Critical Biography*, London 1966.

London, Royal Academy, *J.M.W. Turner Bicentenary Exhibition*, catalogue by Martin Butlin, Andrew Wilton and John Gage, 1974–5.

McCarthy, J. I., ' "The Bard" of Thomas Grey: Its Composition and its use by painters', National Library of Wales, *Journal* XIV, 1, 1965, pp. 105–13.

Mackintosh, Robert James, ed., *Memoirs of the Life of Sir James Mackintosh*, 2 vols, London 1836.

Manwaring, Elizabeth Wheeler, *Italian Landscape in 18th Century England; a Study chiefly of the influence of Claude Lorrain and Salvator Rosa on English Taste, 1700–1800*, London 1925, new ed. 1965.

Monk, Samuel, *The Sublime*, London 1935.

Nicolson, Benedict, *Joseph Wright of Derby*, 2 vols, London 1968.

Rawlinson, W. G., *Turner's Liber Studiorum*, 2nd ed., London 1906.

Rawlinson, W. G., *The Engraved Work of J.M.W. Turner, R.A.*, 2 vols, London 1903, 1913.

Reynolds, Joshua, *Discourses on Art*, ed. R. R. Wark, Yale 1975.

The Works of Jonathan Richardson, London 1792.

Roget, J. L. and Pye, J., *Notes and Memoranda respecting the Liber Studiorum of J.M.W. Turner*, London 1879.

Ruskin, John, *Works* (Library Edition), ed. Sir E. T. Cook and A. Wedderburn, 39 vols, London 1903–12.

Russell, John and Wilton, Andrew, *Turner in Switzerland*, Zurich 1976.

Russell, Ronald, *Guide to British Topographical Prints*, London 1979.

Shanes, Eric, *Turner's Picturesque Views in England and Wales*, London 1979.

Smith, William, *Dionysius Longinus on the Sublime, Translated from the Greek with Notes and Observations*, London 1751.

Sotheby, William, *A Tour through Wales, Sonnets, Odes, and other Poems*, London 1794.

Stewart, Dugald, *Philosophical Essays*, 3rd ed., Edinburgh 1818.

Thornbury, Walter, *The Life and Correspondence of J.M.W. Turner, RA*, rev. ed., London 1877.

Usher, James, *Clio; or, a Discourse on Taste. Addressed to a Young Lady*, London, 1769.

Warner, Richard, *A Walk through Wales in August 1797*, London 1798.

Whitaker, T. D., *An History of Richmondshire in the North Riding of the County of York*, 2 vols, London, 1823.

White, Christopher, *English Landscape 1630–1850*, New Haven 1977.

Wilton, Andrew, *Turner in the British Museum*, London 1975.

Wilton, Andrew, *British Watercolours, 1750–1850*, Oxford 1977.

Wilton, Andrew, *J.M.W. Turner: His Art and Life*, New York 1979.

Wilton, Andrew, *William Pars, Journey through the Alps*, Zurich 1979.

Wlecke, Albert O., *Wordsworth and the Sublime*, Berkeley 1973.

Woodbridge, Kenneth, *Landscape and Antiquity: Aspects of English Culture at Stourhead, 1718–1838*, 1970.

Wright, Thomas, *Life of Richard Wilson, R.A.*, London 1824.

Ziff, Jerrold, 'Turner and Poussin', *Burlington Magazine*, CV, 1963, pp. 215–21.

Ziff, Jerrold, ' "Backgrounds, Introduction of Architecture and Landscape": A Lecture by J.M.W. Turner', *Journal of the Warburg and Courtauld Institutes*, XXVI, 1963, pp. 124–47.

CONCORDANCE

Numbers in the right-hand columns are those of catalogue entries.

TURNER BEQUEST

XVI-G	55	R.45	70
XXII-P	13	R.61	44
XXVII-R	1	R.69	32
L-B	3	R.81	72
L-G	14	R.88	48
LVIII-5	18		
LVIII-34	7	RAWLINSON	
LX(a)-A	4	*The Engraved Work . . .*	
LXX-Q	41	R.173	36
LXX-X	107	R.181	34
LXX-Z	5	R.182	35
LXX-b	6	R.214	37
LXXIV-55	22	R.225	62
LXXV-23	21	R.235	79
LXXV-34	19	R.260	83
LXXV-35	20	R.273	84
LXXX-G	51	R.276	38
XCV(a)-G	40	R.279	110
CXVII-Y	94	R.282	86
CXVIII-B	31	R.287	11
CXVIII-X	47	R.288	63
CXIX-R	45	R.290	64
CXX-X	46	R.293	65
CXXI-B	50	R.302	39
CLIV-O	30	R.599	52
CLXXXIX-6	16	R.616	53
CLXXXIX-13	17	R.649	54
CLXXXIX-46	82	R.671	123
CXCV-120	15	R.672	93
CXCVI-N	59	R.751	56
CCLXIII-32	60	R.752	73
CCLXIII-91	80	R.794	49
CCLXIII-128	85	R.795	71
CCLXIII-195	23	R.799	74
CCLXIII-258	97	R.800	78
CCLXIII-262	96	R.801	76
CCLXIII-309(a)	61	R.805	77
CCCXXXII-34	120	R.811	57
CCCXXXIV-2	117		
CCCXXXIV-7	118		
CCCXXXIV-10	119	Catalogue of watercolours in	
CCCXXXV-12	89	WILTON, *J. M. W. Turner, His*	
CCCLII-9	92	*Art and Life*	
CCCLVII-6	69		
CCCLXIV-209	103	65	1
CCCLXIV-224	75	250	2
CCCLXIV-274	121	281	8
CCCLXIV-276	98	365	24
CCCLXIV-281	105	396	27
CCCLXIV-288	112	399	51
CCCLXIV-342	114	533	28
CCCLXIV-350	90	544	81
CCCLXIV-351	100	547	29
CCCLXIV-354	115	571	109
CCCLXIV-362	102	697	33
CCCLXV-36	66	769	75
CCCLXXV-7	12	772	61
		1019	88
		1070	87
RAWLINSON		1143	95
Liber Studiorum		1406	67
		1425	68
R.6	42	1440	99
R.9	25	1484	113
R.15	108	1520	91
R.16	43	1521	101
R.18	9	1526	116
R.19	26	1537	106
R.24	58	1538	104
R.25	10	1541	122

INDEX

Figures in roman refer to page numbers, figures in brackets to note numbers and figures in italics to catalogue numbers.

Academies sketchbook *49*
Addison, Joseph 10, 12, 24(n.6), 28, 30, 31, 66, 105, 189; *37*
Alison, Archibald 30, 47(n.24), 78, 99, 103(n.48, 69), 189
Alpine Gorge 89, 100
Amateur Artist, The 50
Ambleteuse and Wimereux sketchbook *69*
Among the mountains 97
Ancient Carthage – the Embarcation of Regulus 101; *54, 104*
Ancient Italy – Ovid banished from Rome 54
Apollo and Python 72; *42*
Aristotle 15, 24(n.25), 28, 30, 47 (n.11); *54*
Army of Medes destroyed in the desart by a whirlwind 45
Atkyns, John Tracy 25, 26, 30, 47 (n.2)
Avalanche in the Grisons 106

Barlow, Thomas Oldham *57*
Battle of Fort Rock, Val d'Aouste, Piedmont 19, 41, 51, 81, 98
Bay of Uri from Brunnen 108, 109, 114
Study *115*
Ben Arthur 18
Ben Arthur, Scotland 32
Ben Lomond Mountain, Scotland: The Traveller, vide Ossian's War of Caros 44; *40, 70*
Blair, Hugh 12, 24(n.2, 11), 46, 48 (n.83, 85), 74, 77, 80, 103(n.38, 47, 53)
Blake, William 12, 42, 97, 103(n.56)
Bright Stone of Honour (Ehrenbreitstein) and the Tomb of Marceau, from Byron's 'Childe Harold' 97
Bryant, Jacob 12
Burke, Edmund 28–30, 32, 40, 47(n.16), 48 (n.63, 71), 66, 79, 101, 103(n.5, 35, 77–9), 189; *23, 79, 104, 106, 111*
Buttermere Lake with part of Cromackwater, Cumberland, a shower 35–7, FIG VII
Byron, Lord George 77, 97, 103 (n.45); *71, 87*

Calais pier sketchbook *46*
Carlisle 87, 88
Catania, Sicily 77a, b
Cathedral Church at Lincoln 67, FIG. XI, 68
Chain Bridge over the River Tees 39
Chain of Alps from Grenoble to Chamonix 94
Claude, *see* Lorrain
Clint, George *70*
Coalbrookdale by night 86
Coast of Yorkshire near Whitby 58
Coleridge 12, 24(n.12), 28, 47(n.13)
Coniston Fells, Cumberland, Morning amongst the 39, 40, 45
Constance 112
Cooke, George *95*
Cooke, W. B. *65*
Cooper, James Fenimore 9, 10, 24 (n.1), 31, 104
Cooper, John Gilbert *42, 48(n.65)*

Courbet, Gustave 99, 103(n.72)
Coventry, Warwickshire 84
Cozens, Alexander 21, 24(n.25), 44
Cozens, John Robert 24(n.25), 44, 45, 78, 101; *7, 12, 27, 33, 94*
Cradock, Joseph 31, 47(n.26)
Crichton Castle with a rainbow 95

Danby, Francis 49, 71, 78
Dayes, Edward *1, 13*
Decline of Carthage 71
Decline of the Carthaginian Empire 75
Deluge, The
(John Martin 75, FIG XIV
(Nicolas Poussin) 71; *47*
(J. M. W. Turner) 46–9, 71
Destruction of Sodom 45
Devil's Bridge, Pass of St Gothard 19
Diderot, Denis 39, 45, 47(n.52–6), 189
Dido Building Carthage 75
Dolbadern and the pass of Llanberis 5
Dolbadern Castle, North Wales 40, FIG X, 42, 43, 68, 69
Dryden, John 15, 24(n.26)
Ducros, Abraham-Louis-Rodolphe *14, 17*
Dudley, Worcestershire 85, 86
Dunkarton, Robert *10*
Dunstanburgh Castle 36
Dutch boats in a gale: fishermen endeavouring to put their fish on board 46

England and Wales series *1, 11, 37–9, 62–6, 74, 79–81, 83–7, 107, 110, 111*
Entrance to Fowey Harbour, Cornwall 62, 65
Eruption of the Souffrier Mountains, in the Island of St Vincent, at midnight, on the 30th of April, 1812 33
Eruption of Vesuvius 33
Evening of the Deluge, The 49, 53
Evening Gun, The 78
Evening Landscape with Castle and Bridge 2

Fall of an Avalanche in the Grisons 98, 99; 49
Fall of the Rebel Angels 52, 53
Fall of the Tees 36, 37, 83
Falls of the Clyde 9
Field of Waterloo 49, 71, 106
Fifth Plague of Egypt 43–5
First-Rate taking in stores 59
First steamer on the Lake of Lucerne 113
Fisher, S. *84*
Fishermen at Sea 37, FIG VIII, 39, 40
Fluelen: morning (looking towards the lake) 93, 122
Foot of St Gothard 101
Fort Rock, Val d'Aouste, Piedmont, Battle of 19, 41, 51, 81, 98
Forum Romanum 82
Fowey Harbour, Cornwall, Entrance to 62, 65
Fribourg 89
Fribourg, Lausanne and Geneva sketchbook *120*
Fuseli, Henry 15–17, 24(n.27, 31, 38)

Gainsborough, Thomas 21, 24(n.46)

Gandy, Joseph Michael *82*
Garreteer's Petition 69; 50
Gilpin, Rev. William 31–5, 47(n.27, 29, 30), 101, 189; *107, 111*
Girtin, Thomas 42–4, 47(n.33), 72, 103(n.35); *12, 79*
Glacier and Source of the Arveiron, going up to the Mer de Glace 24, 27
Glacier des Bossons 99
Goddess of discord choosing the apple of contention in the garden of Hesperides 42, 49
Goldau 98; 103, 106
Goldau with the Lake of Zug in the distance 104, 105
Goodall, Edward *37, 52, 87*
Gordale Scar 45; *30, 104*
Gray, Thomas 26, 27, 30, 31, 42, 44, 47, 47(n.31); 48(n.70), 72, 78, 100; *31*
Grenoble sketchbook *23*
Grey Mountains 96
Grisons,
Avalanche in the 106
Fall of an Avalanche in the 98, 99; *49*

Hakewill, James *33*
Hannibal crossing the Alps 36, 72, FIG. XIII, 74; *49, 51*
Hardraw Fall 34; 35
Hearne, Thomas *1*
Heidelberg Castle in the Olden Time 92
Heidelberg: looking west with a low sun 92
Heidelberg sketchbook *92*
Hind Head Hill On the Portsmouth Road 10
Hogarth, William 16; *50*
Garrick in the character of Richard III 16, FIG. II
Homer 12, 14, 15, 20, 30
Horace 15, 24(n.23), 25; *54*
Hospice of the Great St Bernard 22
Colour study *23*
Hudson River school 104
Hurrah for the Whaler Erebus! Another Fish! 97
Hume, David 28, 47(n.14), 189

Ilfracombe 65
Illustration to a lecture on Perspective: Interior of a Prison 15
Interior of Christ Church Cathedral, Oxford 14

Jason 69; 42
Jason, from Ovid's Metamorphosis 42
Jeavons, Thomas *64*
Johnson, Samuel 15, 23, 24, 24(n.29, 56)

Kames, Henry Home, Lord 24(n.9), 29, 47(n.17), 103(n.40)
Kant, Immanuel 27, 29, 47(n.7, 18, 19), 103(n.35), 189; *54, 104*
Keelmen heaving in coals by night 39; 73
Knight, Richard Payne 10, 15, 24(n.3, 4, 24), 28, 40, 47(n.9, 12), 48 (n.64, 65), 189

Lake Llanberis with Dolbadern Castle 107
Lake Lucerne: the Bay of Uri from above Brunnen 116

Lake of Geneva with the Dent d'Oche, from above Lausanne 118, 121
from Lausanne 119
from Lausanne:
a funeral 117
tending the vines 120
Lake of Lucerne 49, 123
Lake of Thun, Swiss 25, 108
Landseer, John *36*
Langhorne, John 25, 103(n.11)
Lausanne sketchbook *119*
Lausanne, Sunset 90
Lavater, Johann Caspar 65
Leeds 81, 83, 84
Lewis, Frederick Christian 71
Liber Studiorum 69, 189; 3, 9, 10, 18, 19, 21, 24–6, 31, 32, 39, 42–4, 47, 48, 56, 58, 61, 70, 72, 74, 94, 108
Life-boat and Manby apparatus going off to a stranded vessel making signals (blue lights) of distress 67
Light and Colour (Goethe's Theory) – The Morning after the Deluge 49, 52, 53
Limekiln at Coalbrookdale 86
Lincoln, Cathedral Church at 67, 68, FIG. XI
Little Devil's Bridge over the Reuss above Altdorf 25, 26
'Little Liber' 101; *49, 56, 61, 73–8*
Livy 27, 47(n.4), 72, 103(n.33)
Llanberis Lake, Wales 110
Llandaff Cathedral 68
Llanthony Abbey 1, 24
Llanthony Abbey, Monmouthshire 11, 110
Loch Coriskin 32
Longinus 10, 19, 30, 79, 189
Long-ships Light House, Lands End 63, 65
Lorrain, Claude 19–22, 32, 39, 43, 47 (n.1), 69
Lost to all Hope 68
Loutherberg, Philippe Jacques de 37, 99, 103(n.68); *42, 86*
Jason enchanting the Dragon 42
Lowestoffe, Suffolk 65, 66
Lucerne and Berne sketchbook *89*
Lupton, Thomas Goff *32, 56*
Lyme Regis, Dorset 64–6

Macpherson, James 15
Malham Cove 34; 28, 29
Martin, John 74, FIG. XIV, 103(n.39), 105; *49, 56*
The Deluge 75, FIG. XIV
Melincourt Waterfall 33, FIG. V
Mer de Glace, Chamonix 21
Messieurs les Voyageurs . . . in a snowdrift upon Mount Tarrar 80
Michelangelo 13–15, 17, 19, 20, 47
Expulsion of Adam and Eve from the Garden of Eden 14, FIG. I
Middiman, Samuel *34*
Mill near the Grande Chartreuse, Dauphiny 31
Milton, John 12, 13, 22, 23, 24(n.56), 39, 40, 47(n.22), 97, 101, 103(n.56, 77); *49, 52, 85, 87*
Mont Blanc from Fort Rock in the Val d'Aosta 75; 51
Morning after the Deluge, The 49, 52, 53
Morning amongst the Coniston Fells, Cumberland 39, 40, 45

Morning, from Dr Langhorne's Visions of Fancy 68
Moselle Bridge, Coblenz 91
Moss Dale Fall 34
Mountain Pass: night 80
Mountain Torrent 7
Mountainous Landscape with a Lake 101
Mount St Gothard 25
Mayall, J. J. E. 104

Norham Castle: Study 3, 14
Northcote, James 9; 59
 Loss of the Halsewell 59

Oberwesel 49
Octagon, Ely Cathedral 13
Ossian 15, 55
Ovid 21; 54

Paestum 74, 75
Pannini, Giovanni Paolo 12
Pars, William 189; 19
Pass of Faido 80; 18, 26, 39, 101, 104
 Study 103
Patterdale Old Church 28, 29
Peace – burial at sea 54
Peat Bog, Scotland 70
Pembroke-castle: Clearing up of a thunderstorm 8
Pembroke Castle, South Wales: thunder storm approaching 8
Penmaen Mawr, Caernarvonshire 80; 38
Picturesque views of England and Wales, see England and Wales series
Piranesi, Giovanni Battista 12, 15, 16
Pliny 33
Ports of England series 56, 74
Poussin, Nicolas 20–2, 24(n.50), 32, 45, 69, 71, 72, 74, 103(n.25), 189; 43, 44, 47, 49
 The Deluge 71; 47
 Landscape with a Storm 24(n.50)
 Landscape with Pyramus and Thisbe 72, FIG. XII; 44
Prior, T. A. 92, 93
Pye, John 35

Quilley, J. P. 49

Radclyffe, Williams, 83
Rain, Steam and Speed 122
Raphael 14, 17, 19, 20; 46
Ravine on the pass of St Gothard 20
Regulus, Ancient Carthage – Embarcation of 101; 54, 104
Rembrandt 69
Reni, Guido 17
Reynolds, Sir Joshua 13–19, 20–2, 30, 33, 37, 42, 45, 47, 65, 66, 69–71, 74, 98, 189; 44, 50
 Mrs Siddons as the Tragic Muse 18, FIG. III
Richardson, Jonathan 9, 12, 24(n.14), 189
Richmond Hill 37
Rivers of England series 56, 73, 74
Rivers of Europe series 88
River with cattle and mountains beyond 6
Rockets and blue lights (close at hand) to warn steam-boats of shoal waters 67
Rome: The Forum with a Rainbow 82
Rome: The Portico of St Peter's with the Entrance to the Via Sagrestia 16
Rosa, Salvator 32, 40, 45, 69, 72; 42

Ruskin, John 80, 102, 103(n.54, 71, 81, 83), 106, 189; 7, 11, 19, 26, 29, 31, 36, 43, 55, 70, 75, 83, 86, 91, 99, 104, 105, 108, 122

Salisbury 102
Salisbury, Wiltshire 83
Say, William 44, 58
Scene in the Welsh Mountains with an army on the march 41
'Scottish Pencils' 7, 18, 29, 32
Scott, Sir Walter 32, 71, 87, 95
Seelisberg, by moonlight 113
'Sequel to the Liber Studiorum' 101
Shade and Darkness – The Evening of the Deluge 49, 53
Shakespeare, William 15, 22
Shelley, Percy Bysshe 104
Shields Lighthouse 76
Shields, on the River Tyne 73
Ship in a Storm 61
Shipwreck 46; 56
Simmer Lake, near Askrigg 109
Sinai's Thunder 53
Slave Ship, The or
Slavers throwing overboard the dead and dying – Typhoon coming on 98, FIG. XVI; 49, 106
Smith, John 'Warwick' 34
 Melincourt Cascade 34, FIG. VI
Smith, W. R. 39, 62, 63, 65
Snowstorm, Avalanche and Inundation – a scene in the upper part of the Val d'Aosta 101
Snow storm: Hannibal and his army crossing the Alps 32, 72, FIG. XIII, 74; 49, 51
Snow storm: a steam boat off a harbour's mouth 99; 61
Soane, Sir John 15, 82
Spithead sketchbook 10
St Catharine's Hill, Guildford 80
Steamboat in a storm 113
Stewart, Dugald 29, 46, 47(n.8, 20), 48(n.86), 76, 100, 103(n.2, 44, 73), 189
Stone Henge 102; 61, 74, 75, 79
Stonehenge at daybreak 72, 86
Storm off Dover 55
Storm over a rocky Coast 60
Stormy sea 66
Study for a Historical Composition: the Egyptian Host in the Red Sea 45
Study of an Industrial Town at Sunset 85
Study for 'The Deluge' 46
Study for the loss of a Man o' War 59
Sun of Venice going to Sea 100; 68

Teniers, David 19
Tenth Plague of Egypt 69; 44–6
Thomson, James 21–4, 24(n.52), 25, 29, 32, 36, 37, 42, 47(n.1, 32, 40, 44), 68, 98; 51
Thoresby, Ralph 27, 28, 44, 47(n.6)
Titian 21, 69, 71, 72
Tummel Bridge sketchbook 18
Turner, Charles 9, 25, 42, 43, 56, 73, 108

Upper Fall of the Reichenbach: rainbow 27

Vernet, Claude-Joseph 39, 45, 99, 102
 Sea port by Moonlight 38, FIG. IX
Vesuvius in eruption 101
Via Mala 102

View in North Wales 4
View through the columns of St Peter's Piazza, Rome 12
Vintage at Macon 69; 57

Wallis, Robert 53, 79, 86
War. The Exile and the Rock Limpet 76, FIG. XV; 54
Ward, James 45; 30
Ward, William 91
Warkworth Castle, Northumberland 68; 73
Warner, Richard 80, 189
Waterloo, Field of 49, 71, 106
Watteau, Antoine 19
Westall, Richard 42
Whale, The 69
Whales (boiling blubber) entangled in flow ice, endeavouring to extricate themselves 97
Whitaker, T. D. 189; 36, 37, 109
Wigstead, Henry 38
Wild Landscape, with Figures, at Sunset 40
Wilkie, David 50, 54
Willmore, James Tibbitts 11, 38, 49, 110, 111
Wilson, Benjamin 16
Wilson, Daniel 54
Wilson, Richard 21, 22, FIG. IV, 24 (n.44, 49), 37, 39, 40, 69, 71, 72, 74, 103(n.24), 189; 43
 Celadon and Amelia 71, FIG. IV
Wölfflin, Heinrich 24(n.16), 80, 189
Woollett, William 22, FIG. IV, 103 (n.24); 19
Wolverhampton 68
Wordsworth, William 25, 97, 189; 71
Wreck of a transport ship 46; 54, 57
Wreck on the Goodwin Sands 68
Wright of Derby, Joseph 37, 47(n.50), 189; 33, 86

Yarmouth Sands 67

Zoffany, Johann 16
Zurich 90, 93, 123
Zurich: fête, early morning 93